AMERICAN FURNITURE of the NINETEENTH CENTURY

AMERICAN FURNITURE of the NINETEENTH CENTURY

Celia Jackson Otto

CASTLE BOOKS · NEW YORK

Copyright © 1965 by Celia Otto
All rights reserved

First published in 1965 by The Viking Press, Inc.
625 Madison Avenue, New York, N.Y. 10022

Published simultaneously in Canada by
The Macmillan Company of Canada Limited

Designed by Nicolas Ducrot

Library of Congress catalog card number: 65-21483

This edition published by arrangement with THE VIKING PRESS, INC.

CONTENTS

INTRODUCTION

This book is an attempt to make an accurate record of the furniture evolutions of the nineteenth century in America. Many years ago, having attended numerous exhibitions of furniture of this period, I began to collect photographs, and with much research completed records of the English and French styles.

When I turned to documenting American furniture of the same century the challenge was much greater. It was apparent that French influence played an important part. Thomas Jefferson's furnishings from his Paris house were all shipped to America; the Monroes had a quantity of furniture for the White House made in Le Havre; and after the French Revolution in 1789 many families had emigrated to America, bringing some of their possessions. The names of some of the cabinetmakers are still well known: Charles Honoré Lannuier, C. A. Baudouine, and Alexander Roux of New York, A. Eliaers of Boston, A. G. Quervelle of Philadelphia, Michel Bouvier, Prudent Mallard, and François Seignouret of New Orleans. Later in the century Charles Grohé and Léon Marcotte arrived. All left their mark on American furniture styles. However, there were characteristic differences between the work of the Old World and that of the New; among the fine, established American cabinetmakers were such strong individualists as Duncan Phyfe and John Seymour and his son Thomas, whose styles were indigenous. Furthermore, in different regions of the country different woods were favored by the local makers; the work in Salem, for instance, was distinguished not only by first-class design and craftsmanship, but also by the use of much light wood on dark mahogany. In Baltimore the frames of Hepplewhite-type chairs were painted, and in the West domestic cherry and walnut were favored over mahogany. Thus the distinguishing characteristics of local craftsmen became a study in itself.

American furniture styles deriving directly from the French comprised the Empire, Restauration, French antique (later better known as rococo), the Renaissance style of Napoleon III, and the Second Empire of the Empress Eugénie with its Louis XVI interpolation. These were all adapted for the American market and continued to be made in large quantities through the eighties. In the nineties, most of the traditional features of cabinetmaking were abandoned, and there followed a definite development of new and distinctive designs, evidenced in the catalogues issued in Grand Rapids and Cincinnati.

In preparing the illustrations I have included pictures of French prototypes as well as contributions of American designers and makers whose skill and imagination set the style for their contemporaries. The examples have been chosen with the aims of identifying the distinctive features of each period and the special characteristics that mark the work of individual craftsmen or centers of cabinetmaking, and of showing how, in the natural course of events, furniture styles were influenced by social and historical developments outside the world of furniture.

7

THE CLASSIC PERIOD

At the beginning of the nineteenth century there were four main furniture centers in the United States: Philadelphia, New York, Boston and Salem, and Baltimore. Although communications were bad, furniture in the homes of wealthy citizens was in no way provincial, but of fashionable elegance.

At first American taste favored the universally adopted neoclassic style. Hepplewhite and Sheraton fashions were continued from the eighteenth century, and the American versions developed into a distinctive classic style, which, however, did not persist long after the first decade.

The French influence of the Directoire style, which was briefly popular, is seen in some American Directoire features: the scrolled top of a chair or settee back; the new back and cyma ends of the "Turquoise" settee; a bed, with head- and footboards of equal height, designed to be placed sideways against the wall; the use of columns, pilasters, and term figures on stiles.

In 1800 Philadelphia had Henry Connelly and Ephraim Haines, both conservative cabinetmakers in the Sheraton manner, and Joseph Fuches, Joseph Barry, and David Evans, three of the most prominent chairmakers. In New York, Duncan Phyfe, his reputation already established, was the leader in style and production. Other outstanding New York cabinetmakers were Michael Allison, John Budd, William Mills, Charles Honoré Lannuier, and Joseph and Edward Meeks. Makers of chairs included Gilbert and Thomas Ash and John K. Cowperthwaite.

The furniture output of Boston and Salem at the beginning of the century was also large, and consignments were shipped to other parts of the country. John Seymour and his son Thomas were foremost among a number of well-known Boston makers, including Ebenezer Knowlton, William Lemon, and Elijah Sanderson. In Salem there were Edmund Johnson, William Hook, John and Charles Lemon, and Thomas R. Williams. Their lavish use of light wood veneer on mahogany furniture, together with the slender-baluster Salem leg, contributed to a distinctive New England style.

In Baltimore local furniture closely followed the original Hepplewhite and Sheraton styles. Many British cabinetmakers arrived on Clippers to settle in this prosperous port. Hugh and John Finlay had a fashionable clientele, and much of their furniture was finely painted. Their accomplishments included a group of furniture for the White House made from designs of architect Benjamin Henry Latrobe.

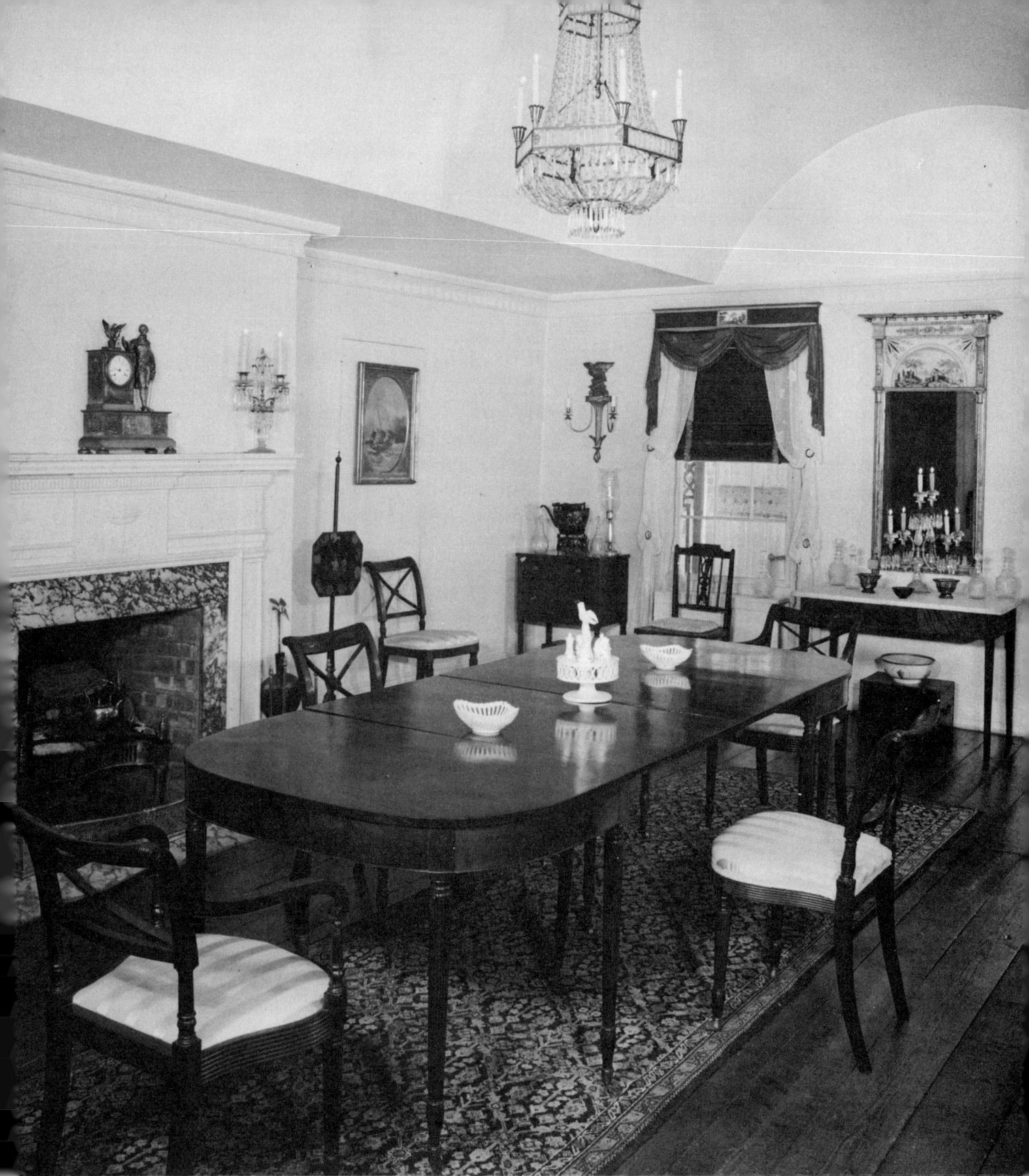

1. In Mrs. Harry H. Benkard's dining room the purity of style is maintained. The Duncan Phyfe square-backed chairs are family heirlooms; those at the windows have an ornamented vertical splat in the back and the six stretcher rails that were used on fancy chairs. The two-section table with rounded ends, blockings on the frieze, and five turned legs on each section is typical. The high serving table with drawers is a type frequently made by Phyfe. (*Courtesy Antiques Magazine.*)

In other, scattered, localities along the eastern seaboard excellent furniture was made, notably by Stephen Badlam in Dorchester, Massachusetts, John Carlile and Holmes Weaver in Rhode Island, Matthew Egerton, Jr., in New Jersey, and Jacob Forster in Charleston, South Carolina.

Bedroom Furniture

Already in the last decade of the eighteenth century a domesticated form of the American field bed had been successfully introduced. The frames of these beds were variously made in mahogany, maple, cherry, birch, or soft woods such as chestnut and pine. At the beginning of the nineteenth century the design of the field bed, like that of all furniture, showed the classic influence in its plain outlines and simply designed posts and headboards. The New York price list of 1815 specified, as "extras," square-framed headboards or footboards, which could be paneled, carved, or upholstered. The canopy frame could be arched, crossed ogee or crossed double cyma. Fine netted or hand-embroidered draperies and coverlets enhanced the appearance of the beds.

A number of four-poster beds, most of them very handsome, were made in leading furniture centers. The style prevailed in the South, where the cornice was necessary to hold the mosquito curtain.

Charles Honoré Lannuier, the French cabinetmaker who established a New York workshop in 1805, introduced the French Directoire bed: this was designed to be placed sideways against the wall. The type was also adopted by Duncan Phyfe, as exemplified in the bed he made for Miss Throop in 1808. The French model was closely followed. Head- and footboards and front posts were of equal height; the back posts were six feet high, with curved slats on the wall to take a half-dome or corona, from which curtains were draped.

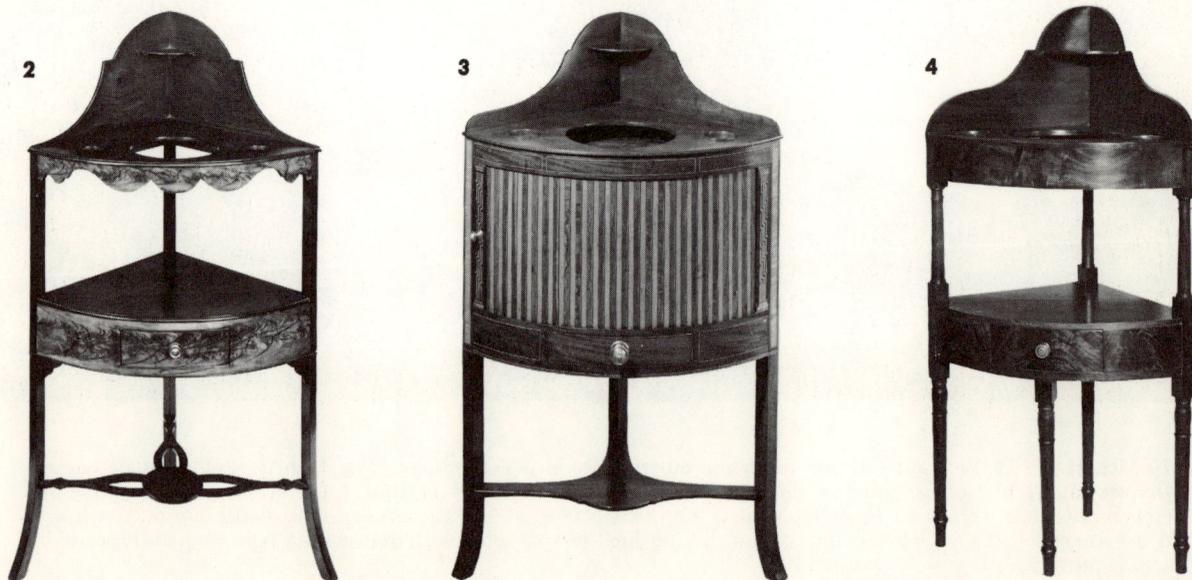

Plantation beds continued as a distinctive type. Early nineteenth-century examples were made with classic simplicity. They had four tall, massive posts and a full tester — not for a valance and curtains but with rails to take the mosquito net. On these early beds the frame and posts were not held together in the traditional manner by screws; instead, a tenon and mortise in the heavy posts and rails and the great weight of the tester afforded the necessary stability. Mattresses were high, to accommodate trundle beds.

A simpler type of bed, the low-post bedstead, was frequently made in local woods. Heavy posts were made in variants of baluster, block, and bulb; the headboard was a flat panel, shaped, with four tenons extended to be attached to the inside of the posts. At the foot there was sometimes a turned rail.

The time of the bedroom furniture suite had not yet arrived. Until about the middle of the century, with few exceptions, all items for the bedroom — beds, wardrobes, washstands, mirrors — were designed separately.

As the classic period advanced the mirror on the wall was replaced by a toilet mirror, with or without small drawers in its base. Bureaus were also made, although it is interesting to note that none were specified in New York price lists of 1802 or 1815. Probably the blanket chest was the type favored for the bedroom, the bureau being regarded more as a piece for the living room.

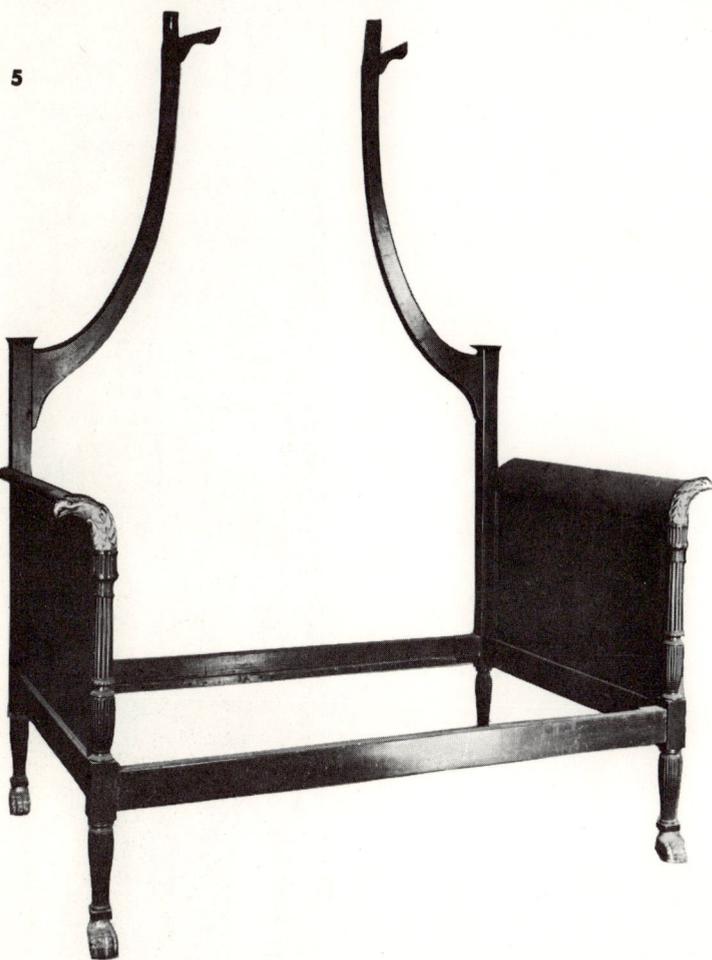

5

2, 3, 4. A corner washstand was a favored classic type. It generally has a peaked splashboard, a drawer, and a shaped shelf stretcher. Of the three illustrated, two are in the Museum of Fine Arts in Boston. The Seymour example, paneled with stringing, has a tambour cupboard door of mahogany and satinwood. A washstand by William Hook, c. 1808, also in mahogany and satinwood, has a shaped apron, three square-section legs, and small fan brackets under the drawer. On a third, attributed to Ephraim Haines, in the collection of Mr. Henry P. McIlhenny, small columns are used as supports, and a fourth leg is recessed in front. (4: *Photo: Philadelphia Museum of Art.*)

5. Bed in the Directoire manner by Charles Honoré Lannuier. It is made to be placed sideways, with front posts surmounted by eagle heads and, on the back posts, high shafts with swivel arms for curtains. The type was copied and was specified, even to the eagle heads, in the Cincinnati price list of 1836. (*Joe Kindig, Jr.*)

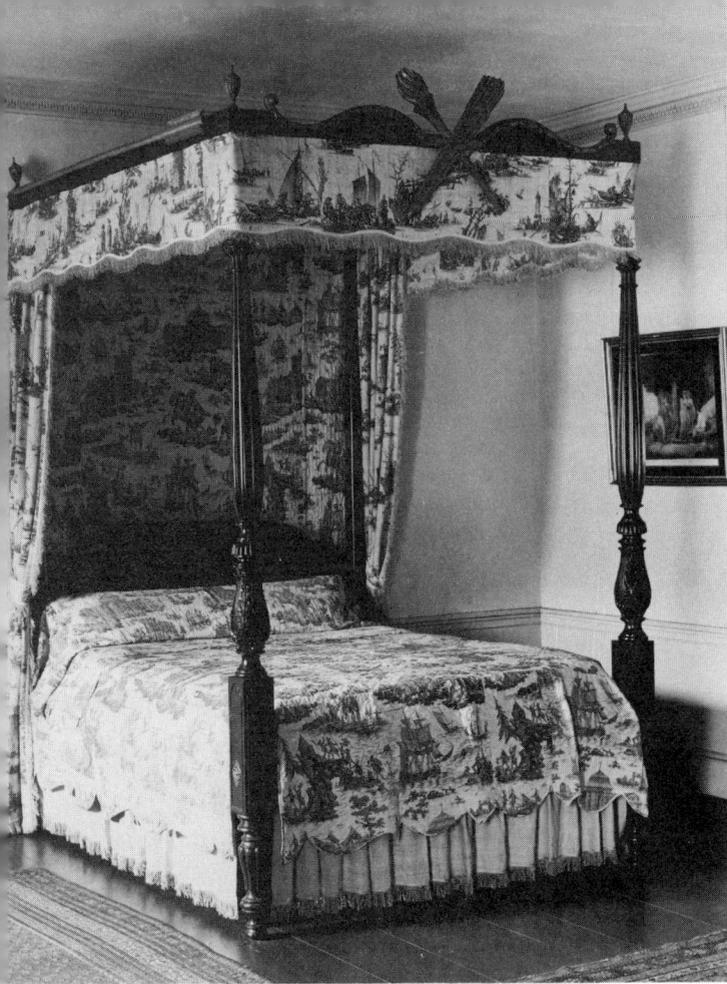

6. Four-post bed in the classic manner, made in 1809 for David Pingree. Its headboard is plain and flat; the ribbed posts rest on a foliate vase and heavy baluster legs. The black and gold cornice has a serpent scroll outline and quiver and torch trophy. Gilding is by John Doggett of Roxbury, Massachusetts. Similar beds, with the square leg of the eighteenth century, are in the Crowninshield bedroom in Pingree House and in the Metropolitan Museum of Art, New York. (*Museum of Fine Arts, Boston.*)

7. One of a pair of impressive plantation beds, classic in their austerity, with tapered baluster posts resting on the spoon-gouged blocks, to which the rails are attached without screws. The headboard is joined to the posts by extended tenons — a practical adjustment to the varying width of the posts. (*Mr. and Mrs. Charles J. Byrne, Cherokee, Natchez.*)

8. An elegant version of the classic high-post bedstead in Sweetbriar, Fairmount Park, has slender posts with small urn finials on spoon-gouged square blocks. The baluster legs have a knop above the foot; the headboard is plain, low, segmental. (*Philadelphia Museum of Art.*)

9. The low-post bedstead was in general use for simple bedrooms. In this classic example from Sunnyside, Tarrytown, the headboard is peaked, with four tenon extensions, the legs turned and slightly tapered. (*Sleepy Hollow Restorations.*)

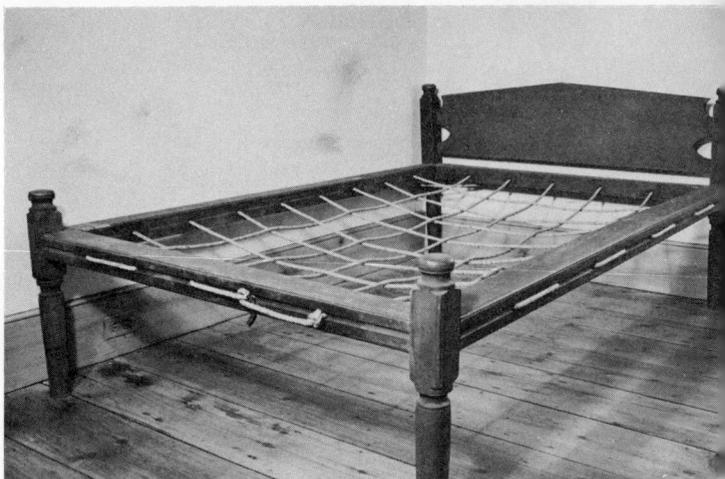

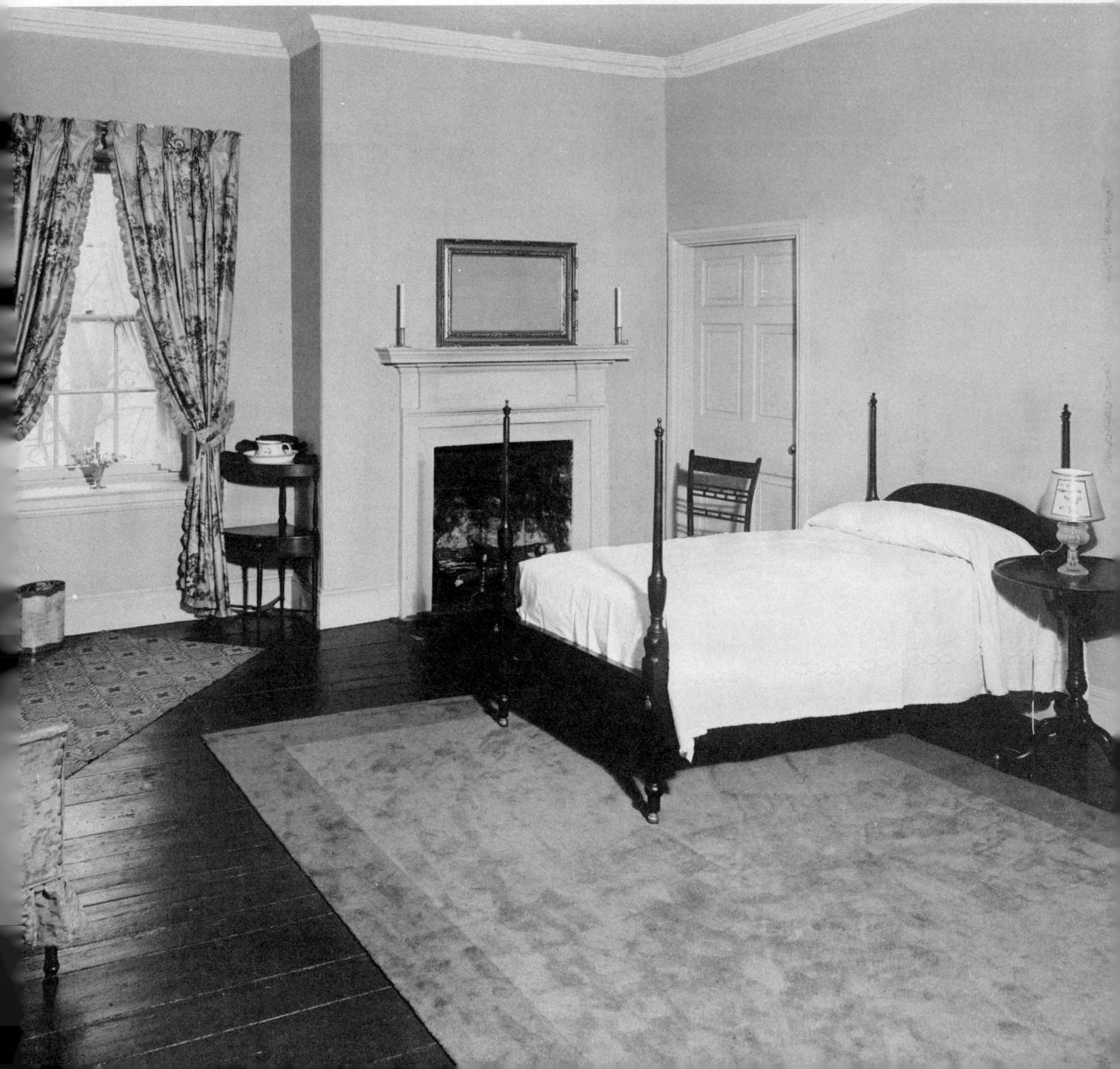

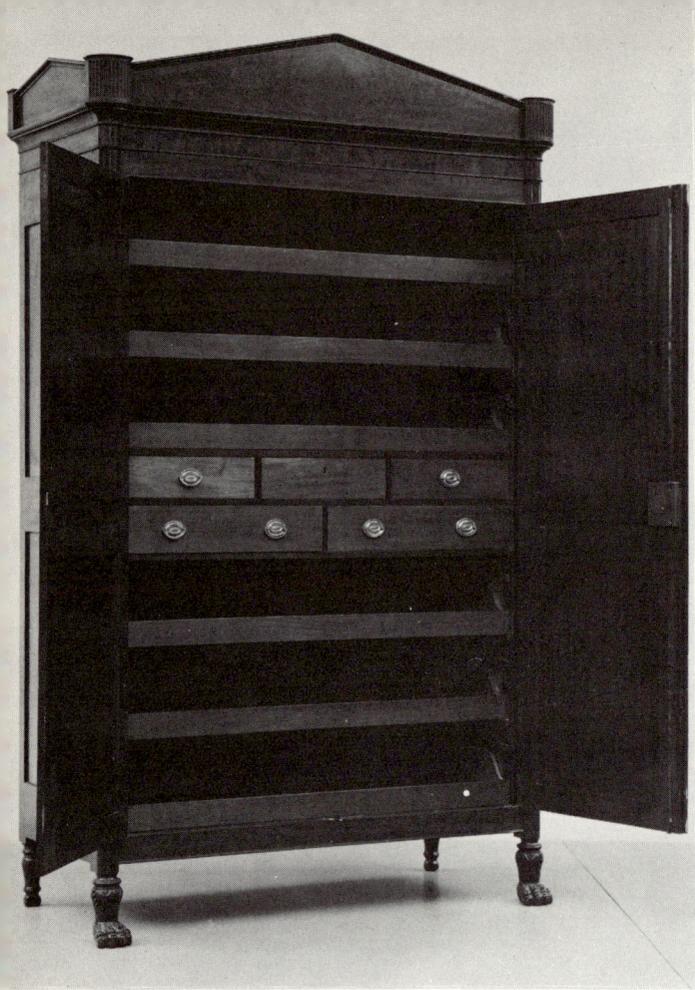

10

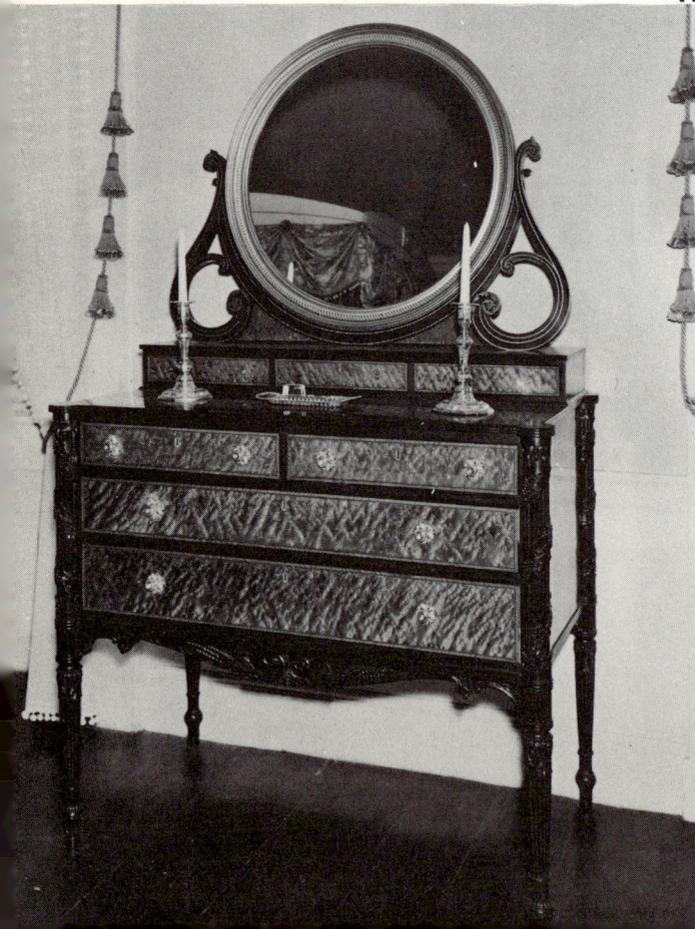

11

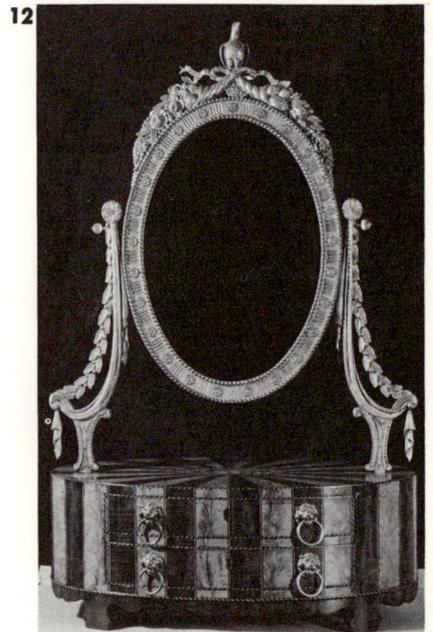

12

10. The press was still used for the storage of clothing. This example in mahogany, fitted with sliding trays and drawers, is termed a wardrobe in the New York price list, 1815. (*Metropolitan Museum of Art.*)

11. The Elias Haskett Derby dressing table in mahogany and bird's-eye maple, made between 1805 and 1808 by the Seymours. The base, with four drawers, is raised on short legs; at the back is a full-width case of drawers and a circular gilt mirror on ebonized supports conforming with the base of the mirror. (*Essex Institute, Salem.*)

12. A Seymour toilet mirror, c. 1809, in the style of the French *coiffeuse portative*. Its oval base, with cosmetic drawers, is veneered from a central ellipse on the top in bands of mahogany and feathered satinwood. The carving of the mirror frame, with supports of bay leaves, drapery and scrolls, and an eagle cresting, is attributed to Samuel McIntire. (*Museum of Fine Arts, Boston.*)

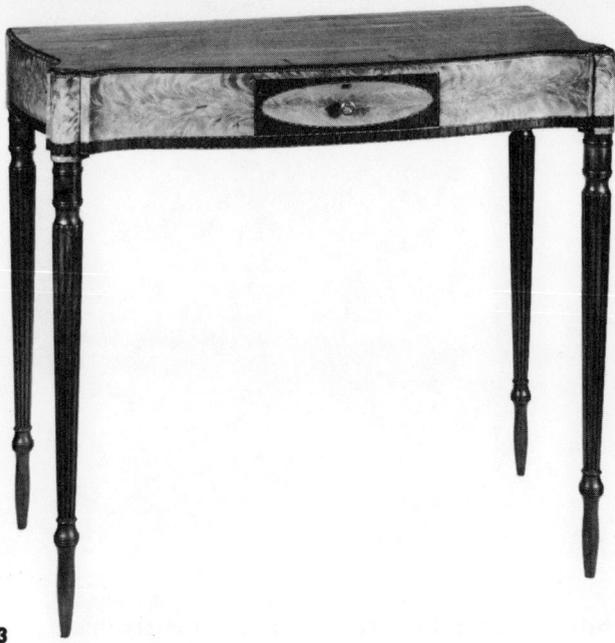

13

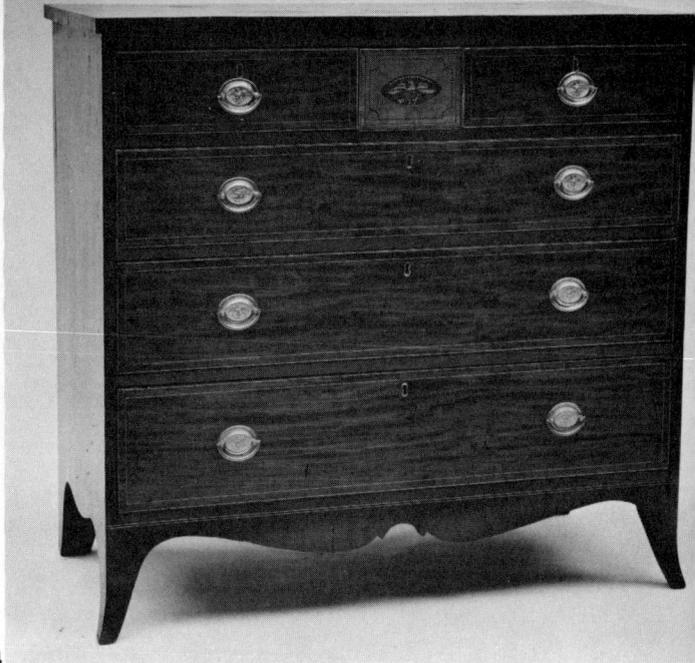

14

13. A Salem-type mahogany dressing table with serpentine front and ends, made by William Hook in 1808. The top, with ribbed edge, is expanded at the front angles to cover colonnettes surmounting fine Salem legs. Low in the center of the satinwood frieze is a small mahogany drawer with its escutcheon set sideways. (*Museum of Fine Arts, Boston.*)

14. Hepplewhite bureau with the label of Michael Allison. In the center of the three drawers is an inlaid eagle with shield and stars. Elliptical brass mounts are embossed with an eagle. An inscription on the bottom of one drawer reads, "Maria May Scott's chest of drawers given her by her mother, Elizabethtown, 1810." (*Metropolitan Museum of Art.*)

15. A small Sheraton classic toilet mirror with three drawers has French bracket feet. The frame of the oblong mirror is cross-banded. (*Philadelphia Museum of Art.*)

16. The drawer fronts of this Sheraton bureau (probably from Portsmouth, New Hampshire) are in three sections — a mahogany center with maple fans, flanked by cross-banded panels. In the center of a shaped apron is a rectangular tab. (*Henry Ford Museum, Dearborn.*)

15

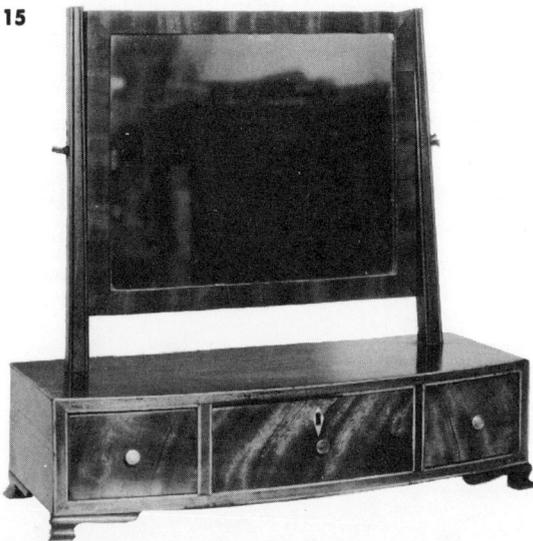

16

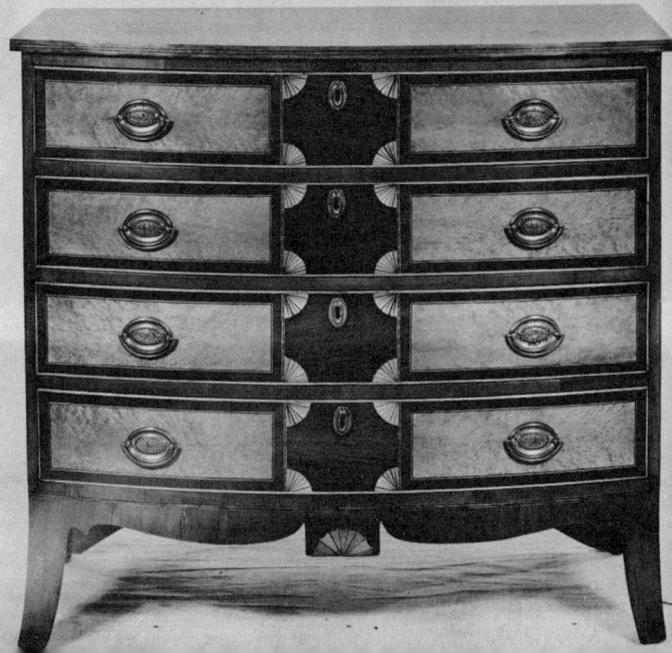

Chairs

Chairmaking was an important branch of the furniture industry. Cabinetmakers frequently made dining or parlor chairs with upholstered seats; the remainder, and by far the greater number of chairs — Windsor, Grecian, and "fancy," with wooden or mitered rush seats — were made in separate chairmaking establishments.

In 1802, the *New-York Book of Prices for Cabinet and Chair Work, Agreed upon by the Employers*, printed by Southwick and Crocker on Water Street, included the square-back chair. This new type appeared in four variants, each with seat rails for "stuffing over and plain taper'd legs."

No. I — "Straight top and stay rail; four upright splatts, straight seat."

No. II — "Three urn splatts, sweep stay and top rail with a brake [break] in ditto, the splatts pierc'd; sweep seat rails."

No. III — "Gothic arches and four turned columns, sweep stay and top rail with a brake in ditto."

No. IV — "Drapery bannister with feather top, a splatt on each side to form an arch with the top rail; bannister and splatts, pierc'd. Sweep stay and top rail, with a brake in ditto; sweep seat rails."

The square-back chair was widely made with variants of the cross, trellis, and drapery bannister. Duncan Phyfe, the Seymours, Connelly, Haines, and other makers produced their own versions.

From the beginning of the century there was marked expansion in the production of fancy chairs. These were made not in mahogany but in domestic woods, which were in abundant supply. The frames were often painted.

Baltimore was renowned for its fancy painted chairs, and the quality of local examples was above average. Usually the chairs were painted in beige or ivory and ornamented in color. Most of them had upholstered seats, which were more highly regarded than rush. John Staples, Thomas Renshaw, and his ornamenter, John Barnhart, were prominent among the early makers in Baltimore.

Patterson and Dennis of John Street, New York, announced "Elegant white, coquilocot [poppy], green and gilt Drawing Room Chairs, with cane and rush seats." This was an early use of the term "Drawing Room" instead of "parlor." Another maker, William Buttre, of the Bowery, also advertised black, white, brown, gold, and coquelicot chairs.

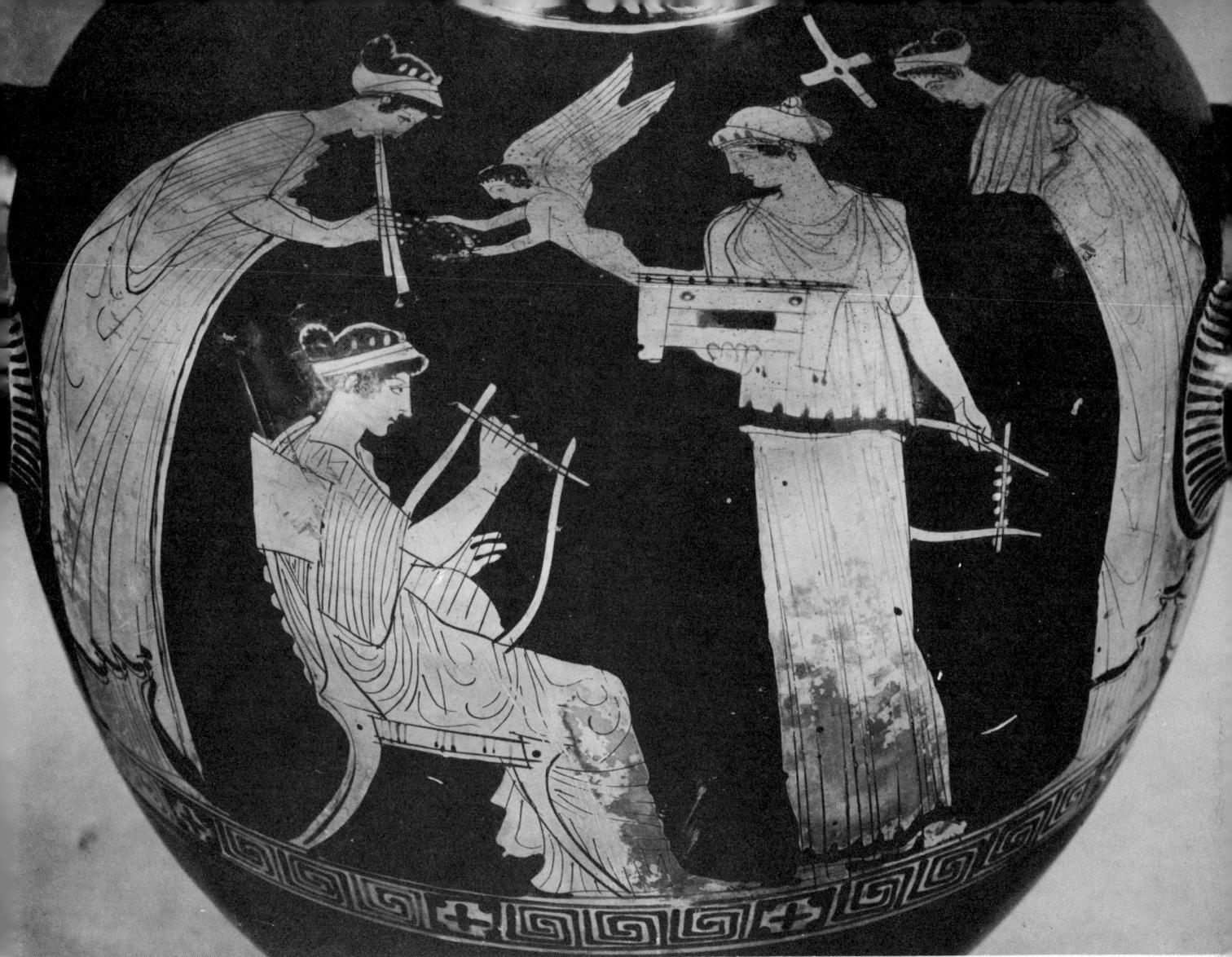

17

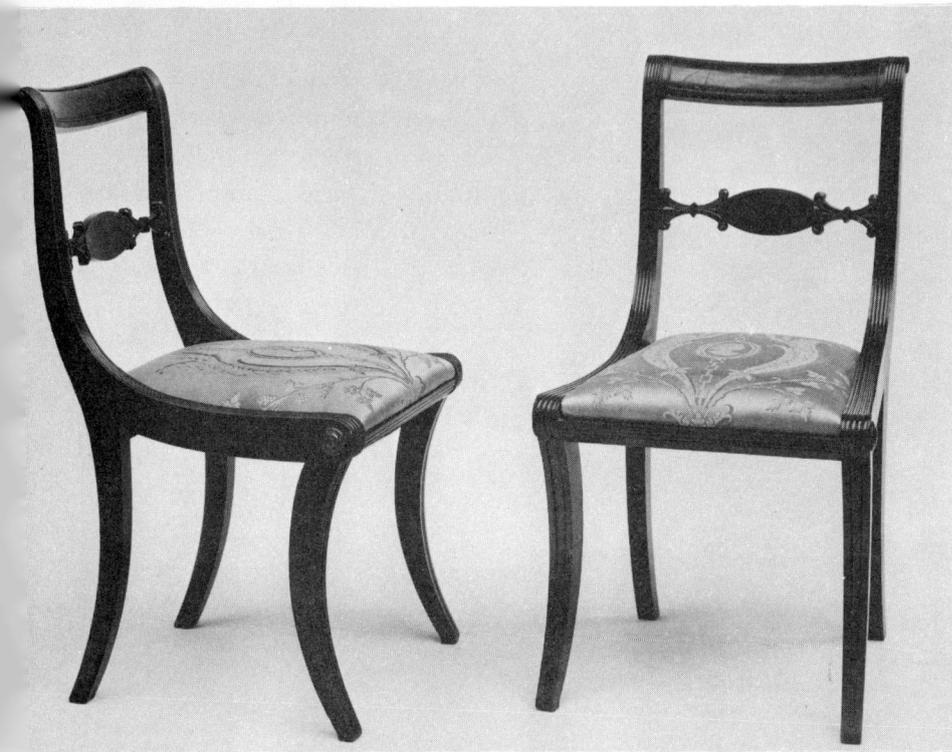

18

17. The Greek classic chair (klismos) is depicted repeatedly in painting and sculpture. Here it is clearly shown in a scene of women musicians, painted on a Greek hydria, c. 500–420 B.C. (*British Museum.*)

18. This American classic chair is of a type attributed to Duncan Phyfe. The curved stay rail is carved with a medallion and paired lotuses; a concave curved tablet is set between the uprights, and the whole of the top is scrolled. It was used as a dining or occasional chair. (*Metropolitan Museum of Art.*)

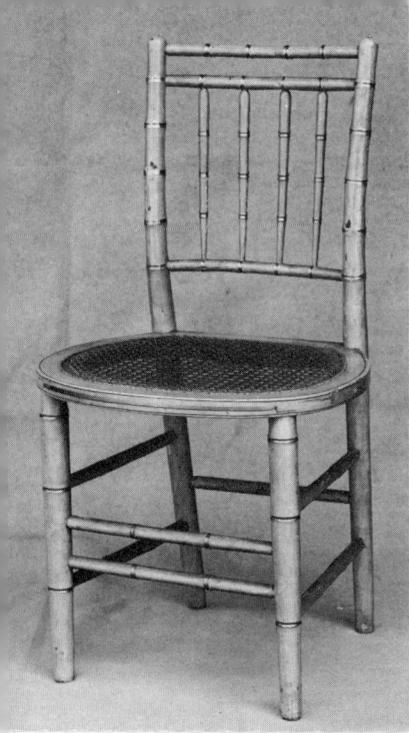

19

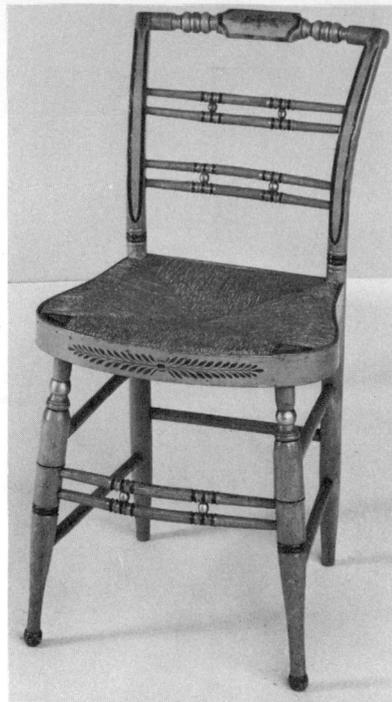

20

19. In Sheraton's *Cabinet Dictionary*, 1803, he refers to "Bamboo or Bamboe, a kind of Indian reed, used in the East for chairs ... imitated in England by turning beech in the same form and making chairs in this fashion" — an idea that was widely adopted in spite of the work involved. This cane-seated fancy chair, painted and gilded, has seven stretchers; posts for legs, tapering as uprights; square back. Gilded bamboo joints are carefully matched. (*Metropolitan Museum of Art*.)

20. The frame of a cream-painted maple fancy chair is partly bamboo-turned, with gilding. Paired bamboo stay rails are separated by two gilt balls, similar to those on the front stretcher. The reeded seat is mitered. This detail — bamboo rails separated by small balls, double or triple — was used by a number of early makers, among them Thomas Ash, Charles Fredericks, and Wheaton and Davis, who, in 1817, specified in an advertisement "Fancy Chairs ... Bamboo, Plain and Gilt Balls." (*Henry Ford Museum, Dearborn*.)

21. A square-back chair, one of a set in chestnut, has an urn splat flanked by vertical rails. Flowers are finely painted in natural colors on a simulated rosewood ground. (*Metropolitan Museum of Art*.)

22, 23, 24. On two "square"-backed chairs attributed to John Seymour the "square" (veneered with satinwood and carved with paterae) encloses a ribbed, concave-sided diamond. The satinwood tablet flanked by spindles between the uprights — a type very widely used — was shown in the *London Book of Prices*, 1808 (24). (22: *Metropolitan Museum of Art*. 23: *Museum of Fine Arts, Boston*.)

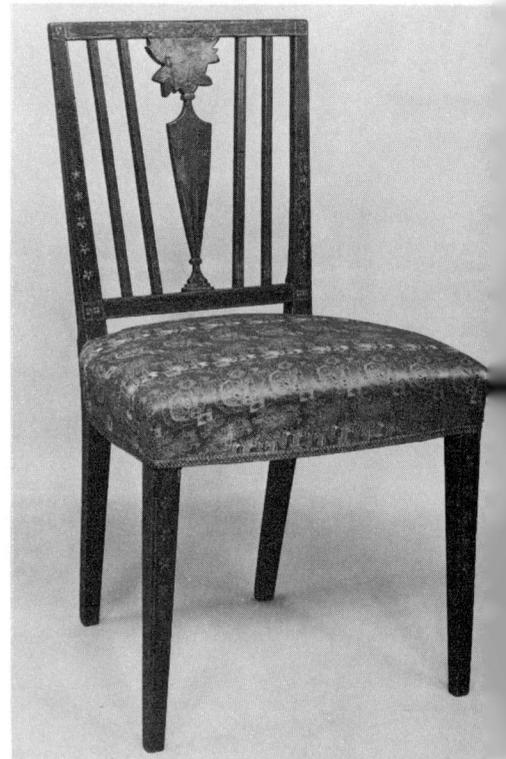

21

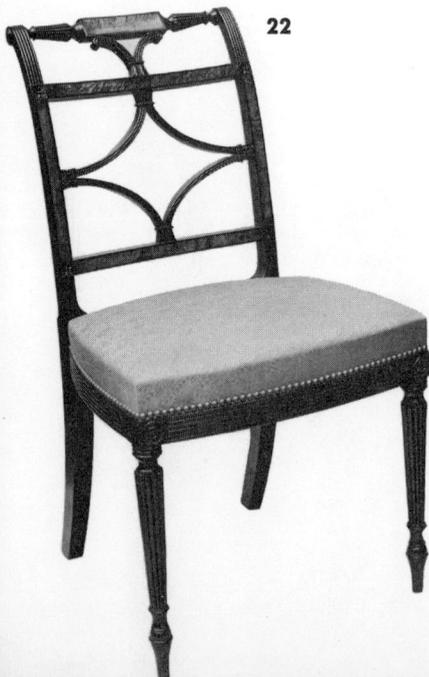

22

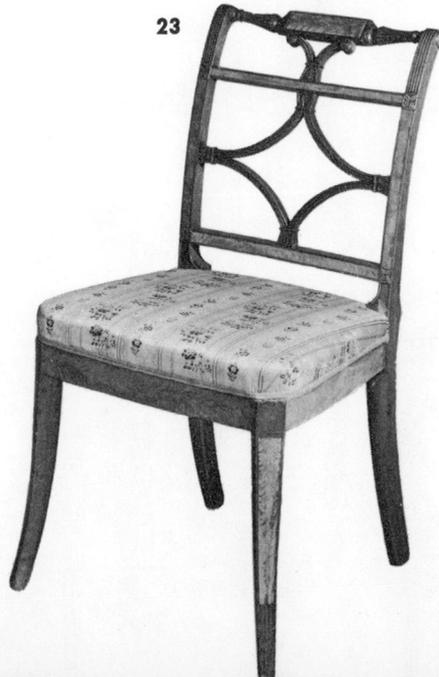

23

24

25. A classic square-back chair attributed to Henry Connelly has columnar uprights and back filling. The front legs are ribbed with foliate-carved capping and vase toes. (*Mr. Henry P. McIlhenny. Photo: Philadelphia Museum of Art.*)

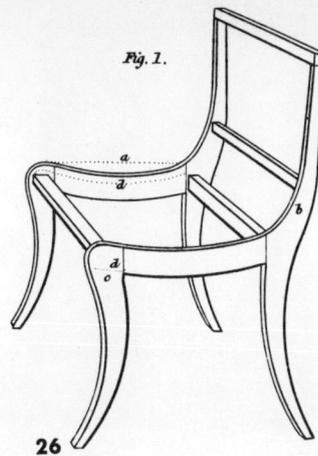

Fig. 1.

26

27

25

26, 27. In 1805, in his *Cabinet-Maker, Upholsterer, and General Artist's Encyclopaedia*, Sheraton introduced a full-page illustration (27). "This chair framing is not only new, but calculated for firmness and strength. . . ." It was adapted from the Greek klismos, a type known to all students of antiquity, but Sheraton added a stay rail and filling in the back and introduced it for the parlor. It quickly developed into one of the main chair styles of the century and was illustrated as the Trafalgar (26) in the *London Chair-Makers and Carvers' Book of Prices for Workmanship as regulated and agreed to by a committee of Master Chair Manufacturers and journeymen,* 1808. This style was widely used during the American classic period in examples ranging from finest dining and occasional chairs to painted chairs with reeded seats.

28. One of a pair of mahogany square-back chairs that correspond with number II in the 1802 price list — "three urn splatts, sweep stay and top rail with a brake in ditto . . . plain taper'd legs, stuffing over the rail." The "splatts could be pierc'd," but the maker of this chair preferred the more fashionable inlaid decoration in satinwood. (*Museum of Fine Arts, Boston.*)

29. A square-back chair, attributed to Henry Connelly, may represent his version of number IV in the 1802 price list — described as "a drapery bannister with feather top, a splatt on each side to form an arch with the top rail; bannister and splatts pierc'd. Sweep stay and top rail with a brake in ditto." (*Mr. Henry P. McIlhenny. Photo: Philadelphia Museum of Art.*)

28

29

30

31

30. The frame of this upholstered classic Shaker open-arm chair is beechwood. Shaped, flat armrests are set on capped baluster supports. The back legs and uprights are united, with acorn finials. (*Grand Rapids Public Museum.*)

32. Although the windsor chair continued to be made as a utility chair, more sophisticated versions occasionally occur. The frame of this example (sometimes called a Sheraton windsor) is bamboo-turned; the back is ninespindled, with a rail and tablet cresting. (*Philadelphia Museum of Art.*)

31. Martha Washington open-arm chair with back and seat united and armrests set on leaf-carved baluster and vase supports. The tablet and scroll pediment are in classical style, carved with drapery swag and crossed arrows. The ground is pitted in the manner of Samuel McIntire, to whom this chair is attributed. (*Essex Institute, Salem.*)

33. Henry Connelly's square-backed chair is constructed of the columns which he frequently used. Paterae at the corners serve to accentuate the square. (*Mr. Henry P. McIlhenny. Photo: Philadelphia Museum of Art.*)

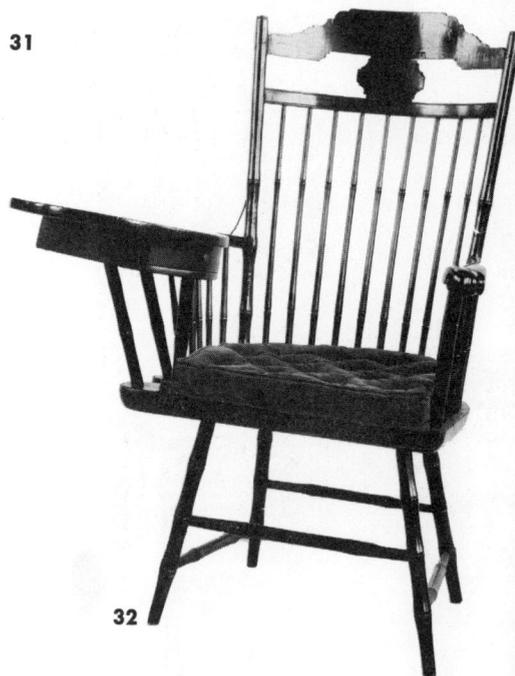

32

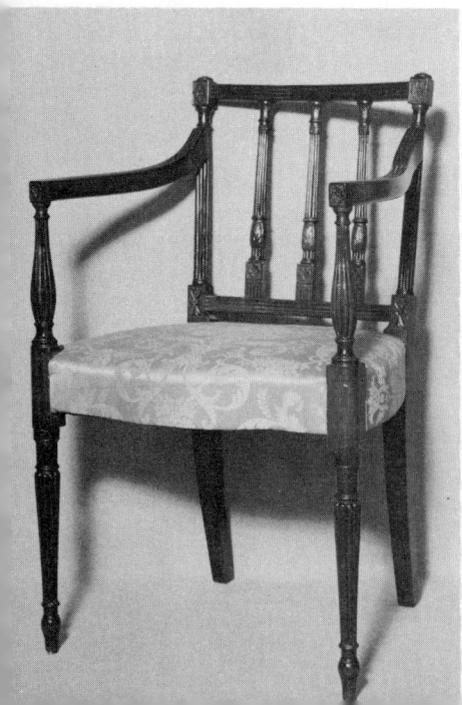

33

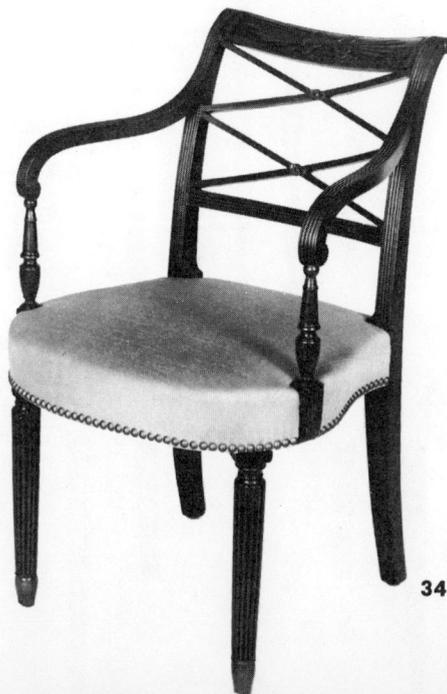

34. Early nineteenth-century squarebacked chair made by Duncan Phyfe. The legs are ribbed, and the seat is shaped. (*Henry Ford Museum, Dearborn.*)

34

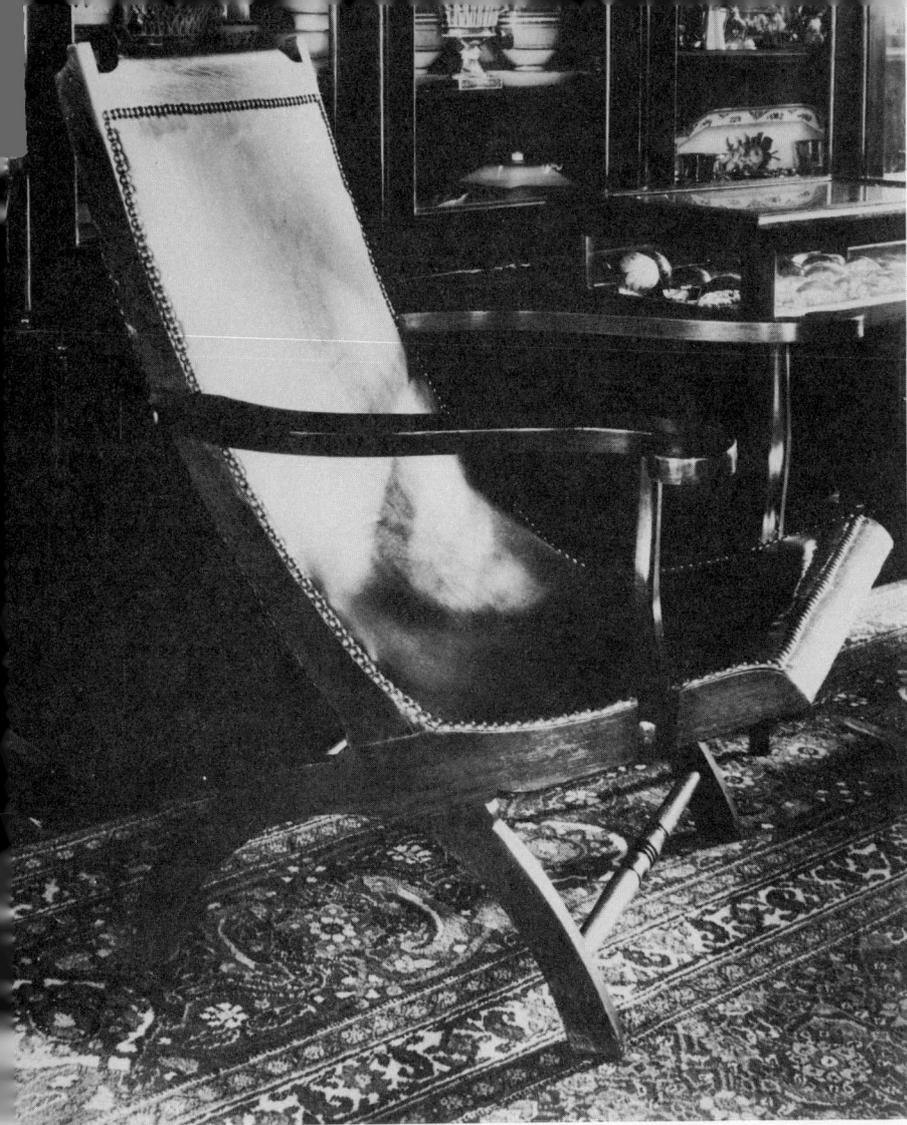

35

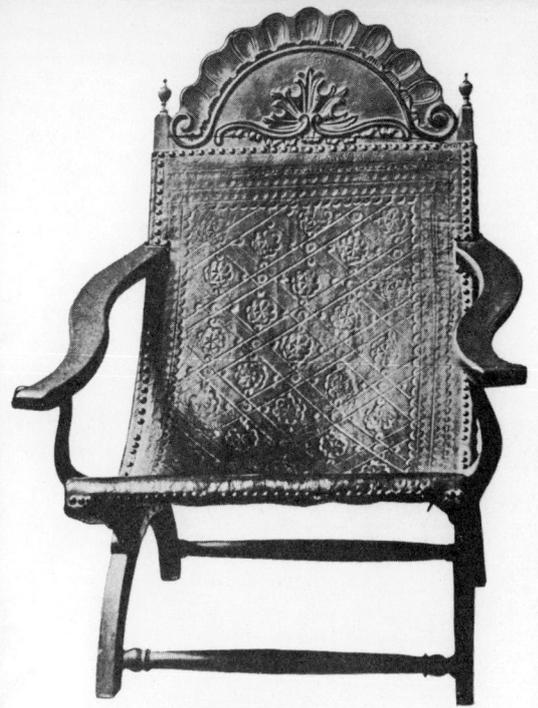

36

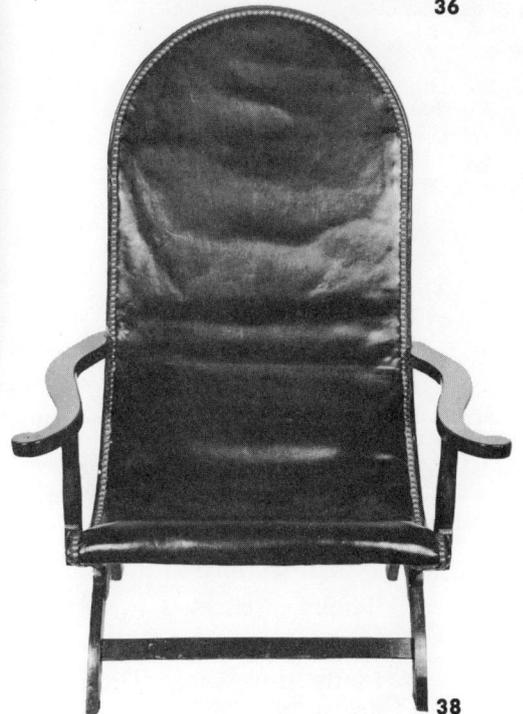

38

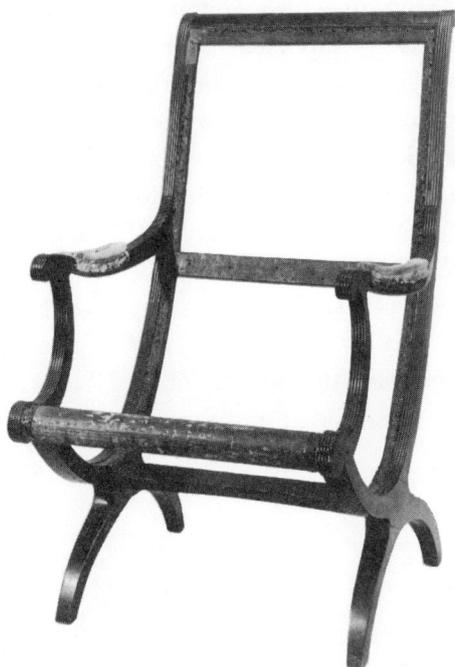

37

35, 36, 37, 38. A seventeenth-century Spanish chair (36), illustrated by G. R. Domenech in *Muebles antiquos españoles,* 1874, may have served as a model for contour chairs made in America, with a curule base extended at the back as uprights and leather back and seating in one piece, nailed to the frame. A pair still at Monticello, one of which is illustrated (38), was given to Thomas Jefferson in 1819 by Thomas B. Robertson of New Orleans. The back is arched, armrests are flat. The design for the frame of a contour chair (37), attributed to Duncan Phyfe by Mr. John S. Walton, saved much work by its substitution of leather upholstery on the back and seat. The chair with a level tablet (35) is in Monmouth, Natchez, where the terms "Spanish" and "Spanish steamer" are still used. In 1839 Joseph Bradley and Co., 317 Pearl Street, New York, were awarded a Diploma for Specimens of Spanish Chairs by the American Institute of the City of New York.

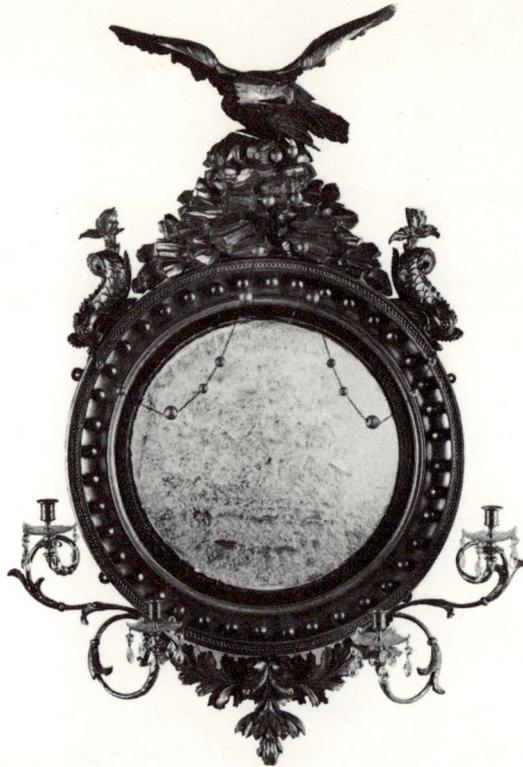

39

Mirrors

During the classic period, small vertical hanging mirrors of Sheraton type were fashionable. The bases were plain, the sides straight, and the tops covered with unconventional moldings or pilasters. A new feature was a slender Gothic spiral or a "rope molding" in the center of the frame. A horizontal panel at the top was painted, frequently with a landscape or seascape.

The circular mirror, with eagle cresting and beads in one of the moldings, persisted. A new design was the low, horizontal mantel mirror in three sections with a Sheraton-style frame.

Larger mirror plates began to be used. These were usually imported. The inventory of Thomas Jefferson in 1815 included mirrors ranging from fifteen inches to thirteen feet.

In the *Boston Yankee* of 1812 Paul Mondelly of 63 Cornhill announced that he had received by the ship *Ganges* from Tonningen a large assortment of looking glasses to be sold for cash, wholesale or retail. He had likewise on hand an "Extensive Assortment of gilt framed looking glasses, warranted to be of the best workmanship in the United States; Convex Mirrors; Old Frames re-gilt and mirror and old Looking Glass Plates new silvered."

In April 1816 Gridley and Blake included "250 Looking Glasses, all prices" in an auction sale.

Oliver of Norwich, Connecticut, working in the early nineteenth century, offered "looking Glasses, Gilt and Mahogany Frames." Mahogany is seldom mentioned and was comparatively little used.

22

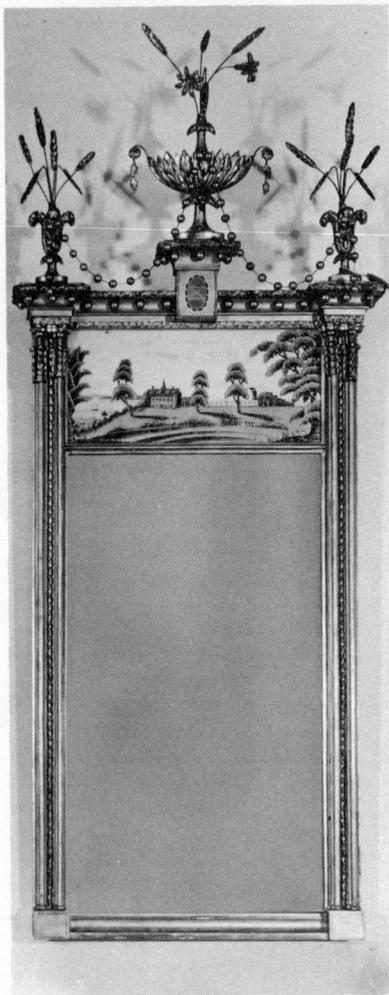

39. Gilt-framed circular mirror with eagle cresting flanked by dolphins. The scrolled metal candle arms have glass drip pans and luster drops. (*Museum of Fine Arts, Boston.*)

40. Vertical mirror with two cluster-column pilasters flanking a rope molding on the stiles. The glass panel is painted with a landscape; the cavetto cornice, expanded over the stiles, has spaced beads. (*Henry Ford Museum, Dearborn.*)

41. A large gilt-framed mirror, made c. 1810. The beautiful cresting is composed of a figure of Peace with trophies and fruit-filled cornucopias. At the base are a foliate garland, two doves on a quiver of arrows, and an olive branch. (*Brooklyn Museum.*)

42. Sheraton-type gilt-framed mirror in three sections. The oval and oblong panels at the top are painted; the frieze is plain, with spaced balls, and the molded cornice is broken over the stiles. (*Art Institute of Chicago.*)

40

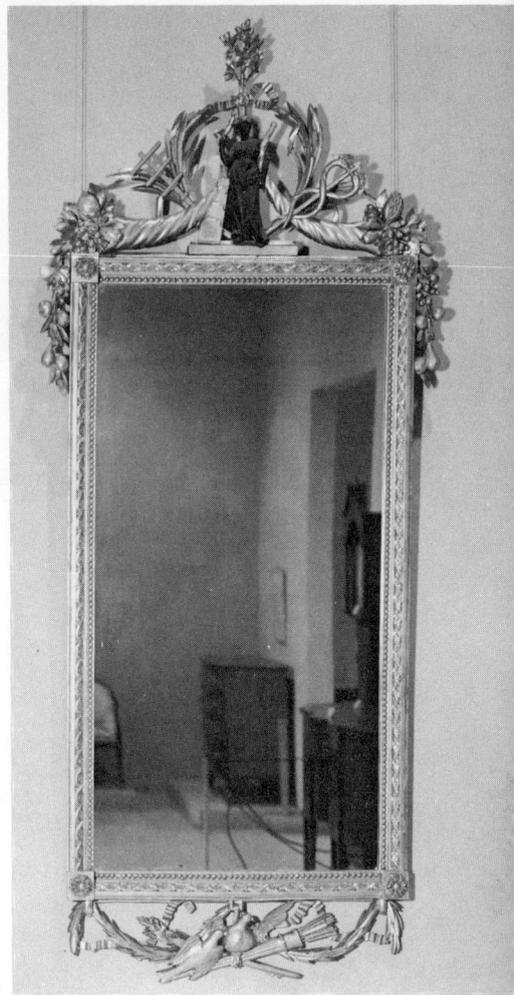

41

42

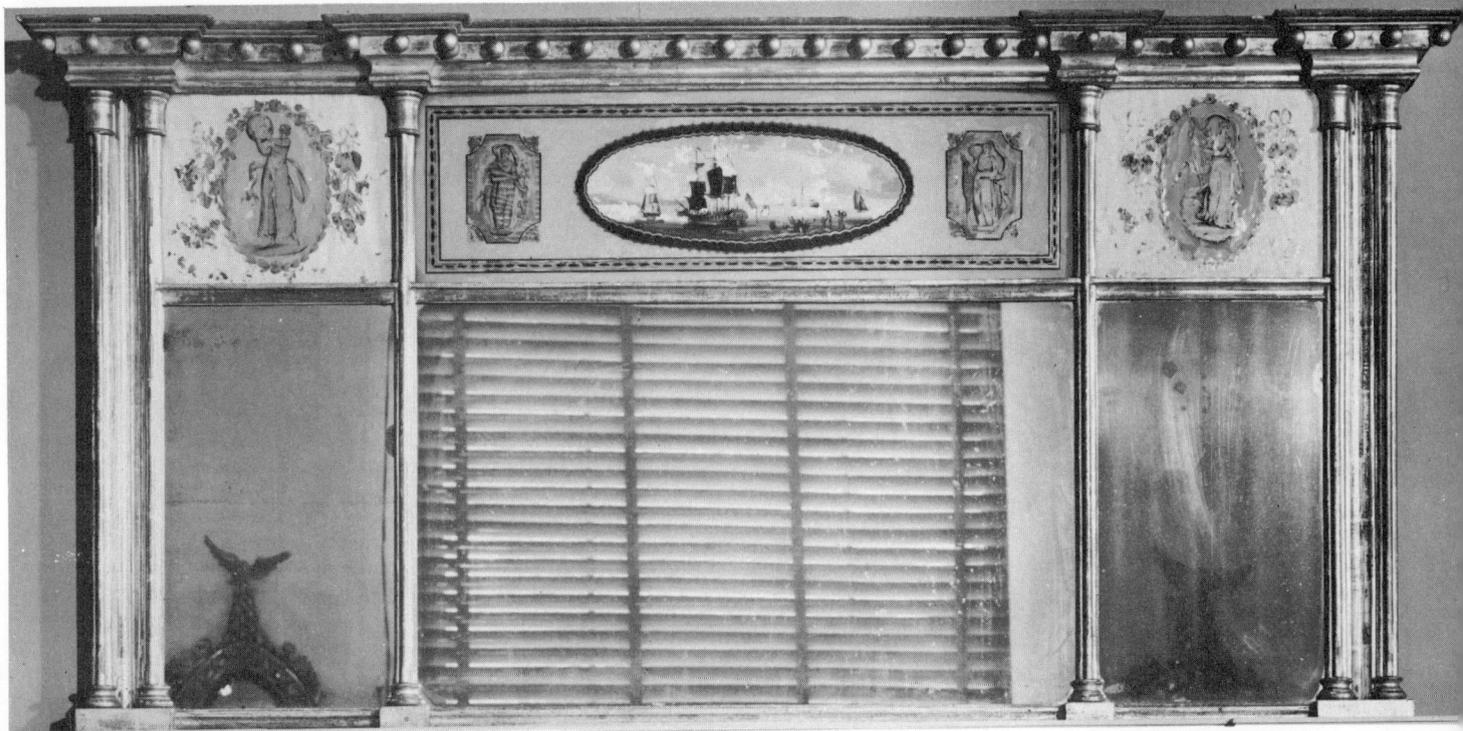

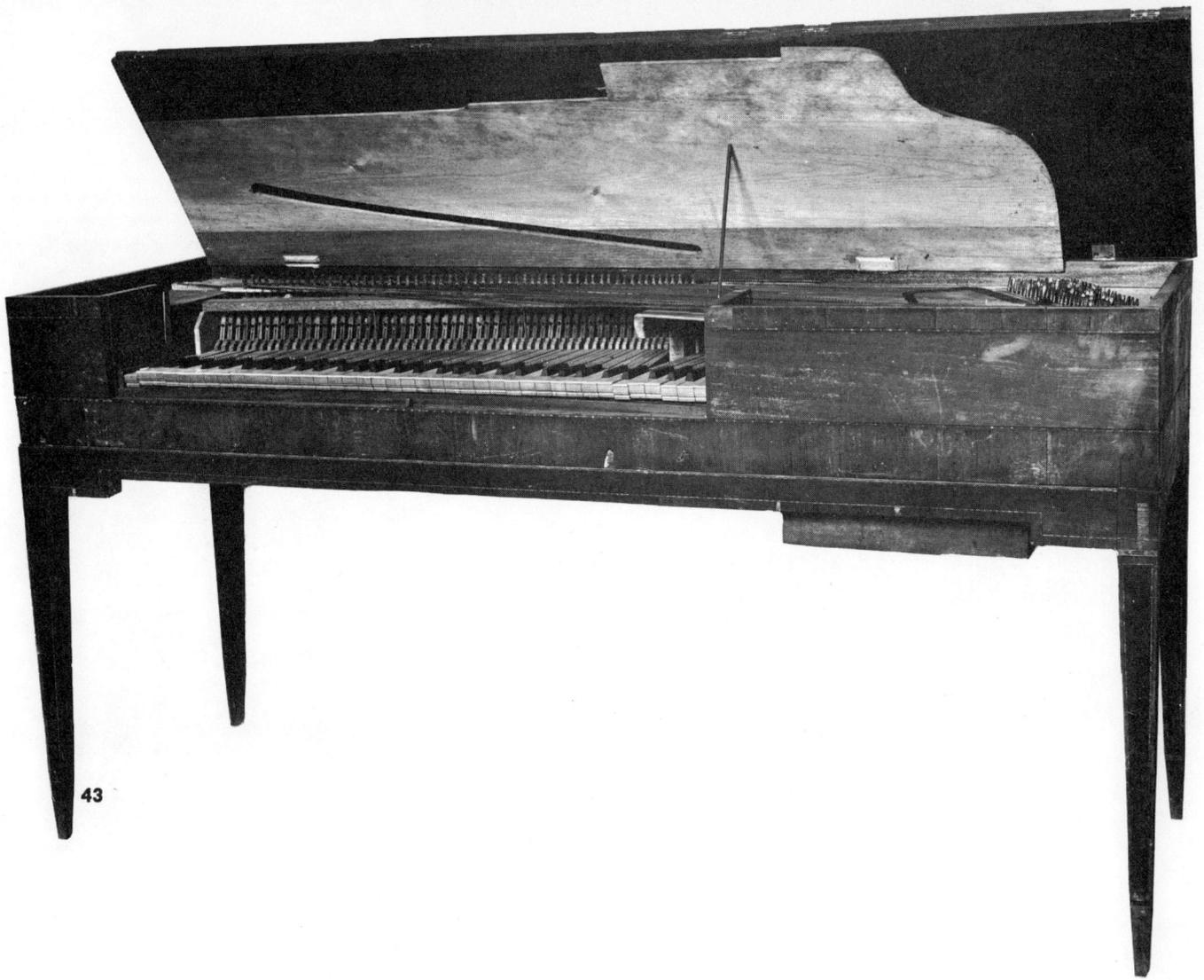

43

Musical Instruments

Music was a favorite diversion in America, and various instruments were available, though not in quantity. Among the most popular in the home were the spinet, guitar, harp, and piano. Thomas Jefferson had a spinet, a guitar, and three violins, and a piano which he bought in 1800 for 264 dollars. In New York John Jacob Astor advertised for sale "an assortment of Piano Fortes of the newest construction."

A pioneer in the use of iron in piano construction was John Hawkins, an Englishman who settled in Philadelphia. His instrument, later known as the cottage pianoforte, was patented in England in 1800 as Hawkins' portable grand piano, and the instrument aroused universal interest.

In the *Boston Yankee* in 1812, Babcock, Appleton, and Babcock advertised that they had just completed an offer for sale at their Piano Forte Ware-House, No. 18 Winter Street: "6 Pianos 2 Bass Viols first rate. N.B. The above instruments will be warranted 10 years if desired and may be returned at any time by paying common rent. Repairing as usual."

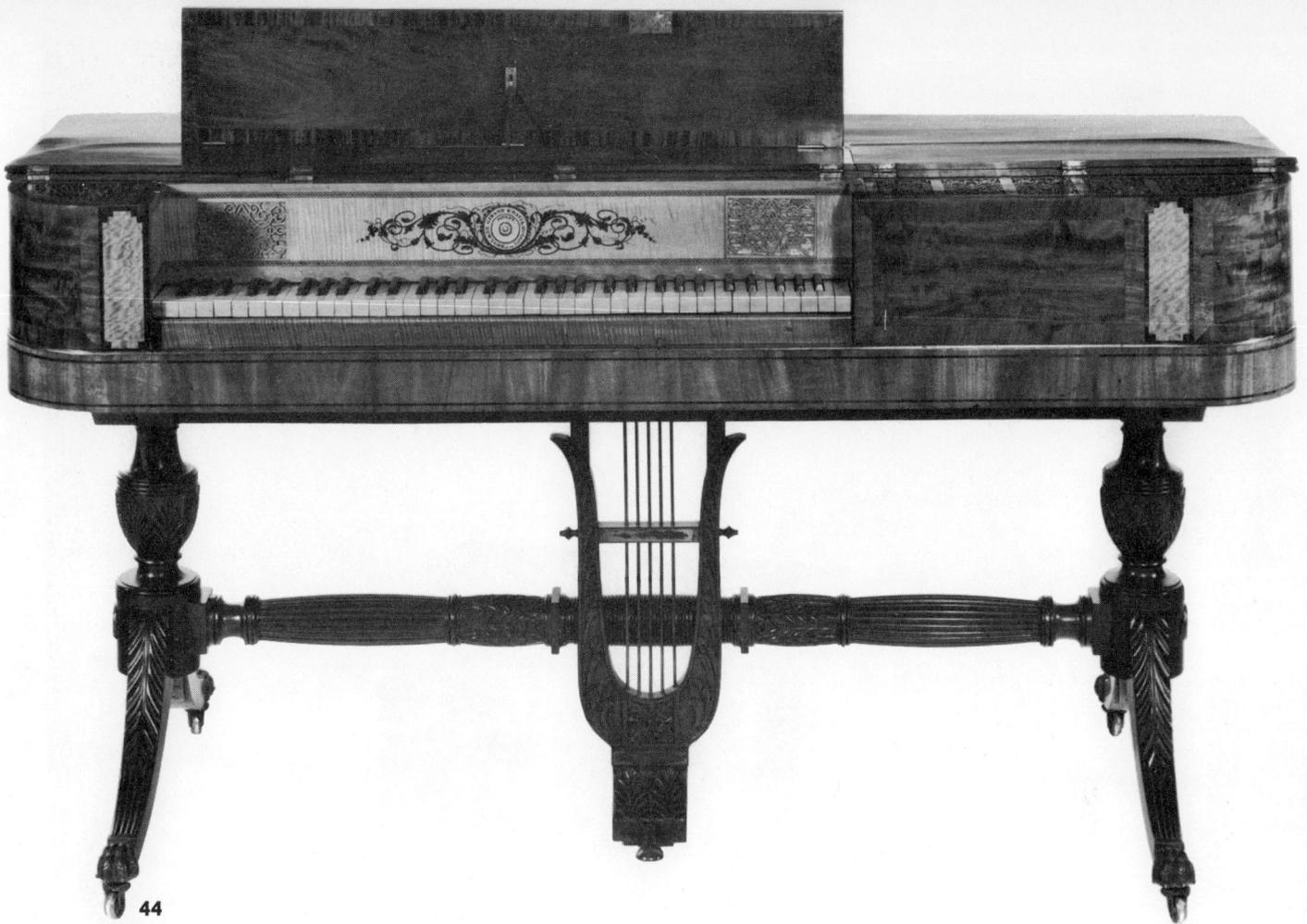

44

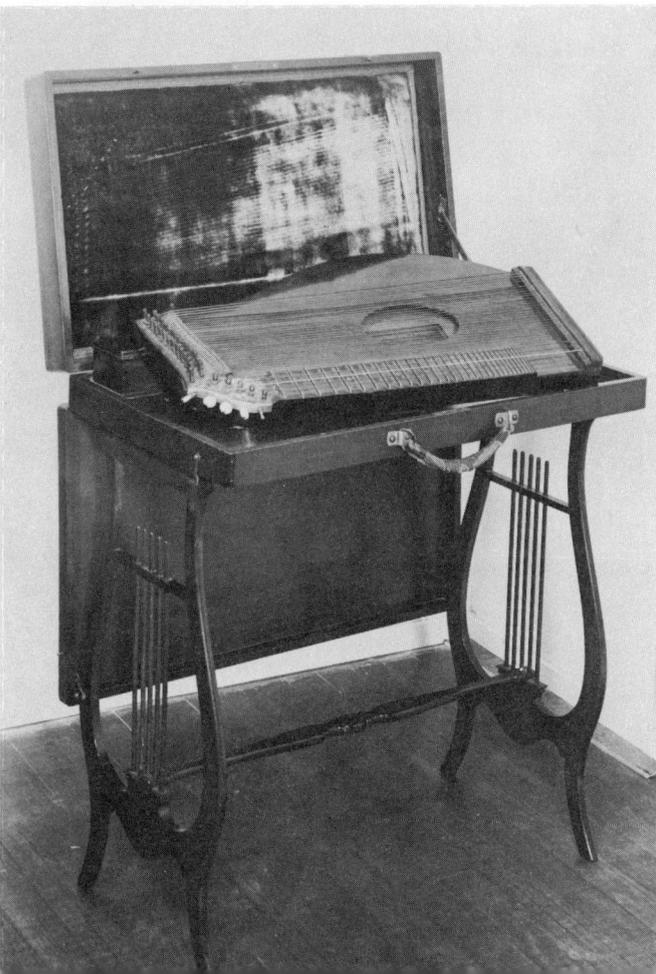

45

43. An early-nineteenth-century piano by Benjamin Crehore, Boston. The mahogany case is in the Hepplewhite manner, with panels reserved by stringing on the legs; flange toes are simulated by inlay. Bands of stringing in fine, varied design outline the construction. (*Metropolitan Museum of Art.*)

44. This piano, patented by Gibson and Davis of New York and London, has the firm's name inlaid on the back of the keyboard. The *cheval* base has vase standards on paired Greek-curved legs. The lyre-shaped pedal holder is foliate-carved. (*Henry Ford Museum, Dearborn.*)

45. Collapsible mahogany zither and stand with lyre supports, attributed to Duncan Phyfe. The stretcher is removable and the legs fold so that the whole instrument can be packed and enclosed within the two lids, which form a case five inches deep. The hinged handle is leather. (*Grand Rapids Public Museum.*)

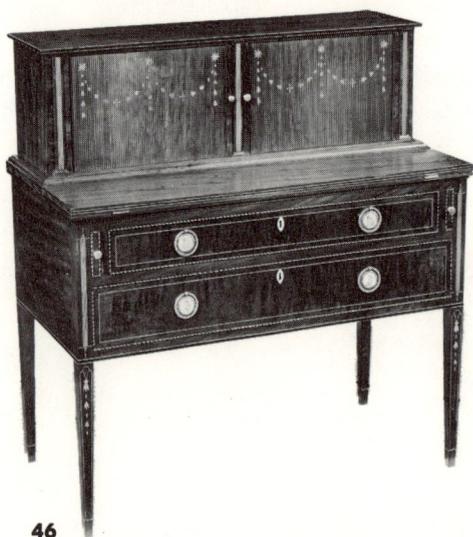

46

Secretaries

The Hepplewhite secretary bookcase in mahogany was favored at the beginning of the century. This handsome and practical piece of furniture was the focal point of any room in which it stood. However, as the taste for lighter furniture developed, other types appeared, among them a secretary with a table base, a recessed *cartonnier,* and a hinged, full-width flap opening forward for writing. Drawers and compartments in the *cartonnier* were enclosed within tambour doors. A small French *bonheur-du-jour,* bought for Martha Washington at the sale of the Comte de Moustiers, French Minister to the United States, probably served as a model. Countless variants of the *bonheur-du-jour* were made, and a specifically American type developed, some examples of which far excelled the French prototype in construction and finish. The Seymours made several tambour-fronted secretaries of superlative quality.

In later examples a bureau base or a bookcase were added — or both — which did not improve the appearance. The fashion lasted until about 1820.

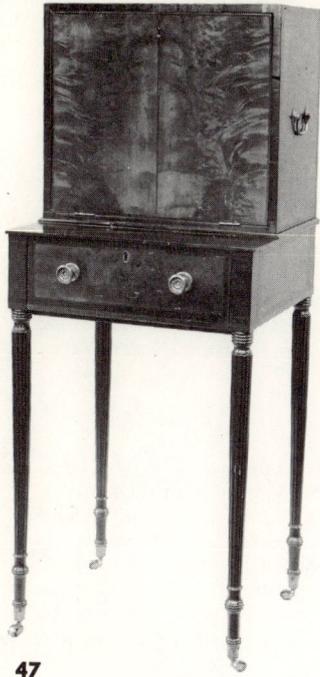

47

46. A fine Seymour secretary in mahogany with inlay of tulipwood and satinwood has Bilston enamel mounts with ring handles. The *cartonnier* has two fine-slatted tambour doors inlaid with double swags of husks suspended from florets. The stiles are inlaid to simulate pilasters. (*Museum of Fine Arts, Boston.*)

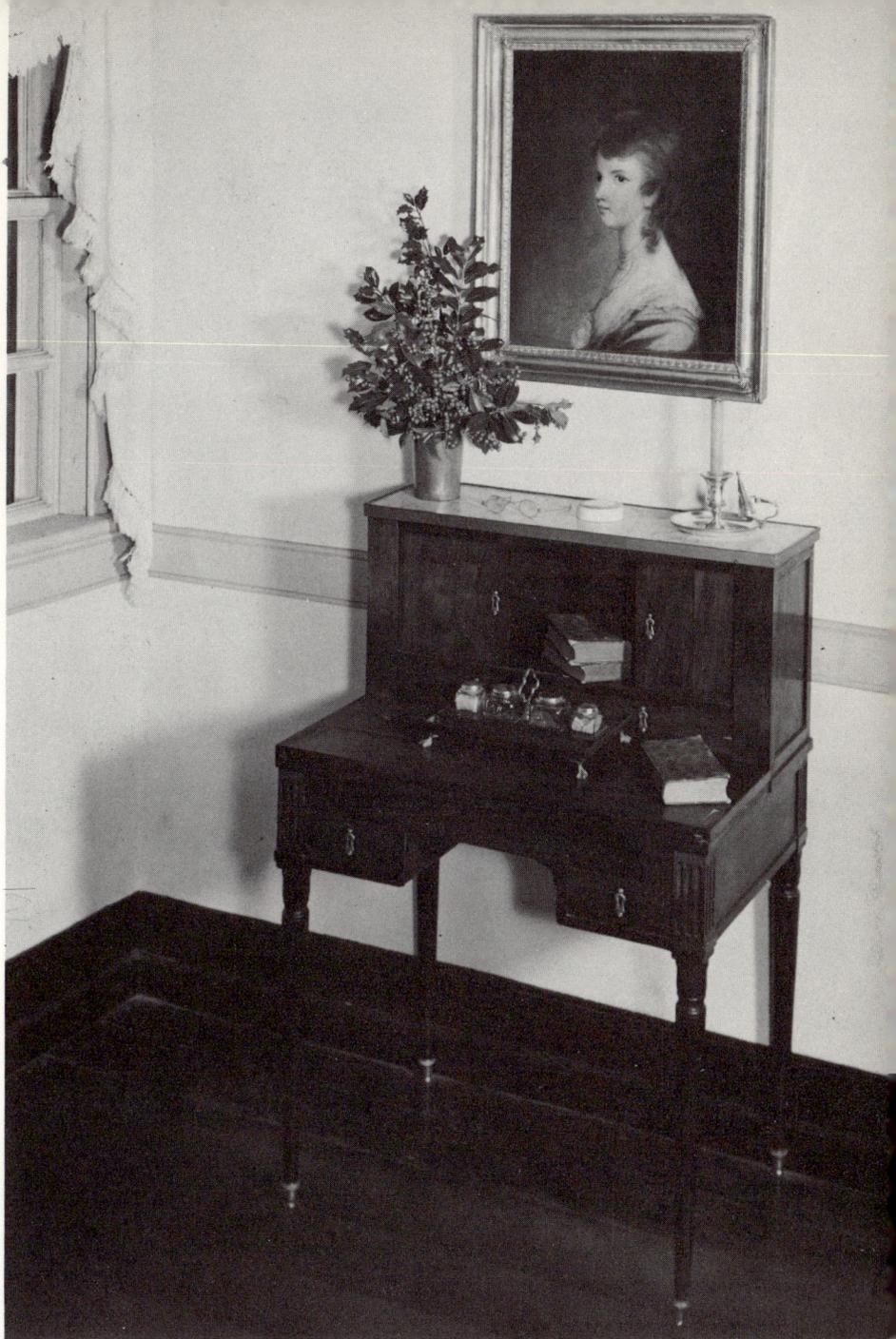

49

48

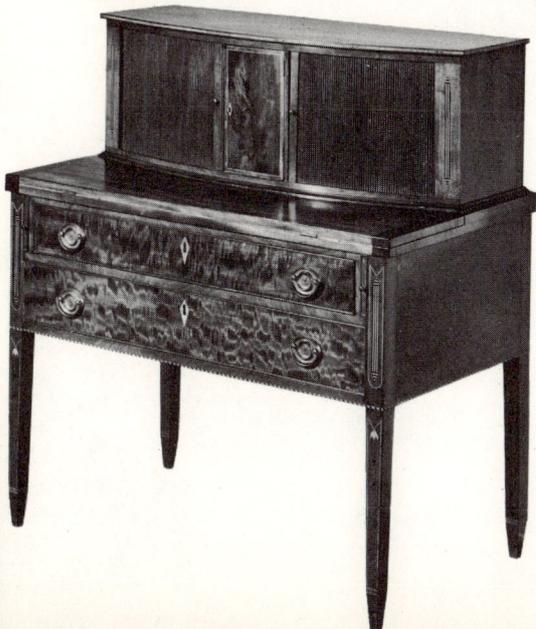

47. Small fall-front secretary in satinwood and mahogany on a table base, with one drawer in the frieze. (*Metropolitan Museum of Art.*)

48. Mahogany and satinwood secretary with an unusual bow-fronted *cartonnier*. The reeded bars inlaid on the stiles, flanking the tambour doors, match those on the stiles below. (*Henry Ford Museum, Dearborn.*)

49. Small French *bonheur-du-jour* in mahogany, formerly owned by Martha Washington. It probably served as a model for many small secretaries during the classic period. The marble top and kneehole front were not copied. (*Mount Vernon Ladies' Association.*)

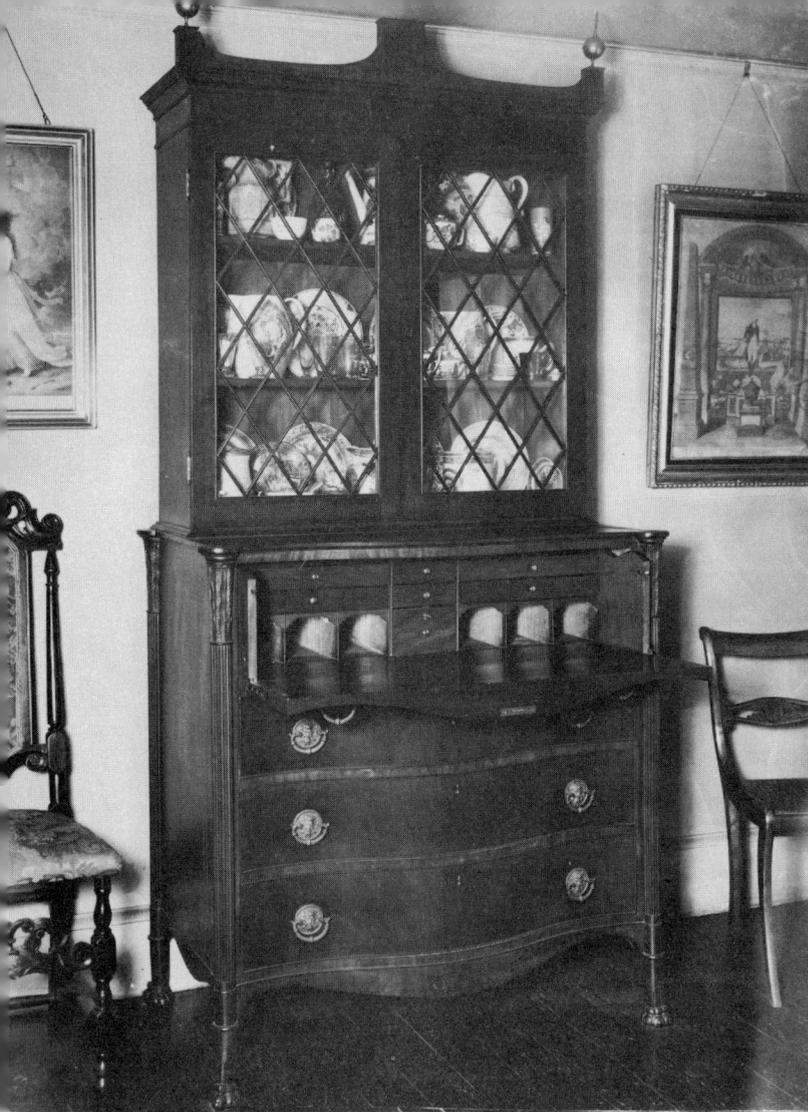

50. Mahogany secretary bookcase with serpentine front, made by William Hook. The secretary drawer opens over three full-width drawers. The legs, irregular shafts on paw feet, are continued upward on the four corners as reeded colonnettes with a water-leaf corona. (*Essex Institute, Salem.*)

51. Nathaniel Appleton of Salem, Massachusetts, made this mahogany secretary bookcase in Hepplewhite style c. 1807. It has trellis astragal tracery on the glass doors of the top and a block-and-spindle pediment. The eagle on an orb is said to have been carved by Samuel McIntire. (*Essex Institute, Salem.*)

52. A small mahogany secretary with bureau base, fifty-five inches high, made for Captain Jonathan Hassam in 1808. The base contains a cupboard and two drawers partitioned for bottles over two full-width drawers. The *cartonnier* has tambour doors. (*Essex Institute, Salem.*)

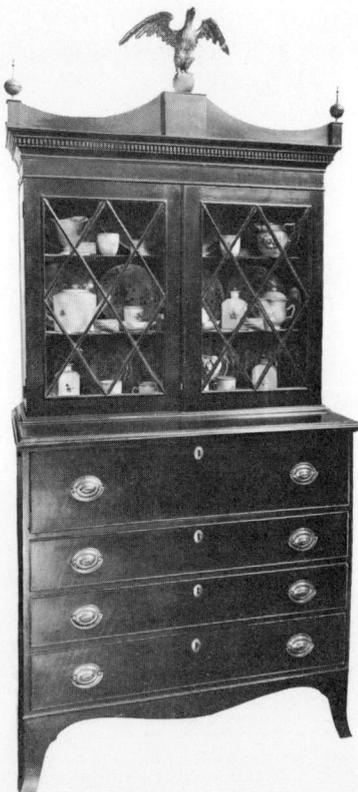

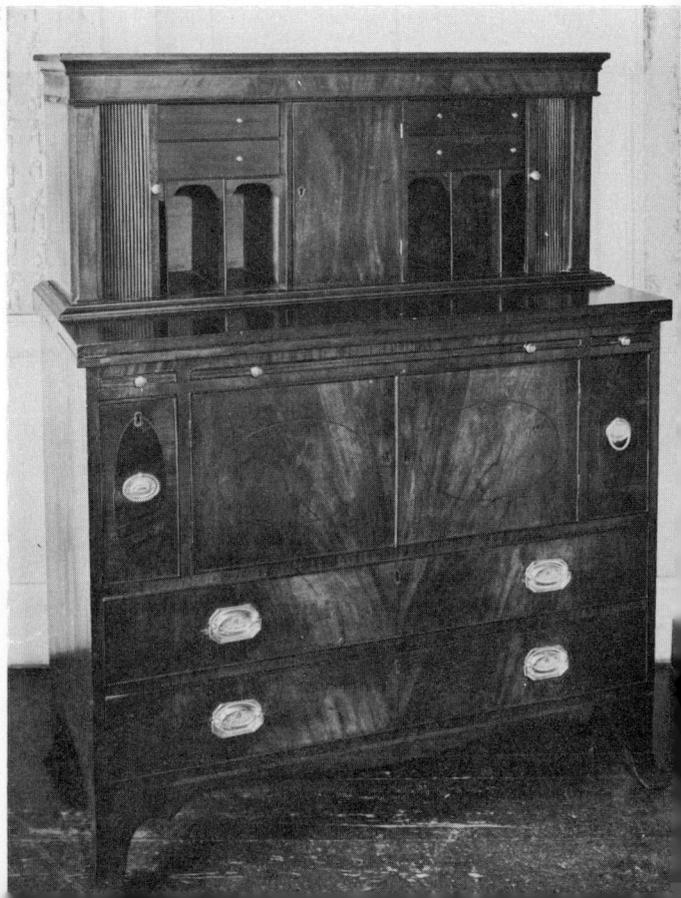

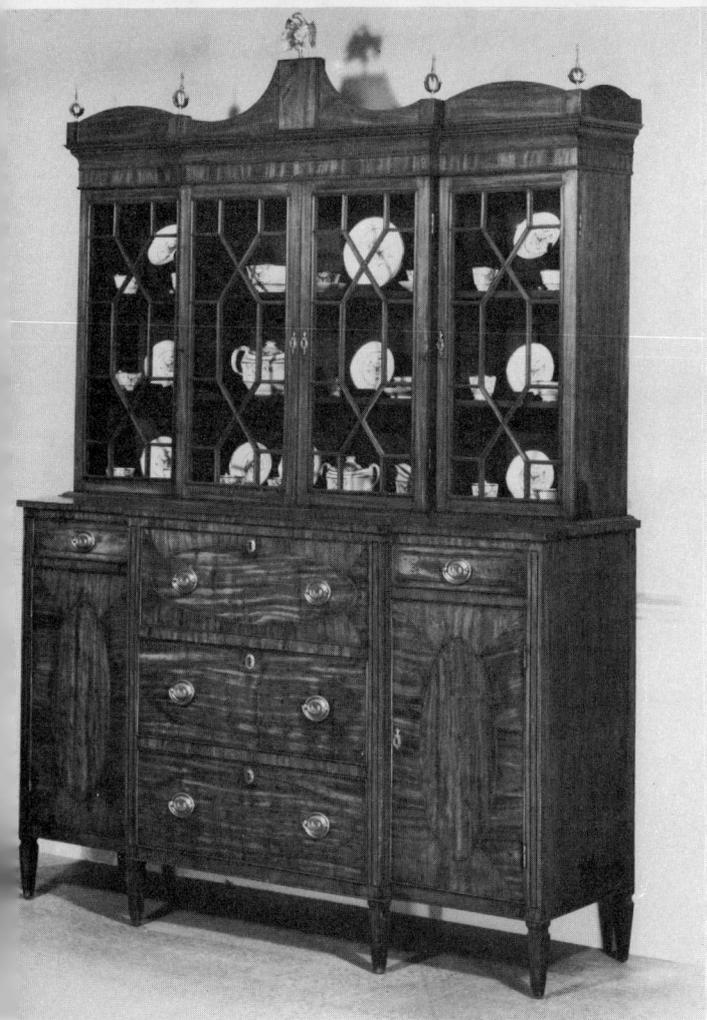

53

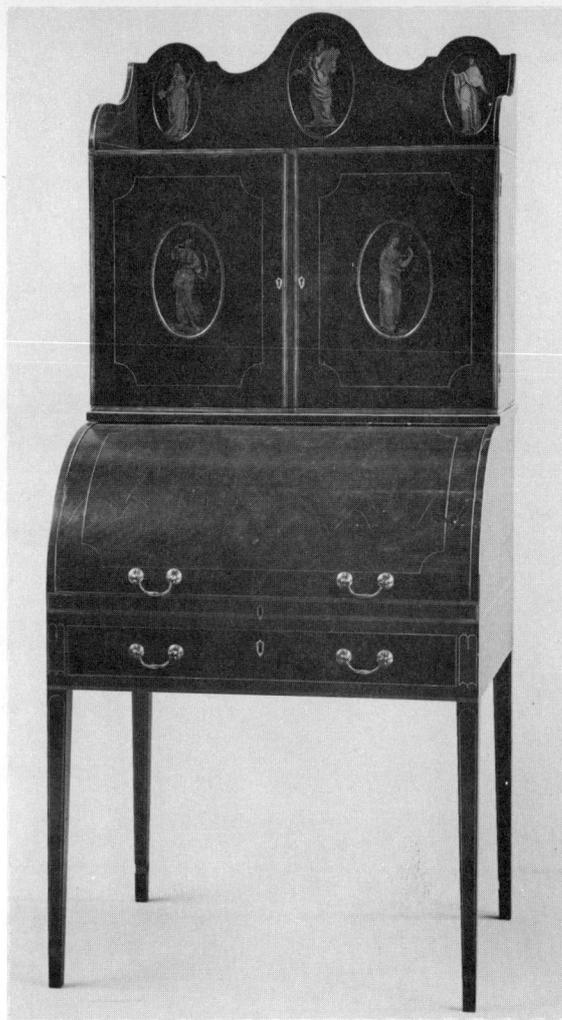

54

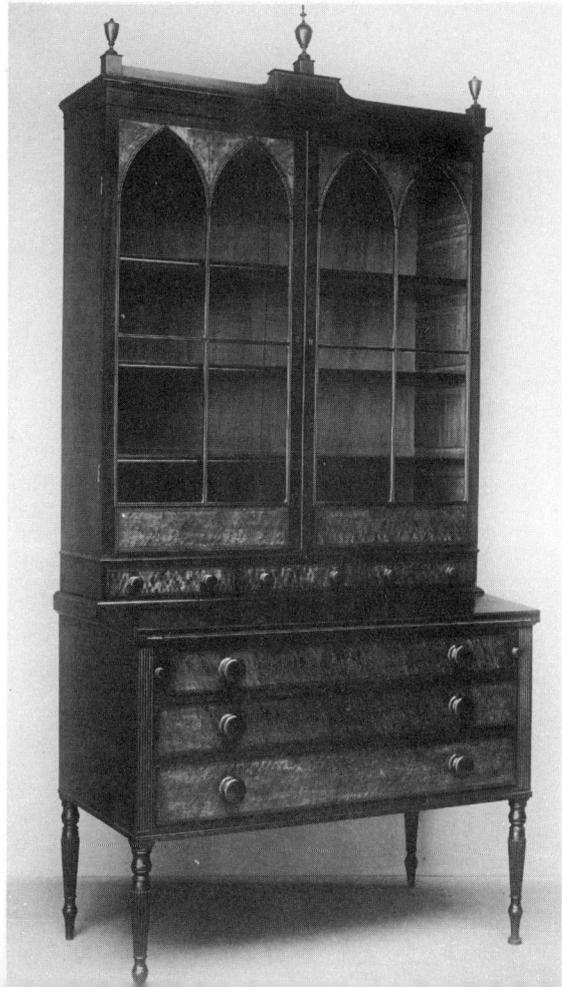

55

53. A handsome breakfront mahogany and satinwood bookcase with the label of Edmund Johnson of Salem, (died 1811). It is in three sections, with a secretary compartment over drawers in the center and a drawer over a one-door cupboard at each end. The doors are veneered with an oval in a mitered surround. (*Henry Ford Museum, Dearborn.*)

54. Mahogany secretary in Hepplewhite style. The small oval panels of the recessed cabinet are reserved in moldings and painted with Biblical and emblematical figures. The table base has a cylinder fall over the secretary and a drawer in the frieze. Painted decoration was much favored in Baltimore, where this secretary was made. (*Metropolitan Museum of Art.*)

55. Secretary bookcase in mahogany with bird's-eye maple. The slope-top hinged writing flap replaces the secretary drawer. Paired Gothic-arched panels with wood spandrels enclose the bookcase, which rests on a shallow tier of three drawers. (*Metropolitan Museum of Art. Gift of Mrs. Russell Sage.*)

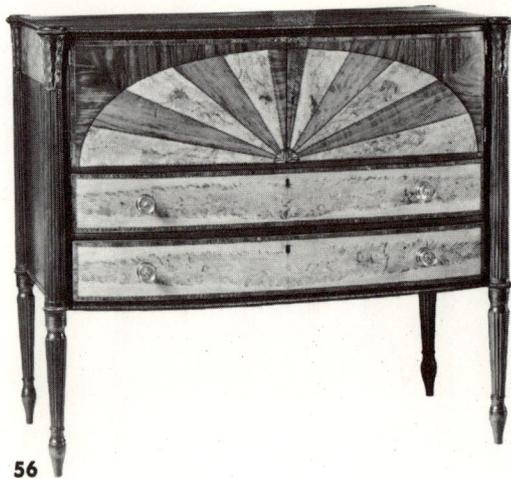

56

Sideboards

Fine sideboards in Sheraton and Hepplewhite styles, with certain features in common were firmly established by 1800.

Stringing and delicate inlay were used as ornament. The *New-York Book of Prices*, 1802, specified: "Pannelling with string on Pilasters, Legs, Stump Feet, Table Claws, etc. . . . Forming a square or oval pannel with a single string. . . . Hollow or round, diamond or octagon end. . . . Gothic hollow, astragal end, hollow corner end." All these features are found on furniture of this early period, with the addition of pendent husks, drops, diamonds, urns, and paterae in round, square, or oval shapes. Double stringing was much used by American cabinetmakers.

As time progressed, the traditional three-section sideboard underwent many changes — chiefly through the addition of drawers and cupboards.

56. Satinwood and mahogany sideboard made by William Hook in 1809. The cupboard is inlaid in satinwood and mahogany with a broad-rayed lunette that has mitered spandrels. Colonnettes with water-leaf caps are attached to the angles, and the top is expanded to cover them. (*Museum of Fine Arts, Boston.*)

57. Philadelphia mahogany sideboard in three sections. The two end cupboards are deepened almost to pedestal proportions. Panels are finished with stringing and cross-banding, outlined by checkered inlay. (*Henry Ford Museum, Dearborn.*)

58. Semicircular butler's desk in mahogany. In the center, the secretary drawer opens over three full-width drawers, and on either side are cupboards with broken-corner panels. The slender splayed legs form part of the shaped apron design. (*Museum of Fine Arts, Boston.*)

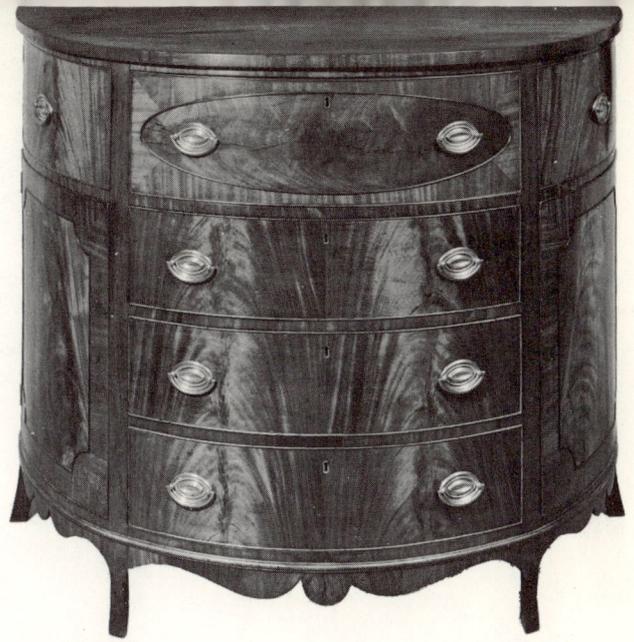

58

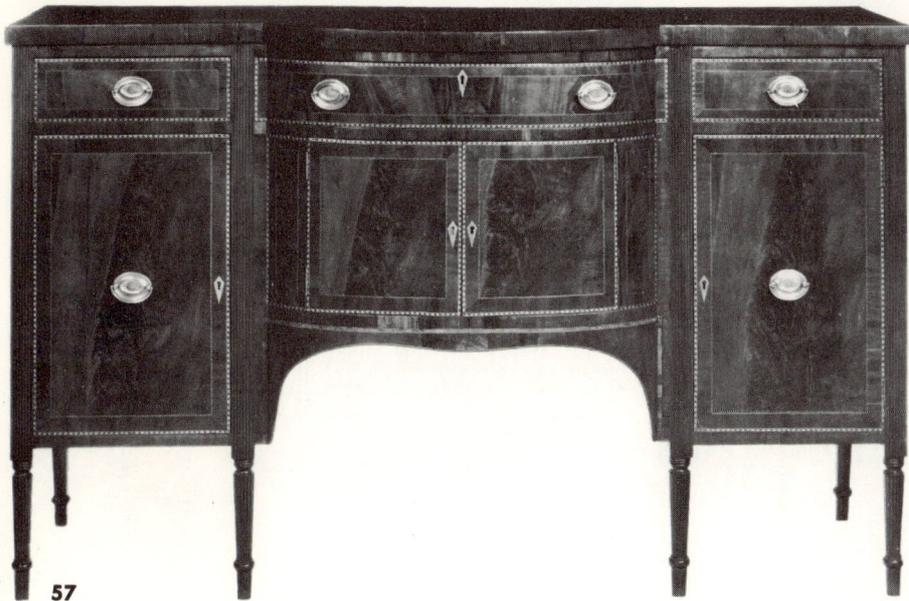

57

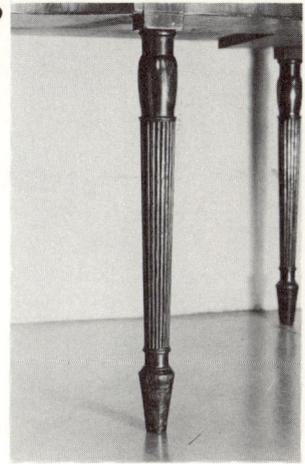

59

59. Henry Connelly favored this type of leg for his furniture. It is known that Ephraim Haines, whose work closely resembles that of Connelly, had legs and splats turned by Barny Schumo (*Philadelphia Museum Bulletin,* Vol. 48, No. 237, p. 39), and the fact that the height of this leg is adjusted by blocks would support the supposition that Connelly followed the same procedure. (*Philadelphia Museum of Art.*)

60. Few semicircular commodes in the Adam manner appear to have been made in America, and this one by Thomas Seymour must be among the finest. The bill for it, with an 1809 date, still exists. The commode is arranged with four tiers of drawer fronts in three vertical sections, those at the end consisting of shelves within doors simulating drawer fronts. The top is veneered alternately with feathered mahogany and satinwood, rayed from a semicircle painted with shells and foliage by John Penniman of Boston. (*Museum of Fine Arts, Boston.*)

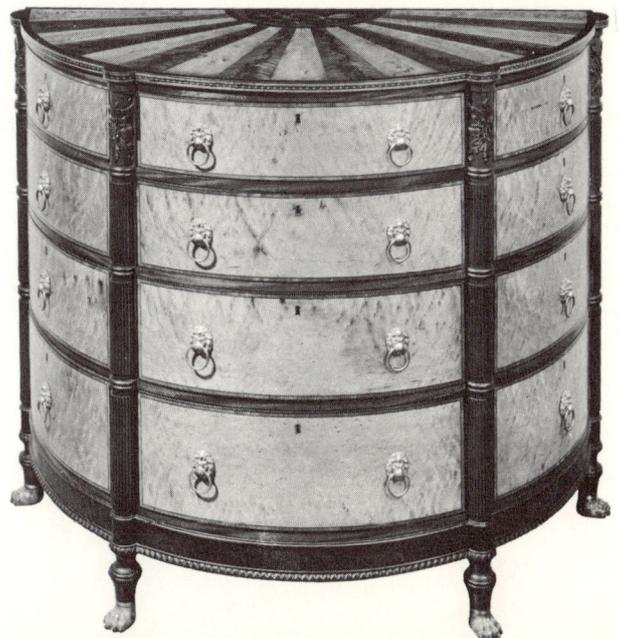

60

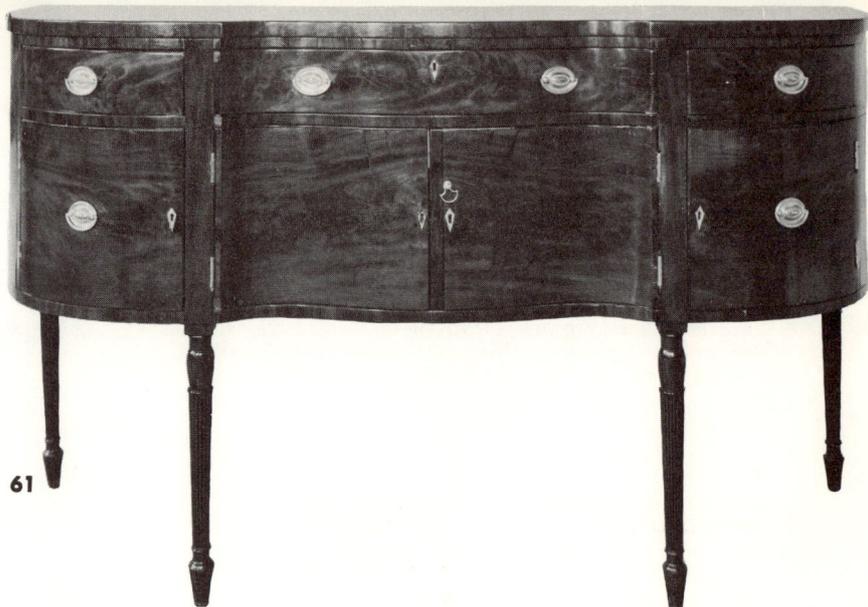

61. Sideboard by Henry Connelly of Philadelphia. The construction, with three sections of drawers over cupboards, is varied by a serpentine front with rounded ends. (*Philadelphia Museum of Art.*)

61

62

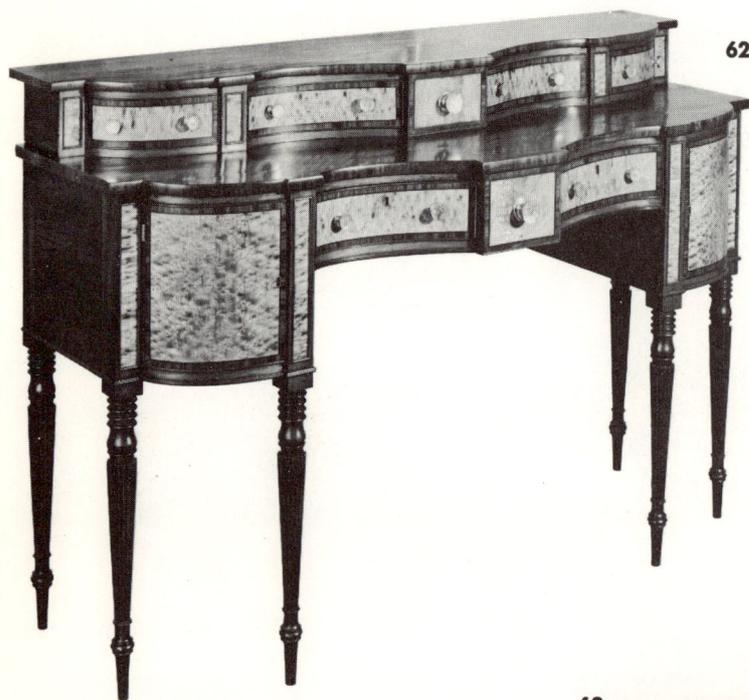

62. Two-tiered Seymour sideboard, constructed in exaggerated serpentine, with a small drawer in the center flanked by concave drawers and cupboards. A shallow, hollow superstructure matches in contour, with two hinged drawer fronts providing access. (*Museum of Fine Arts, Boston.*)

63

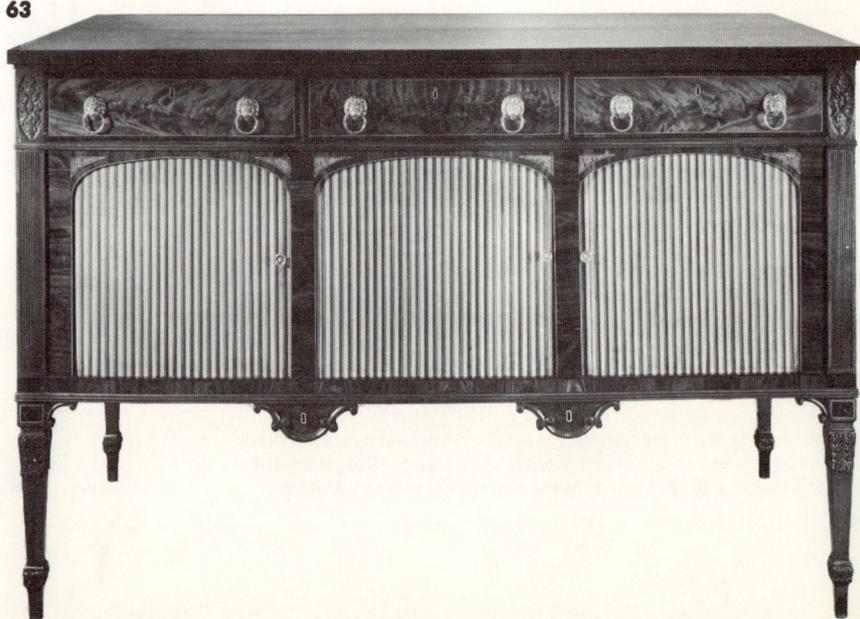

63. Sideboard in satinwood and mahogany, with drawers over three tambour door cupboards framed and hooded in mahogany, has two pendent escutcheon tabs. (*Museum of Fine Arts, Boston.*)

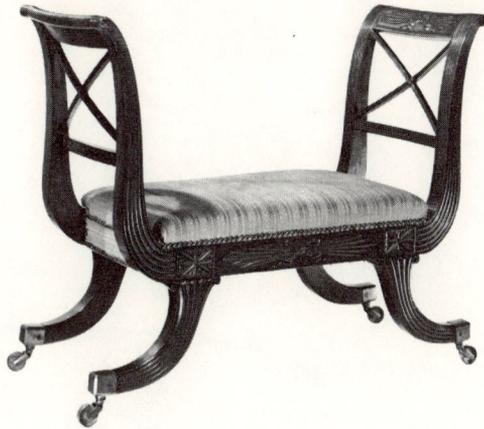

Settees

Hepplewhite and Sheraton settees were popular at the beginning of the nineteenth century. The back, seat, and arms were upholstered, and little woodwork showed. Sheraton's designs for a "Grecian squab" and Grecian sofa, published in 1792, proved to be an important influence. The "squab," with a headrest, shortened back, and no foot, was designed for reclining. The Grecian sofa was a settee and had back and ends of equal height.

A marked change in settees came with the introduction of the French Turquoise settee. The body remained the same, but the arms, instead of being at right angles to the seat, were low and cyma-curved, with the ends of the level back hollow-curved to meet them. Four legs were used instead of the six or eight of the French Directoire prototype. The Turquoise settee lasted, with many variants, until 1833, when Joseph Meeks and Sons introduced their new styles to the American market.

In the New York price list of 1818 the Turquoise can be identified: "square back, straight front, arms with two sweeps [cyma]. Mahogany capping on ditto and on the top rail. . . . Hollow cornered or round top rail."

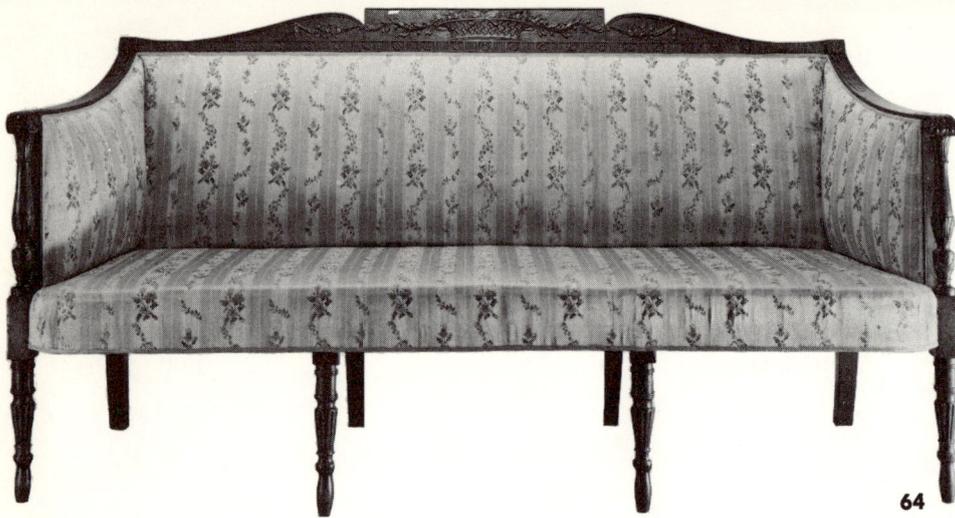

64. A typical Sheraton settee with carved front legs and cappings on the arms. The carving on the back, attributed to Samuel McIntire, consists of a narrow band of Doric triglyph and the Sheraton classic cresting — a horizontal block between horizontal scrolls — its surface pitted and carved with a Marie Antoinette basket of flowers and berries flanked by drapery swags. (*Museum of Fine Arts, Boston.*)

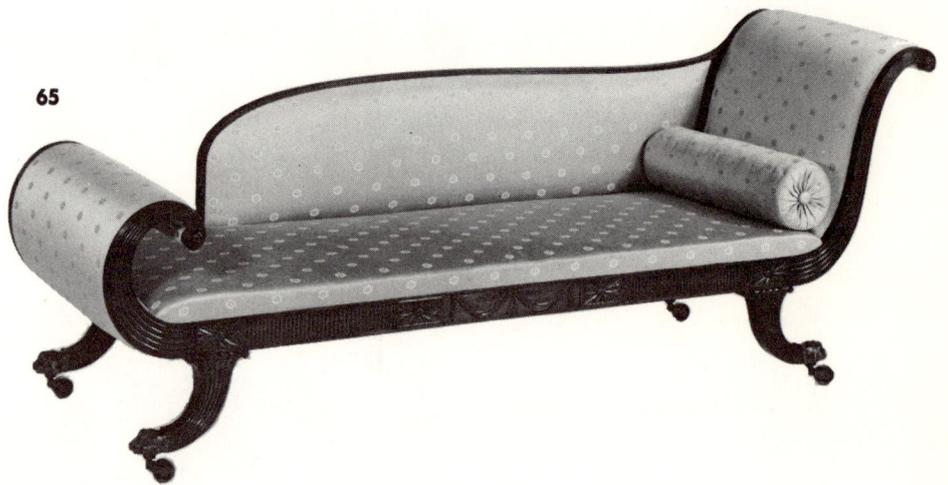

65. A mahogany Greek couch, for reclining, reveals the perfection of Duncan Phyfe's design and construction. The head end is cyma scrolled, the back shortened, the foot swept inward in a bold scroll. The New York price list, 1815, reduced this type to a simple formula: "A Grecian Couch — all plain . . . when both ends alike four shillings extra." (*Henry Ford Museum, Dearborn.*)

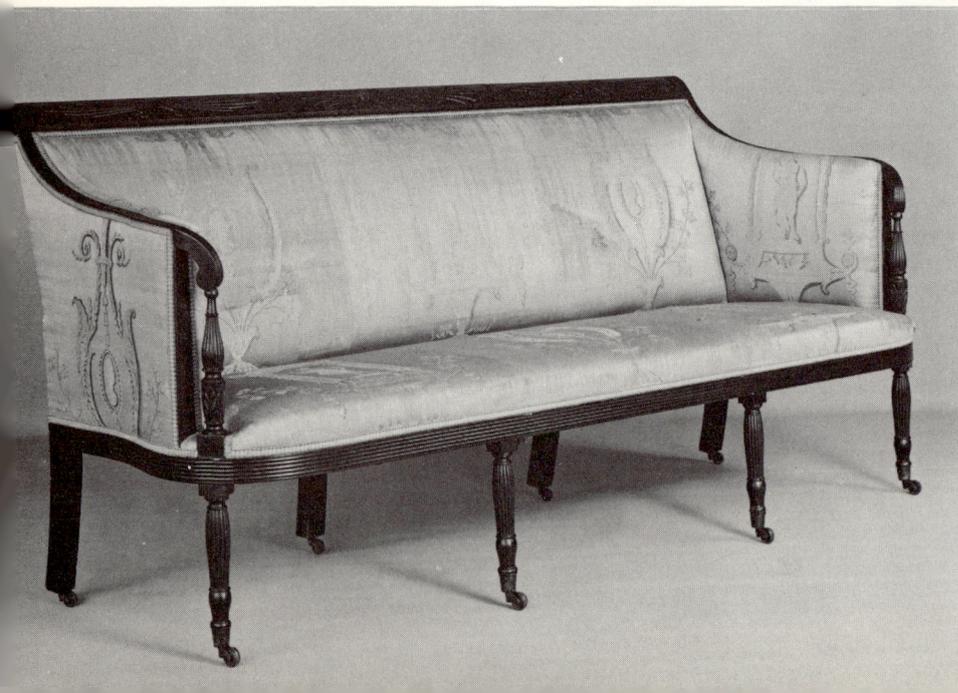

66. A Sheraton settee by Duncan Phyfe with back and arms united and detached balusters on the front angles of the seat. The full-width tablet on the back is scrolled and carved. (*Metropolitan Museum of Art.*)

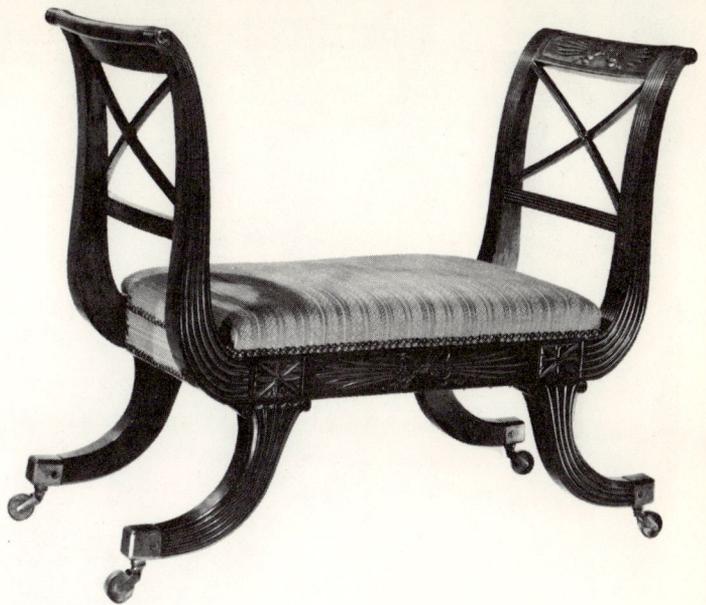

67. Mahogany settee, made by Jonathan Peele Saunders in 1811. This is an adaptation of the Turquoise, with back and cyma ends of equal height. The back, capped with a narrow rail, slopes toward a central oblong tablet with pitted ground, carved in low relief by Samuel McIntire with paired cornucopias. (*Essex Institute, Salem.*)

67

68

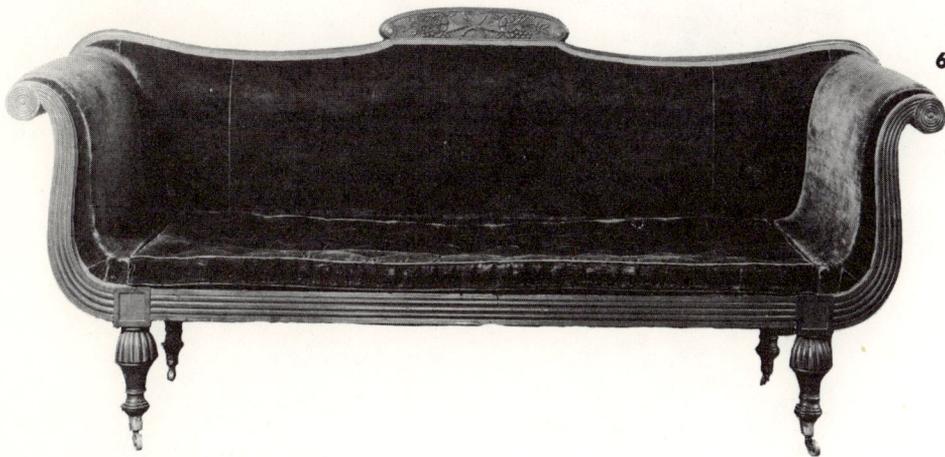

68. Mahogany window bench made by Duncan Phyfe. The ends are in the style of the square-back chair, with cross filling and carved tablet. Patera-carved oblong blockings are set over the fluted cornucopia-shaped legs. (*Henry Ford Museum, Dearborn.*)

69. This three-chair-back settee is part of a set of Sheraton seat furniture in chestnut, finely painted in natural colors on a simulated rosewood ground. (*Metropolitan Museum of Art.*)

69

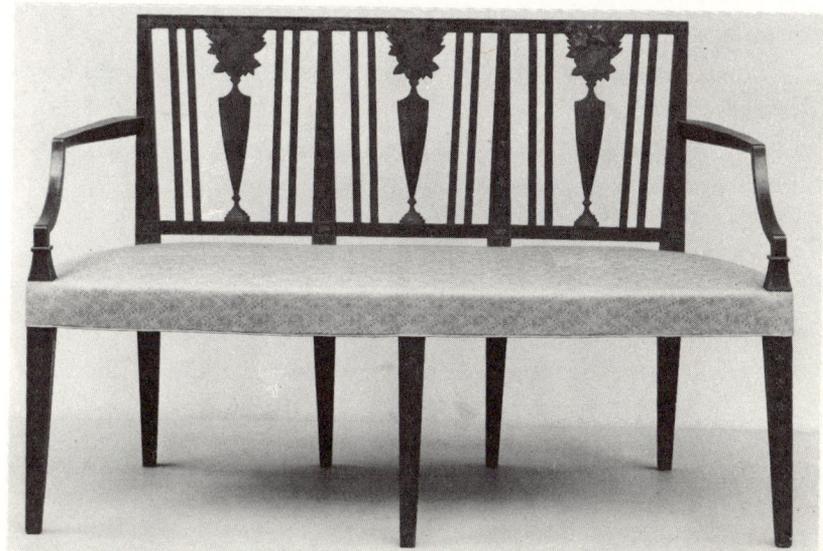

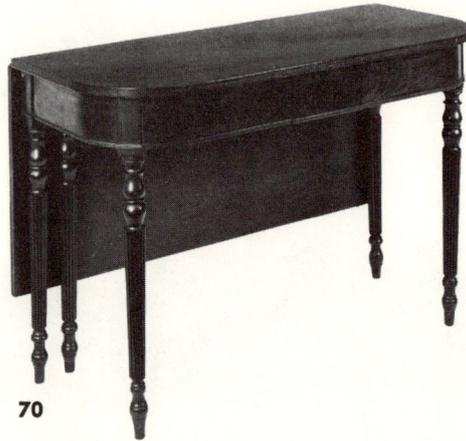

70

Tables

In tables, generally, a choice seemed to exist between straight, turned legs or a pillar on three or four Greek-curved legs, although Hepplewhite dining tables on square, tapered legs persisted. In addition, dining tables with hinged flaps were made in two or three sections, either on legs or pillars.

Small occasional tables were made with oblong or oval tops on balusters and three ogee legs instead of with a circular top on pillar and cabriole legs. A number of work tables — either oblong or Duncan Phyfe's astragal-end type — were made with fixed instead of lift-up tops, so that they could serve as occasional tables or lamp stands.

Pembroke tables, some of very fine quality, served as tea or breakfast tables, and probably a larger size, covered with a cloth, was the table around which the family gathered in the evening. Folding-top card tables received much attention, both in design and construction. When folded, these tables served as consoles. In some cases, ends were concave or convex, the two front legs being set under the narrowed center section, changing the outline.

71. A mahogany dining table in two sections. Each has a rounded end, one hinged leaf, and four square, tapered legs, one of which is a fly leg. An American eagle in a small medallion is inlaid in the frieze. (*Metropolitan Museum of Art.*)

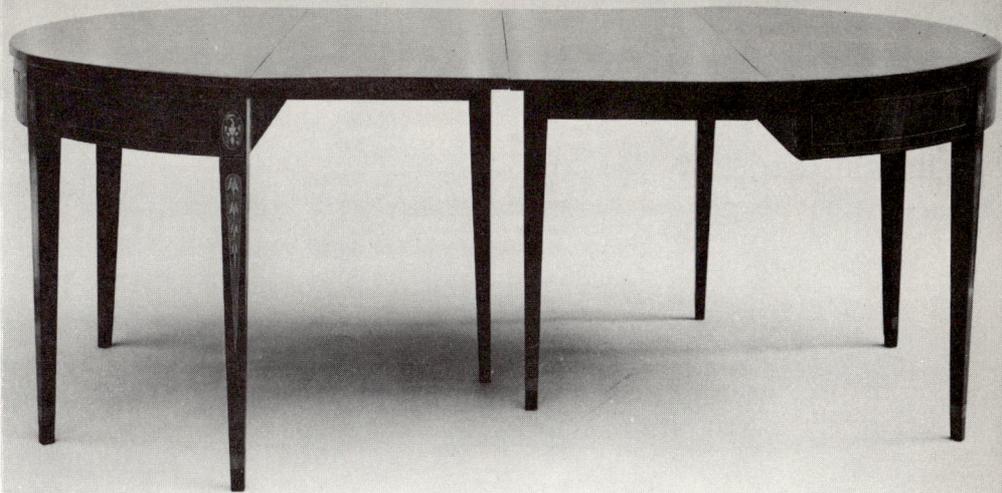

71

72

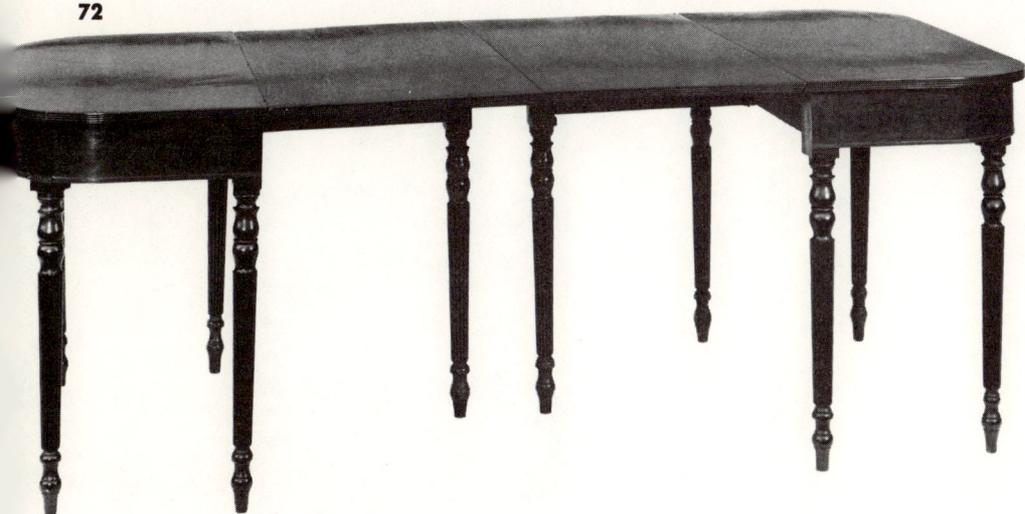

70 and 72. A marked change in the classic style is seen in this dining table in two sections, each a console with a hinged leaf falling at the back. There are five legs—one a fly leg—with ribbed shaft, bulbs, and a double-knopped foot. (*Kenneth Hammitt, Woodbury, Conn.*)

73

73. A two-section dining table with rounded ends has a frieze and a reeded rim; the matching frieze and rim on the extra leaf are unusual. Each section, on a ribbed vase pillar and Greek-curved legs, has a slender turned leg for extra support. (*Metropolitan Museum of Art.*)

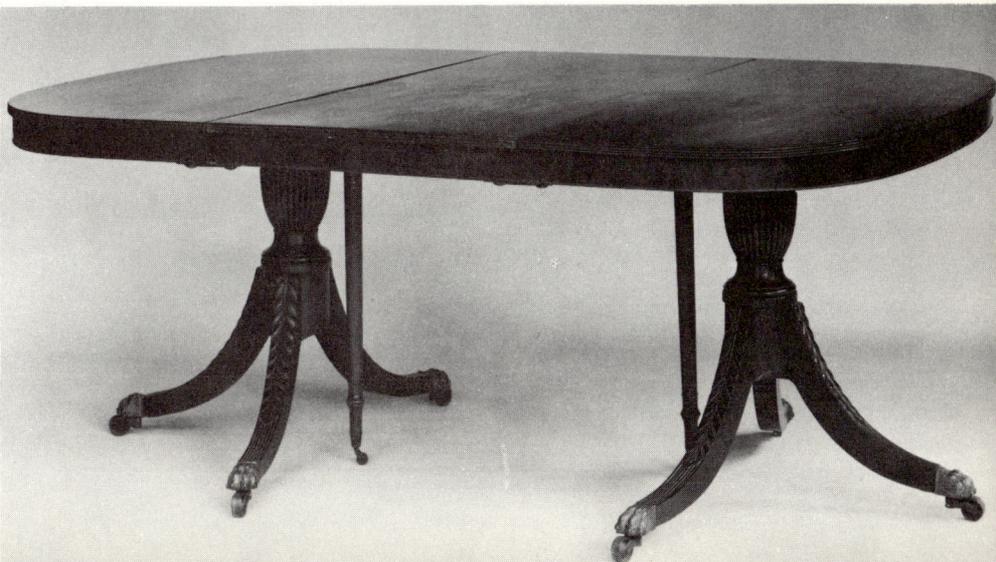

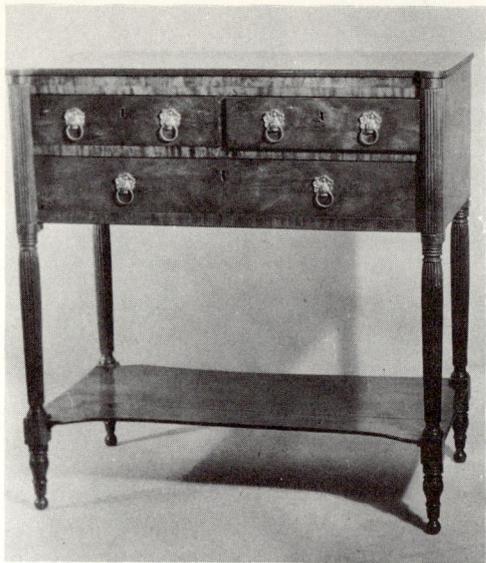

74. A rectangular buffet by Duncan Phyfe with three drawers and a stretcher shelf. The ribbed legs are continued on the front angles as attached colonnettes, with the top expanded to cover them. (*Museum of the City of New York.*)

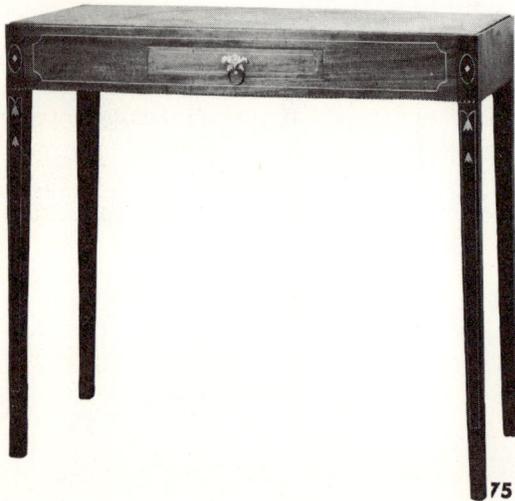

75. Small serving table in mahogany, finely designed and finished, with a small drawer in the center frieze. A marble top is sunk flush with the table edge. The panels are reserved by stringing and inlaid with diamonds and pendent husks. On the lower edge of the frieze and on the legs at flange height are lines of fine checkered inlay. (*Essex Institute, Salem.*)

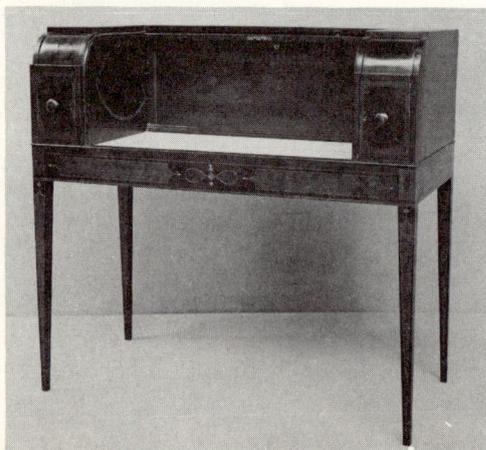

76. A distinctive type of mixing table with a tambour cover, marble top, and decanter cupboards. The details of the inlaid decoration are unusual. (*Metropolitan Museum of Art.*)

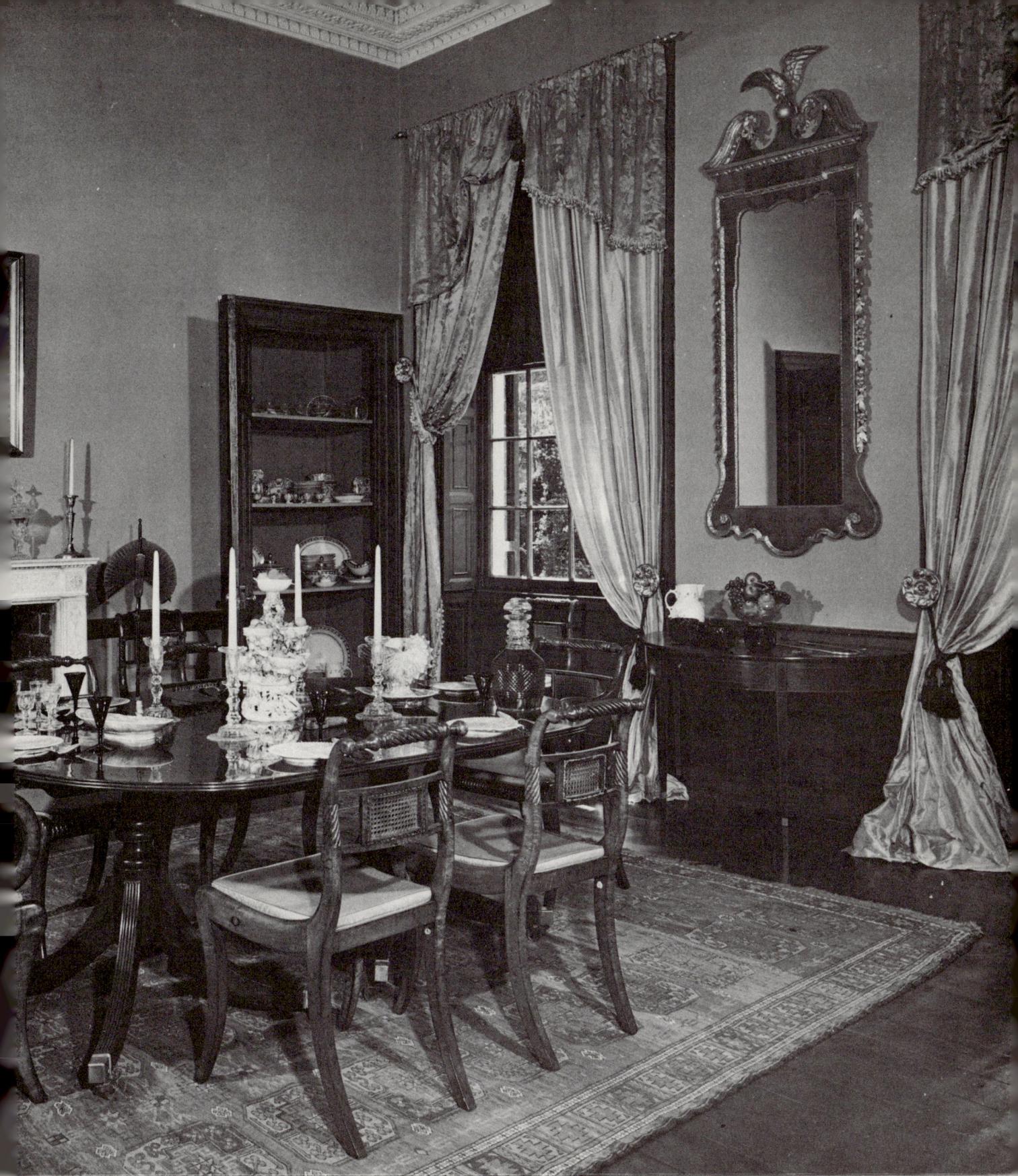

77. In the dining room of Woodlawn, the home of Nellie Custis Lewis, adopted daughter of George Washington, the classic two-section dining table has a reeded edge and pillar base. The caned maple chairs are similar to an English type designed by George Smith in 1808. (*Woodlawn Plantation, Mount Vernon, Virginia.*)

78. Card table with chamfered corners on the folding top and on the box base with a paired lyre support. Greek-curved legs are carved with water leaf. (*Metropolitan Museum of Art.*)

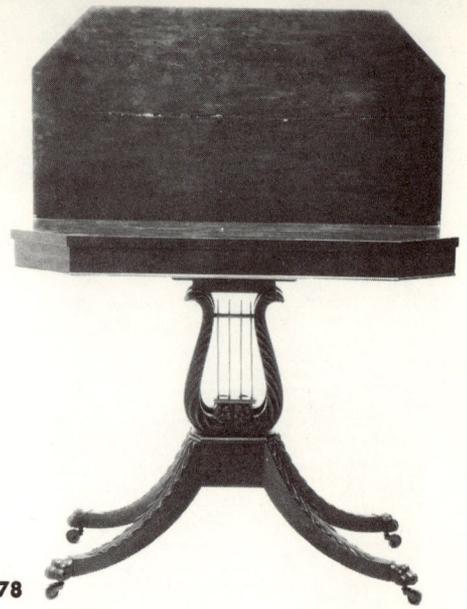

78

79. A card table with the stamp of Michael Allison has carved blockings with a pendent finial on the frieze and a pillar on three Greek-curved legs, one of which, as specified in the 1815 New York price list, was ."to turn out with the joint rail" when the top was opened. (*Metropolitan Museum of Art.*)

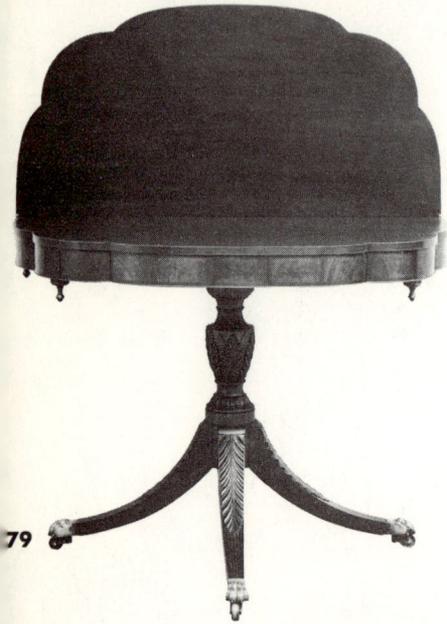

79

80

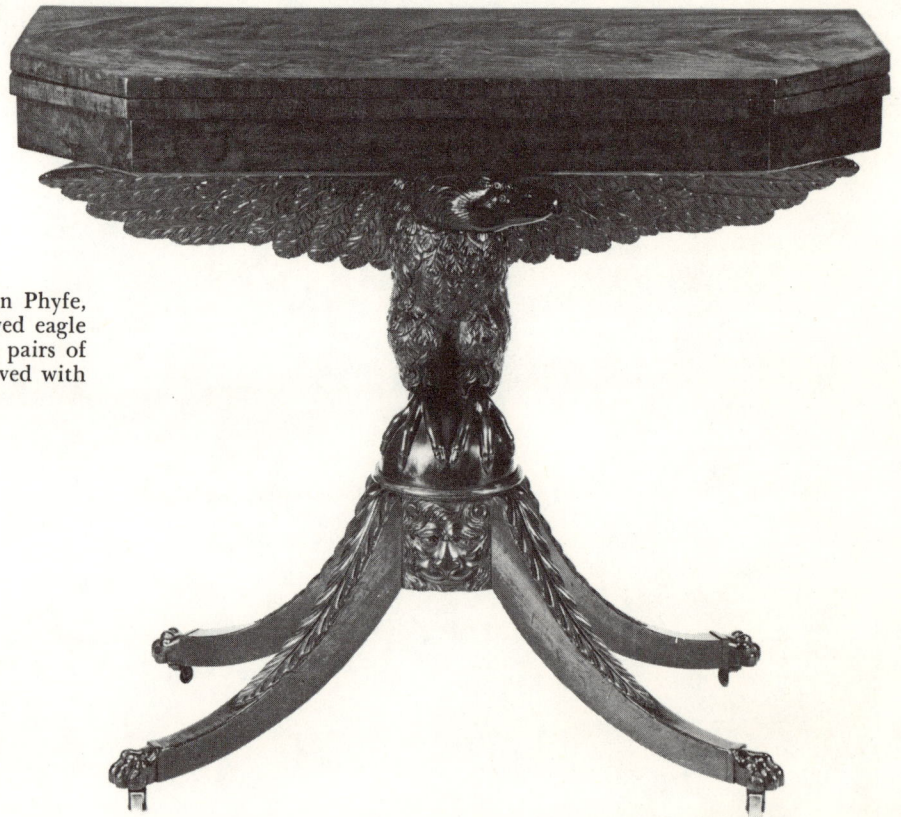

80. Mahogany folding-top card table by Duncan Phyfe, designed as a console, with a magnificently carved eagle with outspread wings supporting the top. Two pairs of Greek-curved legs are attached to a cylinder carved with a lion mask. (*Museum of Fine Arts, Boston.*)

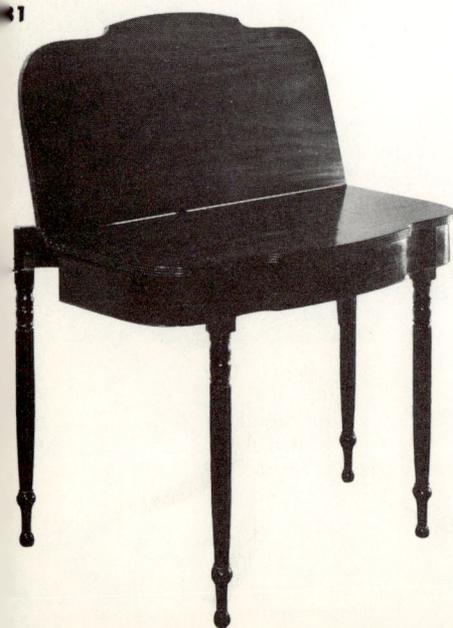

81. Mahogany folding-top card table. The reeded rim is bowed in the center and joins, with small angles, the curves of the rounded ends—a feature apparently introduced by Henry Connelly. (*Philadelphia Museum of Art.*)

82. A Regency sofa table with end flaps and two drawers in the frieze has a *cheval* base on plain standards and Greek-curved legs. The turned stretcher rail is set in blocks with chamfered corners. (*Essex Institute, Salem.*)

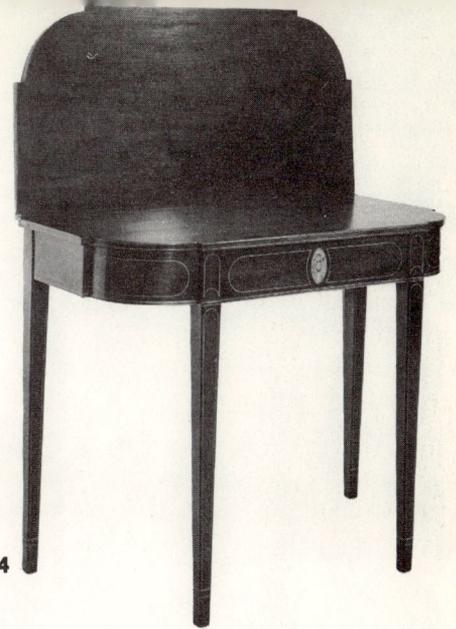

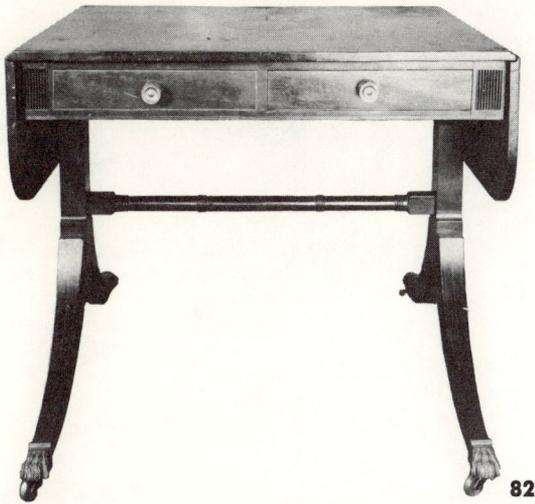

82

84

83. Fine design, construction, and finish distinguish this labeled Pembroke table by Holmes Weaver of Newport, Rhode Island. Double stringing outlines the top; covered urns inlaid in satinwood are on the frieze. Festoons, inlaid pointed panels, and triangles on the toes decorate the legs. (*Museum of Fine Arts, Boston.*)

84. Impeccable design and finish distinguish a mahogany folding-top card table attributed to Matthew Egerton, Jr., of New Brunswick, New Jersey. The corners of the table are broken-rounded. On the center panel, inlaid in a small medallion, is an American eagle with shield, arrow, and olive branch. (*Mrs. Thomas H. Powers.*)

85. Pembroke table with rounded, hinged flaps, crossbanded edge, and one drawer in the frieze. Blockings are extended downward over the ribbed and turned legs. (*Metropolitan Museum of Art.*)

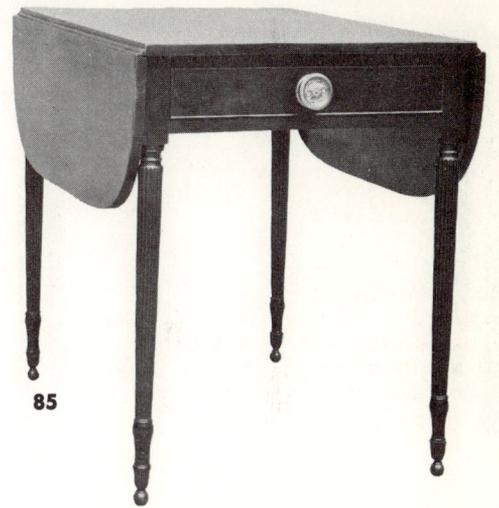

85

86. This classic Pembroke table with hinged, scalloped flaps, pendent finials, and a carved vase pillar on Greek-curved legs conforms to the accepted type. (*Metropolitan Museum of Art.*)

83

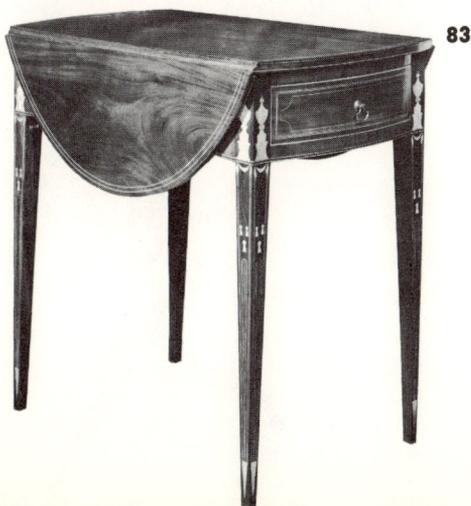

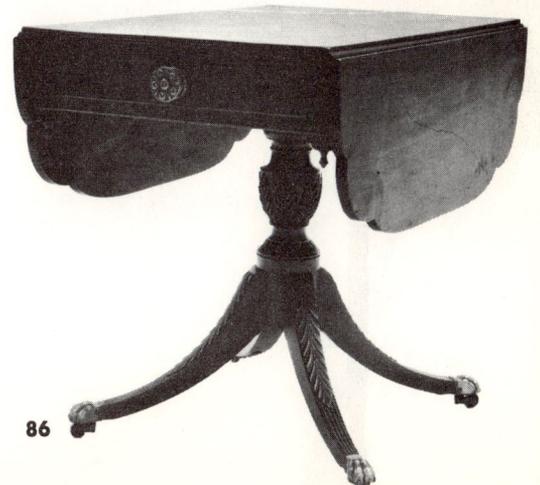

86

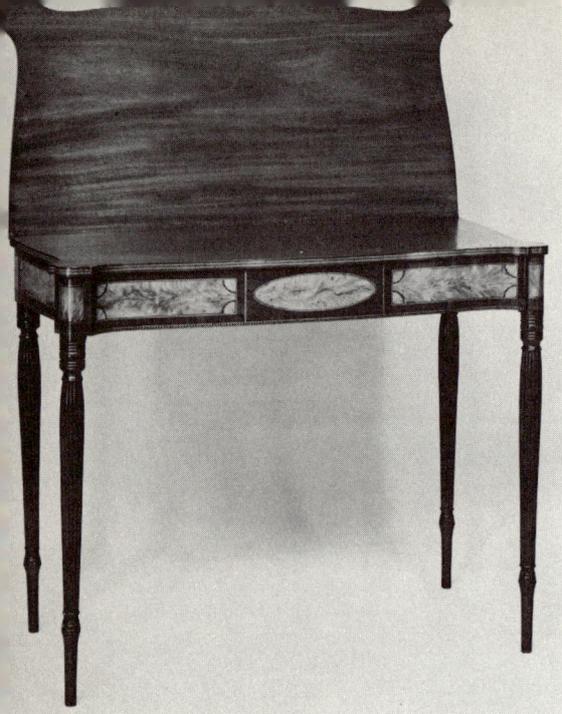

87

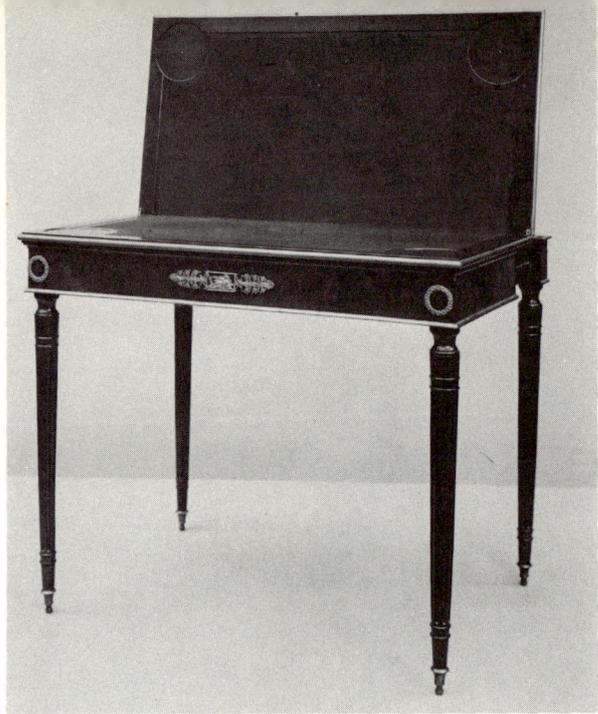

88

87. The front of this Salem-type card table is slightly bowed, with corners expanded in broken-rounded projections to cover colonnettes on the corners of the frieze. (*Metropolitan Museum of Art.*)

88. Card table by Charles Honoré Lannuier in the Louis XVI manner, with ormolu mounts and ribbed legs. (*Metropolitan Museum of Art.*)

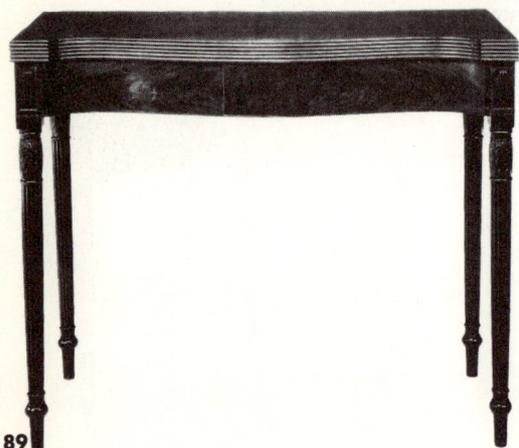

89

89. A folding-top card table attributed to Henry Connelly, with reeded edge, serpentine frieze, and legs with carved and ribbed detail. (*Taft Museum, Cincinnati.*)

90, 91, 92. Three typical classic occasional tables set on baluster stems with three ogee legs. One oblong example (90) has broad chamfered corners; another (92), with a molded serpentine edge, is set on a "twisted flute with fillet" as specified in the *London Book of Prices*, 1802. Both were gifts of Mrs. Russell Sage to the Metropolitan Museum of Art in 1909. An oval-topped table with four-scalloped edge (91) is in the collection of Mr. and Mrs. J. Balfour Miller of Hope Farm, Natchez.

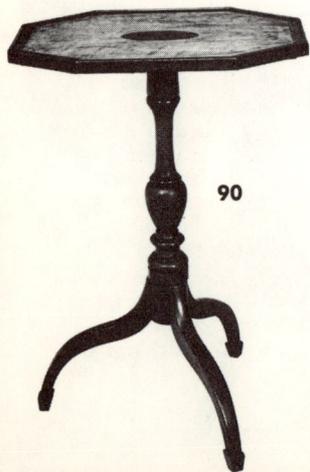

90

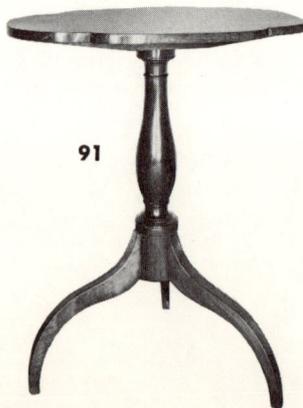

91

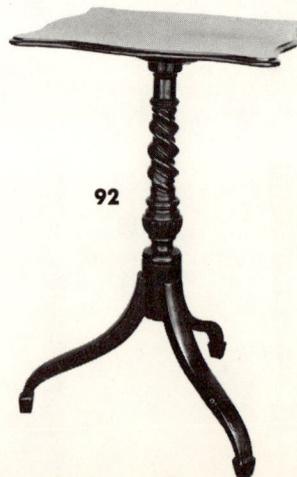

92

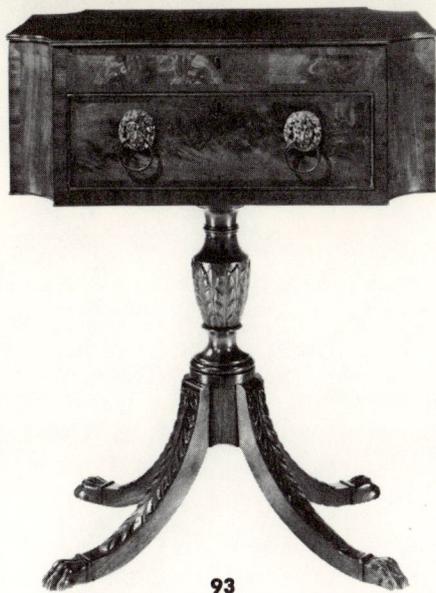

93. An oblong sewing table with lift-up top and one simulated drawer front above a single drawer. The frame is outlined by cross-banding. (*Henry Ford Museum, Dearborn.*)

94. Sewing table in mahogany and satinwood in the Salem manner, with broad chamfered corners and a pouch. The tapered legs are set under the center of the chamfers. (*Henry Ford Museum, Dearborn.*)

93

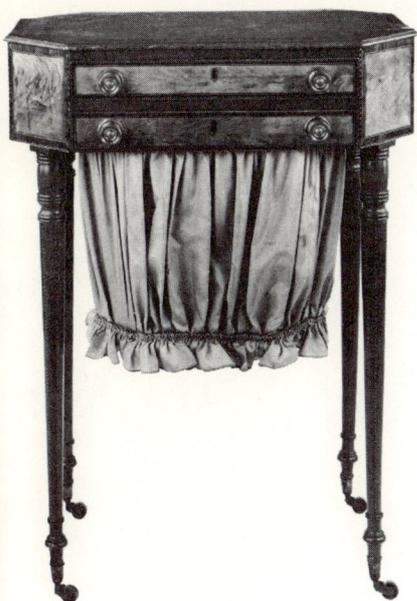

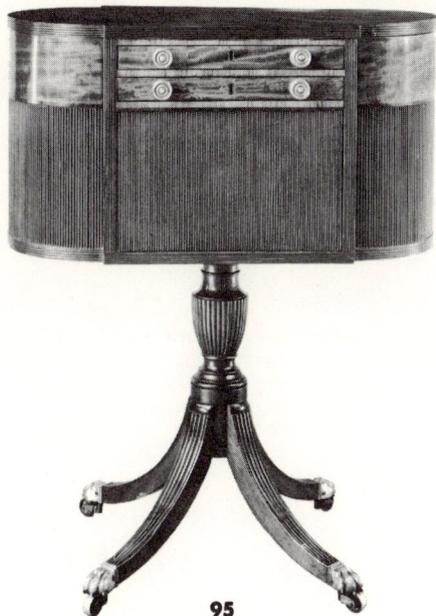

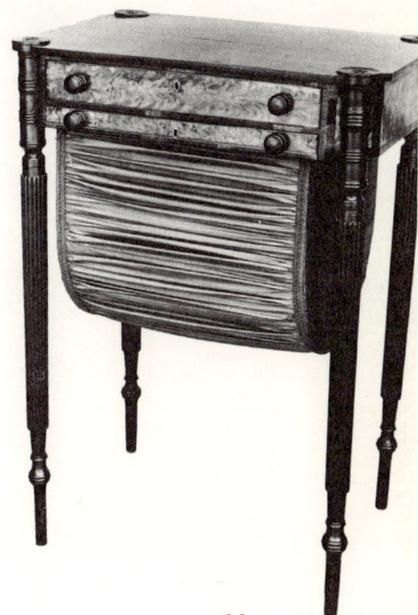

94

95

96

97

95. The astragal-end sewing table was apparently originated by Duncan Phyfe, to whom this example is attributed. The rounded, slightly narrowed ends have hinged covers, and a deep tambour section replaces the pouch. The vase pillar and cylinder are set on four Greek-curved legs with brass paws. (*Museum of Fine Arts, Boston.*)

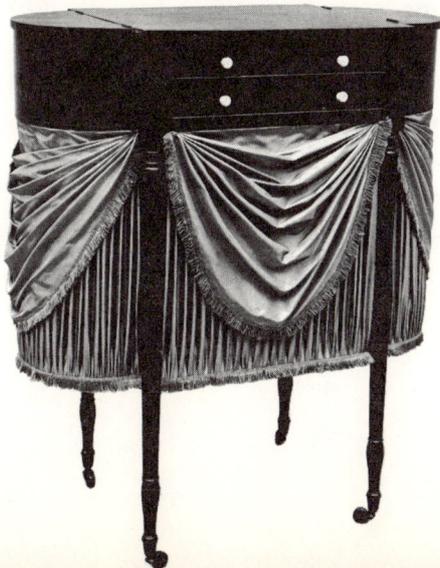

96. Mahogany sewing table with chamfered corners and ribbed legs that continue upward as three-quarter colonnettes. These are finished at the top with applied paterae. The lower drawer front is simulated, with a slide to hold the pouch. (*Metropolitan Museum of Art.*)

97. Sewing table with astragal ends and a deep silk pouch. The legs are attached under the corners of the table, so that the rounded ends project. (*Metropolitan Museum of Art.*)

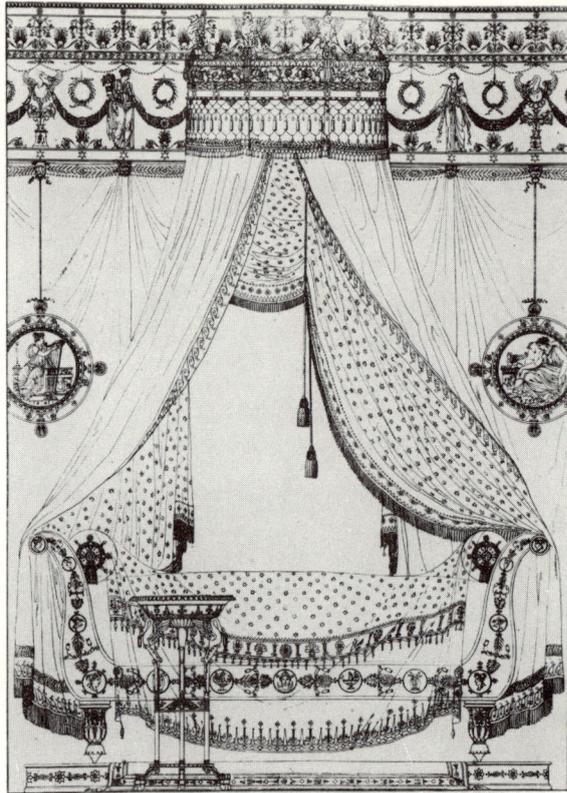

98. Design from *Receuil des Décorations intérieures* issued in 1801 by Charles Percier and Pierre Fontaine.

THE EMPIRE PERIOD

The foundations of the French Empire style were laid in 1800, when, as First Consul, Napoleon took up residence in the Tuileries. Practically all former possessions of the Crown had been destroyed or dispersed, and Napoleon commissioned Charles Percier (1764–1838) and Pierre Fontaine (1762–1835), two young architects who had studied in Rome and had been associated with the painter Jacques Louis David, to redecorate and furnish the Tuileries in the shortest time possible. Jacob Desmalter was employed as cabinetmaker. Desmalter's famous father, Georges Jacob, had retired in disfavor in 1796, and his son's production increased until about a thousand workmen were employed in his shop. The bulk of the furniture known as Empire was manufactured by the Desmalter firm. By 1804, when the coronation of the Emperor was celebrated, a representative background giving an impression of wealth, power, and stability had been achieved.

In America the French Empire style was much favored. As early as 1808 furniture made in the full Empire manner by Duncan Phyfe for Miss Louisa Throop consisted of a console table with a fine ormolu mount, a secretary with full-length Roman columns, and a bed, to be set sideways against the wall, with ormolu Egyptian heads and feet on its pilasters. After cessation of war with France in 1814, the American Empire style developed rapidly. Mahogany furniture in geometric designs with much crotch veneer and fine ormolu mounts was typical. Front legs were generally in the form of lion hocks or paws carved with wings or acanthus. Handles were abandoned on case pieces. Distinctive American features included the use of Greek-curved legs with a definite projection on the knee, a multiplication of sections in pillars and posts, and painted or stenciled imitation of metal ornament. The style lasted through the twenties, a heavier, coarser version being produced in the thirties.

The abacus platform base generally replaced the pillar and tripod. These platforms were boxed, and four supports were set on chamfered corners over four legs. White-and-gray and white marble were much used, a large quantity of this material coming from quarries in western New England.

The machine saw was patented in 1820, and from this time onward cabinetmakers procured their sheets of veneer, figured or plain, direct from the lumber yard. This probably accounted for the widespread and effective use of vertical crotch veneer in mahogany. Notable was Thomas Seymour, who used satinwood crotch veneer superbly.

The furniture industry in New York was active and had sufficient prestige to enjoy extensive exports. In 1819 the *Daily Georgian* advertised: "Elegant and Fashionable Furniture by B. J. Jordan [listed as an auctioneer] will be sold before my store. A quantity of mahogany furniture, sideboards, bureaus, high post bedsteads, etc. All warranted workmanship. Just received from New York."

In Boston too the furniture industry was flourishing. In 1816 Gridley and Blake announced for sale at their warehouse "A Great Variety of Genteel House Furniture, consisting of the following articles, viz: 34 Bureaus, 16 Secretaries with and without Book Cases — 12 pair elegant Grecian and common card tables — 40 Pembroke and Dining Tables, some of which are in the Grecian style, with claw feet — 150 Bedsteads, comprising high post and field, mahogany, richly carved — 1 Commode — 11 Sofas and Sofa Bedsteads — 7 Easy and lolling Chairs — 25 Wash and Light stands — 5 Sideboards — 4 Toilet Tables — 250 Looking Glasses, all prices — 10 Portable Desks — 700 Bamboo and Fancy Chairs — 3 Ladies Work Tables . . . no work will be recommended but in proportion to its real quality . . . but as to a great outcry of *cheap cheap*, it would be superfluous, as it is so well known that G and B never sold in any other way."

The *Philadelphia Cabinet and Chair Makers' Union Book of Prices . . . established in 1828 by a committee of employers and journeymen* was published in Philadelphia, "to avoid those vexatious litigations that but too frequently occur." Invaluable information on furniture of the American Empire period is authenticated in this publication.

99. (OVERLEAF) Parlor of the Bartow Mansion, Pelham Bay, New York. The furniture is typical Empire. A pair of oblong, mirror-backed consoles with gilt metal mounts flanks the windows. The center table has a circular marble top on a massive turned pillar and three "spoke" legs on gadrooned bulb feet. Four open-arm chairs with padded backs show interesting variation: on one the straight armrests terminate in lion heads; two have the Marie Louise curved armrests; the fourth is tub-shaped with detached scroll arm supports in front. The back of the large settee has arms with columns at right angles to the seat. (*Courtesy Antiques Magazine.*)

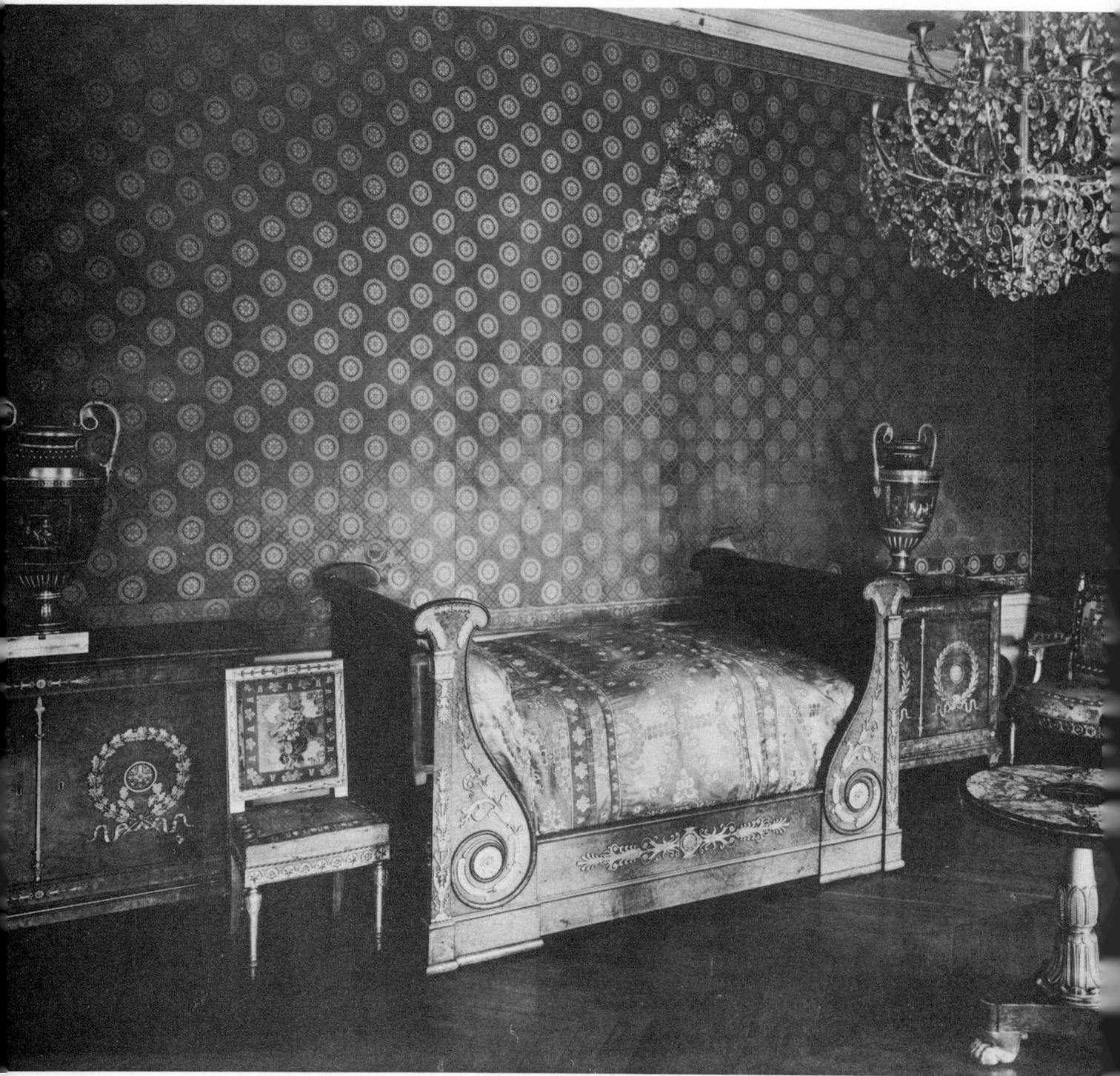

100. The tapestry covers of the chairs made for Napoleon's bedroom in the Grand Trianon are an example of the magnificent textiles used to upholster Empire furniture. (*Photo: Bulloz.*)

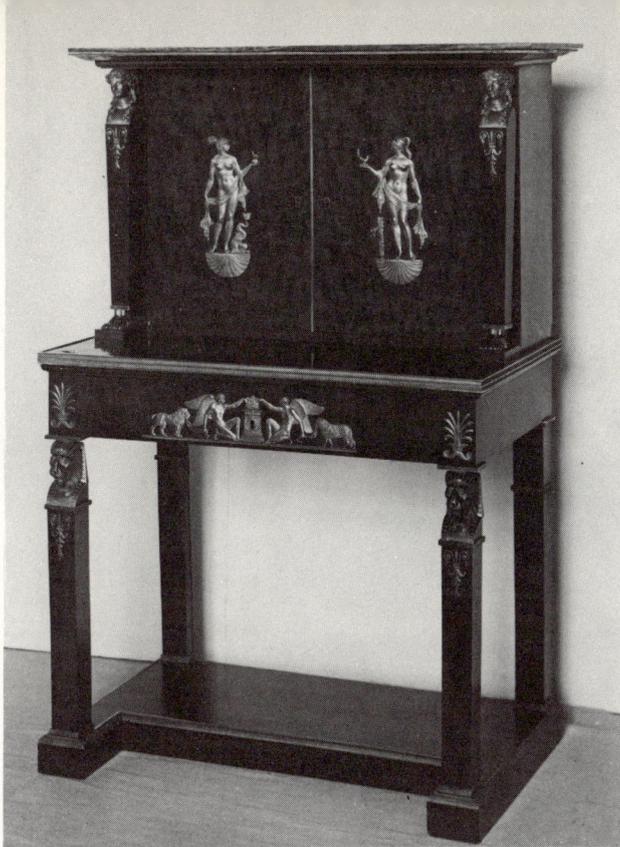

101

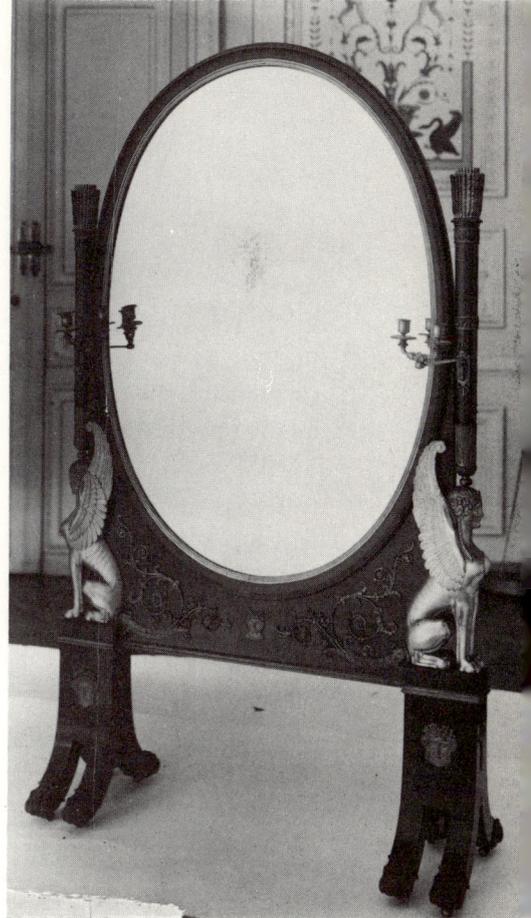

103

101. *Bonheur-du-jour* in mahogany with ormolu mounts, made by Charles Joseph Lemarchand, member of a well-known French cabinetmaking family. (*Musée des Arts Décoratifs.*)

102. Typical Empire *fauteuil*, with front legs and arm supports united in a female Egyptian term. Egyptian detail, which frequently occurs in Empire furniture, was sponsored by Baron Dominique Vivant Denon, who accompanied Napoleon on his Egyptian campaign, had a room furnished in the Egyptian manner, and in 1802 published *Voyage dans la basse et haute Egypte.* Stamped "Jacob D." (Desmalter). (*Musée des Arts Décoratifs.*)

102

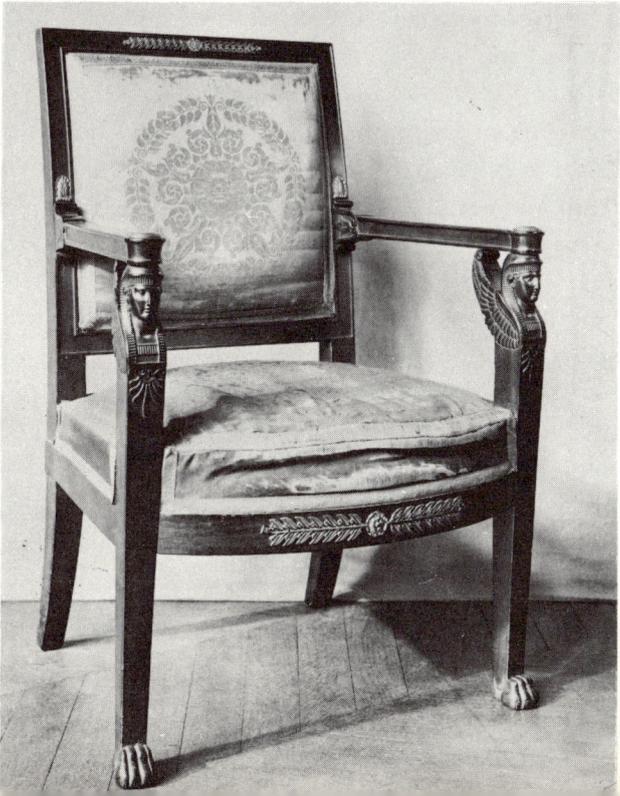

103. The oval mirror of a *cheval* glass made for Marie Louise was swung on quiver supports set on the head of seated sphinxes. (*Palais de Compiègne.*)

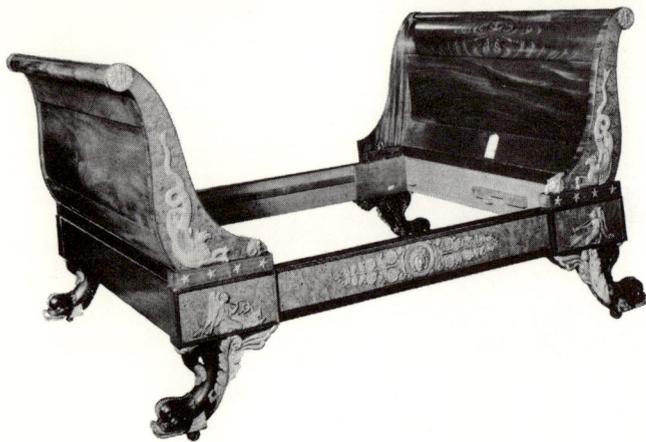

104. Bed with labels of Charles Honoré Lannuier, from the Van Rensselaer manor house, Albany.

Bedroom Furniture

The field bedstead and high-and low-post bedsteads continued to be made during the Empire period. As the fashion for the high post developed, the field bed declined in popularity. The former, intended for the best bedrooms, was made in mahogany, maple, or cherry. In the South handsome four-posters persisted, with posts turned in multiple members.

A French bedstead, specified in the New York price list of 1815, was in Empire style. This followed the field bed, and, since it was a novelty, little scope was given for variants. The bed was listed as "Three feet wide, with scroll ends, one pannel or more in each to come to within five inches of the top of the scroll . . . ogee legs extra from plain sweep." In the Philadelphia price list of 1828, the size is given as six feet by four feet, with extras for glued blocks on the front to receive columns — this when the bed was placed sideways against the wall. Columns, swan necks, and terminal figures were favored on the front posts. Bedding and coverlet were inside the frame.

The dressing bureau with hanging or toilet mirror was gradually superseded by the dressing table. John and Thomas Seymour seem to have been pioneers in this development. Although the bureau was modified in depth and set on legs, it was still ill-adapted for sitting.

In the 1818 supplement to the *New-York Book of Prices*, specifications for the modern type of dressing table at last emerged. The basic norm was a round- or elliptic-front dressing table on four plain, turned legs. The top drawer could be partitioned and extra drawers added. The kneehole, six inches deep between two short drawers, provided convenience in sitting.

In 1820, in the *Independent Chronicle and Boston Patriot*, Nehemiah Jones advertised furniture for sale by auction — "Many Manufactured by the late Mr. Bass, Deceased — Toilet Tables with Glasses of the most approved fashion and several very superior." Mr. Bass was probably the cabinetmaker Elisha Bass, of Hanover, Massachusetts.

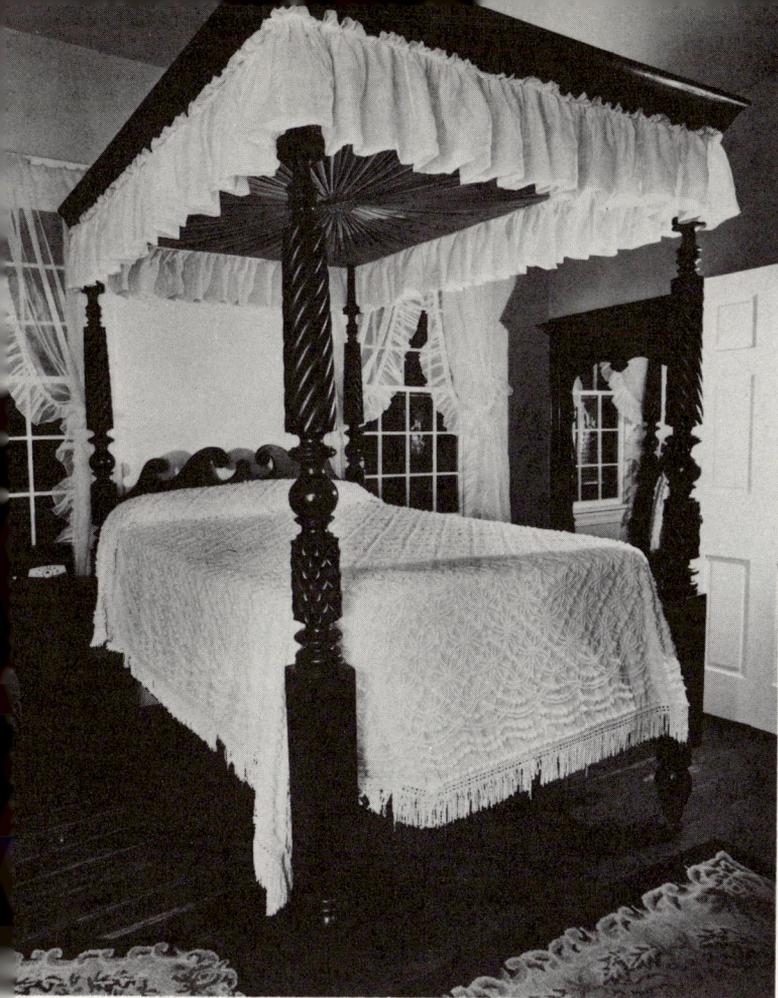

105

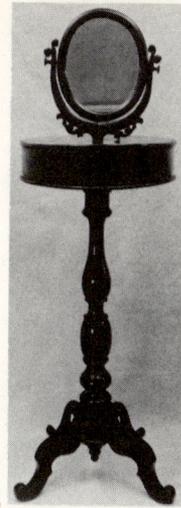

106

105. Plantation bedstead with full tester and cyma-molded cornice. The four posts are alike, with multiple sections in true Empire style — spiral shaft, vase, and cylinder finely carved with pineapple facets. (*Ayres P. Merrill family, Airlie, Natchez.*)

106. Late Empire shaving stand on a multiple-membered pillar and three scrolled legs — a small scroll superimposed on each. The circular case has a drawer and an oval mirror on its center. (*Museum of the City of New York.*)

107. Empire dressing bureau by William Hook of Salem, with short legs, turned with multiple members. The mirror, in a plain molding frame, is on scroll supports with spurs and small projecting roundels; its box base is bow-fronted. (*Essex Institute, Salem.*)

108. Square washstand in mahogany. The top is expanded to cover ribbed baluster supports with Egyptian leaf coronas. The boxed shelf stretcher contains a drawer. (*Metropolitan Museum of Art.*)

109. A washstand in accordance with the description "Inclosed Bason Stand . . . plain door and one drawer" was specified in the New York price list of 1815. Superior finish is seen in the cylinder fall front, cock-beading, ribbed legs, and reeded stiles. (*Metropolitan Museum of Art.*)

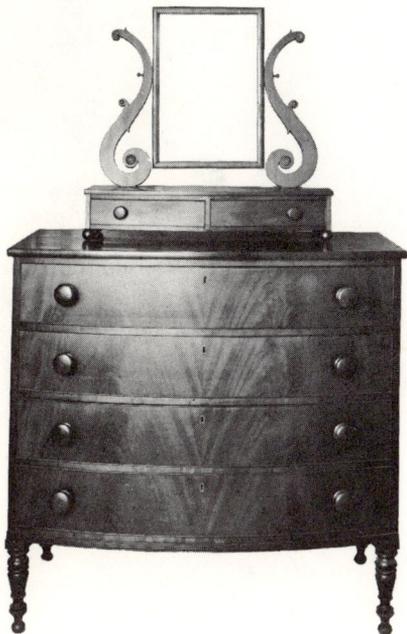

107

108

109

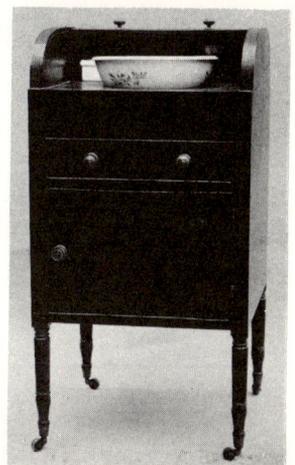

110. This unusually sophisticated example of the low-post bedstead corresponds with specifications in the Philadelphia price list of 1828: "Low Post, poplar, 6 feet by 4 feet." (*Woodlawn Plantation, Mount Vernon, Virginia.*)

111. High-post bedstead with trundle bed has ribbed legs and two footboards. The bureau, at right, has a projecting top drawer and plain Roman columns on the stiles. (*Harrison Mansion, Vincennes.*)

112. The posts at the foot of this mahogany field bed are multiple-membered, with vase, spiral-turned shaft, and roundel tapering sharply up to the rails of the canopy. (*Essex Institute, Salem.*)

110

111

112

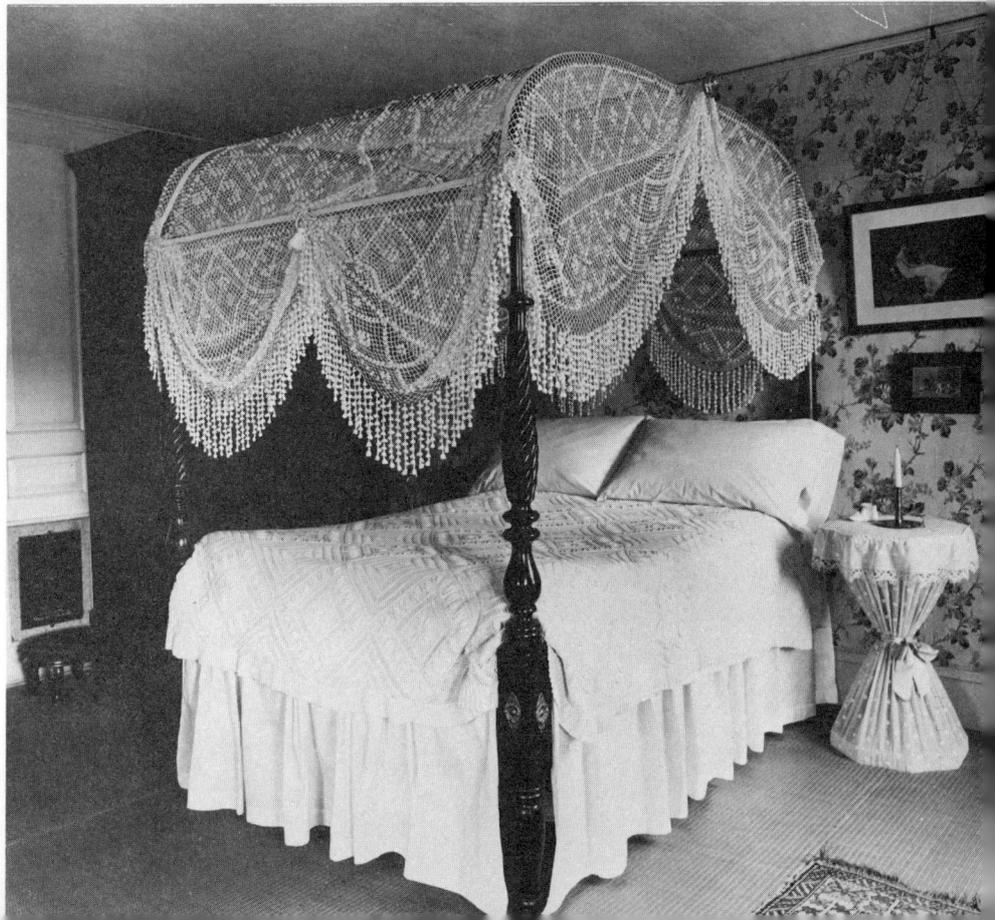

Chairs

The first signs of Empire influence on American chairs seem to have been an extension of the uprights above the tablet, the use of an important motif — lyre, harp, eagle, cornucopia — on the stay rail, and a projection of the knee. The frame was rounded, edged with astragal ribs instead of reeded — "Pannelled out betwixt two beads" — as Rudolph Ackerman described it in *Repository of the Arts,* 1809–1829.

The main Empire side and dining chair, however, had a broad klismos tablet set on top of the uprights and a stay rail. Both of these were shaped and carved. Legs were Greek-curved, seats were slip-in, and gilded metal mounts or — more frequently — painted or stenciled ornament were used for decoration. In the Philadelphia price list of 1828 extras on plain chairs were "Brass or wood line in top rail round the pannel" and "scroll or knee to front leg."

In France there had always been a preference for chairs with padded backs. These were introduced into America and were fairly widely used, but more for parlors than for dining rooms.

An innovation was the introduction of the classic curule base, referred to in price lists as "Grecian Cross." Phyfe made several versions with this base. Boston advertisements show a variety of types. In 1820 an advertisement listed "1 set Bamboo chairs; rocking chairs; Mahogany chairs with hair bottoms; 2 Rose Wood Calcutta chairs with arms; a dozen of new Chairs, in imitation of rose wood, with cane bottoms, made in the best manner." In 1821 a Boston auction held by David Forsaith included three thousand chairs at all prices.

From the late 1820s White and Hamilton, the Allegheny Chair Manufacturing Company in Pittsburgh, supplied chairs and settees for hundreds of Ohio River steamboats as well as furniture for hotels. The chairs they made are frequently mistaken for Hitchcock chairs.

In 1829 Mr. Charles W. James, late of Philadelphia, advertised from his Cincinnati Chair Manufactory "Fancy Grecian Drawing Room and Windsor Chairs, Lounges, equal in every respect, to those made in the Atlantic Cities . . . the greatest variety of Chairs in the Western Country."

Windsor chairs continued to be widely made; they were also used for Boston rockers with seats rolled up in the back and down in the front. Boston spring-seat rocking chairs were advertised in the *New York Evening Post* in 1830.

113

114

113, 114. Among the furniture made for Marie Louise in 1810, when she stayed overnight at Compiègne on her way to Paris to marry Napoleon, was a set of chairs. The armrest and its support were joined in a curve instead of at right angles, a change from the usual Empire *fauteuil* design. This new style was adopted in a set of furniture made in America, with Egyptian decoration. (113: *Palais de Compiègne.* 114: *Philadelphia Museum of Art.*)

116. Duncan Phyfe's Empire chair shows the classic frame, to which a lyre with foliate-carved horns has been added between stay rail and tablet. The face of the front legs has "a reed worked in the center and the edges rounded to it." (*Metropolitan Museum of Art.*)

115. Fancy chair of maple and beech, painted and partly gilded. The double stay rail encloses an oval panel, scrolls, and balls. The front stretcher rails are paired, with three balls. (*Metropolitan Museum of Art.*)

117. One of a set of four chairs. The curved tablet with a recessed panel framed in molding and the stay rail with paired, fruit-filled cornucopias emphasize the Empire styling. (*Henry Ford Museum, Dearborn.*)

117

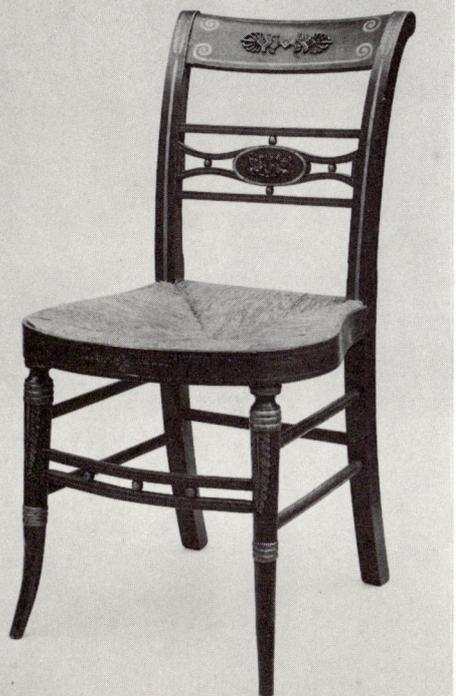

115

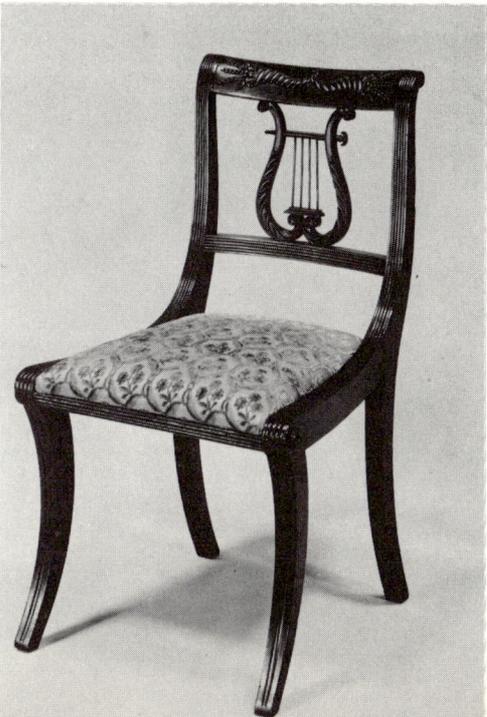

116

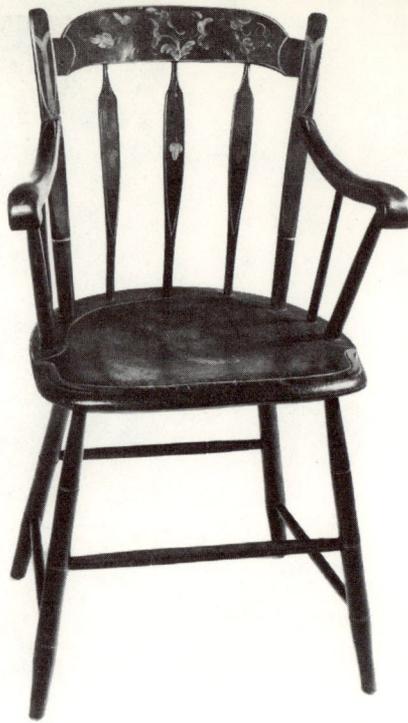

118. Pine and maple chair, made by Joel Pratt, Jr., of Sterling, Massachusetts, with windsor-style base and bamboo-turned legs and stretchers. The back is in the Hitchcock manner, with three flattened splats, and knuckle-end arms set on a spindle and a baluster. (*Henry Ford Museum, Dearborn.*)

119. Duncan Phyfe made a quantity of seat furniture with the curule base. Here he set the curules under the sides, with brass paws in front and a waisted baluster stretcher. Variants have the curule across the front and plain legs behind. (*Metropolitan Museum of Art.*)

119

120

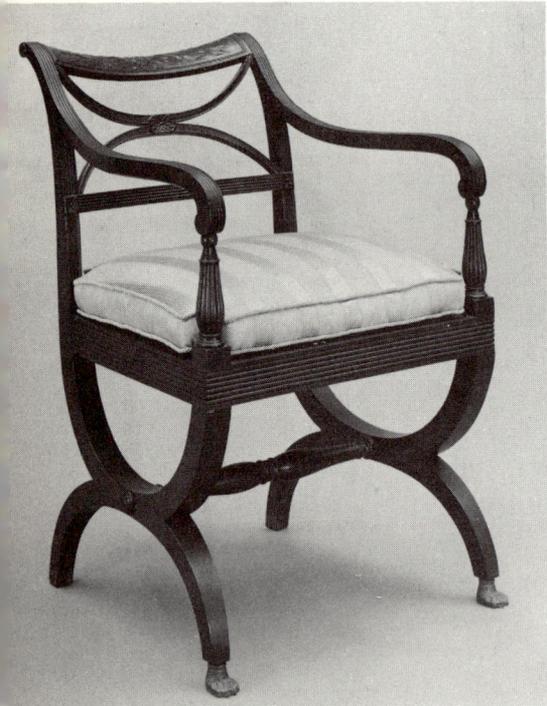

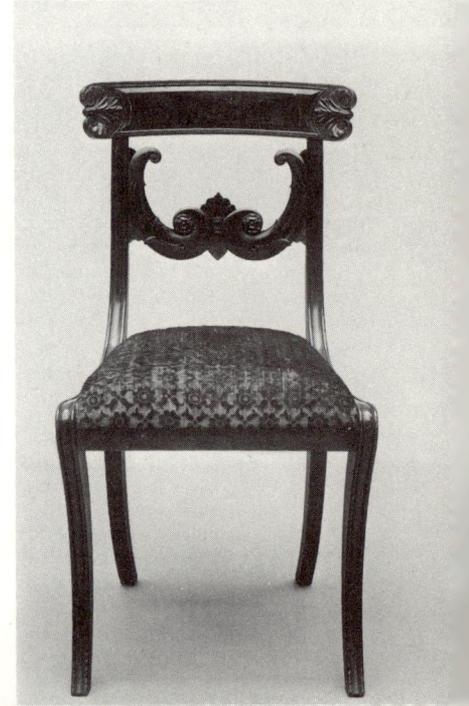

120. The tablet of this chair is carved and shaped at the ends; the stay rail of paired lotus scrolls is attached to the inner sides of the uprights. (*Metropolitan Museum of Art.*)

121. The classic frame of an early type of Empire side chair is "pannelled out betwixt two beads." Knees are projected, the front seat rail recessed. The stay rail, facet-carved, displays an eagle on a rocky base. (*Cooper Union Museum.*)

122. Dining or side chair carved on the uprights to conform with a broad stay rail of paired scrolls and a patera. (*Philadelphia Museum of Art.*)

121

122

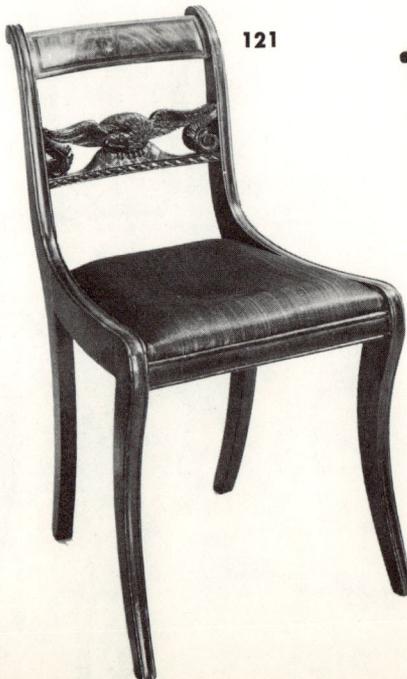

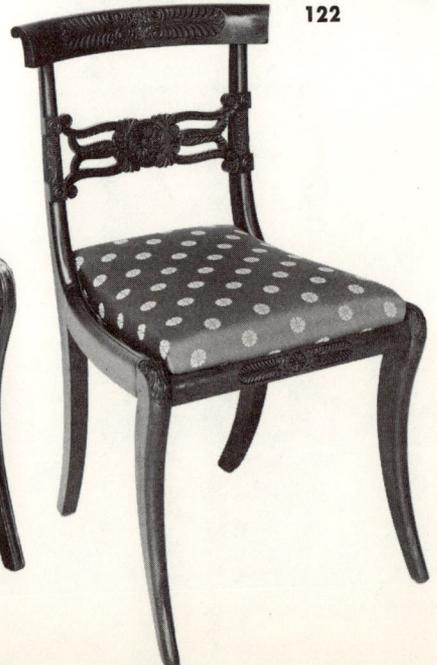

123. This fancy chair, painted in the black and gold favored for Empire furniture, has paired cornucopias on a narrow stay rail and Greek-curved front legs terminating in canine hocks. (*Philadelphia Museum of Art.*)

124. Boston rocker with a windsor chair base. The seat rises at the back and is rolled in front. Turned uprights enclose eight contour-carved spindles. (*Henry Ford Museum, Dearborn.*)

124

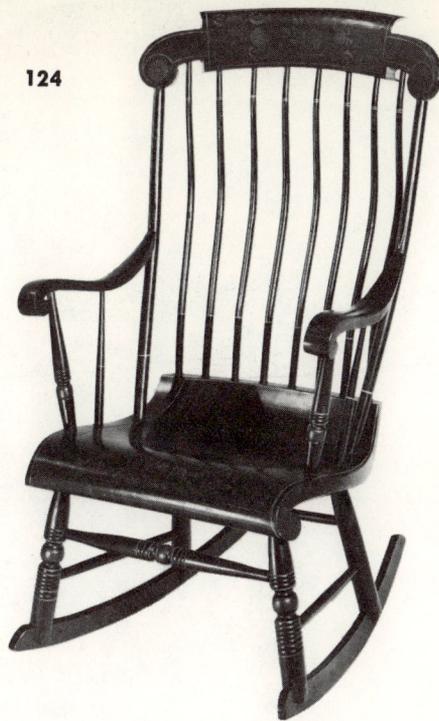

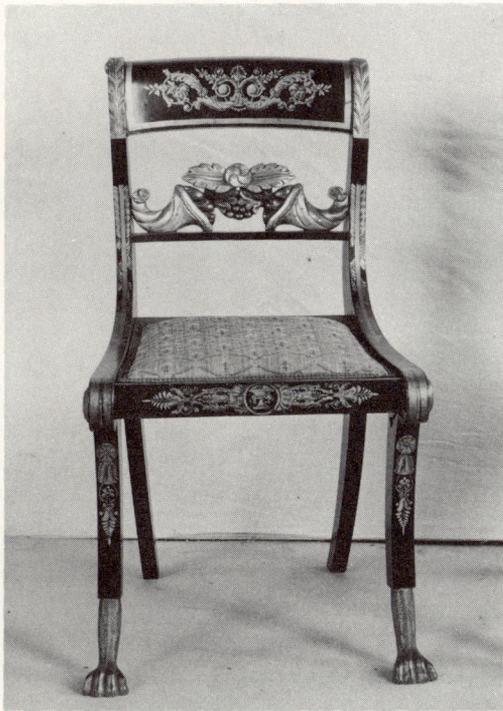

123

126

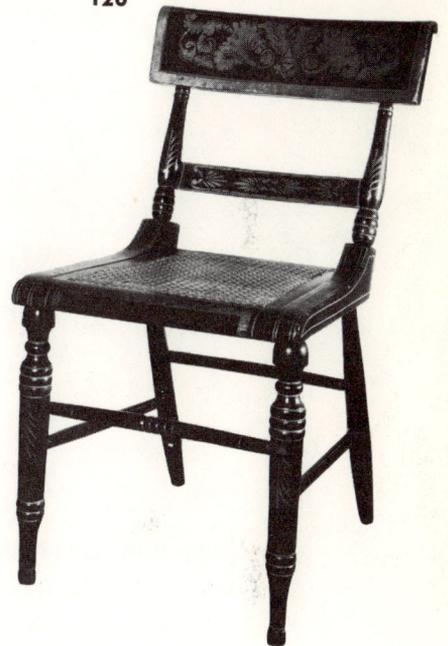

125

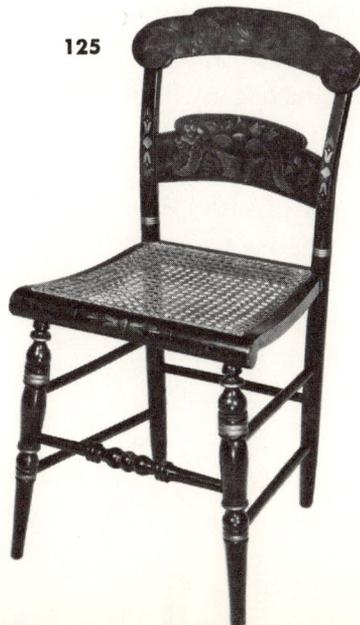

125. Painted chair by Hitchcock and Alford, c. 1836 — a sophisticated type with caned seat and broken-arched stay rail and tablet. (*Henry Ford Museum, Dearborn.*)

126. Ornate black chair with gilt stenciling. A broad tablet is set on baluster uprights with *bateau* extensions at the back of the seat rails. (*Philadelphia Museum of Art.*)

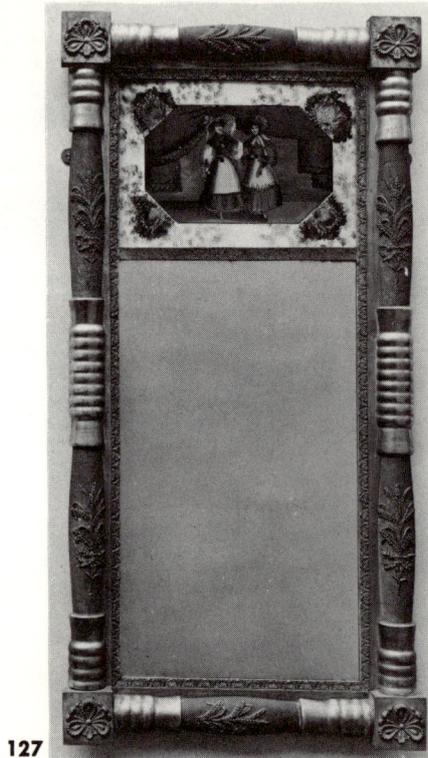

127

Mirrors

The use of mirrors increased in the Empire period. The small vertical hanging type, with painted or ornamented panel at the top and no cresting, persisted. A new type was a horizontal mirror in three sections for the mantelpiece. One of these mirrors was used in President Jackson's bedroom at The Hermitage. Frames were usually pine, coated with gesso; much of the ornament was carved or, more frequently, molded in small-scale design. The majority of frames were gilded, but a few were made in mahogany. In the Museum of the City of New York there is a vertical hanging mirror in a mahogany frame which bears the label of Duncan Fraser, 58 Chatham Street, New York.

In 1820 S. Lothrop, 71 Market Street, Boston, advertised "looking glasses, toilet do." and a month later, "Toilet Tables with Glasses of the most approved fashion and several very superior." In 1821 "a Large Mirror, Sixty-six inches by twenty-seven inches" was offered. In 1830 a notice appeared in the *New York Evening Post* — "Sold at Auction, Elegant Pier Glasses, French Plates, 65 inches by 23 inches, 60 inches by 30 inches." In that year mirror plates were first ground and polished by steam.

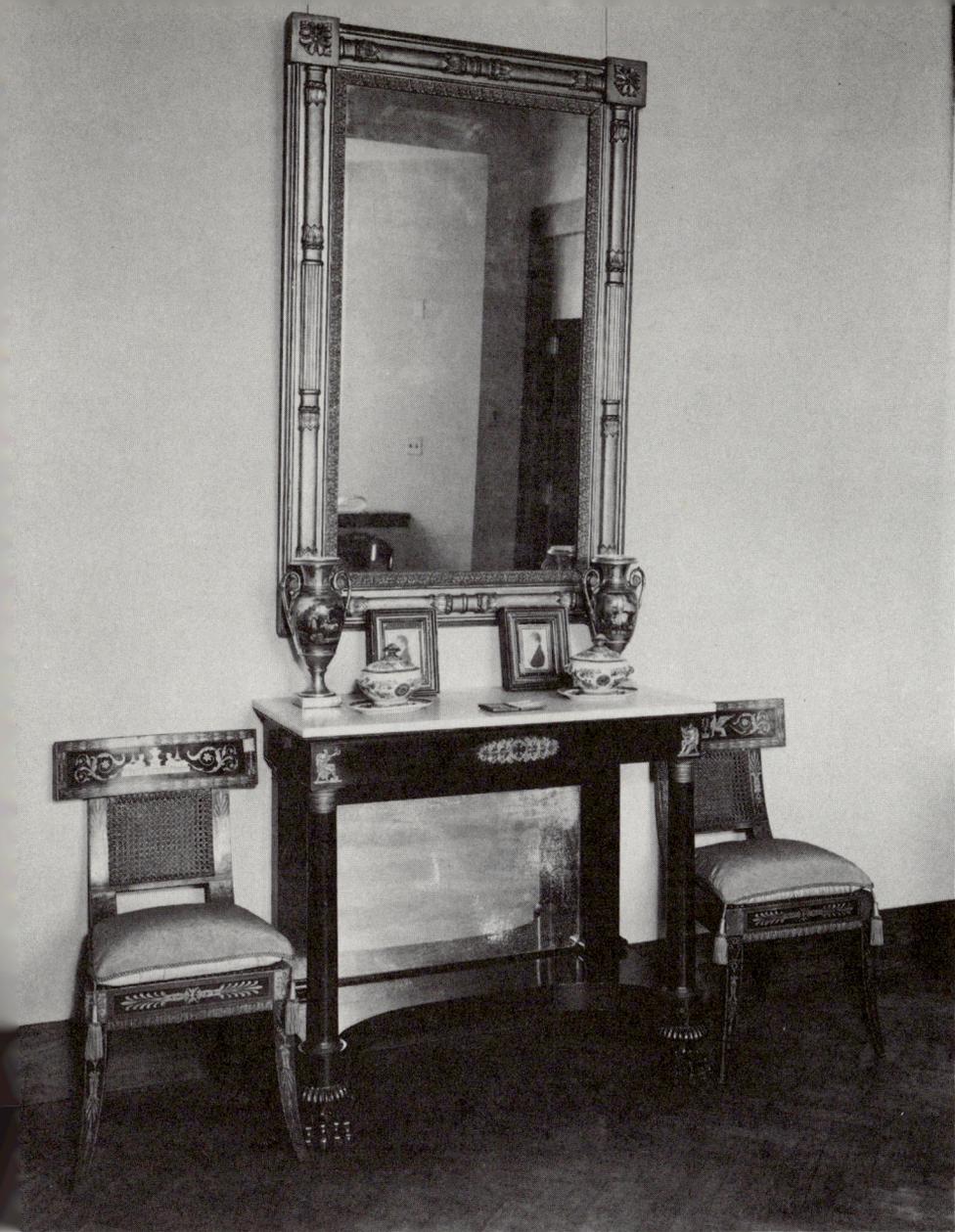

128

129

127. Hanging mirror with the frame in typical split-baluster and ringed sections, and small-scale ornament on a band around the glass, frame, and blockings. At the top is a panel painted with two belles in Empire dress. (*Metropolitan Museum of Art.*)

128. In this group the mirror frame has applied split-baluster ornament between patera-carved blockings. The typical marble-topped console has Roman column supports and a mirror back. Stenciled designs embellish the caned chairs. (*Philadelphia Museum of Art.*)

129. Mantel mirror in three sections divided by typical Empire baluster and ring stiles; its base is coved, the cornice ovolo with corner blockings. Ornament is intricate on a small scale, with natural floral sprays and running vine. (*Stanton Hall, Natchez.*)

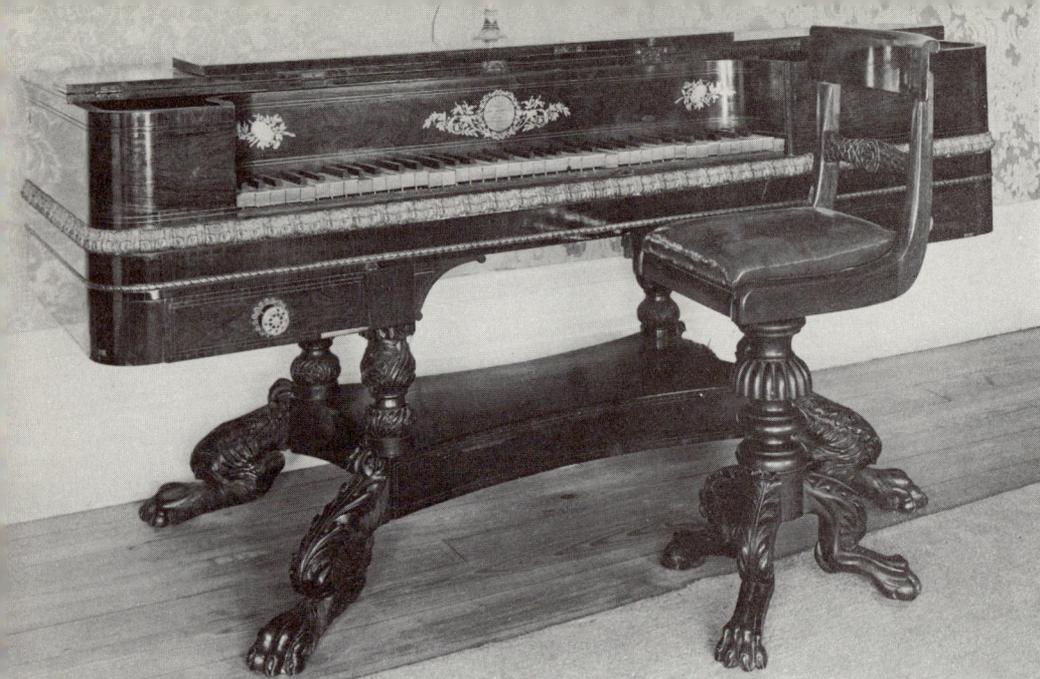

130

130. Rosewood piano case with bands of carved, gilt molding. The frieze is arched in the center and flanked by drawers with ormolu handles. The unusual abacus platform base on lion hocks has foliate-carved vases as supports. A small inlaid medallion reads "John Kearsing from London. John L. Rickers, 187 Broadway, New York." (*Mr. and Mrs. Douglas H. McNeill, Elmscourt, Natchez.*)

131. This ornate gilded rosewood pianoforte was made by Loud Bros., founded in 1816 by Thomas Loud, an Englishman, in Philadelphia. In 1830 T. Loud, Piano Forte Maker from 280 to 458 Broadway, advertised in the *New York Evening Post*. The firm failed in 1837. (*Metropolitan Museum of Art.*)

132. Music chair with adjustable, drop-in seat on a turned pillar base with flat-section cabriole legs. Cornucopias are carved on the stay rail. (*Henry Ford Museum, Dearborn.*)

Musical Instruments

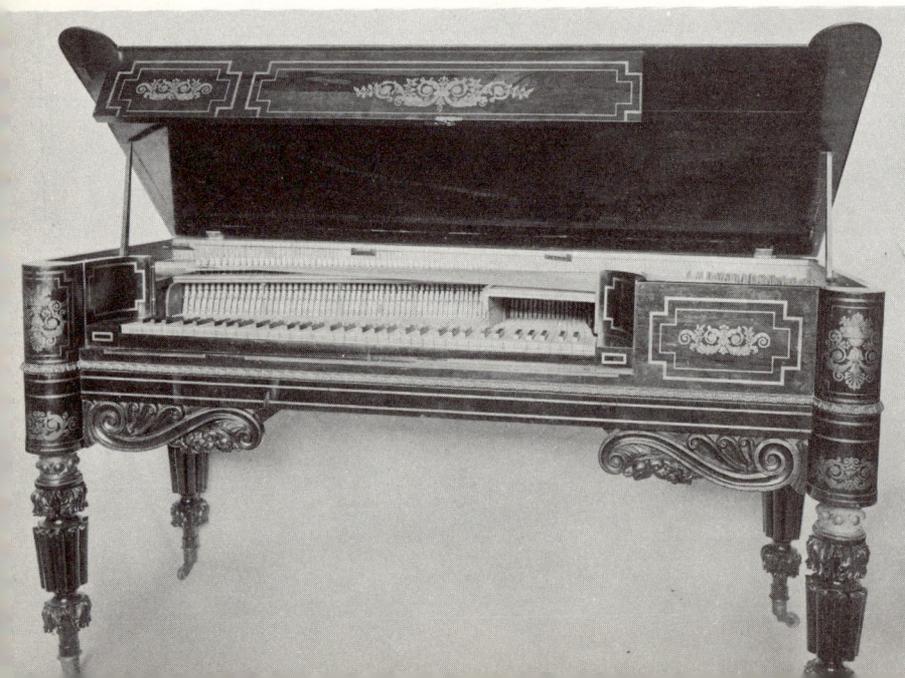

131

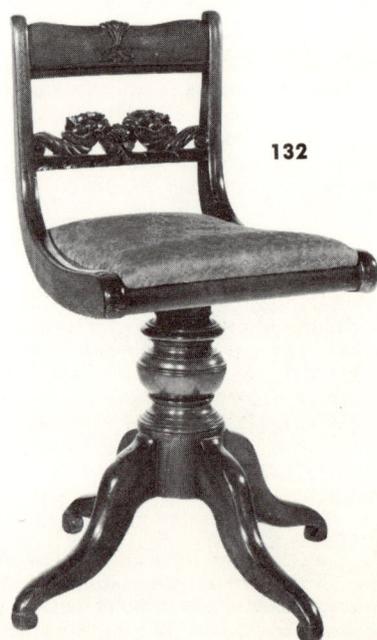

132

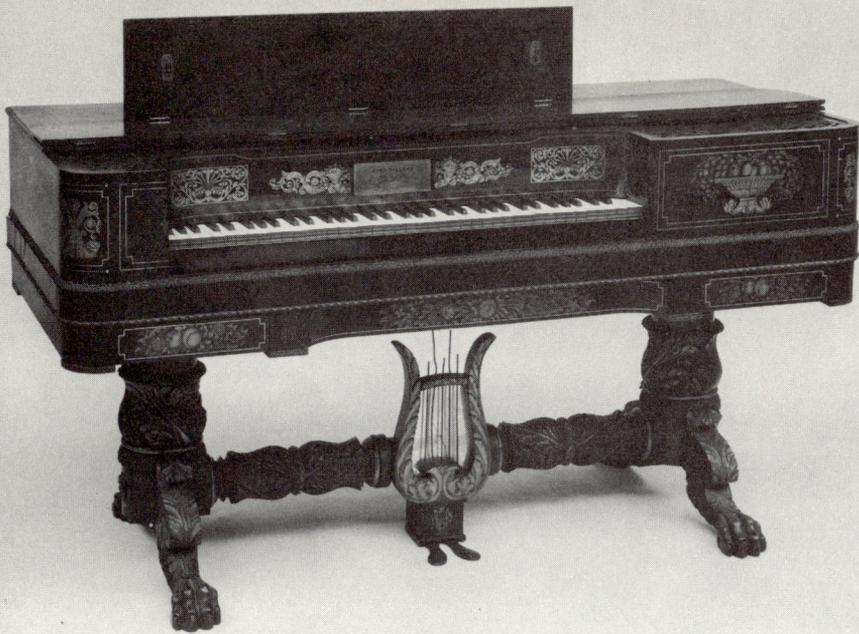

133

133. The mahogany case of this piano by John Tallman has a concave section at center front, flanked by music drawers, often used on Empire pianos. The pedal holder is mirror-backed. Tallman was working in New York in 1825. (*Metropolitan Museum of Art*.)

134. Piano made by John Geib and Son, who were listed in New York directories between 1804 and 1815. John Geib, established before 1800, was one of the leading makers of organs and pianofortes; in 1815 John Geib, Jr., maker of piano actions, advertised that he could be found at Duncan Phyfe's shop. In 1817 pianos were sold at 25 Maiden Lane, New York, by Geib, Astor, and Clementi; in 1821 the firm advertised "a large and handsome assortment of Piano Fortes of the latest fashion . . . including some by Clementi and Co., and Astor and Co., of London." (*Museum of the City of New York*.)

135. Gadroon beading outlines the well-designed case of this upright piano, manufactured by Robert and William Nunns of New York (listed 1824–1832). The legs are ribbed, and the front of the case is finished with silk rayed from a metal passion flower. Before this time, the square piano had predominated, although the portable grand patented by John Hawkins in 1800 was an upright instrument. (*Brooklyn Museum*.)

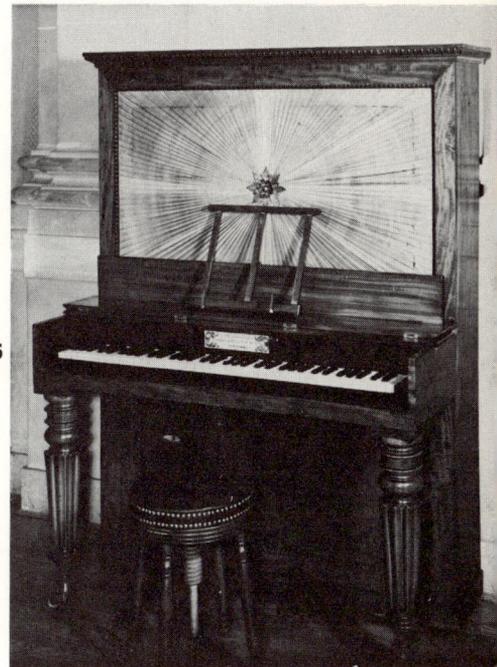

135

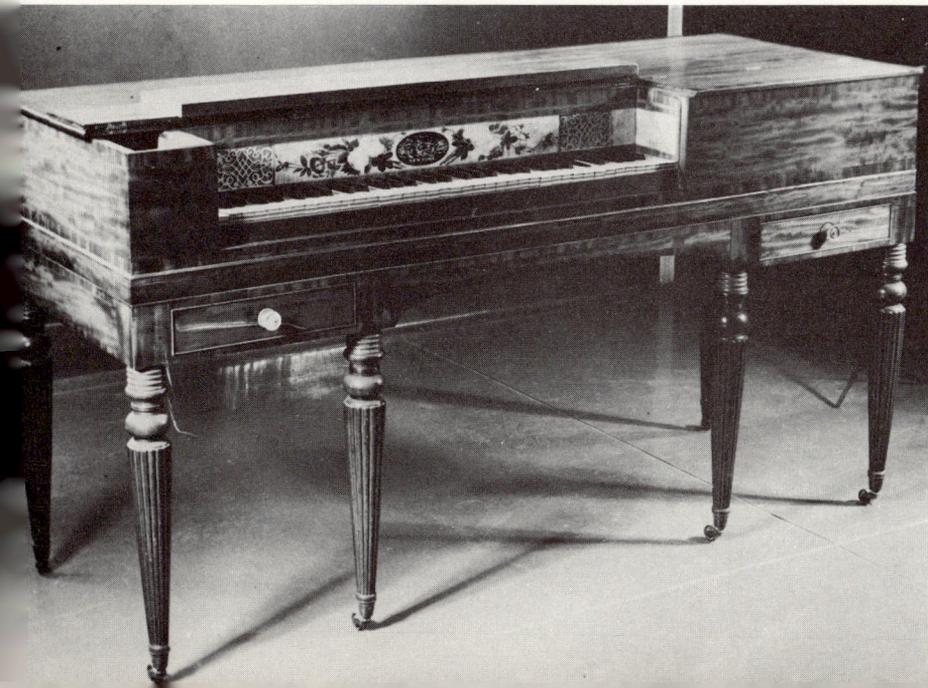

134

Secretaries

The Empire secretary bookcase was neat and compact. It was of rectangular shape, frequently with Roman columns on the stiles of the base, and sometimes with the secretary drawer projecting. Acanthus-carved lion paws were commonly used as front feet. A new feature was a fillet or beveled cornice projecting sharply over a plain frieze. Twenty-eight·designs for tracery of glazed doors, including two in Gothic style, were illustrated in the 1815 *New-York Book of Prices*. Paired arch-head panels were favored at first, later giving way to plain rectangular tracery.

The French fall-front secretary and the cylinder-fall writing table were included in the New York list of 1818 and the Philadelphia price list of 1828. These types do not, however, seem to have been made in quantity.

Thomas Jefferson owned a mahogany desk, made c. 1815. This piece was designed with a table base on five turned legs, one a fly leg to support the hinged fall-down front. A low superstructure at the back had a shallow tier of three small drawers. Another fine example of Empire design is the desk in the library at Strawberry Mansion, Fairmount Park. It is broad and oblong in shape, with rounded corners and a low tier of drawers at the back. In the frieze a secretary drawer over a cupboard base with a recessed center is flanked by multiple-membered colonnettes set on roundel feet.

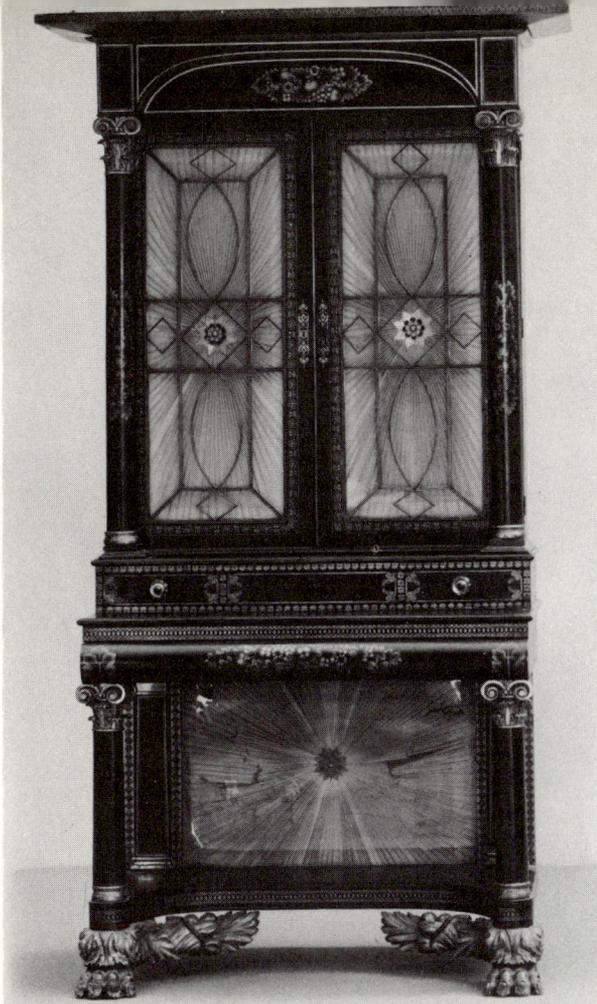

136. Late Empire secretary bookcase veneered in dark mahogany with gilding and stenciled ornament. Doors are backed with silk rayed from a metal passion flower. The writing drawer is torus-fronted. (*Metropolitan Museum of Art.*)

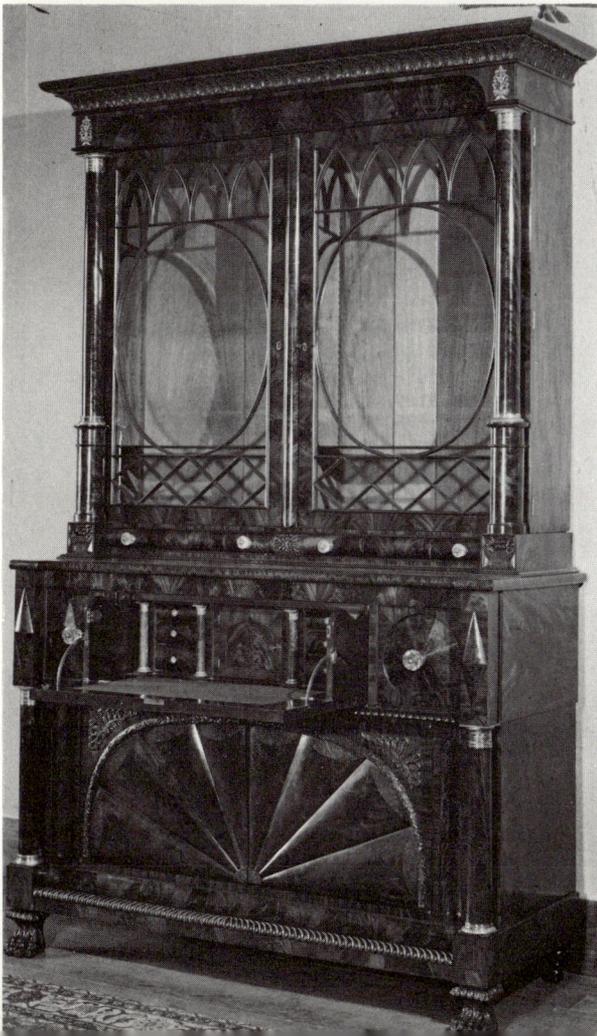

137. Ornate secretary bookcase bearing labels of Antoine Gabriel Quervelle of Philadelphia is of complex construction. Drawers and facet-carved blockings flank the center section, and there are detached columns on upper and lower sections. (*Philadelphia Museum of Art.*)

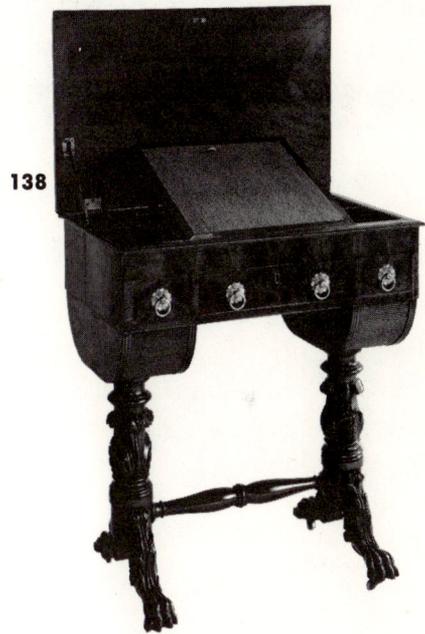

136

137

138

138. Rosewood writing and work table on a *cheval* base has a lift-up lid and rising writing slide; a center drawer between simulated drawers covers the reeded "pouch" sections. (*Brooklyn Museum.*)

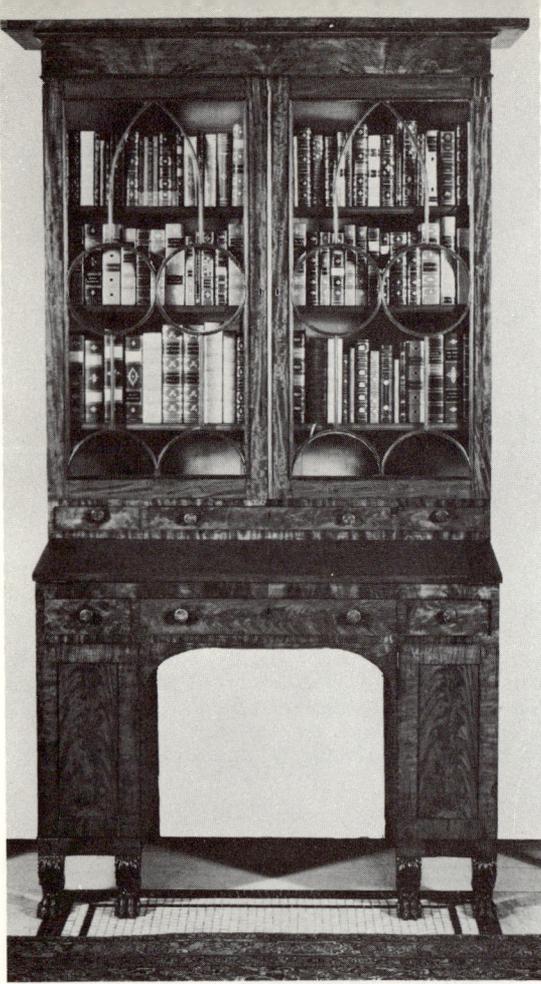

139 Chamfered front corners and Gothic tracery on the glazed doors distinguish this secretary bookcase. (*Mrs. W. S. R. Beane and family, Elgin Plantation, Natchez.*)

140. Secretary bookcase with projecting hinged box writing desk on a bureau base has glazed doors with paired arch-head panels and a plain frieze with a beveled cornice. (*Philadelphia Museum of Art.*)

141. Secretary bookcase, formerly the property of Colonel Henry Rutgers, has an unusual pedestal desk with drawers in the frieze and one-door cupboards flanking an arched kneehole. The recessed bookcase has a hinged, sloping writing flap and three shallow drawers. (*New-York Historical Society.*)

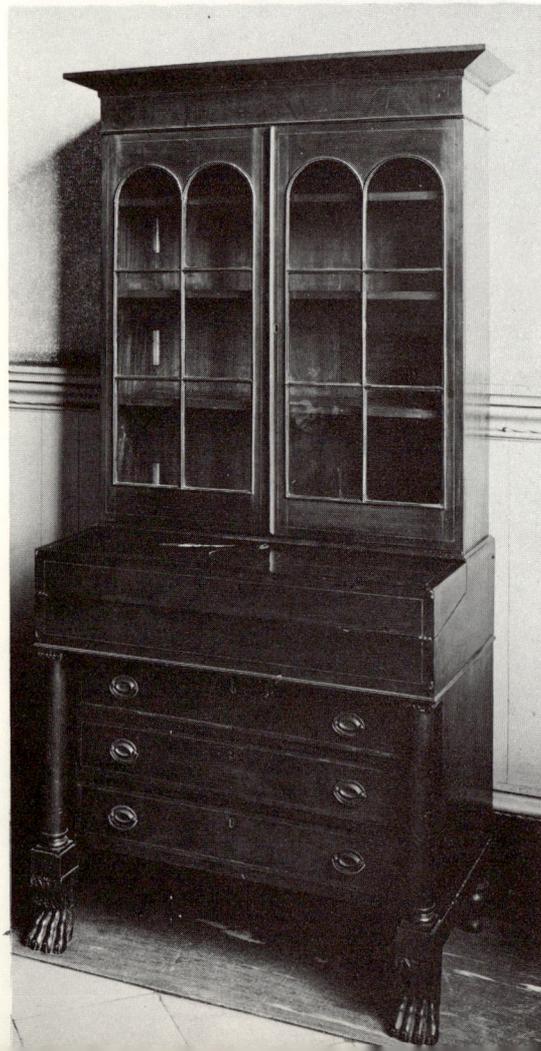

140

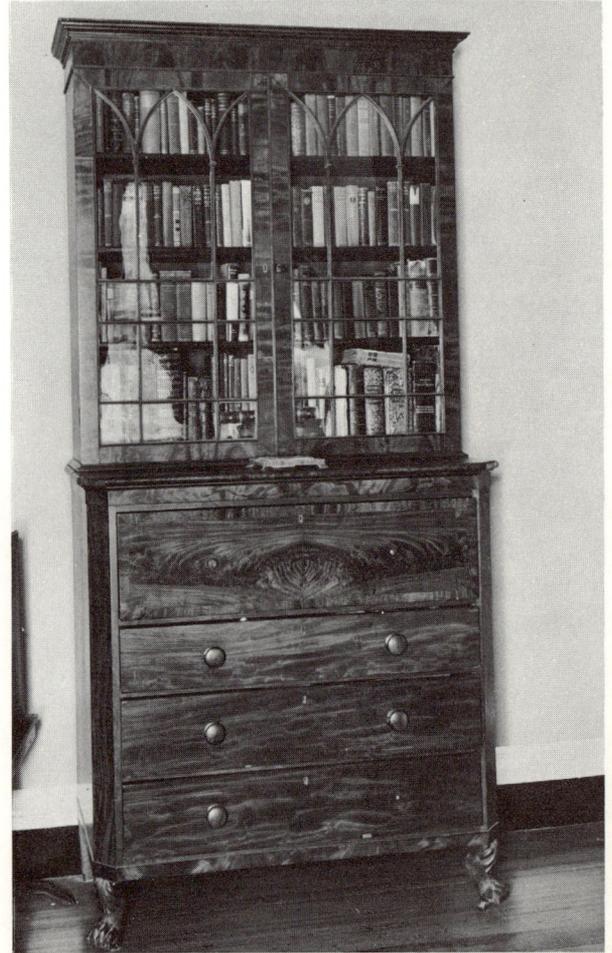

141

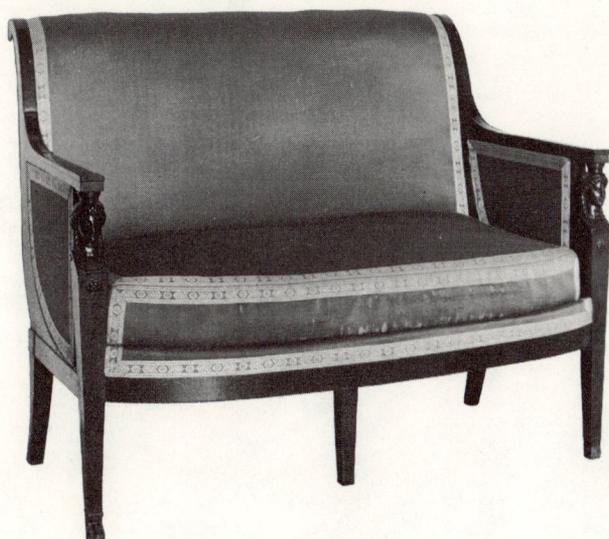

142. French Empire settee. (*Musée des Arts Décoratifs.*)

Settees and Sofas

Probably because the French Empire settee was too stiff and formal for American taste, designs of sofas and settees changed little. Items in the 1818 New York price list included a plain square-back sofa, a Turquoise-type sofa, a Grecian sofa with head end only, a three-chair-back caned settee, and a box sofa. All these pieces had a plain seat rail broken by tablets above the legs. The price list noted, "Tablets veneered with 4 turned stump feet to do."

Empire influence is generally seen in torus seat rails, deep-cut carving, cyma-curved ends with carved facings, a band or tablet on the back, foliate and winged lion hocks used in countless variants, and substantial vase legs. On later versions carved dolphins served as legs.

Later, a new type of settee appeared, in a design possibly taken from Napoleon's writing chairs, which featured an arched back with a capping band turned under in volutes. This, in many versions, was used on the center of the settee back and flanked by expansive horizontal scrolls, which were continued over the ends. Joseph Meeks and Sons illustrated it as number 39 in their 1833 advertisement.

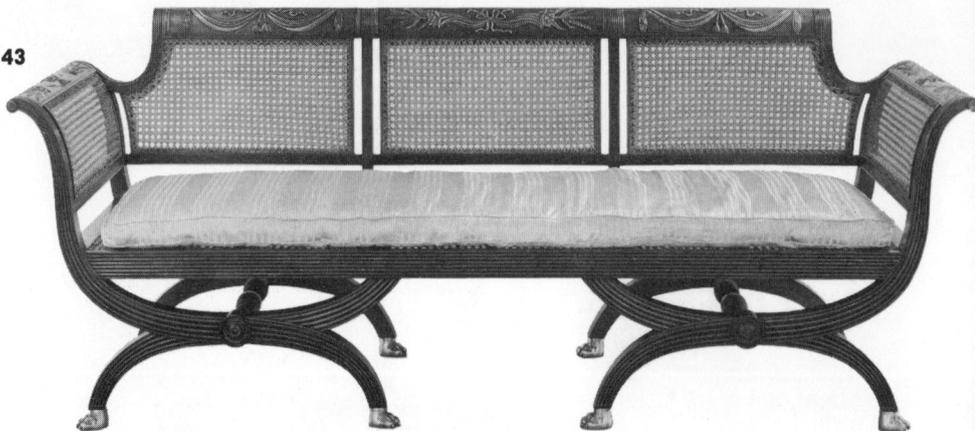

143. Three-chair-back caned settee by Duncan Phyfe set on curules with the outer ends continued as uprights. (*Museum of Fine Arts, Boston.*)

144. Cornucopia scrolls instead of the usual volutes distinguish the arched back of this sofa. (*Miss Myra Virginia Smith, Devereaux, Natchez.*)

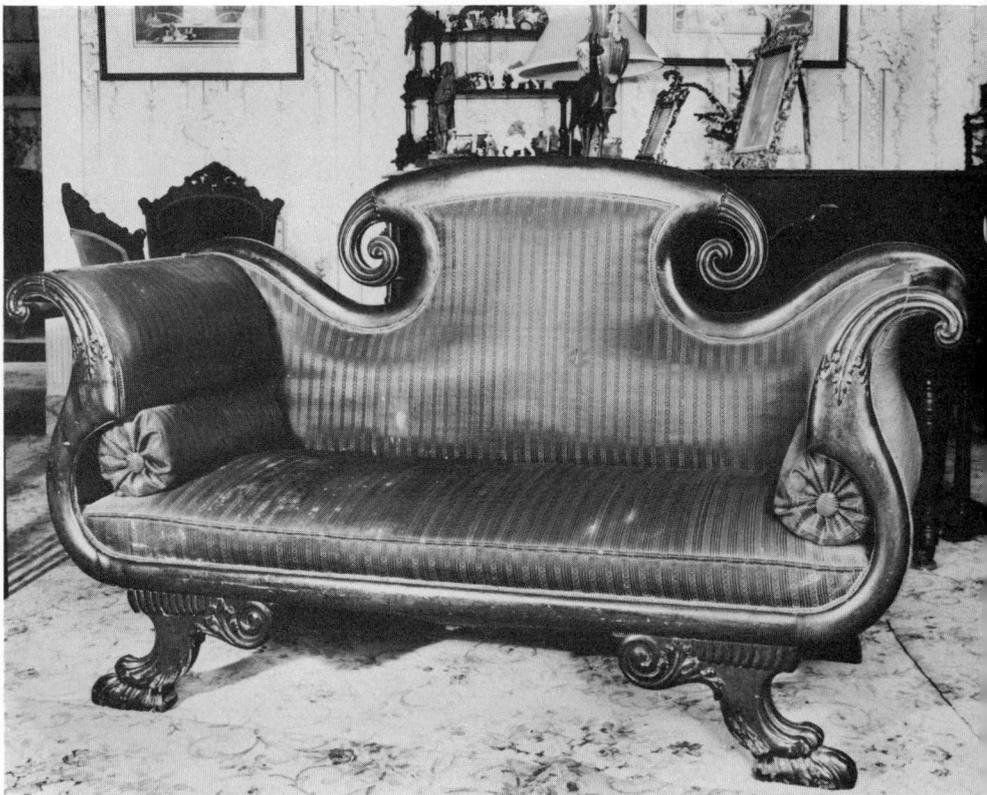

145. Hitchcock cradle rocker, partly bamboo turned, with the cradle rail of three flat slats set horizontally in rounded posts slipped through the seat. (*Henry Ford Museum, Dearborn.*)

146. Carved lion hocks for Empire settees, attributed to Samuel McIntire — one scrolled at the top with a wing extended toward the center of the bracket, the other finished with a row of studs and a leaf. (*Essex Institute, Salem.*)

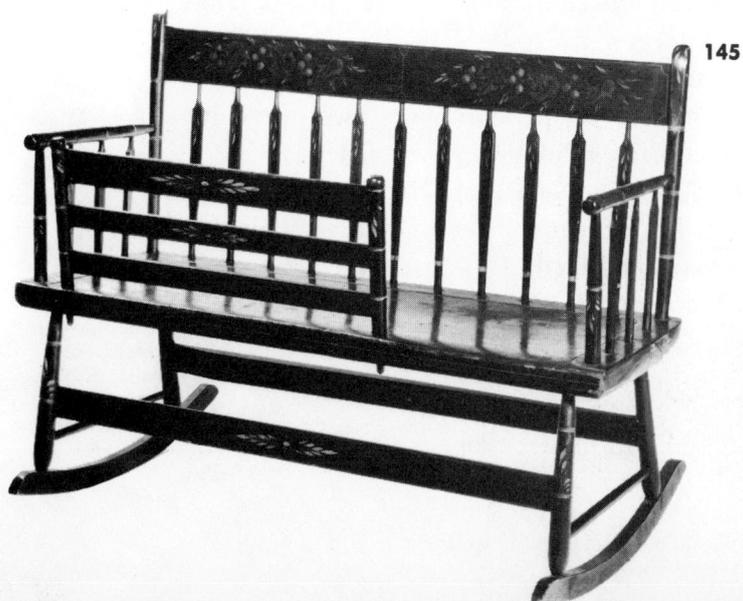

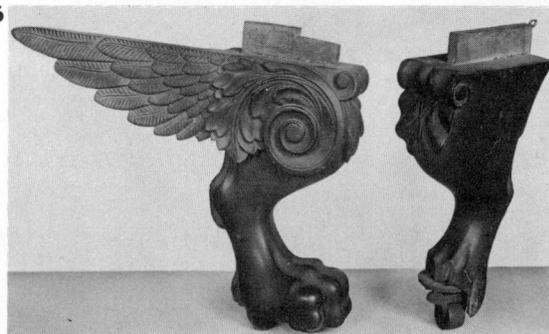

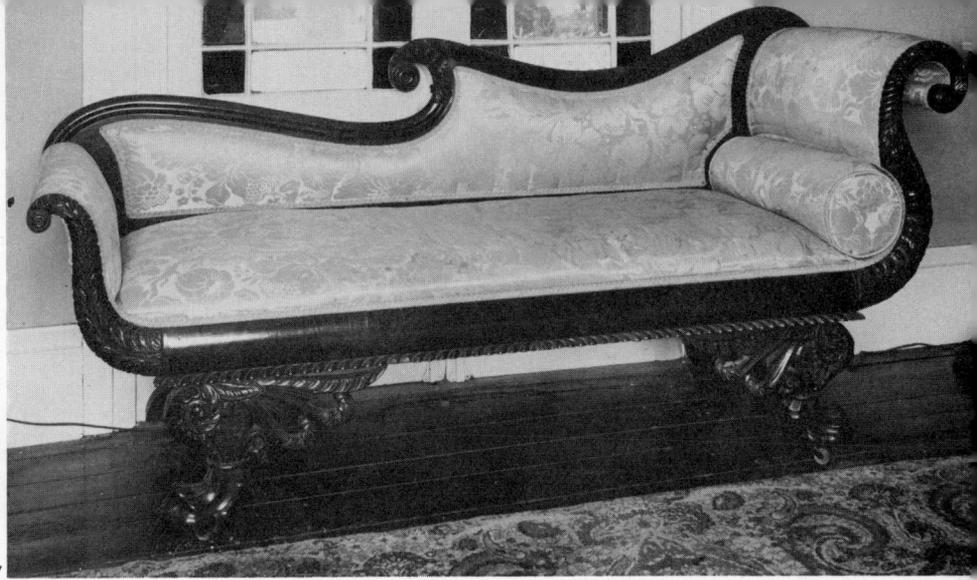

147. Settee, one of a pair, is similar to George Smith's Grecian chaise longue. The unusual, ornate legs perhaps indicate a Philadelphia origin; they occur on a similar pair of settees in a collection there. Another small settee with identical legs has ends of equal height and a back with a capped segmental center. (*Mrs. Joseph B. Kellogg, The Elms, Natchez.*)

147

148

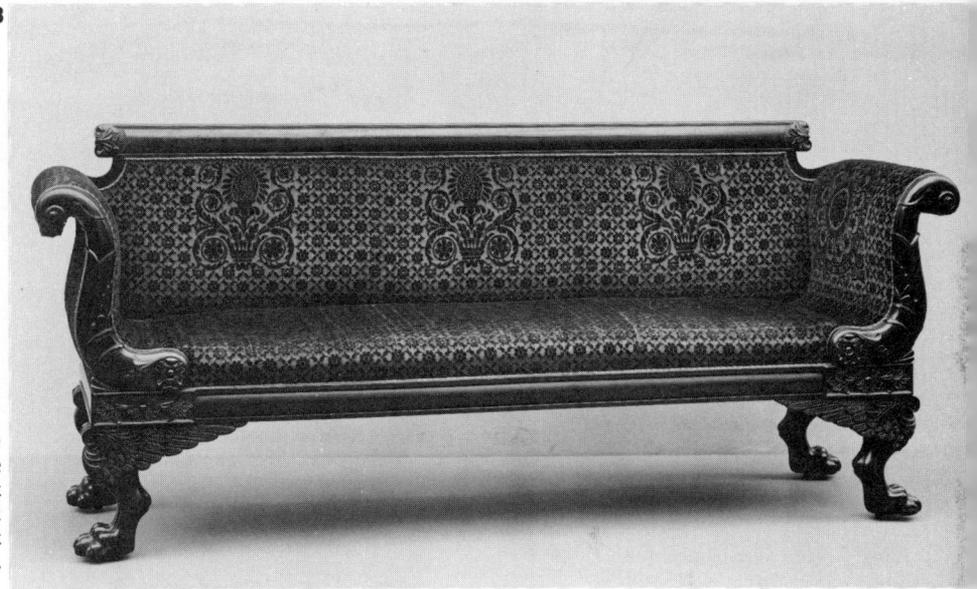

148. Empire version of the Turquoise has cyma ends with carved facings. The back rail is torus-molded with slight carving and hollowed corners. Carved tablets at the ends of the torus front seat rail surmount winged lion hocks. (*Metropolitan Museum of Art.*)

149

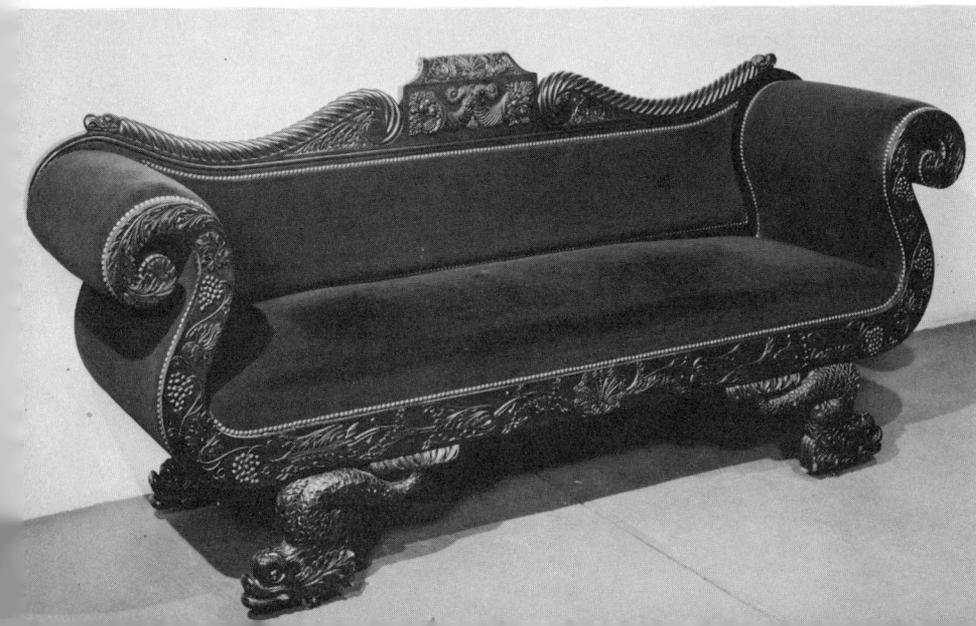

149. Elaborate decoration typifies the late Empire settee. The scroll of the cyma ends is intensified, and the cresting on the back, an Empire version of the classic block, includes scrolls with paired cornucopias and an extra tablet in the center. The four dolphin legs are leaf-carved. (*Philadelphia Museum of Art.*)

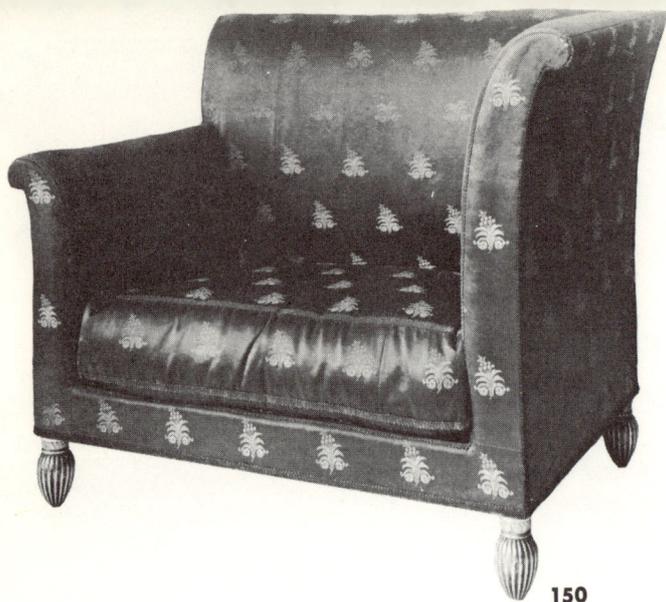

150

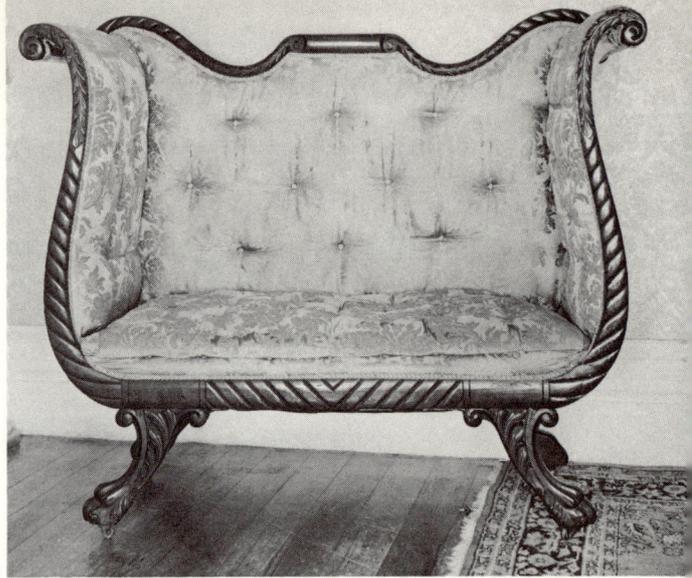

151

150. One of a pair of small *méridiennes* in simple Empire style made in 1810 to flank the bedroom fireplace of Marie Louise at Compiègne. The loose seat cushion represented a change. (*Palais de Compiègne.*)

152

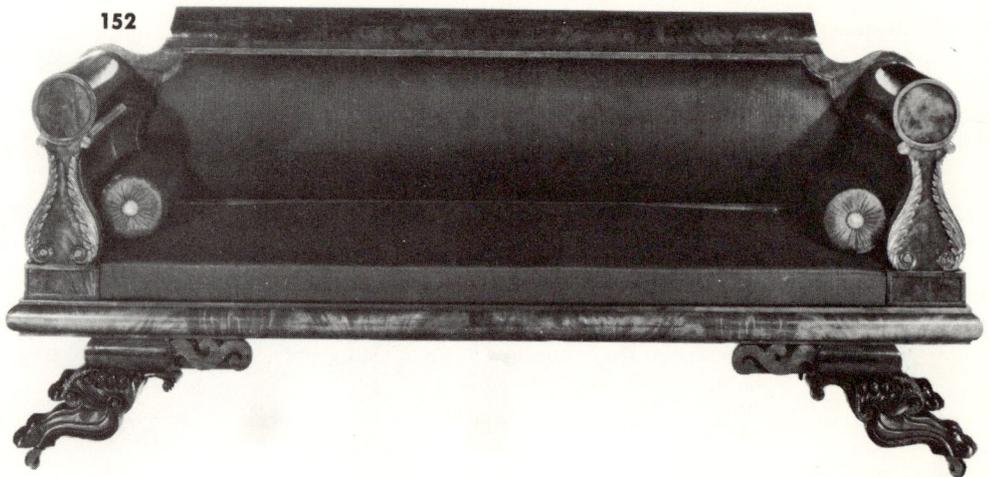

151. American version of the French *sofa à deux* with high back and ends of equal height, spiral-carved frame, and tablets over the stylized lion paws. (*Mr. and Mrs. Douglas H. McNeill, Elmscourt, Natchez.*)

152. Settee with coved back tablet and hollowed corners. The ends in lyre outline topped with a mahogany cylinder are set on blocks on the torus seat rail. Stylized palmette and lion hocks extend under the seat rail. (*Henry Ford Museum, Dearborn.*)

153

153. Paired lyres used horizontally are an unusual feature in the ends of this Duncan Phyfe settee. Wooden chair-back ends were used on French Directoire prototypes of the Turquoise settee. (*Cooper Union Museum.*)

154

154. American Empire settee in the French manner with back and ends at right angles to the seat and distinctive angular vase legs on gadroon-carved bulbs. Wooden facings on the scrolled ends are carved with Egyptian leaf, as is the torus seat rail. (*Philadelphia Museum of Art.*)

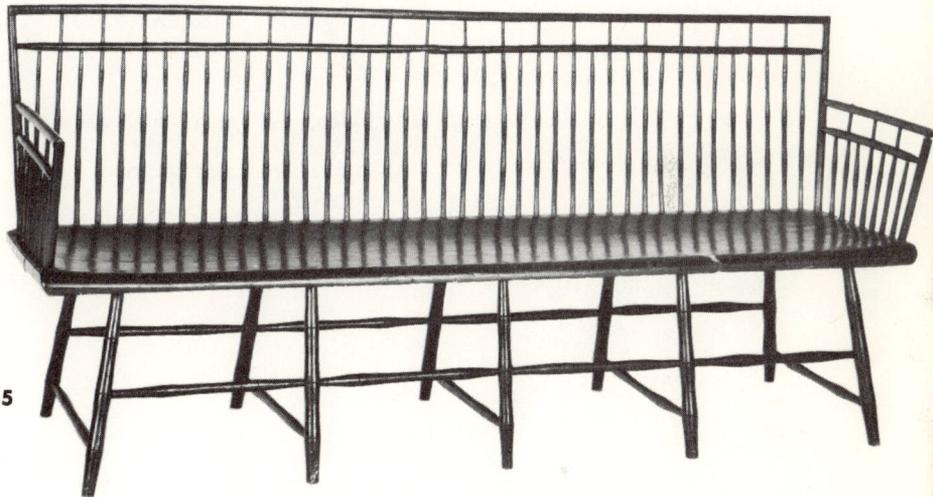

155

155. Bamboo-turned windsor wooden settee with ten legs shows a seat shaped and rounded in front and spindle-filled back and ends. (*Henry Ford Museum, Dearborn.*)

156. Duncan Phyfe's version of the Récamier couch in rosewood with real and simulated ormolu mounts and legs carved with leaf and gadroon. (*Brooklyn Museum.*)

156

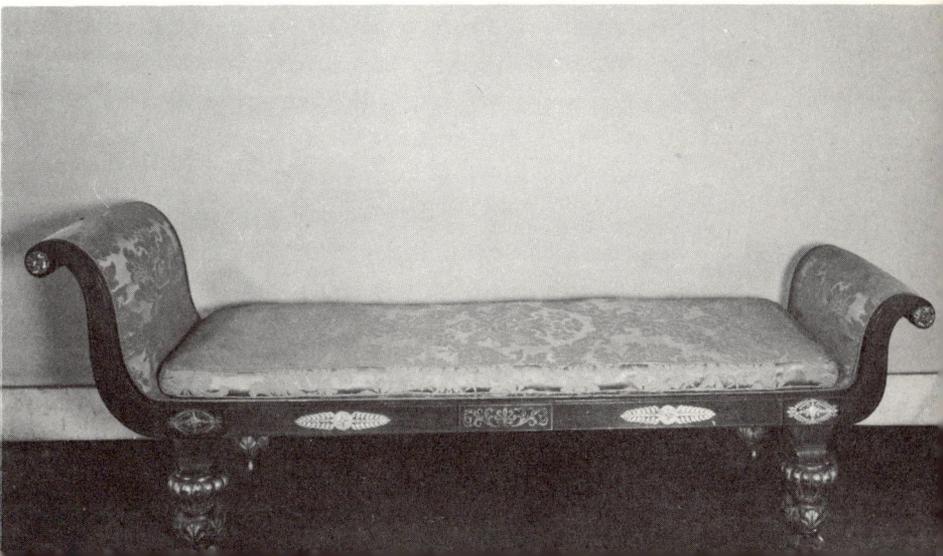

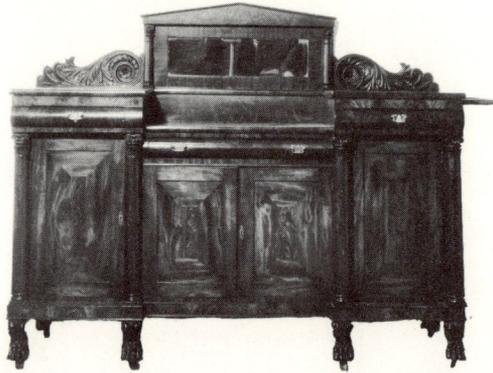

157. Sideboard complying with specifications in the Philadelphia price list of 1828: "Pedestal End Sideboard with sunk center, glass mirror in back." (*Philadelphia Museum of Art.*)

Sideboards

The introduction of pedestal cupboards effected a marked change in Empire sideboards. At first there was a space in the center, but this was generally abandoned in favor of more cupboard accommodation. Much attention was devoted to sideboards in the Philadelphia price list of 1828, which specified, "Plain Sideboard, with cases and a marble top; Pedestal End Sideboard with open center and four solid columns;...Egyptian Sideboard. Egyptian boxes on front of ditto; Pedestal End Sideboards with a sunk center, glass mirror in back; Round Pedestal Sideboard, . . . one solid sweep'd door." Only one back is mentioned in the list, but backs were widely used — low, capped, and occasionally decorated. Doors in the base were banded with sunk or beveled panels. "Four solid columns," as specified, were frequently used.

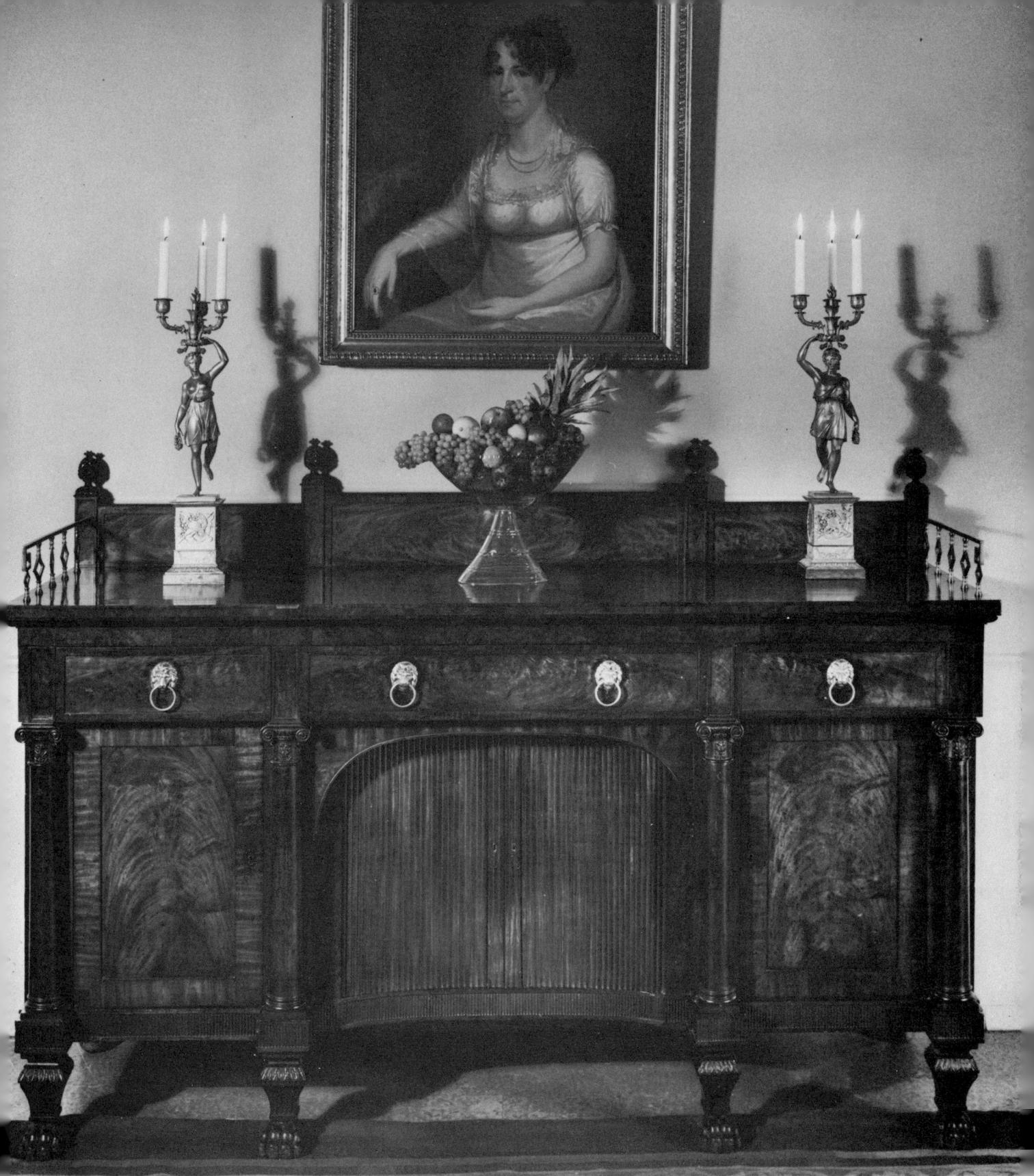

158. Fine sideboard with a projecting frieze, tambour doors, and a spandrel hood in the recessed center section. Roman columns are set on blockings in the plinth, over vase and paw feet. The plain top has a low back with metal grilles and pineapple finials. (*Henry Ford Museum, Dearborn.*)

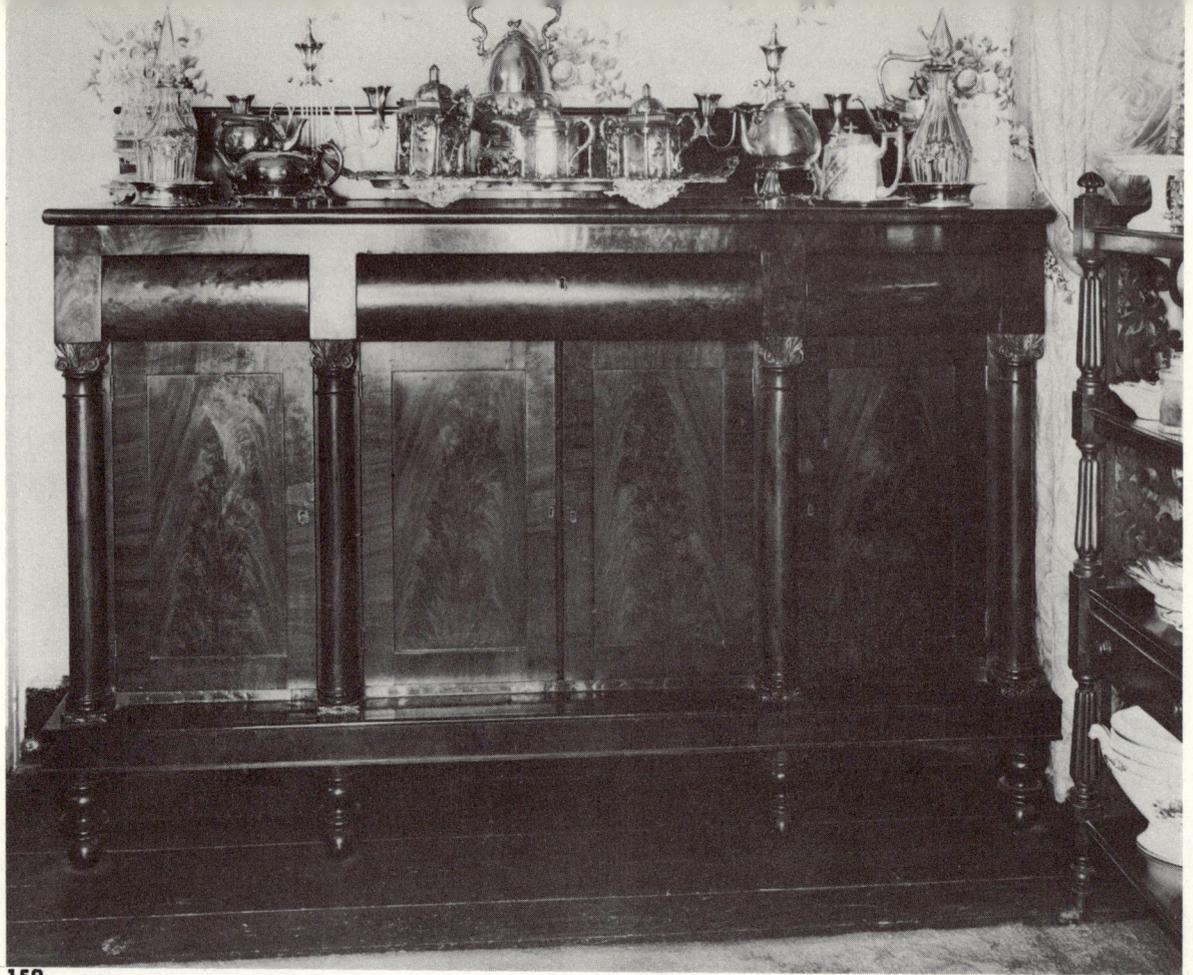

159

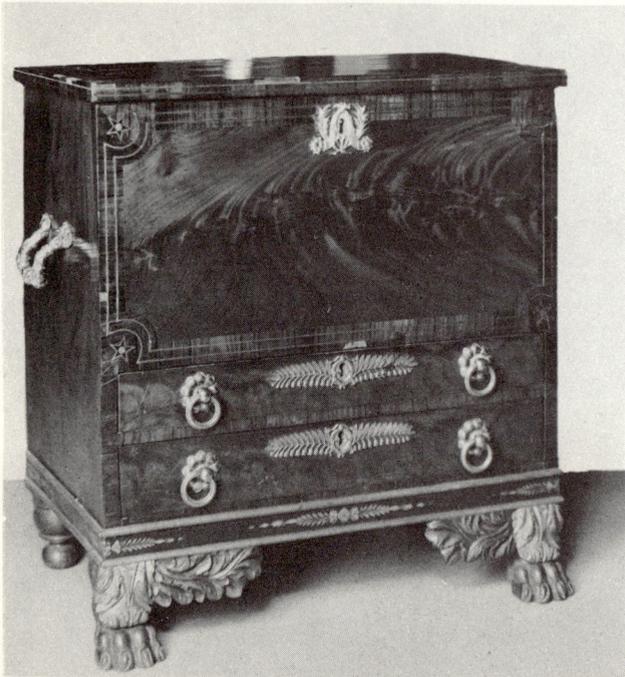

160

161

159. Mahogany sideboard of the type referred to in the *New York Evening Post* of 1830 as "columned." *(Estate of Mrs. Hubert Barnum, Arlington, Natchez.)*

160. Empire plate chest with a lift-up lid. The cross-banded front is decorated with stringing and with stars in the corners. There is a narrow plinth above the acanthus-carved lion paws. *(Cooper Union Museum.)*

161. Empire cellaret in sarcophagus form, with chamfered corners and four lion hocks with volutes at the top. *(Metropolitan Museum of Art.)*

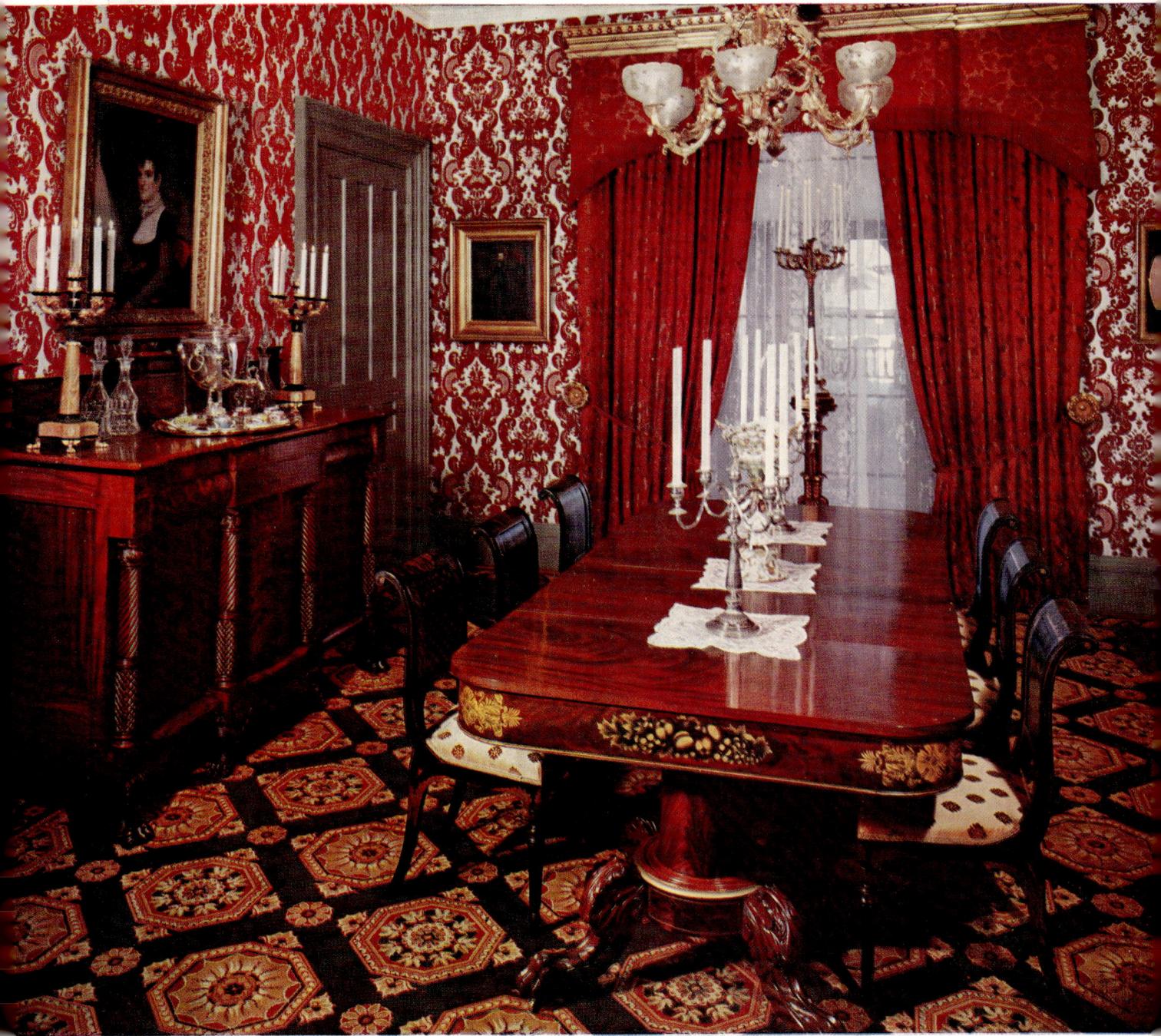

PLATE I. The large mahogany extension table in the dining room at Fountain Elms is in the true Empire style; its frieze is stenciled in gold, and massive tapered pillars are set on roundels to which four acanthus-carved lion legs are attached. The matching sideboard has a low back and three drawers in the projecting frieze; the center drawer is plain; the other two are torus-fronted. Three cupboards with panel doors are flanked by detached foliate-capped columns, carved in spiral and facet patterns and set on plinths over foliate-carved lion paws. (*The Munson-Williams-Proctor Institute.*)

162. Sideboard, a type not widely made, as specified in the Philadelphia price list: "Round Pedestal Sideboard ... one solid sweep'd door." The sunk board has a low panel back with brackets and a capping shelf. (*Historical Society of Pennsylvania*.)

162

163

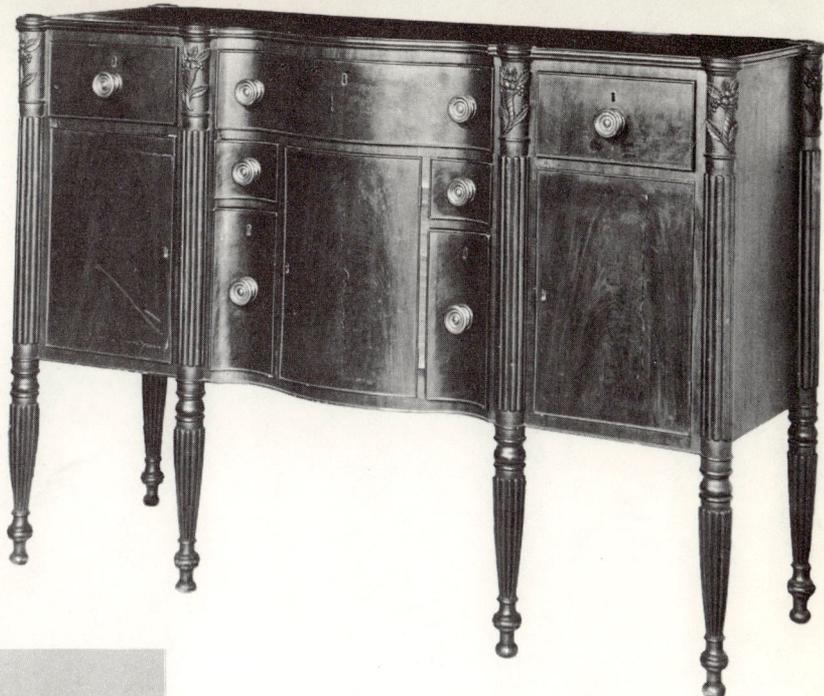

163. Sideboard with serpentine center. Bottle drawers flank the center cupboard. Multiple-membered ribbed legs and attached ribbed colonnettes show early Empire influence. Cornucopia-carved sections on the frieze are attributed to Samuel Field McIntire. (*Essex Institute, Salem*.)

164

164. Egyptian sideboard with fine brass inlaid ornament. Doors of the pedestal ends are beveled to an ebonized panel; a projecting plinth supports columns. Matching knife cases have pagoda-shaped lift-up tops. (*Philadelphia Museum of Art*.)

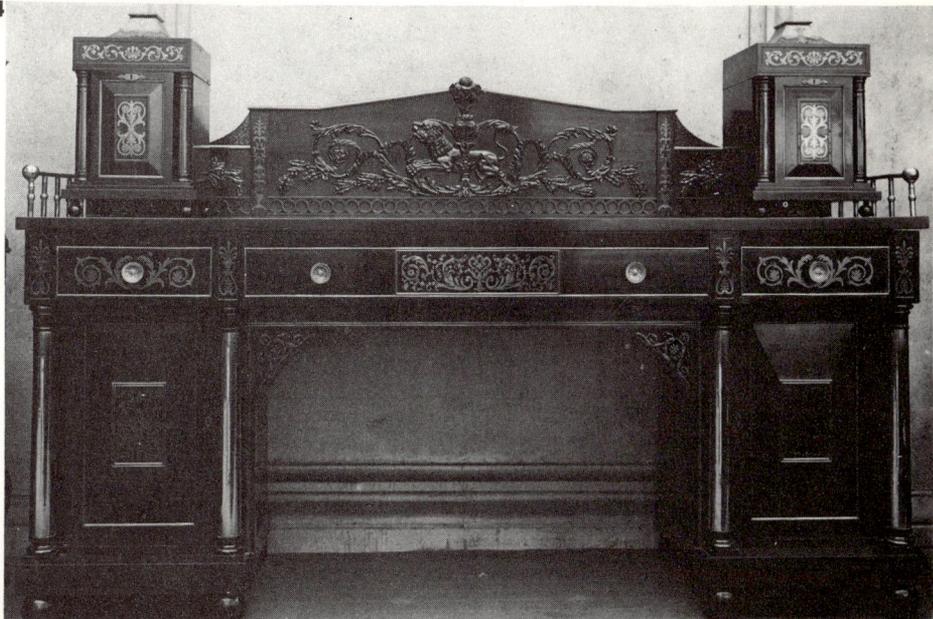

Tables

On Empire tables the change showed chiefly in the legs and bases. On early pieces straight legs were ribbed, generally continued as colonnettes in three-quarter projection over the frieze, or they were turned with a broad spiral. The introduction of the platform base marked a great change. It was composed of a square or oblong boxed abacus section with concave sides and chamfered corners over four legs, with four colonnettes or balusters on its corners as supports to the table. This almost ousted the pillar on Greek-curved legs. The legs on the platform at first remained Greek-curved, with a definite projection at the top, but later they changed to acanthus-carved lion hocks.

A circular-topped table on three supports — frequently Roman columns — and a triangular, boxed abacus base was popular. A number of these in varying dimensions and finish were made. Painting and stenciling, frequently gilt or bronze, were much used as a substitute for the beautiful French ormolu mounts. In the report of the American Institute Fair in New York, 1836, "Specimens of Table Ornamental Paintings by E. Ramsbottom" were mentioned, and also "Graining and Marble Paintings on Glass by John Frost."

Mahogany was widely used, and rosewood for luxury furniture. Consoles in true Empire style were close to French prototypes, with marble tops and Roman columns, ebonized and gilded features, and ebony and metal lines and mounts. Later the table on a pillar base returned. The new version was very heavy, the pillar richly carved and set on a massive roundel or cylinder, to which four acanthus-carved lion hocks were attached. On dining tables the pillar opened in the center, with guide rails in the frame for loose leaves, a frieze being added to conceal them.

76

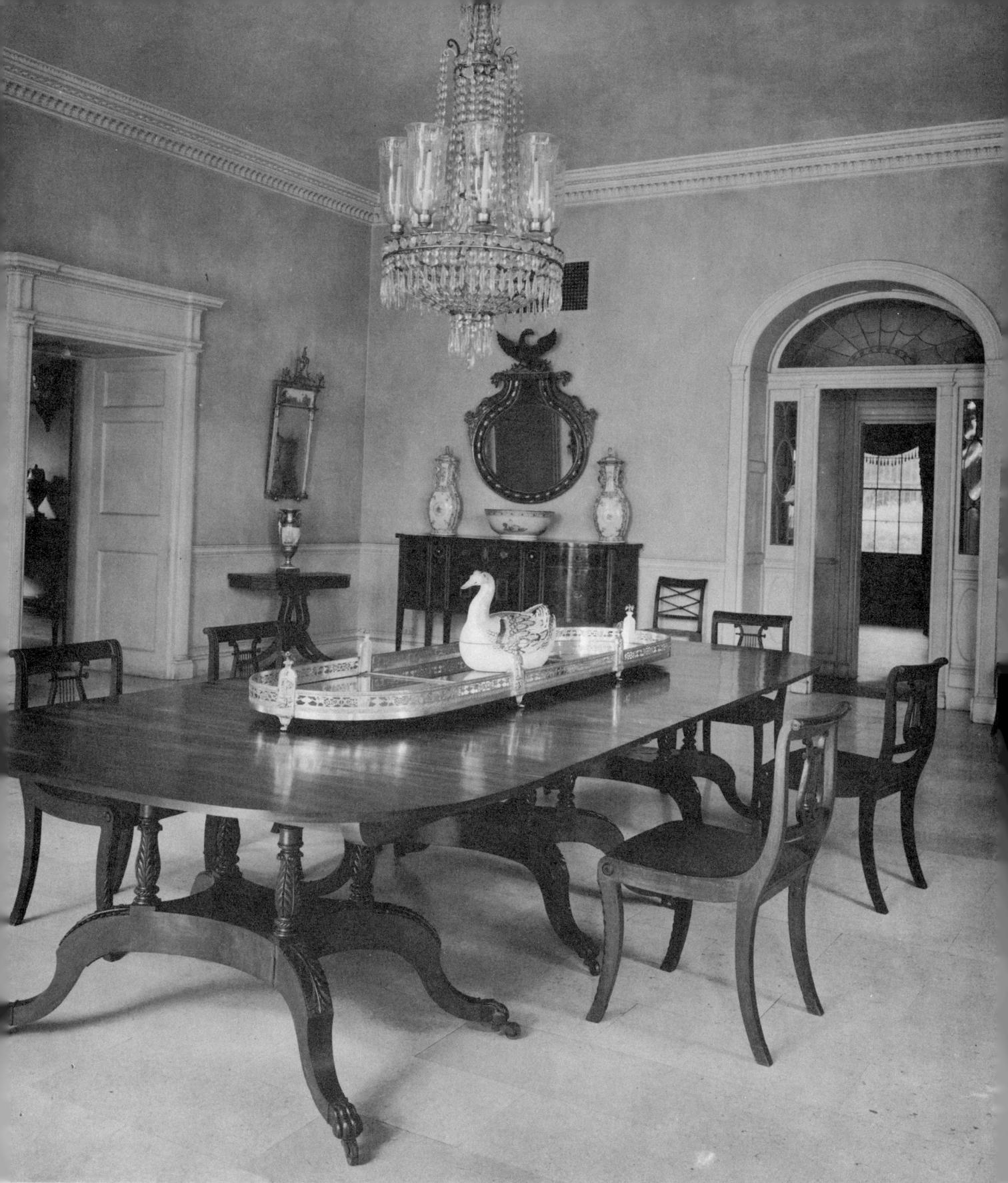

165. Each of three sections of a Duncan Phyfe dining table rests on an abacus platform base with baluster and spiral-turned supports and four broken-cabriole legs with lion paws. (*Metropolitan Museum of Art.*)

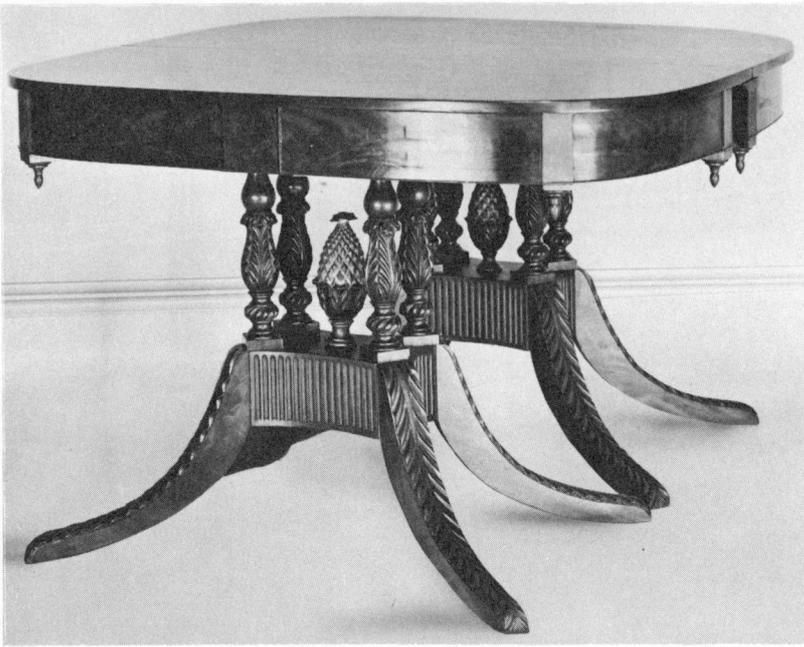

166. On the ends of an early Empire dining table the frieze is plain, with spaced blockings and pendent finials. The fluted oblong abacus platform has a large pineapple finial in the center. (*Henry Ford Museum, Dearborn.*)

166

167. A late Empire dining table is included in the Philadelphia price list: "Circular topped table on a pillar to open in the center for extension with loose leaves on sliders." The lion hocks are carved with acanthus leaves that have tops turned over in the round, a feature of the period. (*Mr. and Mrs. Hyde Dunbar Jenkins, Hawthorne, Natchez.*)

167

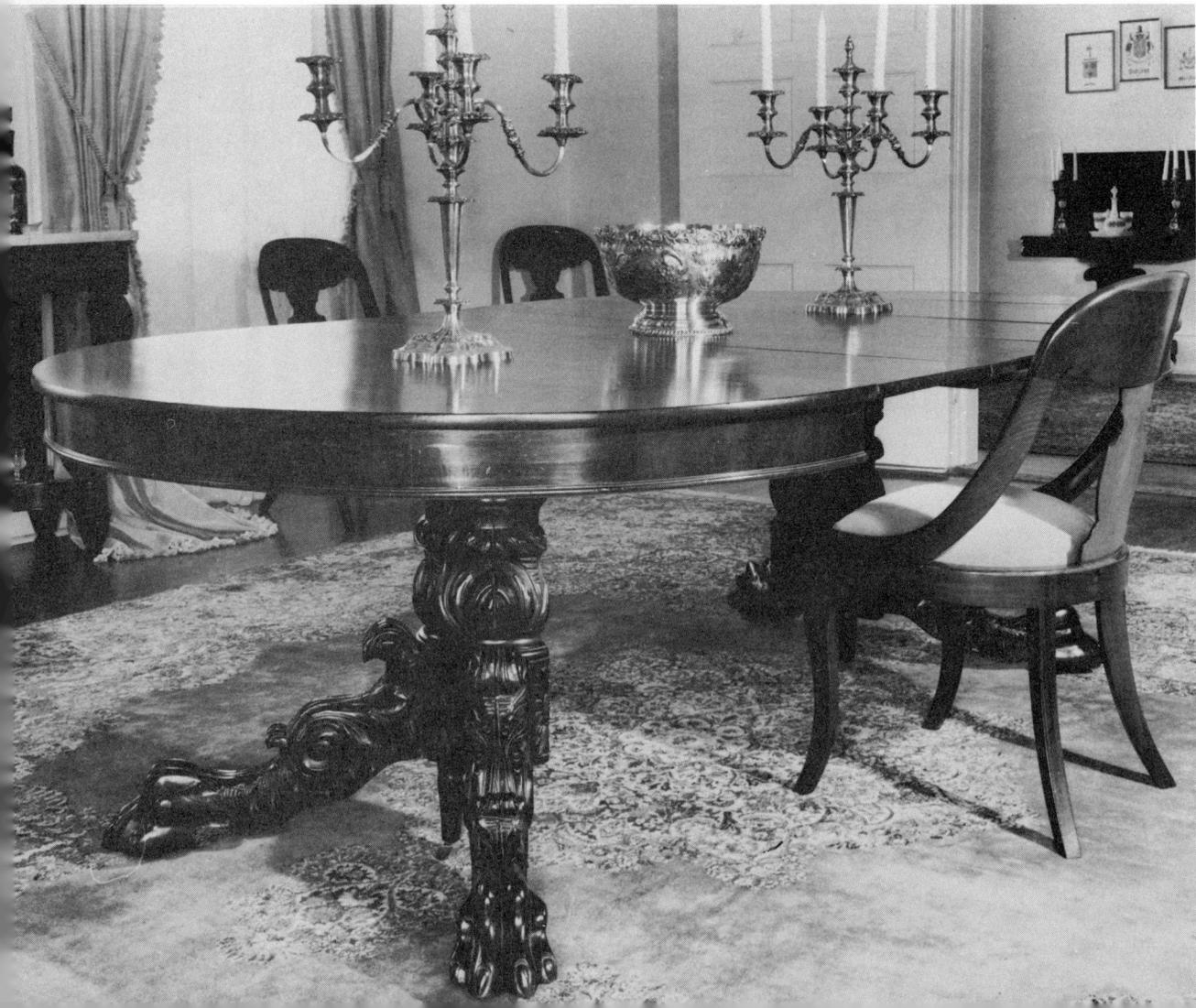

168

168. An Empire dining table, as specified in the Philadelphia price list of 1828: "A Square End Dining Table with flaps, on four feet and two fly legs." This table is extended by two matching consoles, their legs in multiple-membered Empire style. (*Rosalie, Natchez. State Shrine of Mississippi D.A.R.*)

169

169. Empire version of the mahogany cottage dining table, with a cyma-fronted drawer and large hinged flaps, rounded at the corners. The legs have large square shafts, chamfered on the top corners, between ring-and-bulb and vase-turned sections. (*New-York Historical Society.*)

170

171

172

170. Multiple-membered pillars on a platform upheld by carved lion legs with cuffed paws distinguish this table. (*New-York Historical Society*.)

171. The top of a late Empire table is set on a deep spiral-carved acanthus pillar with a roundel base to which four broken-cabriole, foliate-carved lion legs are attached. (*Henry Ford Museum, Dearborn*.)

172. The top of this table bearing the label of John Budd of Fulton Street, New York, is a writing compartment with a hinged lid over two drawers. Legs are spiral-turned above the serpentine stretcher shelf, with turned bulbs on casters below. (*Museum of the City of New York*.)

173

174

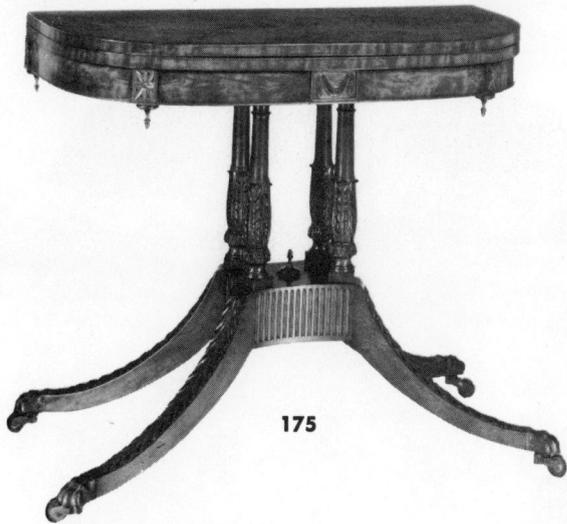

175

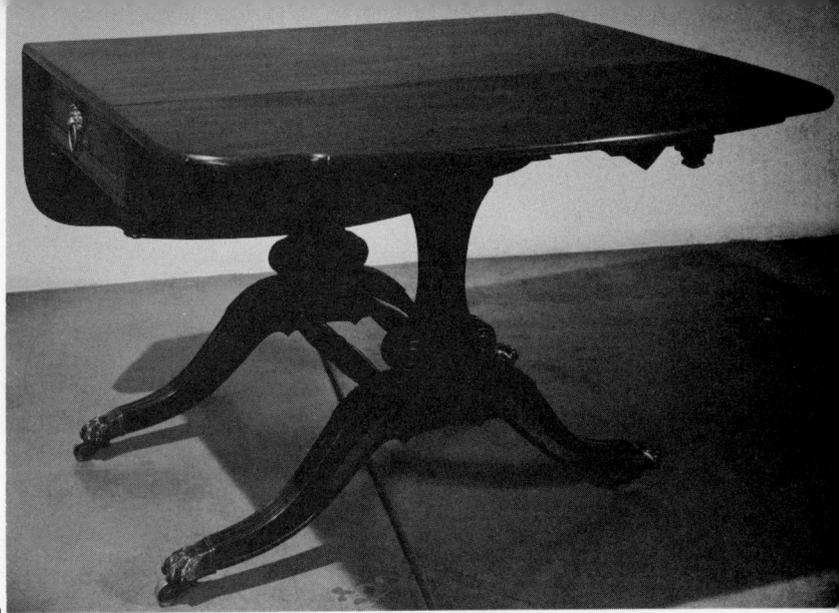

176

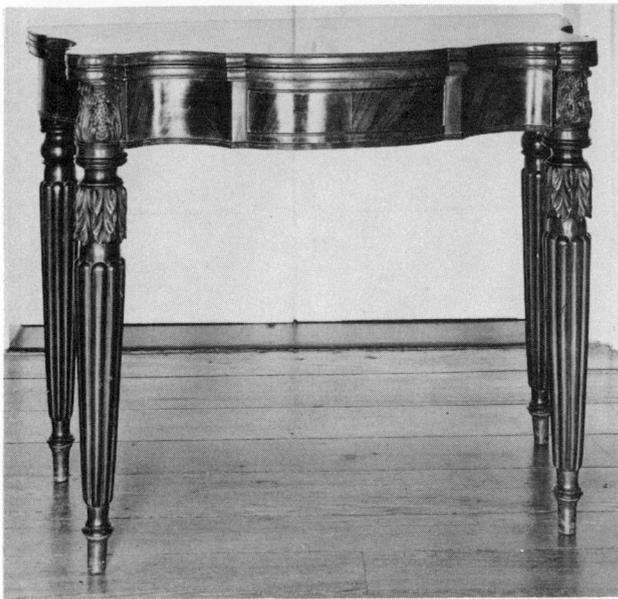

177

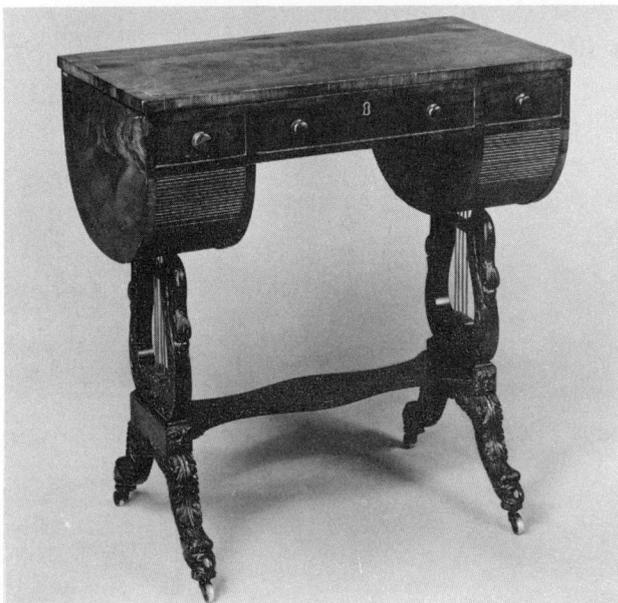

178

173. Drop-leaf table with two deep, hinged flaps in three scallops, labeled "M. Allison's Cabinet and Upho.... Furniture Warehouse—1817." The oblong abacus platform has multiple-membered colonnettes and bold acanthus-carved lion hocks. (*Metropolitan Museum of Art.*)

174. Oblong sewing table with chamfered corners, two drawers, acanthus-carved pillar, and lion legs. (*Philadelphia Museum of Art.*)

175. Card table, one of a pair by Duncan Phyfe, represents an early example of the boxed abacus platform on four Greek-curved legs, with projection at the top and vase and baluster supports. (*Henry Ford Museum, Dearborn.*)

176. A drop-leaf table attributed to Henry Connelly is distinguished by an unusual *cheval* base with flat standards set on angular cabriole legs, leaf-carved and reeded. (*Philadelphia Museum of Art.*)

177. On this card table, the frieze conforms with the broken serpentine top and sides. Leaves are carved on the front angles; legs are turned, with a foliate-carved cap over bold ribbed shafts and knopped toes. (*Mr. and Mrs. Samuel Hopkins Lambdin, Mistletoe, Natchez.*)

178. A small oblong writing and sewing table in the Empire style bears the label of Michael Allison, 1823. The top is hinged; a drawer over the kneehole space is flanked by two simulated drawer fronts and tambour "pouches." The *cheval* base has swan-neck lyre supports on paired cabriole legs. A flat stretcher is expanded in the center to hold a work basket or serve as a footrest. (*Metropolitan Museum of Art.*)

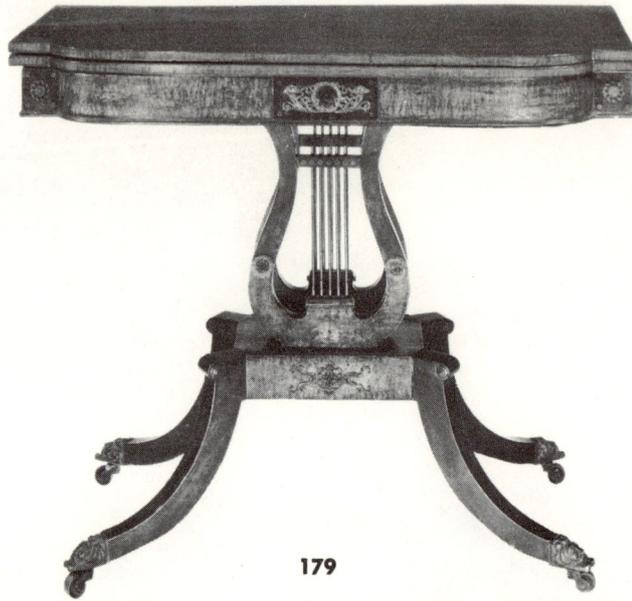

179

CARD TABLES AND SEWING TABLES

Practically all card tables had folding tops, and a great number of them had the platform base. Many handsome and imaginative examples were made by leading cabinetmakers, including the Seymours, Duncan Phyfe, Lannuier, and Michael Allison. Other types of card table had four sturdy legs and, later on, a massive pillar and cabriole legs. The convenient revolving top on an oblong bed with a well in it was specified in the Philadelphia price list of 1828 — "Plain Card Table on legs . . . Pillar and Claw Card . . . Top turns on a swivel half of frame."

In the same very long price list a loo table is specified for the first time. "Loo Table, with solid top, three feet, eight inches in diameter . . . turned pillar, 3 Greek claws, plain rim, two inches deep." A later reference to the top states that it could turn up with clamps and catch. Loo could be played by any number of people, but five or seven were considered best for a good game. In 1821 Nathaniel Hawthorne played lanterloo at Bowdoin College and in 1823 belonged to the Androscoggin Loo Club. Probably many of the large oval- or circular-topped tables of this period, with platform or pillar bases, were made for loo.

At first the construction of sewing tables showed little Empire influence. The platform base was adopted; a writing slide was sometimes added in the top, and there was a gradual relinquishing of the pouch. The basic table remained simple, but there was ample opportunity for extra decoration and a choice of a variety of woods, including mahogany, rosewood, satinwood, maple, walnut, and cherry.

82

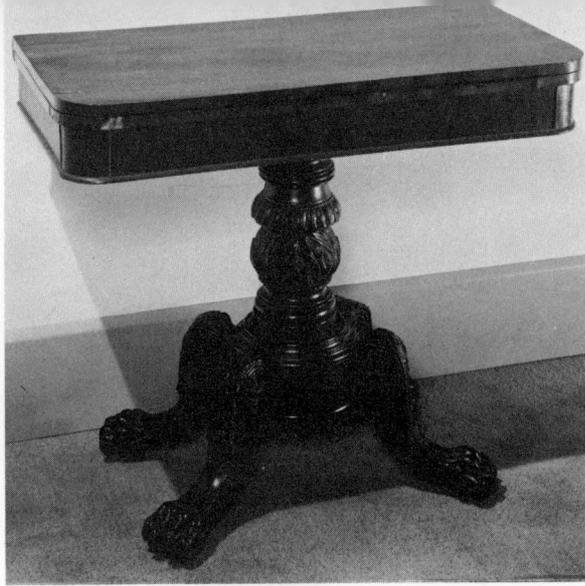

180

179. Folding-top card table in mahogany and maple with ormolu mounts. The front is bowed with level ends. A center support of paired lyres is set on a platform base. A matching sewing table is also in the Henry Ford Museum, Dearborn.

181. Card table front with chamfered corners and brass lyres inlaid on the blockings. The oblong abacus base is set on winged lion legs. Panther heads and necks emerge from the leaf-carved cornucopias in front, and a broad, five-stringed lyre supports the back. (*Metropolitan Museum of Art.*)

183. An unusual lack of ornament distinguishes this late Empire sewing table with massive vase pillar and angular cabriole legs. (*Grand Rapids Public Museum.*)

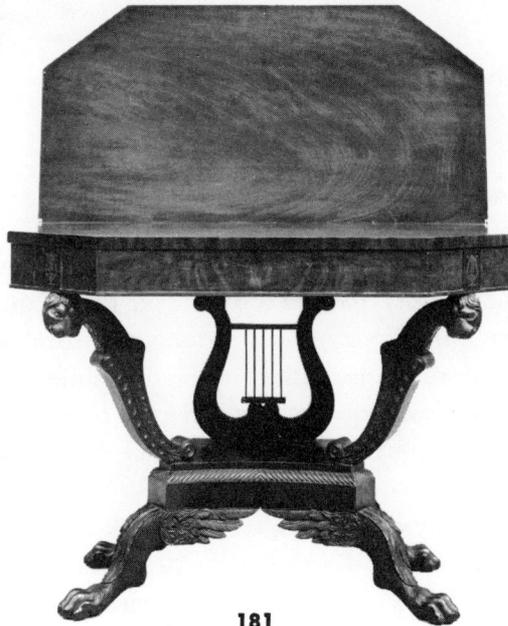

181

180. Late Empire folding-top card table with rounded corners; a massive, acanthus-carved vase pillar on a deep roundel above carved lion hocks forms the base. (*Philadelphia Museum of Art.*)

182. A good version of an Empire sewing table, attributed to Matthew Egerton, Jr., New Jersey, has two drawers and spiral-turned legs. Expansions of the top cover the attached three-quarter colonnettes on the front angles. (*Old Dutch Parsonage, Somerville.*)

184. Sewing table in mahogany with maple veneer and ormolu mounts, one of several known examples, is a type specified in the Philadelphia price list as "framed with stumps...the top projecting to receive," indicating the use of colonnettes attached to the body, covered in this instance by paterae with ivory studs. (*Philadelphia Museum of Art.*)

182

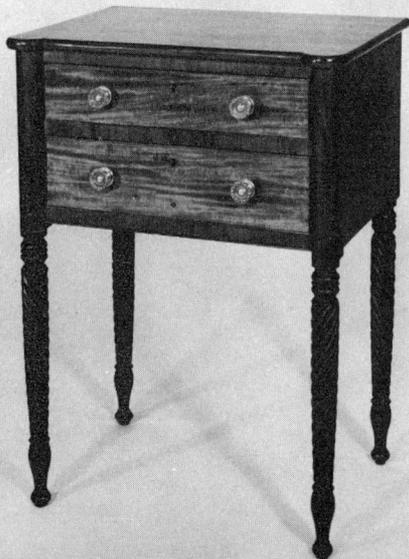

183

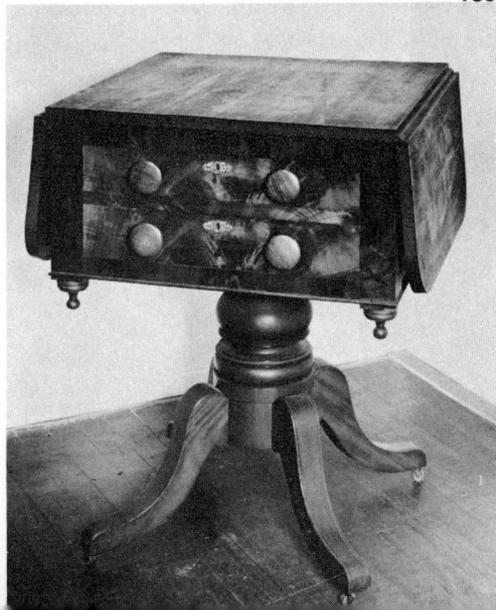

184

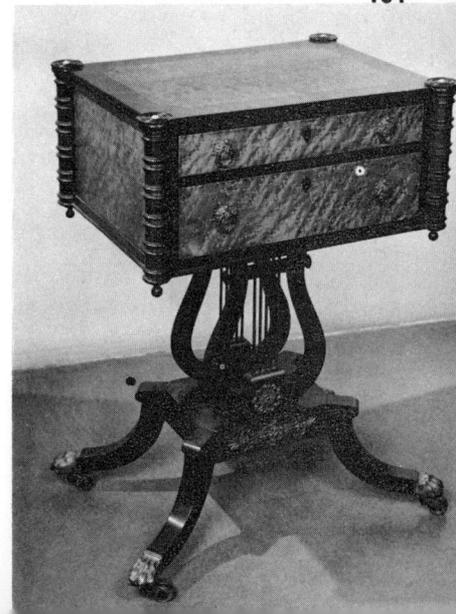

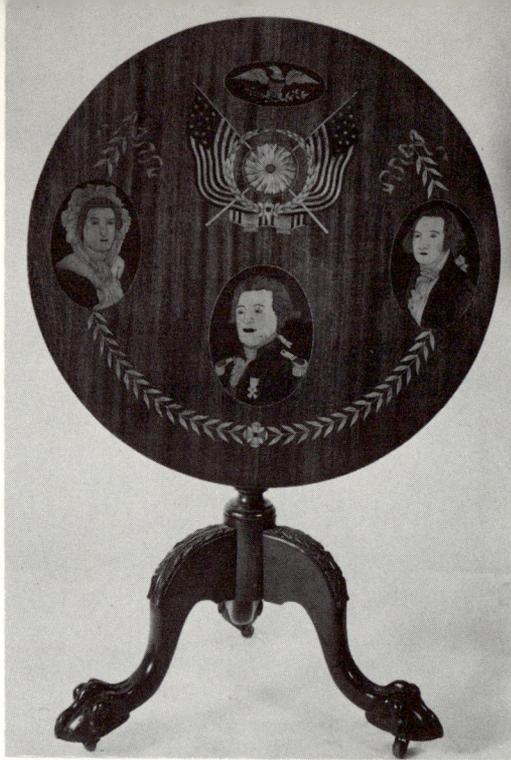

185

CENTER, OCCASIONAL, AND CONSOLE TABLES

Center and occasional tables with circular tops assumed importance during the Empire period. One type, taken from antiquity, had its top set over three columns on a triangular boxed base. Smaller versions of the *guéridon* type had a longer, central pillar on a triangular, round, or "spoke" base. Later, a massive vase pillar, set on a roundel or cylinder on broken cabriole legs, was introduced. These tables frequently had marble tops or were finished to simulate marble. Imported ormolu was sometimes used on American furniture, but gilt stenciling or painting occur more frequently.

It is interesting that only one center table is included in the Philadelphia price list of 1828. This was specified as "Three feet diameter; Turned pillar, 3 claws, Greek."

The console was one of the earliest American items to be made in true Empire style. Hitherto folding-top card tables, many of them superbly made, had served the purpose, but to affluent New York citizens the console, handsome and impressive with marble, mirror, carving, and gilding, seemed eminently desirable.

It is possible that the design was introduced to America by Charles Honoré Lannuier, who had served his apprenticeship in France and, in 1805, was established in Broad Street, New York, with a large and influential clientele.

A standard type of console table emerged whose construction can be summarized as follows: mahogany; oblong; marble top; recessed frieze with applied classical mounts; heavy boxed shelf base hollowed in front; plain Roman columns with gilt cap and base on the front angles of the shelf and flat marble or wooden pilasters at the back, flanking a mirror plate; four low, heavy vase or acanthus and paw feet on which the shelf rests. Fine painting or stenciling in gilt were frequently substituted for metal mounts.

84

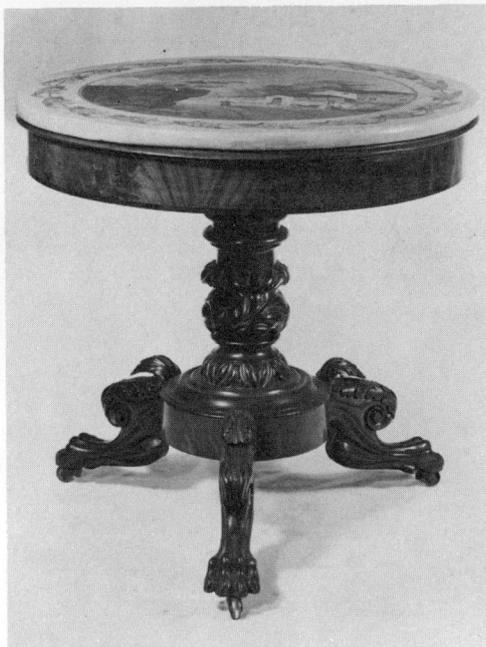
186

185. Inlaid medallion portraits of Martha and George Washington and General Lafayette decorate the top of this mahogany table, which has a pillar and a leaf-carved claw base. It was made in Albany, probably in 1824 to commemorate General Lafayette's visit. (*New-York Historical Society.*)

186 and 187. Mahogany center table with a massive vase pillar and roundel on three broken-cabriole lion legs deeply carved with acanthus. A rural landscape and a band of primrose sprays are painted on the plaster top. (*New-York Historical Society.*)

187

188. The frame of this circular occasional table is stained to simulate rosewood, and small six-pointed stars are inlaid in brass wire on the frieze above the three wooden column supports. Top, frieze, and base are painted with arabesque ornament and classical motifs in gold. (*Cooper Union Museum.*)

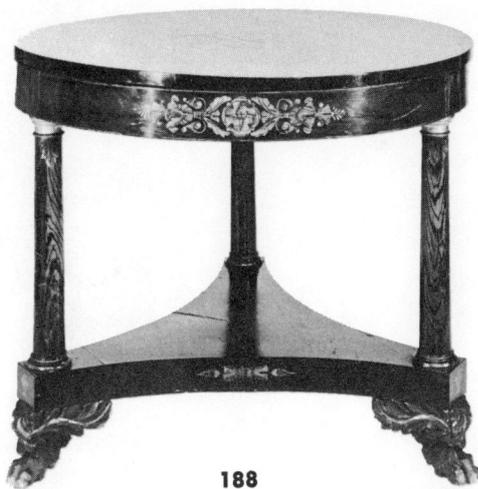

189. Foliage and fruit and an ornamental band are stenciled on the frieze of this marble-topped late Empire center table, part of a group which includes a console and secretary. (*Metropolitan Museum of Art.*)

190. An American version of the French "antique" type of circular-topped table on a triangular base. (*Philadelphia Museum of Art.*)

788

189

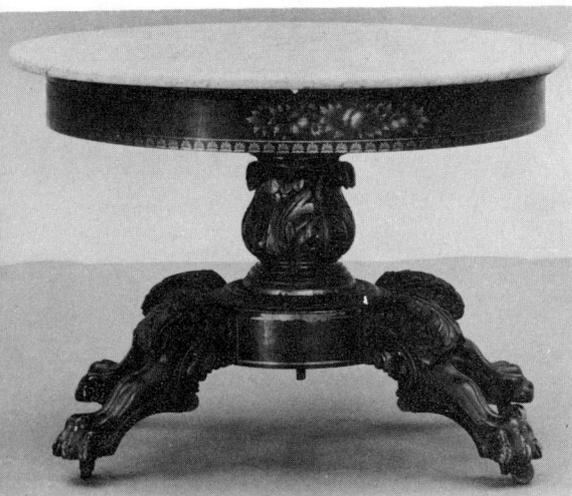

190

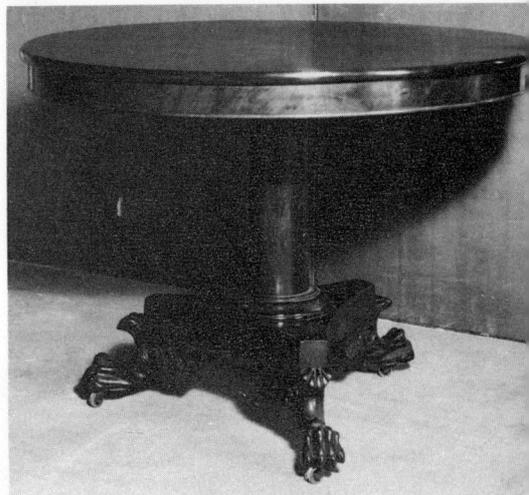

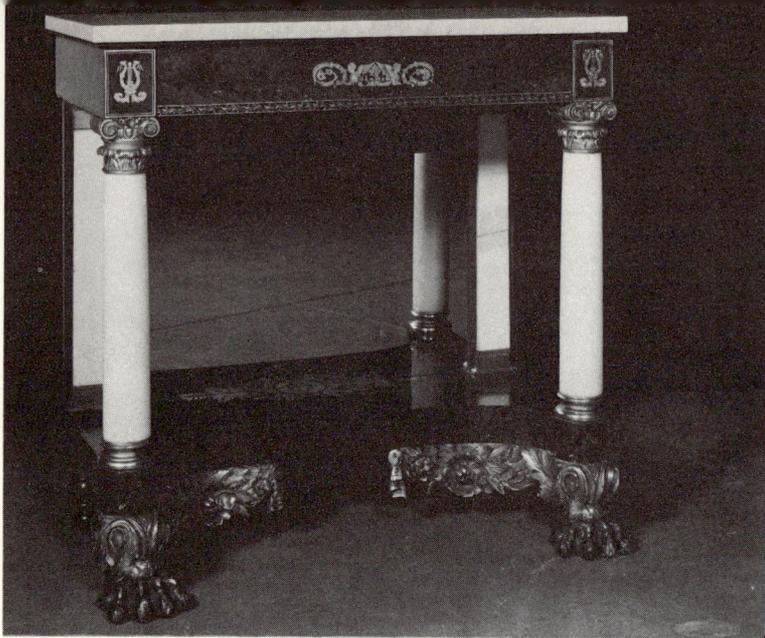

191. Stenciling in half-section, the design completed by the reflection in the mirror back, decorates the low shelf of this console, one of three simple, impressive, and decorative examples similar to number 22 in the Meeks advertisement (see figs. 254 and 255). (*Philadelphia Museum of Art.*)

192. "Hitchcock"-type fruit and foliage stenciling, decorating this marble-topped and columned oblong console, may be seen on the panel above the mirror back. (*Brooklyn Museum.*)

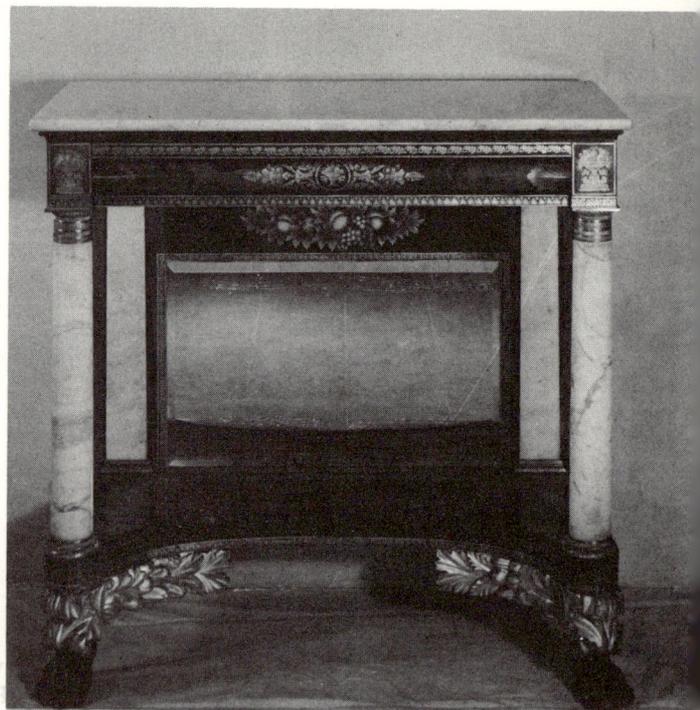

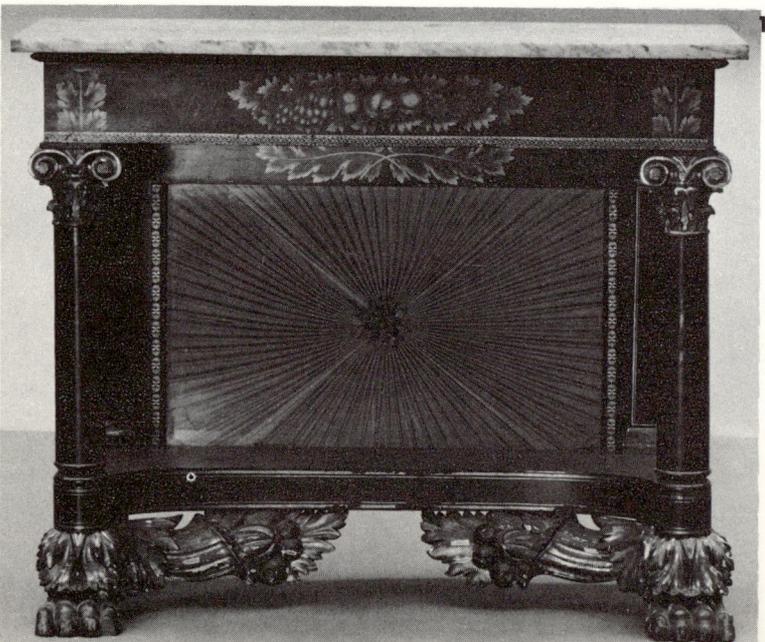

193. Empire console with gray and white marble top. The glass back panel is lined with silk rayed from a passion flower. (*Metropolitan Museum of Art.*)

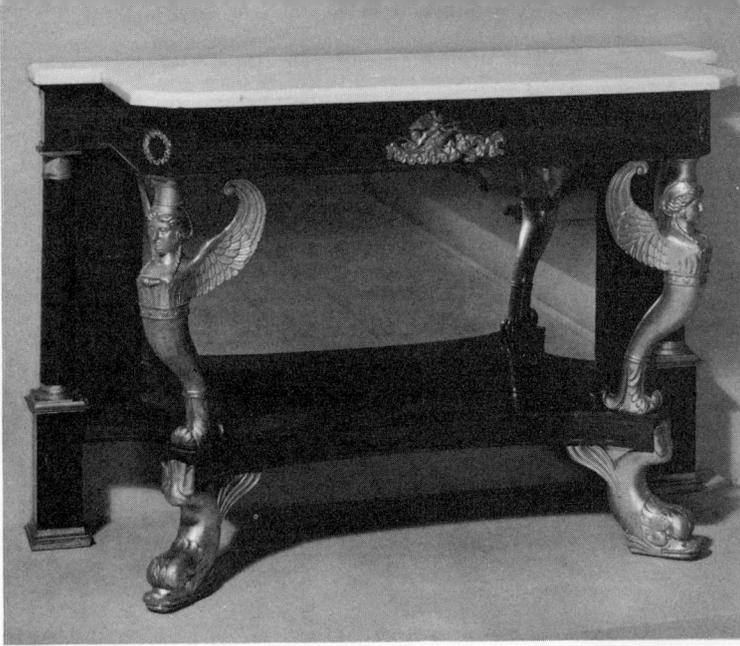

194. Console with narrowed front and monopodia set canted under the chamfered angles. The boxed shelf, narrowed to conform, stands on dolphin feet. (*The Brooklyn Museum.*) These three American Empire consoles (194, 195, 196) were made by or attributed to Charles Honoré Lannuier, who died in 1819. Similar winged female monopodia were used on French furniture with varying bases, but Lannuier seemed to prefer the foliate sheath.

194

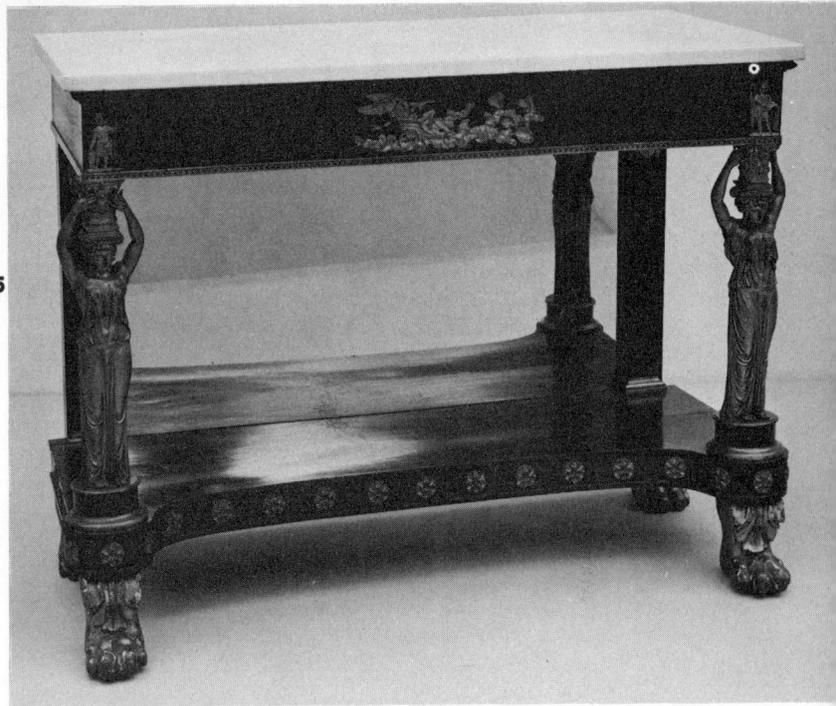

195

195. Plain oblong console with boxed stretcher is expanded at the front angles to accommodate two caryatic figures. Pilasters with metal bases and female masks flank the mirror back; four acanthus-carved lion hocks face forward. (*Metropolitan Museum of Art.*)

196

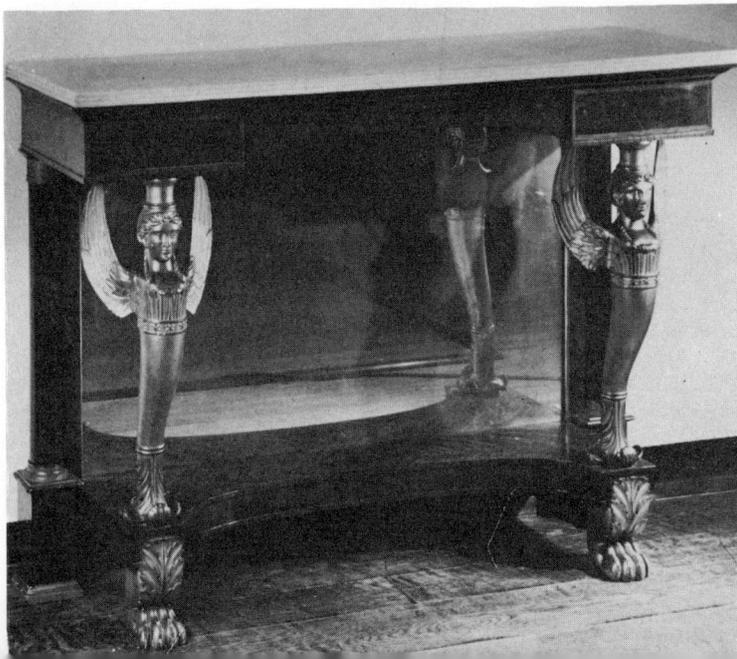

196. Oblong console with the shelf set within the plinths of the columns at the back. The frieze under the marble top is concave in the center, with banded panels under which monopodia are set face forward above acanthus-carved lion paws. (*Museum of the City of New York.*)

THE RESTAURATION PERIOD

The Restauration style in France, lasting from about 1815 to 1830, was launched under the patronage of the popular Duchess of Berry, niece of Louis XVIII and leader of Parisian society. Furniture design, in which the Regency influence is perceptible, was for the most part simple and in good taste. The materials were distinctive. Light woods were favored, chiefly figured ash, maple, burr elm, and lemonwood, with attenuated moldings and delicate marquetry in dark amaranth or palisander. The lotus and scroll serve as identifying design features of the period, as do cavetto moldings and gadroon ornament. About 1827 the French Gothic trend introduced cluster and hexagonal columns.

Large mirror plates, generally plain rectangular but sometimes with an arched top, were used architecturally, chiefly on chimney breasts or wall sections. The mirrors were not framed in wood but fastened with glass studs or rosettes and sometimes finished with an ornamental glass border. This particular style did not gain popularity on the American market, but in 1830, when Restauration furniture was introduced into America, the *New York Evening Post* ran an advertisement which included "Elegant Pier Glasses, French Plates, sixty-five inches by thirty-three inches; sixty inches by thirty inches." Large full-width mantel mirrors with simple gilt frames, rounded top corners, and slight crestings were fashionable. In 1834 Philip Hone wrote in his diary, "Mrs. Ray has the finest house in New York and it is furnished and fitted up in a style of the utmost magnificence; painted ceilings, gilded moldings, rich satin ottomans, curtains in the latest Parisian taste, and splendid mirrors."

Two main sources document American Restauration furniture. The first is an advertisement with forty-four illustrations issued by Joseph Meeks and Sons of New York in 1833 (figs. 254 and 255), which probably introduced the style on the market and influenced production in other areas of the country, and the second is John Hall's *The Cabinet-Maker's Assistant,* published in Baltimore in 1840 (figs. 256–60).

Joseph Meeks belonged to an old, established family of cabinetmakers whose names recurred in the New York directory listings from 1798 to 1868. He evolved a strikingly homogeneous style comprised of simple geometrical construction, heavy quadrangular scrolls as feet or sup-

197. A pair of French Restauration *méridiennes* flanks the fireplace of the drawing room of Mr. Henry P. McIlhenny. The portrait is by Ingres and the sculpture at left by Degas. (*Wendy Hilty.*)

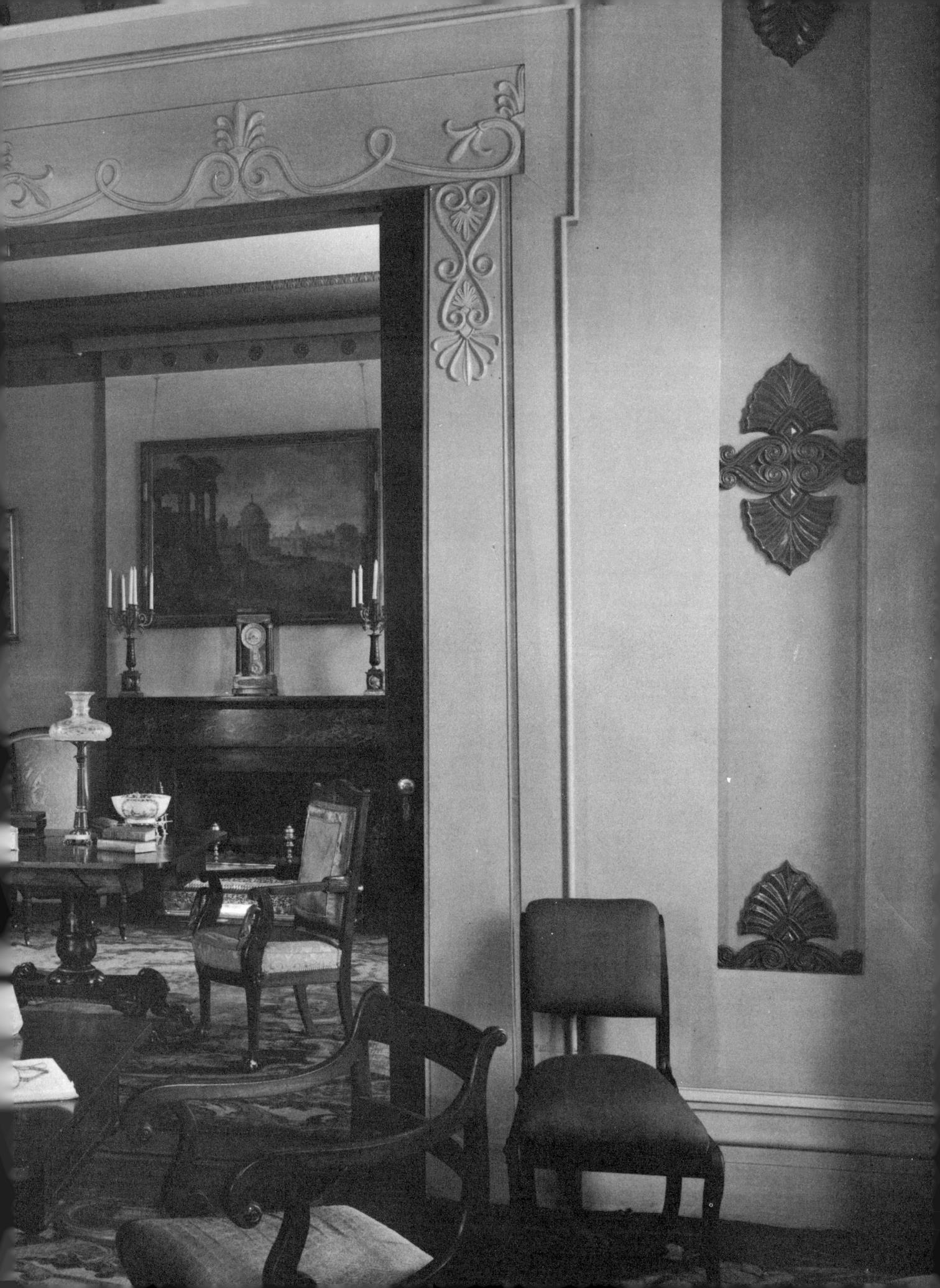

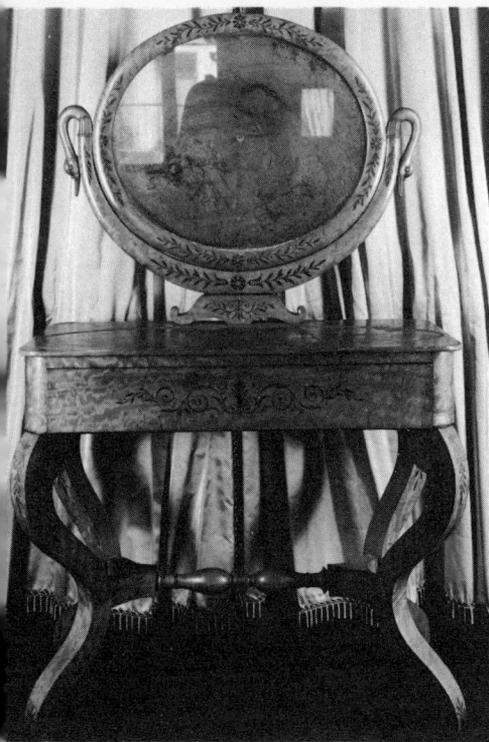

198. (PRECEDING PAGE) The furniture in the double parlor of the Campbell Whittlesey House is in both Empire and Restauration style. Center tables are Empire, as are the piano and the chairs with straight front legs. In the foreground, the folding-top card table on a flat-section pillar and the chairs with console front legs are Restauration.

199. A marble-topped dressing table, with one drawer in its frieze, has a horizontal oval mirror with conforming supports and a small foot; the legs are angular scrolls with a paired-baluster stretcher. (*Roger Imbert.*)

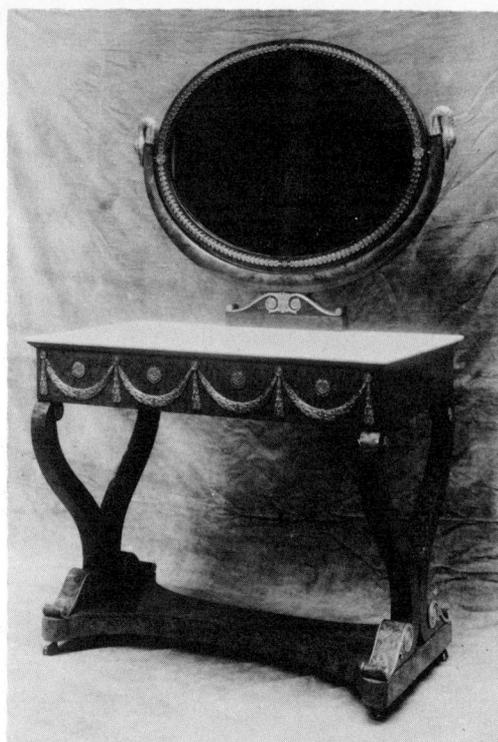

200. Ormolu mounts instead of marquetry make this dressing table unusual. The simple paired-scroll supports, a type illustrated by Hall but not by Meeks, occur frequently on American furniture. The mirror is of a type that found wide acceptance. Its supports conform exactly with the base of the frame above a small domed foot. (*Roger Imbert.*)

202. The interior of this fall-front *secrétaire* by J. J. Werner, mirror-lined and with an arched architectural center flanked by small drawers, is typical of the Restauration period. (*Musée des Arts Décoratifs.*)

201

201. French Restauration *guéridon,* in figured ash with amaranth marquetry, is signed "Werner." There were many variants of the circular-topped table on a tripod base; with a tilt-top it was called *guéridon à l'anglais.* (*Roger Imbert.*)

203. French version of a Regency sofa table has hinged end flaps and a Restauration base with paired scrolls and a flat stretcher. (*Roger Imbert.*)

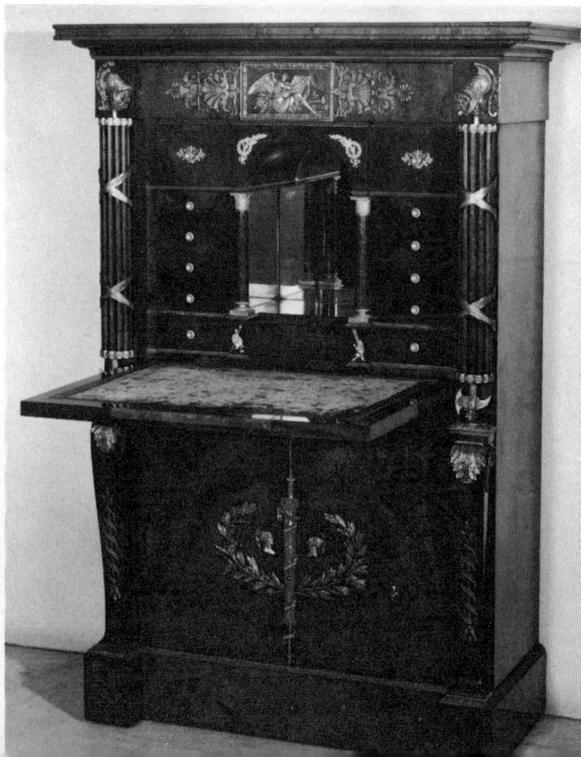

202

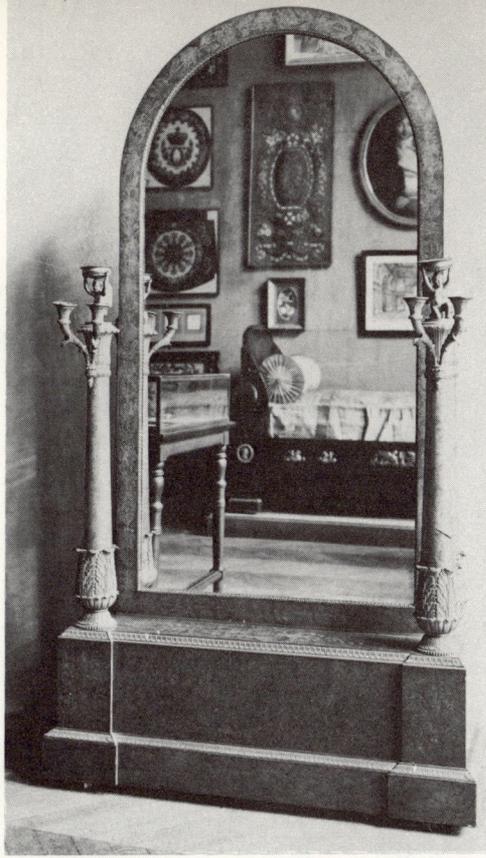

203

204. Tall mirror, framed in figured elm, with marquetry lilies on the plain band and candle holders set on the front corners. The base houses a musical mechanism capable of playing six tunes. It was made for the Duchesse d'Angoulême, the only surviving child of Louis XVI and Marie Antoinette. (*Musée des Arts Décoratifs.*)

205. An almost universally copied console with scroll front supports, mirror back, boxed concave shelf, and paw feet. (*Roger Imbert.*)

206. Bed with ormolu mounts on the columns and the front, straight ends with roll capping, and flat sides in bateau line. (*Musée des Arts Décoratifs.*)

204

205

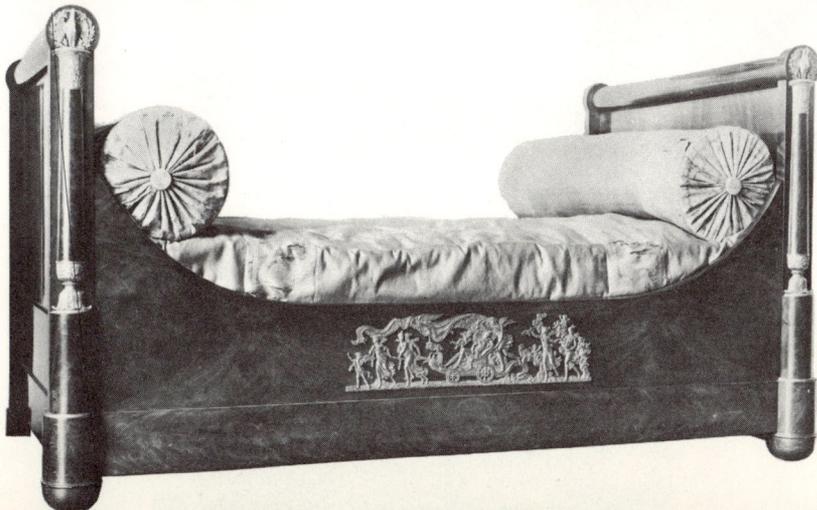

206

ports, and angular vase pillars. Mahogany and rosewood with upholstery of silk or haircloth and with marble tops, either white or black and gold Egyptian, were specified in the 1833 advertisement.

By 1833 Greek Revival architecture was at the height of its popularity. On the banks of the Hudson, in the South, and all along the eastern seaboard, city magnates, ship captains, merchant princes, and planters were seeking furniture for their impressive new homes. Money was abundant and was spent freely, and furniture was shipped everywhere. The Erie Canal, which had opened in 1817, facilitated the transport of goods throughout the country.

The Meeks advertisement obviously seems to have been a bid to gain a footing in this new and prosperous market. Each item was numbered, described, and priced. The furniture was not cheap, one bed with draperies costing six hundred dollars. Meeks stated, "We are constantly getting up new and costly patterns . . . all of which are warranted to be made of the best materials and workmanship and will bear the makers' names and cards inside. . . . Our establishment being one of the oldest and now the largest in the United States, we are able to execute orders, at wholesale prices, to any amount and at the shortest notice." The word wholesale is significant. Hitherto all authenticated Meeks furniture has borne the New York label, but recently a label was found on a small buffet in Louisiana which reads, "J. and J. W. Meeks, Cabinet Makers — 43 and 45 Broad Street, N.Y.C., and 23 Charters Street, New Orleans."

The cabinetmaker was becoming a manufacturer. By 1839 furniture was already on sale in stores. In 1834 Charles H. and John F. Winter, early wholesale and retail furniture makers, advertised in the *Cincinnati Advertiser and Ohio Phoenix* that a very extensive assortment of furniture and upholstery, finished in the best and most elegant manner "after the latest and most approved designs of both Europe and America," would be packed with greatest care to preclude the possibility of injury in transportation. At that time Cincinnati was the chief emporium for supplies to the wealthy, one-crop cotton planters, and constant transportation was available on a fleet of steamboats. In 1836 a *Book of Prices of the United Society of Journeyman Cabinet Makers of Cincinnati* was published, with 163 pages and numerous illustrations, probably reflecting the city's first step in mass production.

Bedroom Furniture

Bedroom furniture now began to be coordinated. Both Meeks and Hall showed bedroom items that matched in character and were related in scale. The two-door full-length hanging wardrobe was new, and columns were frequently used as mirror supports and on stiles. In the Meeks advertisement of 1833, item number 42, a *cheval* mirror, was new to the American market. Suites were not yet made, but a handsome set of matching bedroom furniture could have been assembled from the Meeks offering.

American Restauration beds were of the established French type with head- and footboards of equal height, either in cyma contour or flat with plain panels. Meeks illustrates three beds — two of the French type, the third an example of the four-poster, which was still used for plantation and other important bedrooms.

The Cincinnati price list of 1836 includes only one bed, the French bed, its ample specifications following those of the early Lannuier bed, even to the eagle heads on the front posts. The field bed vanished about 1830, but, with the American high- and low-post bedsteads, there was still ample variety.

207

207. The corner of a bedroom in the Varner-Hogg Plantation House contains a swan-neck Voltaire and a marble-topped dressing table with a large shield-shaped mirror in Restauration style. The rectangular mantel mirror with slightly arched top is an American Restauration type. The side chairs have console front legs, and the base of the folding-top card table is in the Hall style.

208. Dressing bureau with two half-width and three full-width drawers separated by cross-banding, and with a secret drawer in the base. Case drawers flank the marble top. The mirror has a free cavetto pediment and is swung between two pedestals of drawers. (*Mrs. Joseph B. Kellogg, The Elms, Natchez.*)

209. Four-post bed with full tester, made by Prudent Mallard of New Orleans, has cluster-column posts. The rectangular tenon headboard has a four-pointed star on the recessed panel and segmental cresting with capping ending in volutes, similar to that shown by Meeks on sofa number 39 in his advertisement (fig. 255). (*Mr. and Mrs. Orris Metcalfe, Parsonage, Natchez.*)

208

209

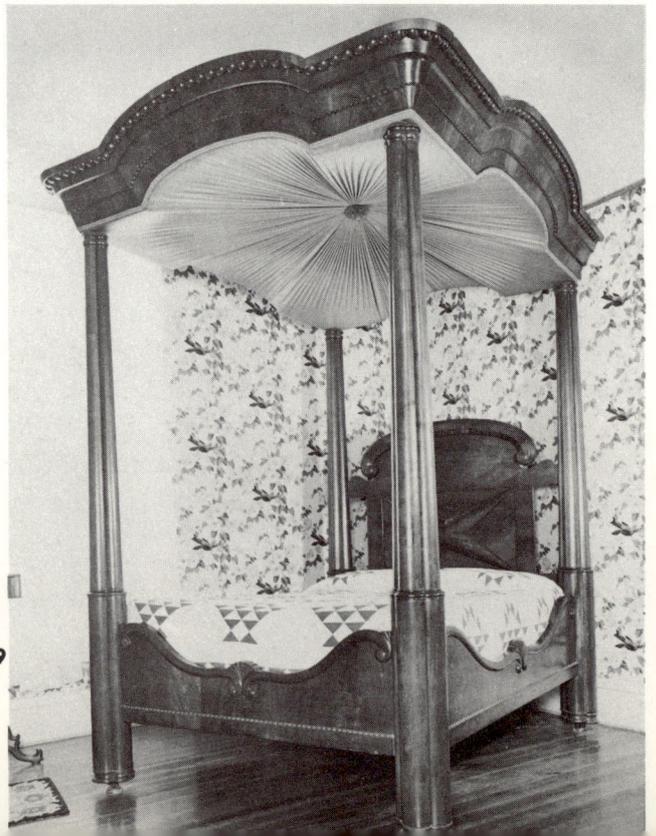

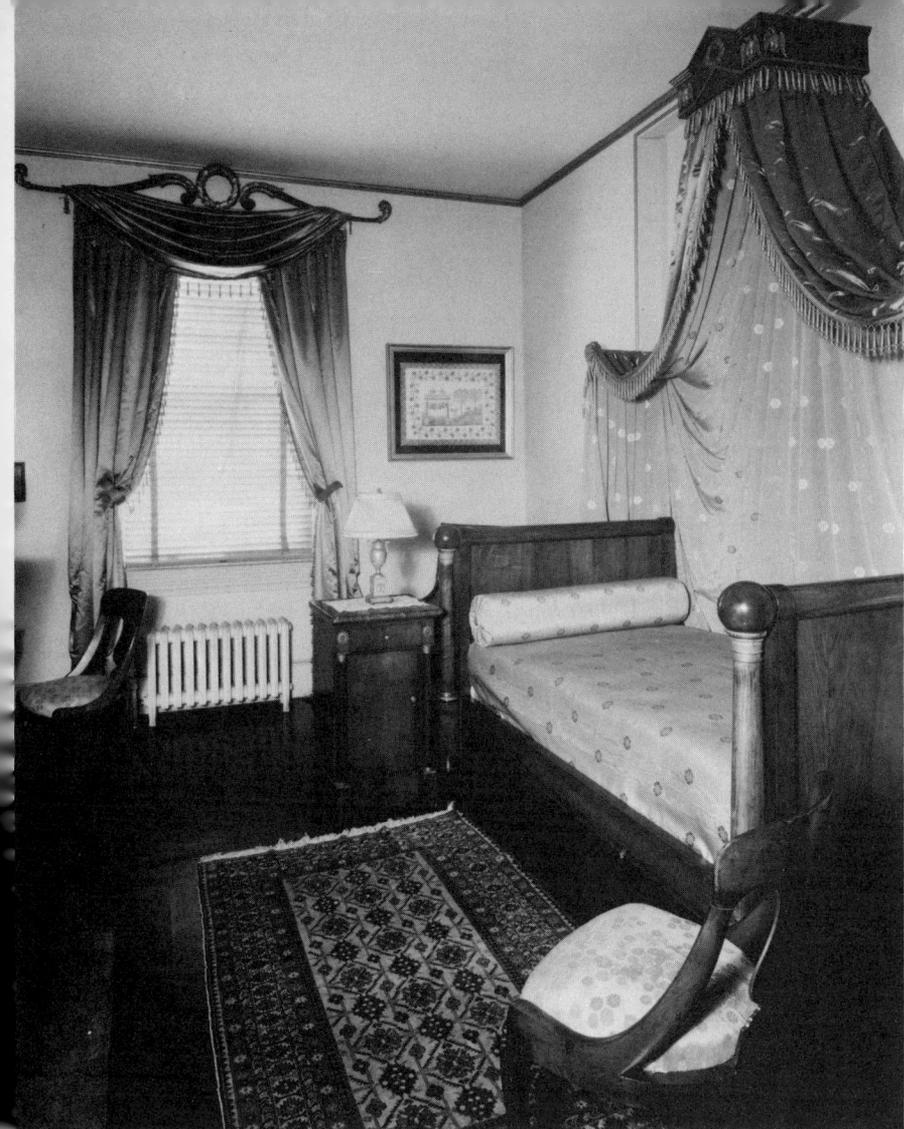

210

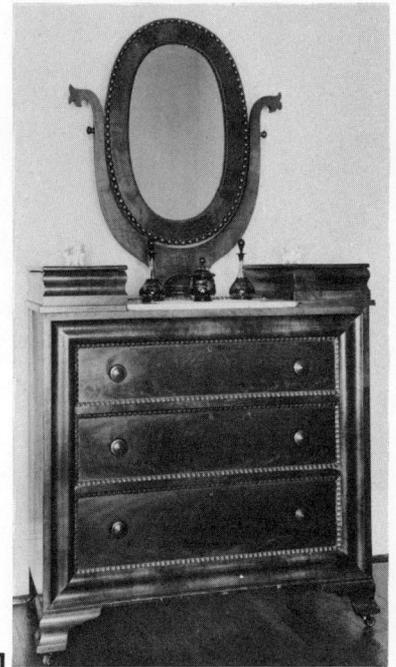

211

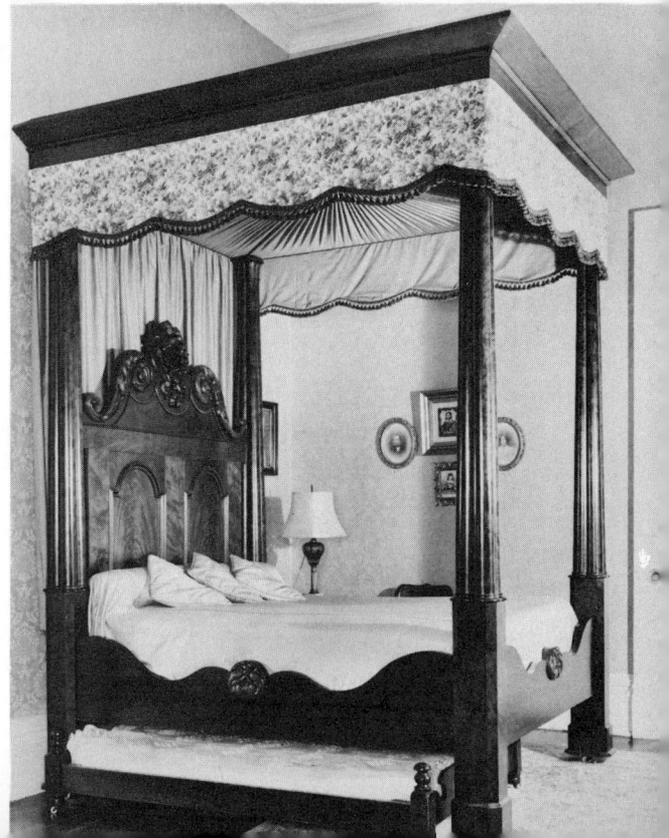

212

210. Bedroom in Strawberry Mansion, Fairmount Park, Philadelphia. Draperies hang from a half corona high on the wall above a rectangular bed with straight head- and footboards, cyma foot rail, plain columns, and metal mounts. The night table is a square pedestal with columns, with a drawer and a recessed one-door cupboard. The gondola-type chairs have vase splats and console front legs. The bed and night table are similar to those in the bedroom of Queen Hortense of Holland, daughter of Josephine, in Malmaison. (*Philadelphia Museum of Art.*)

211. Dressing bureau with the marble top flanked by ogee case drawers; the oval mirror is on flat-section conforming supports ending in triple scrolls on a domed foot. Three full-width drawers are contained within a cyma framing on French bracket feet. (*Mr. and Mrs. Orris Metcalfe, Parsonage, Natchez.*)

212. Plantation bed showing Restauration influence in the lotus-topped cluster columns. The waved tops of the side- and footboards have a center roundel. The trundle bed has miniature posts and bulb feet. (*Mr. and Mrs. Samuel Hopkins Lambdin, Mistletoe, Natchez.*)

Chairs

Although a number of chairs followed earlier designs, a distinctive Restauration type, the *chaise gondole*, was introduced. The term *"gondole"* had been previously applied to French chairs with "tub"-shaped backs, upholstered in one piece — the *bergère* of the Directoire period, and the *fauteuil* — not *chaise* — *gondole* of the Empire. The Restauration *chaise gondole* with its open wooden back — a tablet on a straight or vase-shaped splat, and uprights curved forward to rest on the seat rail — was new. Flat-section scroll front legs were termed "console." Meeks illustrated two versions, both identical with the French, even to an open grip in the arched tablet — a feature much liked in French Restauration chairs. François Seignouret made quantities of these chairs for his New Orleans clientele.

Another distinctive French Restauration chair, much liked in America, was an open-arm, low-seated easy chair called *"le Voltaire."* Its identifying feature is a high contour back. Duncan Phyfe made an early example for John Jacob Astor. In his sale catalogue of 1847, one item reads "Voltaires, rich fig'd crimson Plush, tufted spring seat and back." The fine example in figure 215 was made by Phyfe for Washington Irving, who wrote of an English railway journey during which he sat as comfortably "as in my old Voltaire at the cottage." It is included among the furnishings of Sunnyside, one of the Sleepy Hollow Restorations done by Joseph T. Butler, curator. In an advertisement of an auction in the *New York Times,* "Voltaire and Easy Chairs" were included.

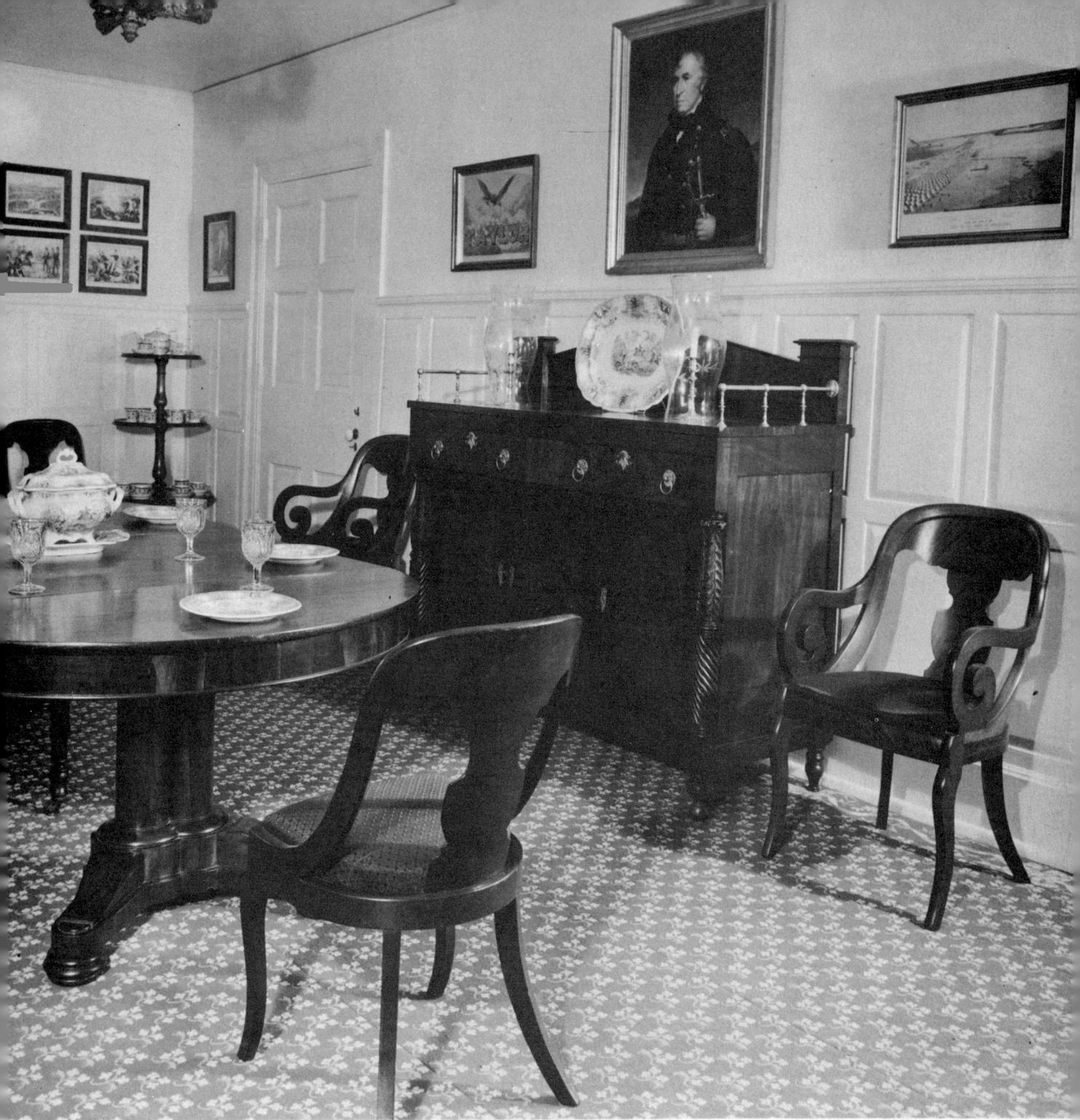

213. The dining-room furniture in the Varner-Hogg Plantation House shows such Restauration features as vase-backed gondola chairs and a sideboard with three one-door cupboards in its base instead of two. The rosewood plantation dining table rests on a massive quadruple-cluster pillar which divides, leaving a slender turned leg on a caster as a center support.

214. American gondola chair with a vase splat, a tablet with Gothic-shaped arches on its lower edge, and plain console front legs. (*Henry Ford Museum, Dearborn.*)

215

215. The Voltaire, an open-arm easy chair with contour back, was made in countless variants through decades. It was a distinctive Restauration item in America. (*Sleepy Hollow Restorations.*)

216. Roman chair, from the 1802 *London Makers' Book of Prices*. A gondola type with choice of square or baluster front legs, it did not find wide acceptance in England.

216

217. One of the many variants of the Restauration gondola chair has a bowed stay rail, uprights and seat united in a curve, and rococo carved cresting. (*Henry Ford Museum, Dearborn.*)

218. French prototype of the *fauteuil Voltaire*. (*Roger Imbert.*)

217

218

221

222

219, 220. Two types of the French *fauteuil gondole,* one with an arched and the other with a level tablet. The back of each is curved and upholstered so that the frame extends onto the side seat rail in the gondola line. Rounded armrests rise high on the frame and slope forward to curve under in a close volute. (219: *Musée des Arts Décoratifs.* 220: *Cooper Union Museum.*)

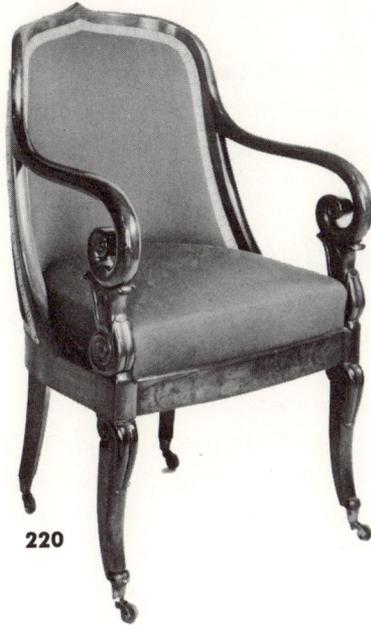

219

220

221. Chair with reeded "dip" seat, broad shaped tablet set on uprights shaved off toward the top, and Greek-curved legs. The construction is similar to that of the Hitchcock chair. (*Grand Rapids Public Museum.*)

222. Open-arm chair with upholstered panel in the back and an open grip in the cresting, uprights and seat rails united; armrests terminating in a double-ended scroll; and console front legs. (*Estate of Mrs. Hubert Barnum, Monmouth, Natchez.*)

223

224

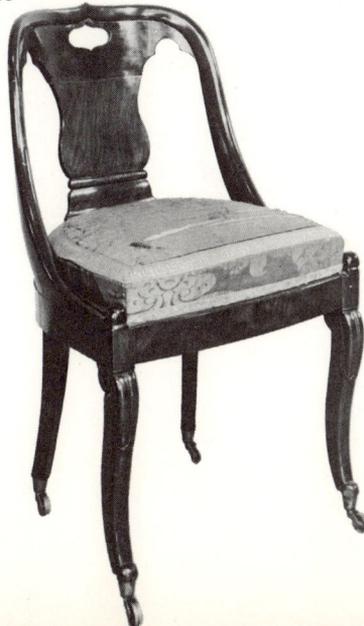

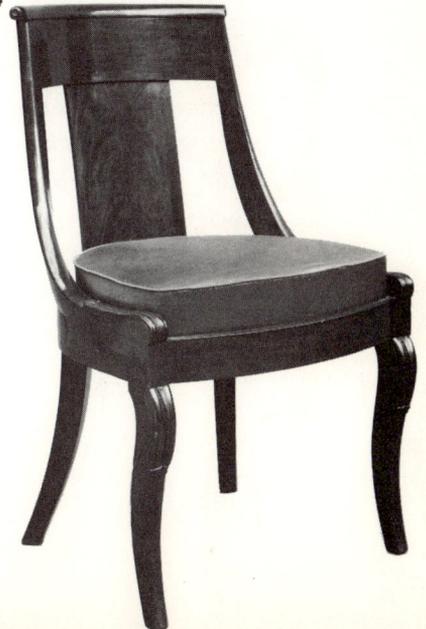

223, 224. There were two definite types of French *chaise gondole;* one had an arched tablet and vase splat and the other a level tablet and straight splat. Lotus-carved console front legs were an identifying feature. (223: *Cooper Union Museum.* 224: *Metropolitan Museum of Art.*)

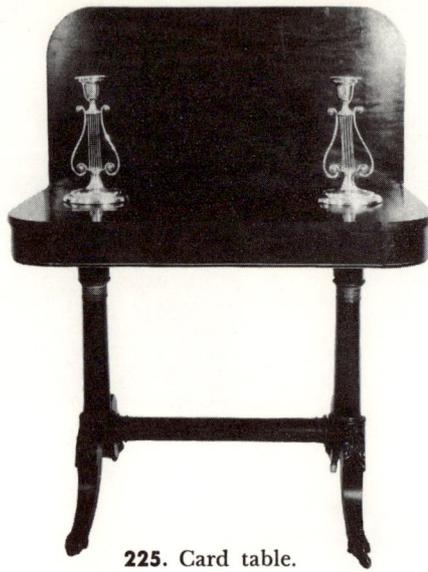

225. Card table.

Duncan Phyfe

Duncan Phyfe established his workshop in Fulton Street, New York, in 1795. He was an exceptionally fine craftsman, and his furniture was handsome, practical, and elegant. Most of the wealthy families of his day were his customers. His furniture was delivered not only in New York but also to Philadelphia, New Jersey, and the Southern plantations. In 1810 he made a carved bed to the order of Henri Christophe, Negro king of Haiti. His work was widely copied.

Phyfe made a Restauration console, with angular scroll front supports, for the dining room of his daughter Eliza. It is labeled "Made by D. Phyfe and Sons," indicating that it was made between 1837 and 1840. After the death of his son Michael in 1840, his label was Phyfe and Son.

In 1837, the year in which Duncan Phyfe took his sons into partnership, he made a set of parlor furniture for Samuel A. Foot, a New York lawyer. It consisted of a pair of card tables with swivel tops folding as consoles, having rounded corners, *cheval* bases with plain column standards, and paired concave legs linked by a column stretcher; a pair of *méridiennes* designed with a flowing curve in the back, sharply scrolled ends of unequal height, plain seat rails, and heavy flanged legs; four tabourets on curule bases, with baluster stretchers from front to back and saddle seats; four *chaises gondoles* with straight splats and level tablets, the seats rounded at the back, and console front legs; and a pair of oblong benches on paired supports. The upholstery is the original crimson mohair woven in a bold design in white. The silver candlesticks were bought from Phyfe. This large and complete set shows clearly Phyfe's definite abandonment of his usual forms for the restraint and simplicity of the Restauration style. The pieces are still in the possession of direct descendants of Samuel A. Foot — Mr. and Mrs. L. Emery Katzenbach II and Mr. and Mrs. William E. Katzenbach.

102

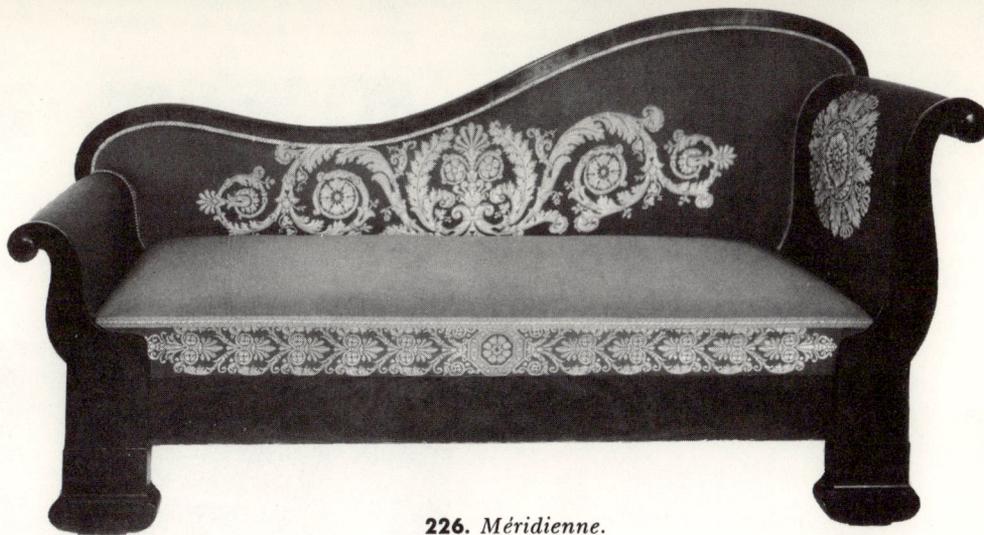

226. *Méridienne.*

227. *Chaise gondole.*

228. Tabouret.

229. *Chaise gondole.*

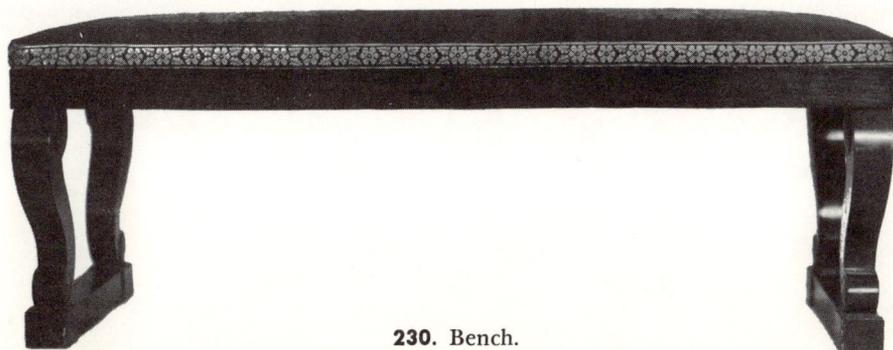

230. Bench.

Musical
Instruments

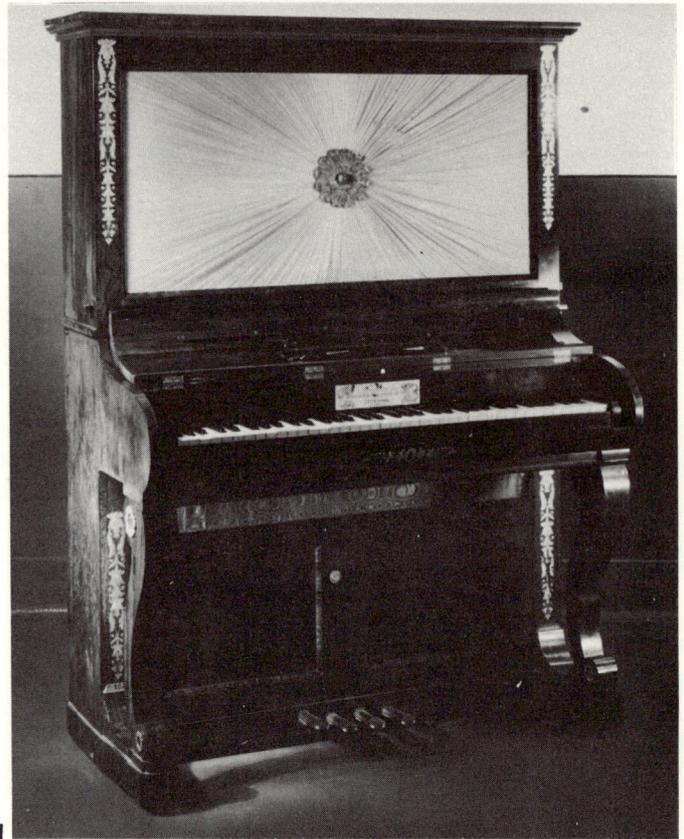

231

231. Rectangular piano made by Robert and William Nunns, 172 Chambers Street, New York, listed 1824 to 1832. Two recessed panels are in the base; the plinth ends extend forward below scroll supports decorated with ormolu wreath mounts. The gilt ornament is stenciled. (*Museum of the City of New York.*)

232. Oblong rosewood piano in the Restauration style made by William Nunns and A. Brumley of New York, 1836. The square end-blockings with concave sides rest on four angular vase supports. The satinwood inlay includes foliage, floral, scroll, and lyre designs. (*Mrs. Bertha Hinshaw, Lake Wales, Florida.*)

232

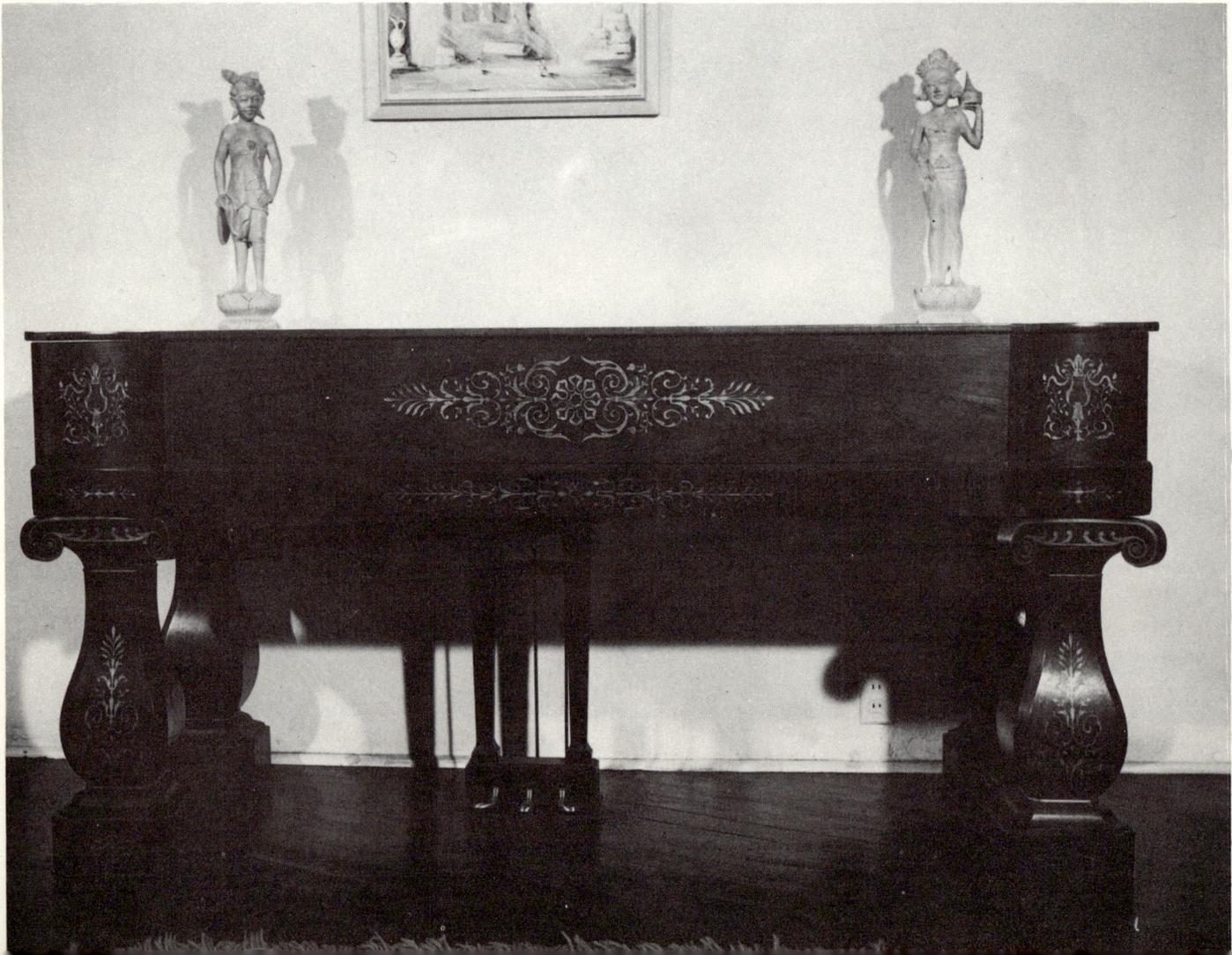

Secretaries

In France the most favored type of *secrétaire* during the Restauration period had a fall-front secretary over a cupboard base. The construction was rectangular, with bracket or bulb feet. Light wood was used, with marquetry in dark wood.

The same type was also made in America, but earlier construction, with a secretary over a bureau or cupboard base surmounted by a glass-fronted bookcase, persisted. American Restauration motifs — the cavetto, lotus, and scrolls — occurred frequently in the design.

Settees

In French Restauration furniture the settee was largely replaced by the *méridienne*, which had been developed during the Empire period. During the Restauration it was promoted from the bedroom to the salon and was used in pairs. In America the type was widely adopted; Meeks advertised it in 1833 as number 23. In the same advertisement, number 39 demonstrated an equally important and exclusively American style — a settee with a segmental and scrolled top to the back, specified in the Cincinnati price list of 1836 as a hog-back. Of the remaining settees in the Meeks advertisement, one was heavily stuffed, with five extra cushions; and another had a full-width tablet on the back and scrolls as facings and as front legs. There was much use of torus, cyma, and ogee molding on the straight front seat rails of these settees.

233. Secretary bookcase with an arch on the frieze, plain columns, bevel-framed door panels, and vase and roundel feet is almost identical with number 41 in the Meeks advertisement (fig. 255), except for Gothic panels on the glazed doors. (*Mr. and Mrs. Douglas H. McNeill, Elmscourt, Natchez.*)

234. Breakfront secretary bookcase, formerly owned by President Andrew Jackson, attributed to Joseph Meeks and Sons, New York. Tiers of shallow drawers below a coved molding flank the secretary drawer. The cupboards in the base have separate plinths wide enough to take lion monopodia. (*Henry Ford Museum, Dearborn.*)

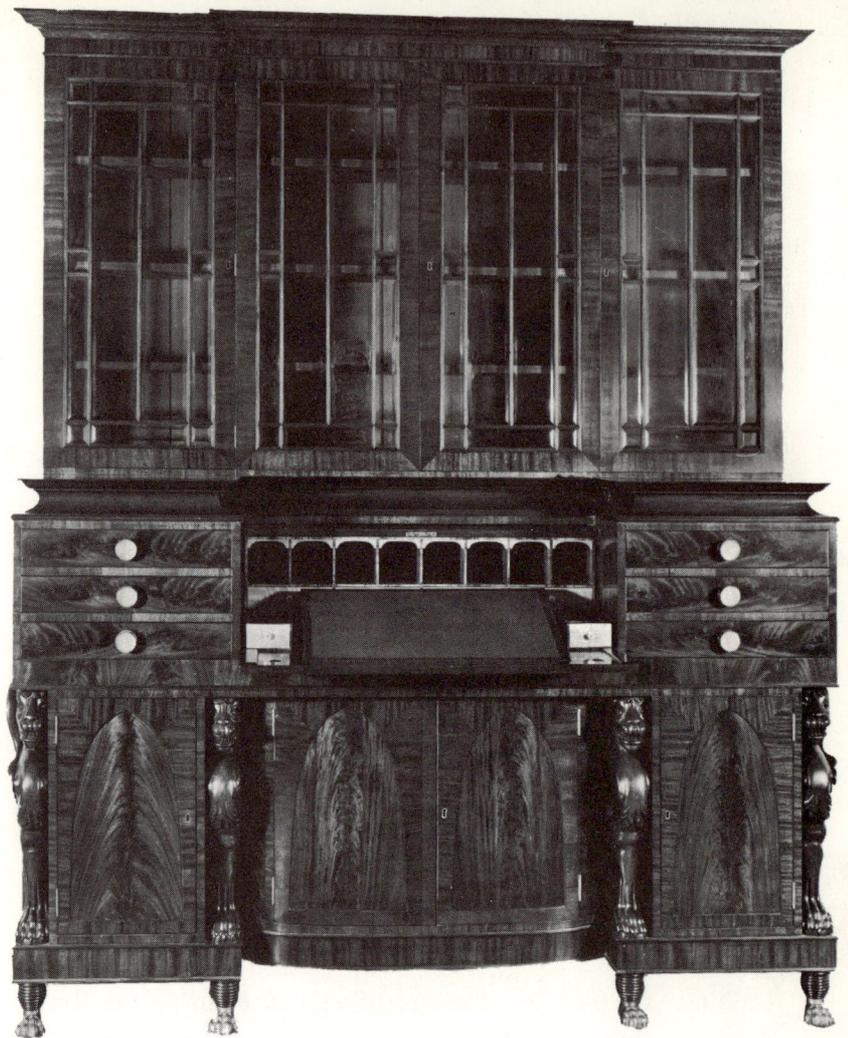

234

233

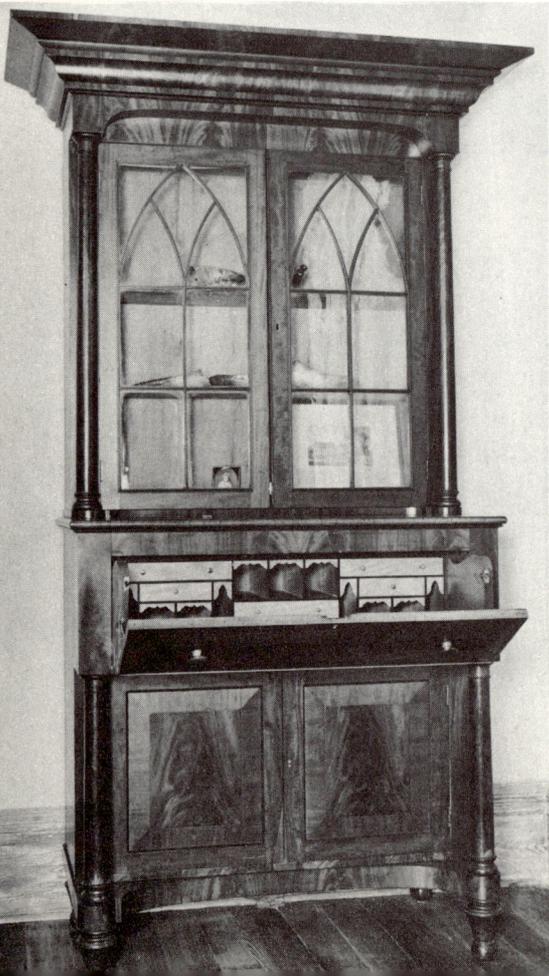

235. Fall-front secretary made for Governor De Witt Clinton is five feet, four inches high. The center of the interior is hooded, with small columns in the Restauration manner. (*Museum of the City of New York.*)

236. Bookcase with two glazed doors in the top, pilasters with lotus capitals, and a cavetto molding in the frieze. The base has two drawers in the ogee frieze, which projects over a recessed and narrowed two-door cupboard. The plinth, coved in front, supports bold detached scrolls canted beneath the chamfered corners of the frieze. (*Rosalie, Natchez. State Shrine of Mississippi D. A. R.*)

237. This compromise between settee and *méridienne*, designed by Duncan Phyfe with unequal ends and sloping back, is evidence of his acceptance of the new Restauration style. (*Metropolitan Museum of Art. Gift of G. Ruxton Love, Jr.*)

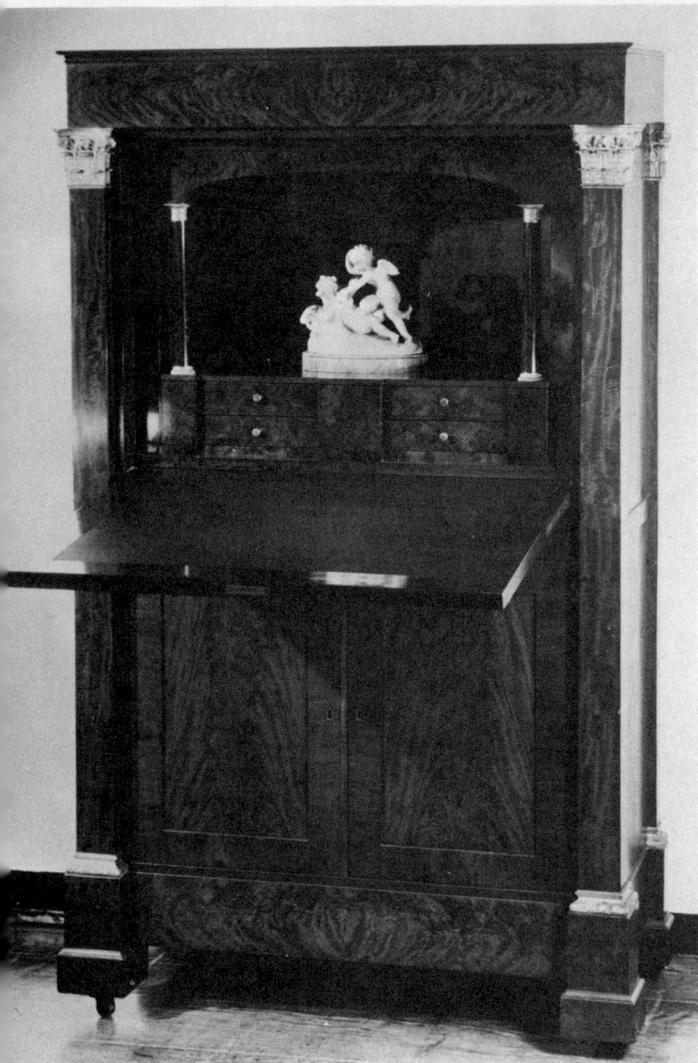

235

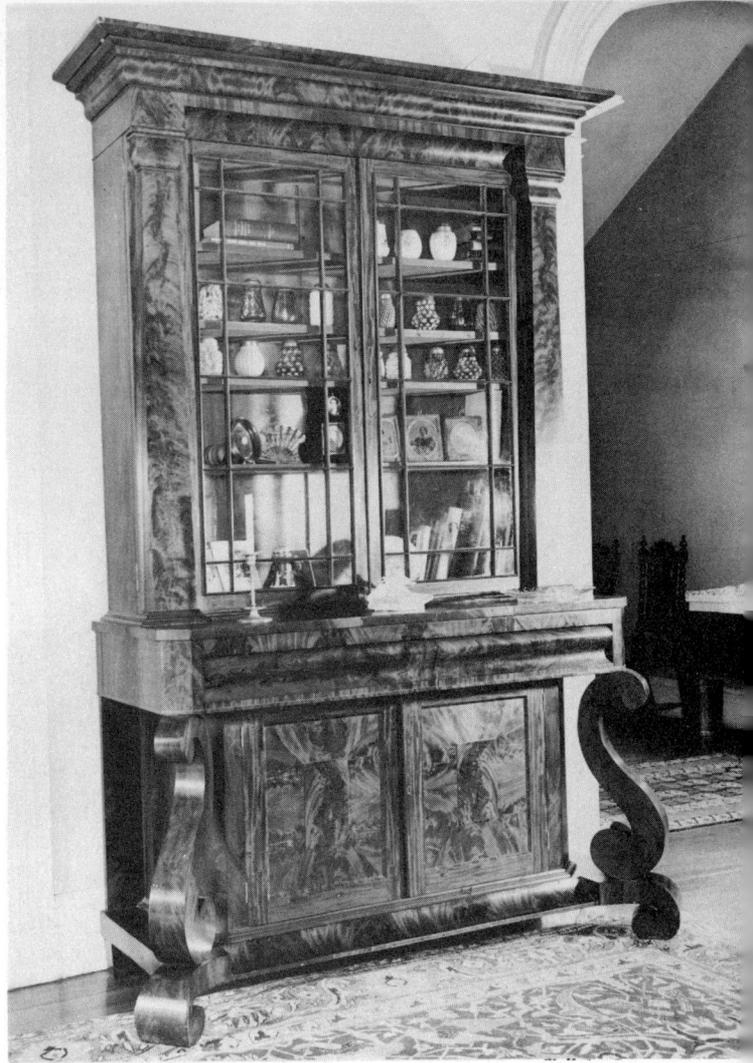

236

237

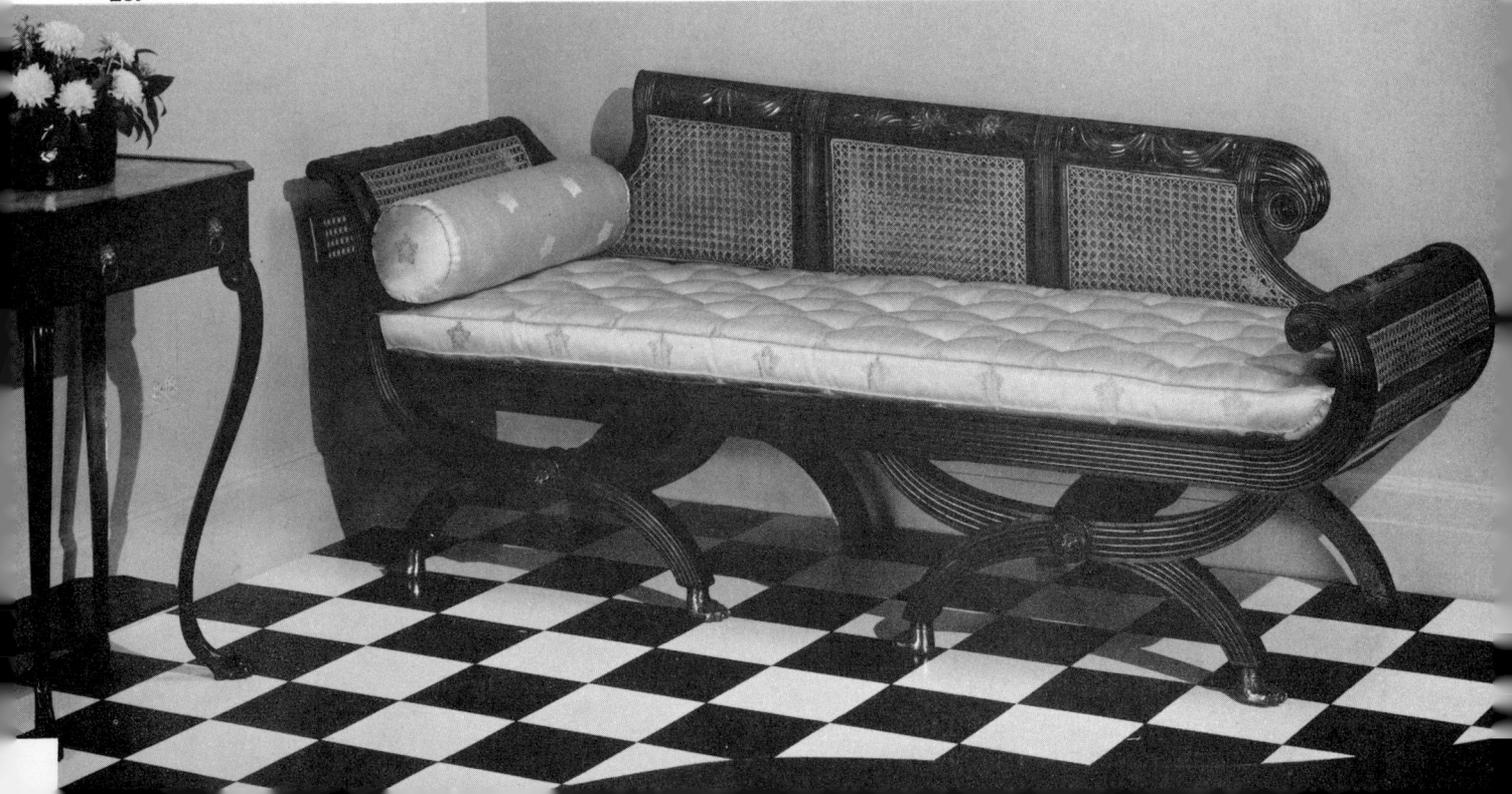

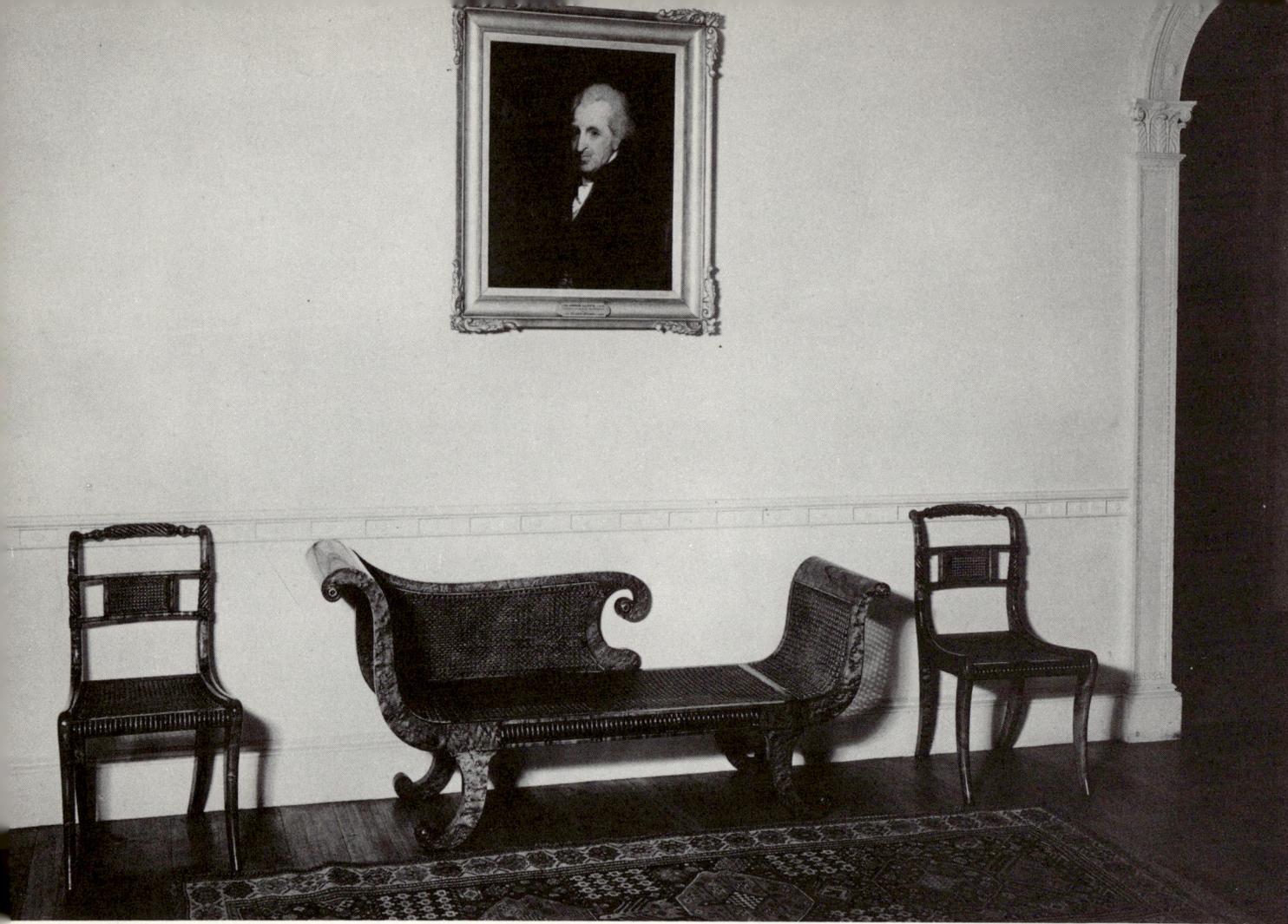

238

238. Unusual set of caned chairs and *méridienne* with frames of bird's-eye maple. This type of chair was introduced in England by George Smith, but the ringed front rail of the seat is American. The top rail of the chair backs — a scrolled center section between spindles — was illustrated in the *London Book of Prices,* 1808, and occurred in many variations on American chairs. (*Philadelphia Museum of Art.*)

239

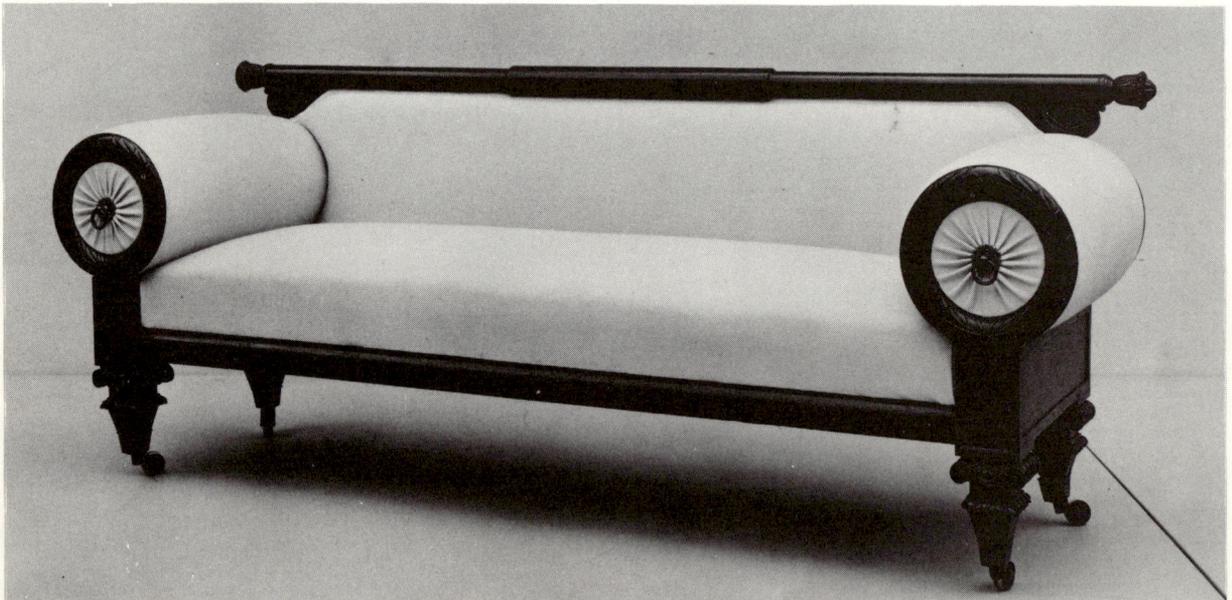

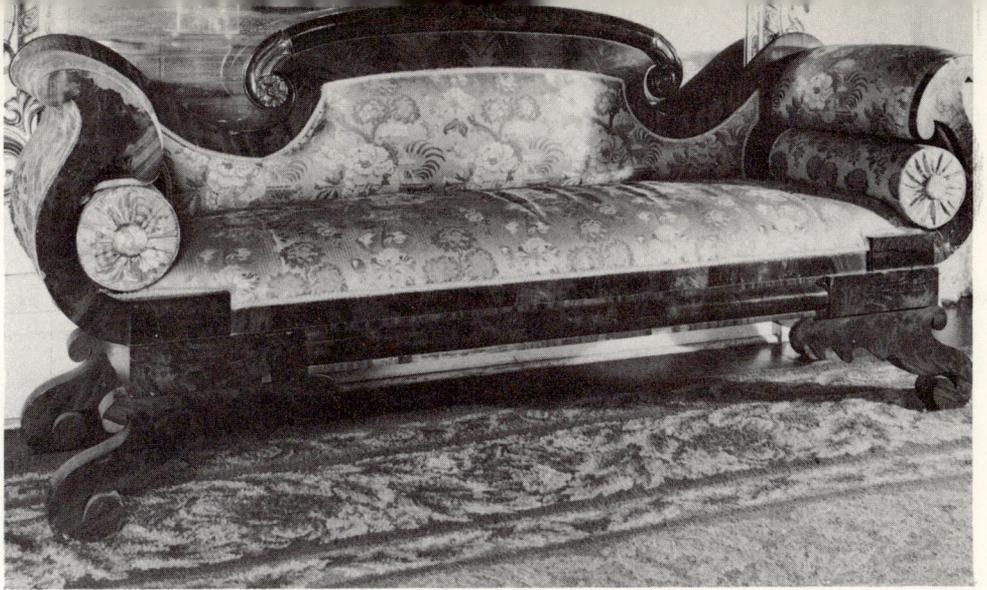

240

239. Settee with plain torus front rail and large upholstered cylinders, their fronts rayed from a metal rosette with a mahogany rim; they are set on boxed ends with recessed panels. The vase legs, with petal rim and scrolled top, are of a type used on several items in the Meeks advertisement (figs. 254 and 255). (*Metropolitan Museum of Art.*)

240. Settee, similar to number 39 in the Meeks advertisement, was quite new and widely made, with many variants. There are two scrolls on each side of the segmental capped back, and the ends are scrolled with double tops. The applied upholstered panel on the back is fully specified in the Cincinnati price list, 1836, as "hog back, including scrolls at end . . . a loose solid back for stuffing on to be screwed to permanent back, one and a half inches thick." (*Stanton Hall, Natchez.*)

241

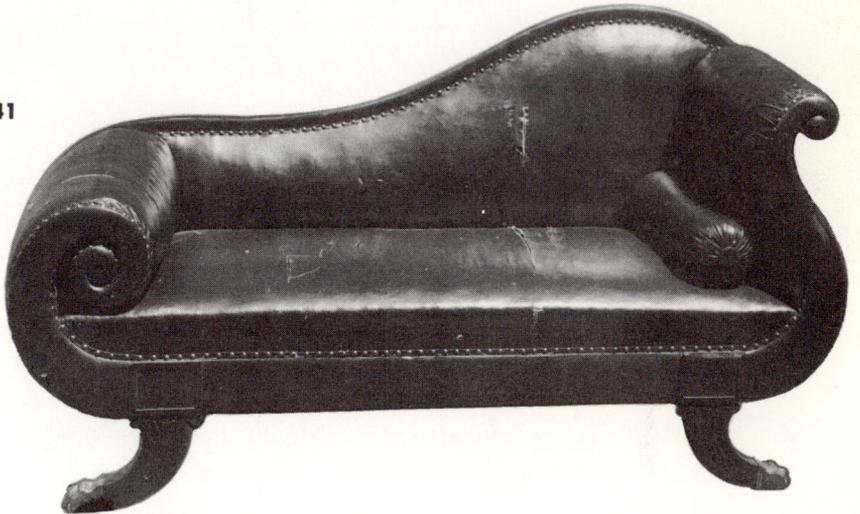

241. An American version of the *méridienne,* with cyma head, sloping back, and scrolled foot. The plain band facing on the front of the seat and the ends is broken by paneled blocks over lotus-carved legs with gilt metal paws.

242. *Méridienne* in mahogany frame — unusual in French Restauration furniture — with upholstered ends, back, and seat. Attenuated cyma facings on the ends are expanded at the base and rest on a plain seat frame. Stylized lotus leaves form the legs. (*Musée des Arts Décoratifs.*)

242

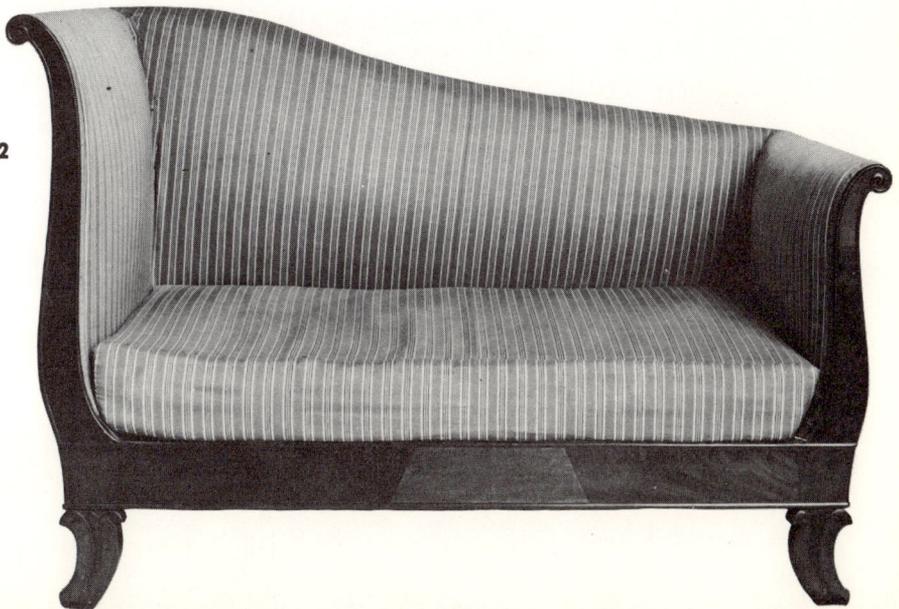

243. Marble-topped table by Duncan Phyfe. (*Metropolitan Museum of Art.*)

Sideboards and Tables

Restauration influence on American sideboards is seen in the simplification of construction and ornament. Marble tops were frequent, drawer fronts were molded but without visible division, and in the design of the base three one-door cupboards predominated. Frequently detached angular scrolls were used on the stiles.

In their 1833 advertisement Meeks shows two sideboards, numbers 33 and 43. Both are rectangular in construction and have drawers in the frieze, which projects over a base with a one- or two-door recessed cupboard flanked by rounded one-door cupboard ends; both also feature plain columns on the stiles, massive scroll feet, and a low capped backboard with elevated sections at the ends.

Restauration tables, which have circular or oblong tops, seldom have four legs; instead, attenuated scrolls are generally attached to the underside of the table or curved sharply inward to be joined to some form of low stretcher or shelf. Circular or folding-top card tables were frequently designed with angular vase pillars — a feature adopted by Meeks, none of whose tables had four legs. Console tables, with oblong tops, have a boxed stretcher shelf with a mirror back and massive scroll supports on the front angles. Marble tops were much used by Meeks; prices were quoted on Egyptian and white marbles. In 1830, in the *New York Evening Post*, "J. Frazee begs leave again to remind those who are about to purchase New Furniture that he has now at his workshop, 442 Broadway, several pair of Marble Pier Tables, just completed, of beautiful pattern."

110

244

245

245. French marble-topped *guéridon* with figured maple baluster stem and ormolu sheath and foot above a four-sided stepped base. (*Roger Imbert.*)

246. The construction of this Restauration sideboard is novel. Shelf-topped back sections on scroll supports are joined by a rod. The frieze has three cyma-fronted drawers, with no division shown. The three-door cupboard base is in vertical torus and cyma moldings with blockings at the front ends as grounds for scroll-shaped stiles. (*Miss Myra Virginia Smith, Devereaux, Natchez.*)

247. Marble-topped console table with a plain frieze, boxed stretcher shelf and mirror back, angular scrolls canted as front supports, and vase feet, as shown by Meeks (figs. 254 and 255). The Renaissance wall mirror has a pierced pediment, with boss and shell. (*Mr. and Mrs. Hyde Dunbar Jenkins, Hawthorne, Natchez.*)

244. Oblong center table with a serpentine marble top and conforming frieze. Two shaped scrolls, with double-ended base, rest on an oblong pagoda platform and small scrolled feet in the Hall manner. (*Mr. S. B. Laub, The Burn, Natchez.*)

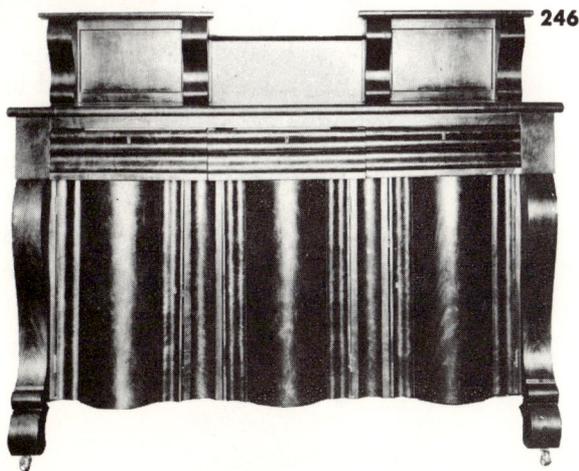

246

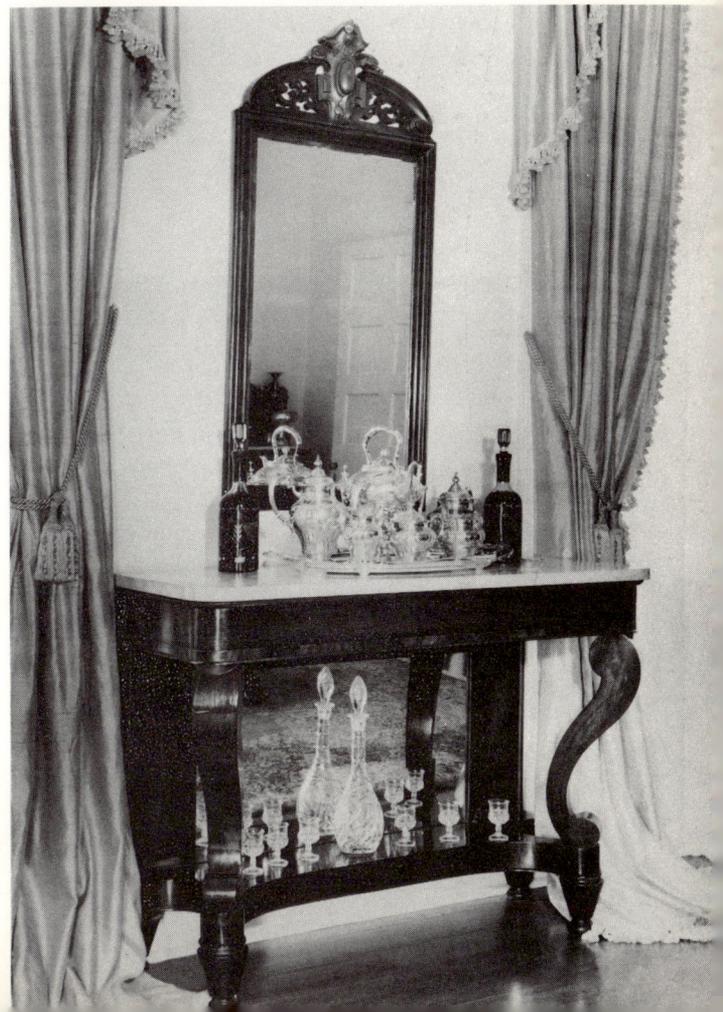

247

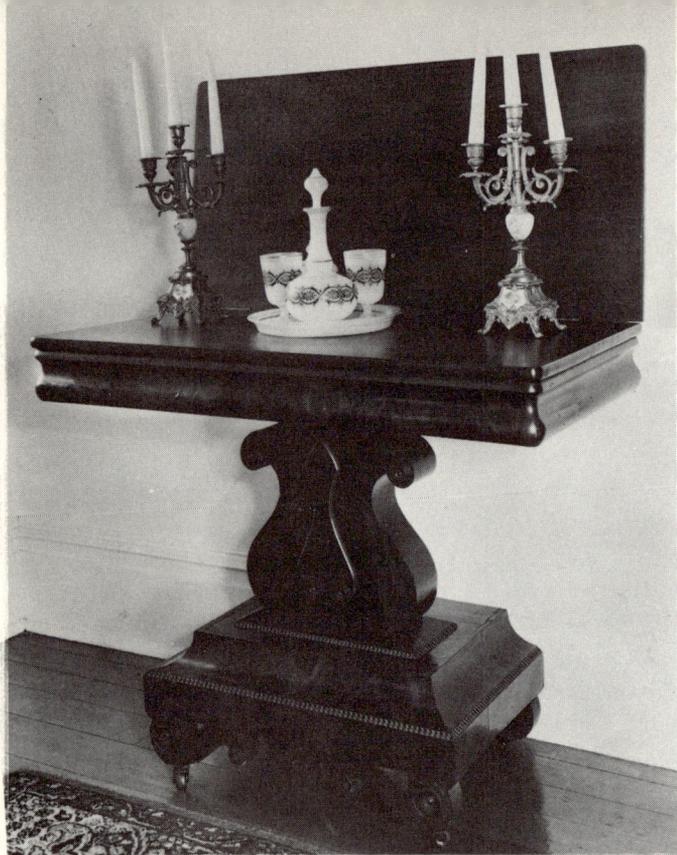

248

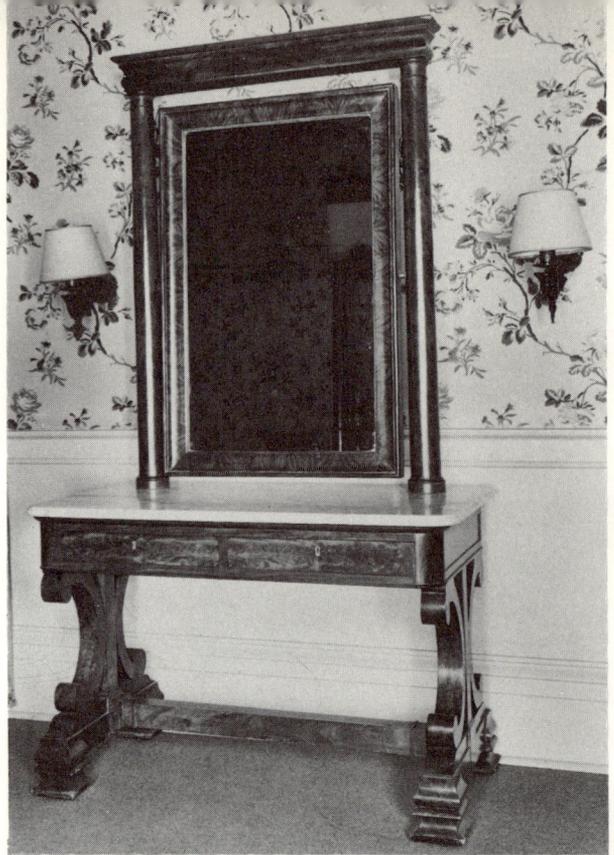

249

248. Folding-top card table with a cyma frieze supported by paired scrolls on a pagoda base with wave moldings. Four horizontal scrolls, with volutes at each end, serve as low feet. (*Mr. and Mrs. Hyde Dunbar Jenkins, Hawthorne, Natchez.*)

249. Dressing table with white marble top and two drawers in the frieze. The *cheval* base has square standards on a stepped bridge base with cavetto block feet and square stretcher rail. The mirror is swung on plain columns joined at the top by a free cyma tablet. This is an unusual type; the majority were made with a bureau or cupboard base. (*Stanton Hall, Natchez.*)

250. Card table with torus frieze and a folding top made to swivel on a hexagonal vase pillar; the platform is oblong, its ends divided to scroll under as feet. (*New-York Historical Society.*)

251. Folding-top card table on a four-sided angular vase pillar, with an oblong abacus base and rising scroll feet attached to its corners; it is practically identical with number 34 in the Meeks advertisement (fig. 255). (*New-York Historical Society.*)

250

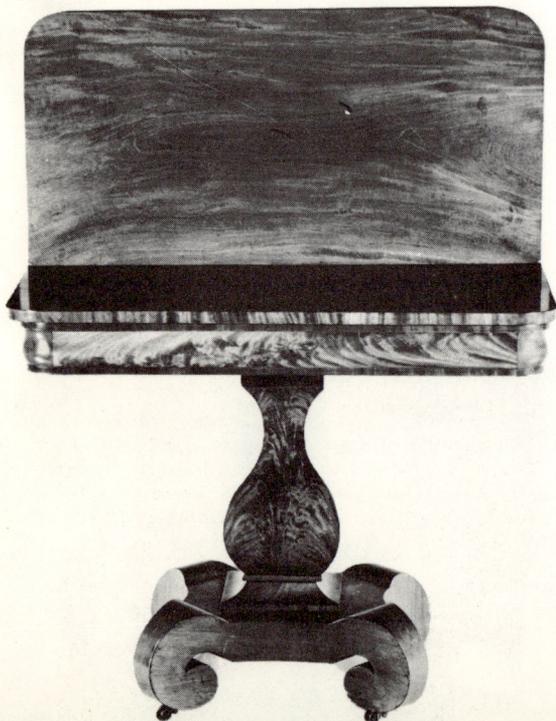

251

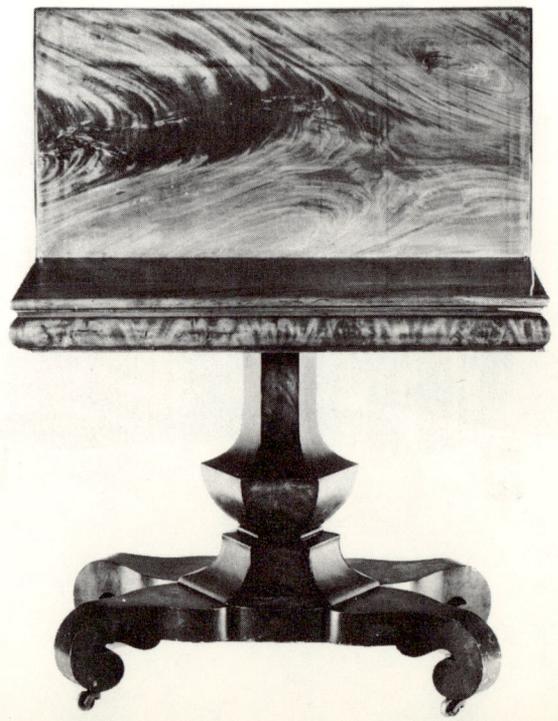

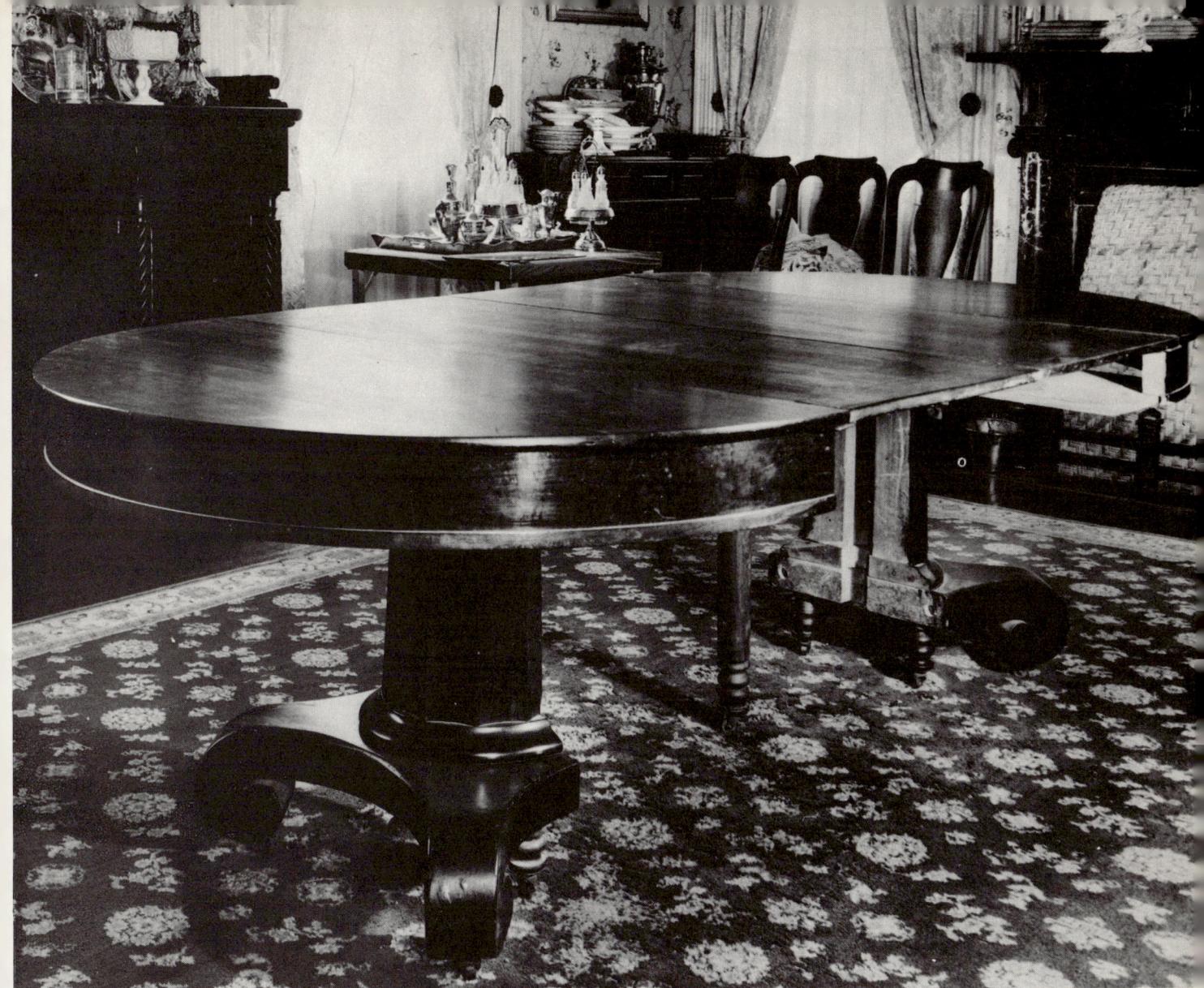

252

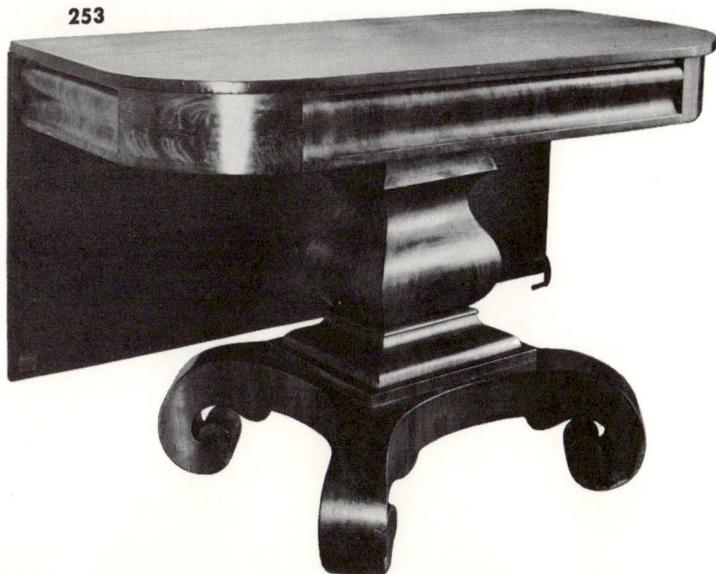

253

252. Extension dining table with rounded ends and frieze. The fluted pillar, with low abacus base on four scrolled feet, divides on four short extra legs with a turned leg in the center. All the legs are on casters. *(Miss Myra Virginia Smith, Devereaux, Natchez.)*

253. This section of a Restauration dining table with a large hinged flap rests on an angular vase pillar and an abacus base with chamfered corners extended to form scroll supports. It is similar to number 21 in the Meeks advertisement (fig. 255). *(Rosalie, Natchez. State Shrine of Mississippi D.A.R.)*

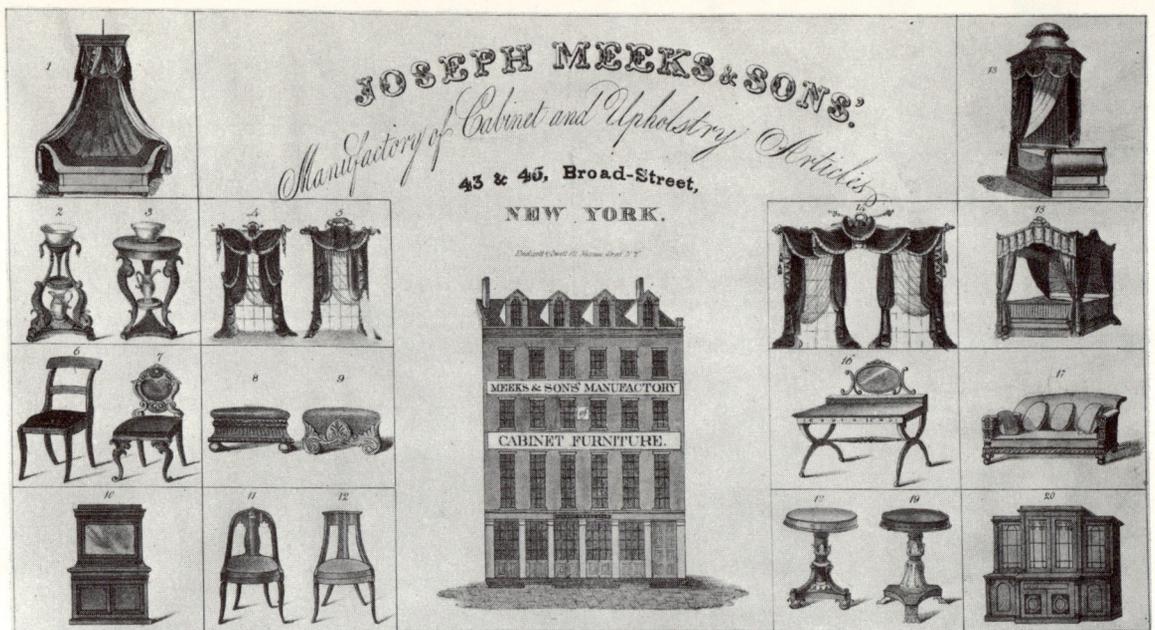

Joseph Meeks and John Hall

In 1833 Joseph Meeks and Sons launched a definite new American style in a handsome colored advertisement. Twenty-two pieces, including all tables, two chairs, sideboards, a *cheval* mirror, two-door wardrobes, and secretaries, show Restauration influence. A few show the influence of George Smith, especially in the vase foot; the others — well-designed and practical — seem to be simple adaptations of Empire types; number 39 is an original version of the Turquoise settee. The advertisement indicates an important, progressive cabinetmaking establishment; their claim to be "one of the oldest and now the largest in the United States" appears to have been justified.

In 1840 the architect John Hall published *The Cabinet-Maker's Assistant* in Baltimore. According to the preface, the book embraced "the most modern style of furniture in an economical arrangement to save labor." The merit of *The Cabinet-Maker's Assistant* lies in its emphasis on construction of extreme simplicity with flat-section scroll supports. Hall's designs, which show strong Restauration influence, were not for the custom trade but were ideal for enterprising manufacturers who intended to use steam-driven machinery for middle-class production.

Among the details and illustrations shown by Hall are nineteen varieties of scroll and block bases running from front to back; his suggestions for pediments include the following: "Take a horizontal scroll of any type, reverse one and unite them." All the pieces illustrated are practical and could be finished in any degree of simplicity or luxury. A minimum of ornament is shown.

It was unfortunate for Hall that his book was published in 1840, the year the new rococo style, with its rich curves and carving, appeared on the American market and immediately became fashionable. There are, nevertheless, many Hall pieces in existence, the name "Hall" being used in reference to style and details of construction taken from his book, as the name "Sheraton" is used to indicate style rather than the name of the maker. Probably the reasons for Hall's success was that his designs of scrolls were all in flat section, with flat sides, whereas rococo scrolls were curved, with irregular bulges and grooves.

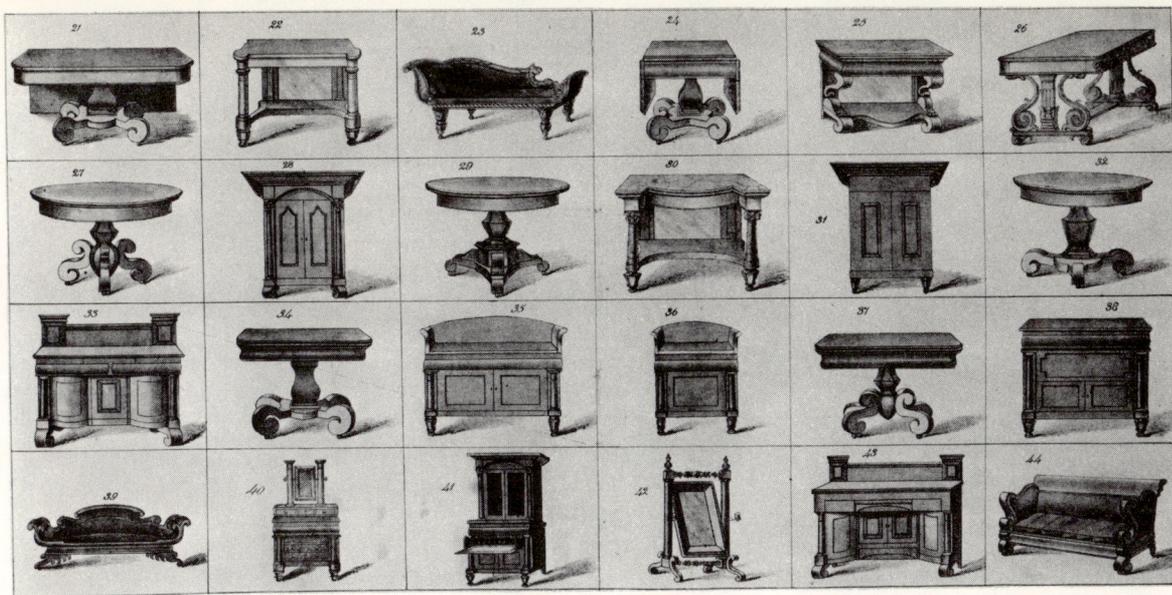

255

The term machine-made is comparative. In 1840 there were many machines, but very few of them were steam-driven. However, in that year, a steam-driven band saw, able to cut out intricate curves from any thickness of wood, was introduced. This was perfectly suited for the manufacture of Hall furniture, with its flat-section supports. It is possible that Hall knew of the machine and compiled his book accordingly.

256

254, 255. Illustrations from the Meeks advertisement. (*Metropolitan Museum of Art.*)

256–60. Typical Hall designs. 256: Chair with plain uprights united with seat rails in a classic curve, and with console front legs, has the level top on the shaped tablet also seen on figure 262. 257: Table with abacus base in the novel form specified by George Smith in his *Cabinet-Makers' and Upholsterers' Guide*, 1826–1828, as "Outline of the Archer's Bow often used as an ornamental finish in its simple form." 258: Version of the French Restauration console with concave stretcher shelf, scroll supports with volutes enlarged at the top, and scroll feet. 259: Wardrobe similar to number 28 in the Meeks advertisement. Instead of columns on the stiles, scrolls are used as arris stops, a detail that became prevalent later. Two-door wardrobes usually had a full-width shelf above "cloak pins." 260: Circular-topped table with hexagonal vase pillar on an oblong abacus base. Chamfered corners of the abacus are not turned under as scroll supports but are set onto the feet, as shown by Hall for all cabinet ware.

259

257

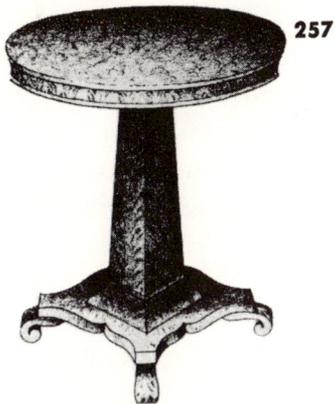

260

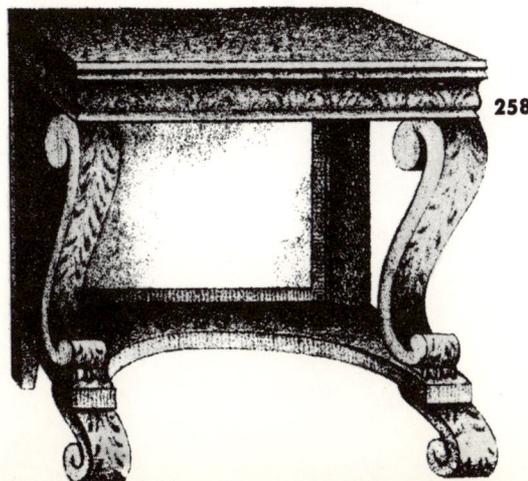

258

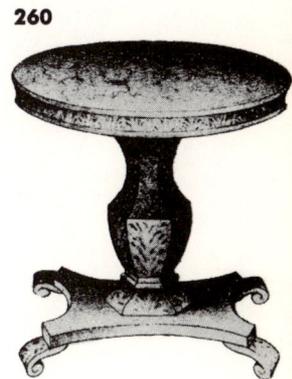

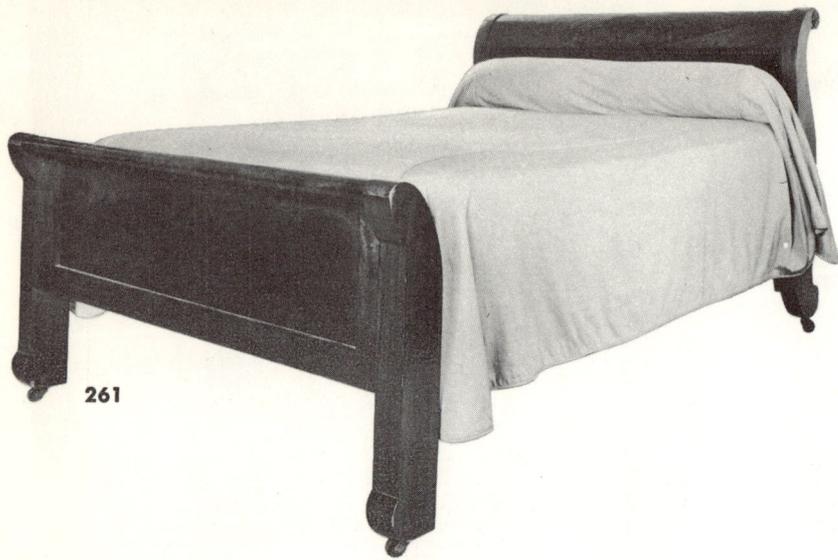

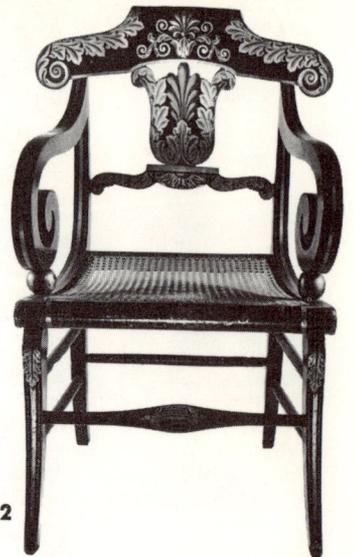

261. Bed with gadroon edging on the panel of the headboard shows Hall's influence in the simplicity of its construction. (*Stanton Hall, Natchez.*)

262. The basic construction of this chair is adapted from figure 146 in Hall's book. The frame is simulated rosewood with gilt ornament. The uprights and seat rails unite in a curve. The front legs are decorated console. The unusual yoke tablet has a level top. The scrolled armrests are a Restauration style. (*Baltimore Museum of Art.*)

263. The table case of a set of musical glasses (or grand harmonicum) which Frances Hopkinson Smith claimed to have patented in 1825 is identical with one of those illustrated by Hall. (*Newark Museum.*)

264. The prolonged influence of Hall's Restauration style is seen in this small melodeon made by Grovesteen and Truslow, who were listed in the New York directory from 1854 to 1856. The rectangular case is set on paired, angular scroll supports. (*Brooklyn Museum.*)

265. Hall included a version of the Voltaire in his *Cabinet-Maker's Assistant*, published in 1840: "Reclining Chair for an Invalid; the position of the back can be varied at pleasure and the projecting part in front can be elongated and adjusted at any angle to the seat." (*Mr. and Mrs. Charles J. Byrne, Cherokee, Natchez.*)

265

266. A Hall-type bureau, formerly the property of President Lincoln, with detached scrolls on the stiles and a cyma-fronted top drawer. The front of the three small drawers recessed on the top is cavetto, as is the rail below the bottom drawer; the cavetto or cove is a feature of American Restauration design. (*Historical Society of Pennsylvania.*)

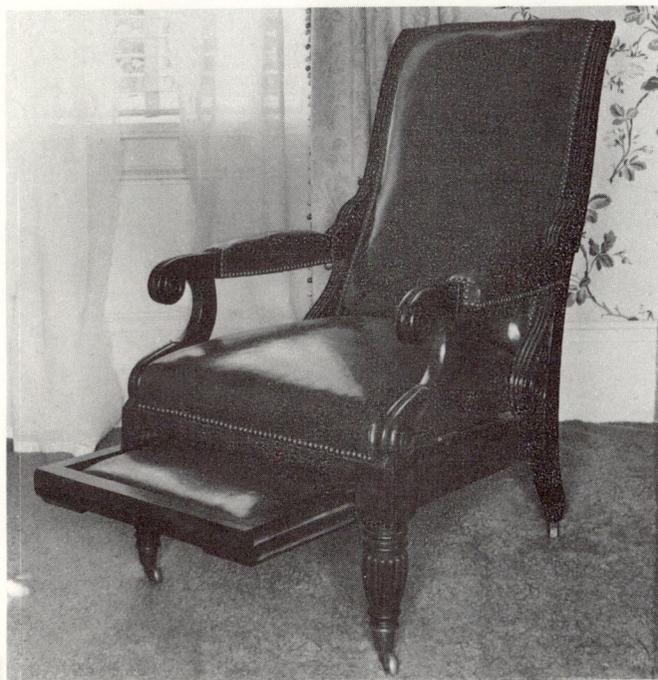

266

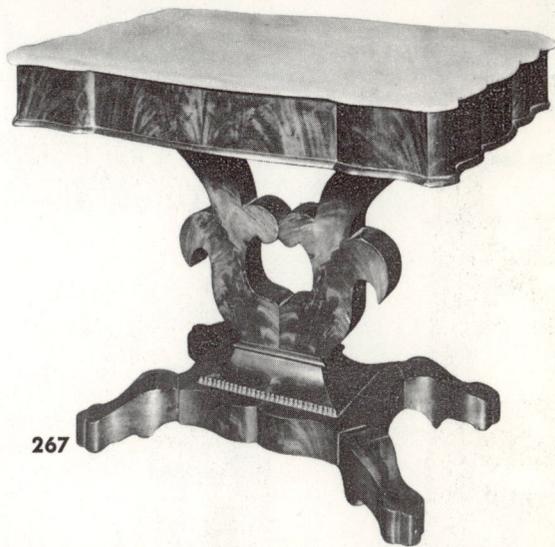

267

267. Center table, with lozenge-shaped marble top and conforming frieze, in the Hall style. The paired, triple-ended scroll support is set on an archer's-bow oblong base over heavy, angular scrolled legs. (*Grand Rapids Public Museum.*)

268

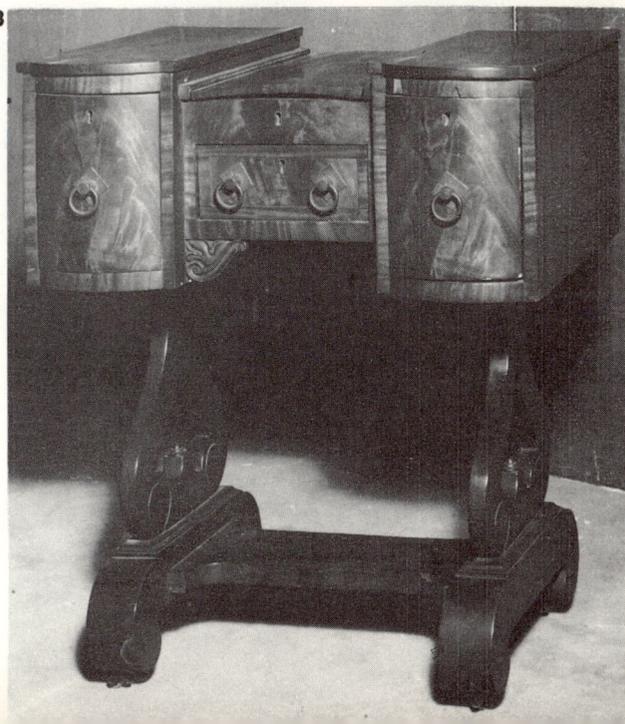

268. Sewing table with paired scrolls is set on the block supports emphasized by Hall as labor saving. A work table illustrated by Hall has shaped and pierced supports on bridges and two convex-fronted drawers. George Smith introduced "wooden bases running from front to back." (*Philadelphia Museum of Art.*)

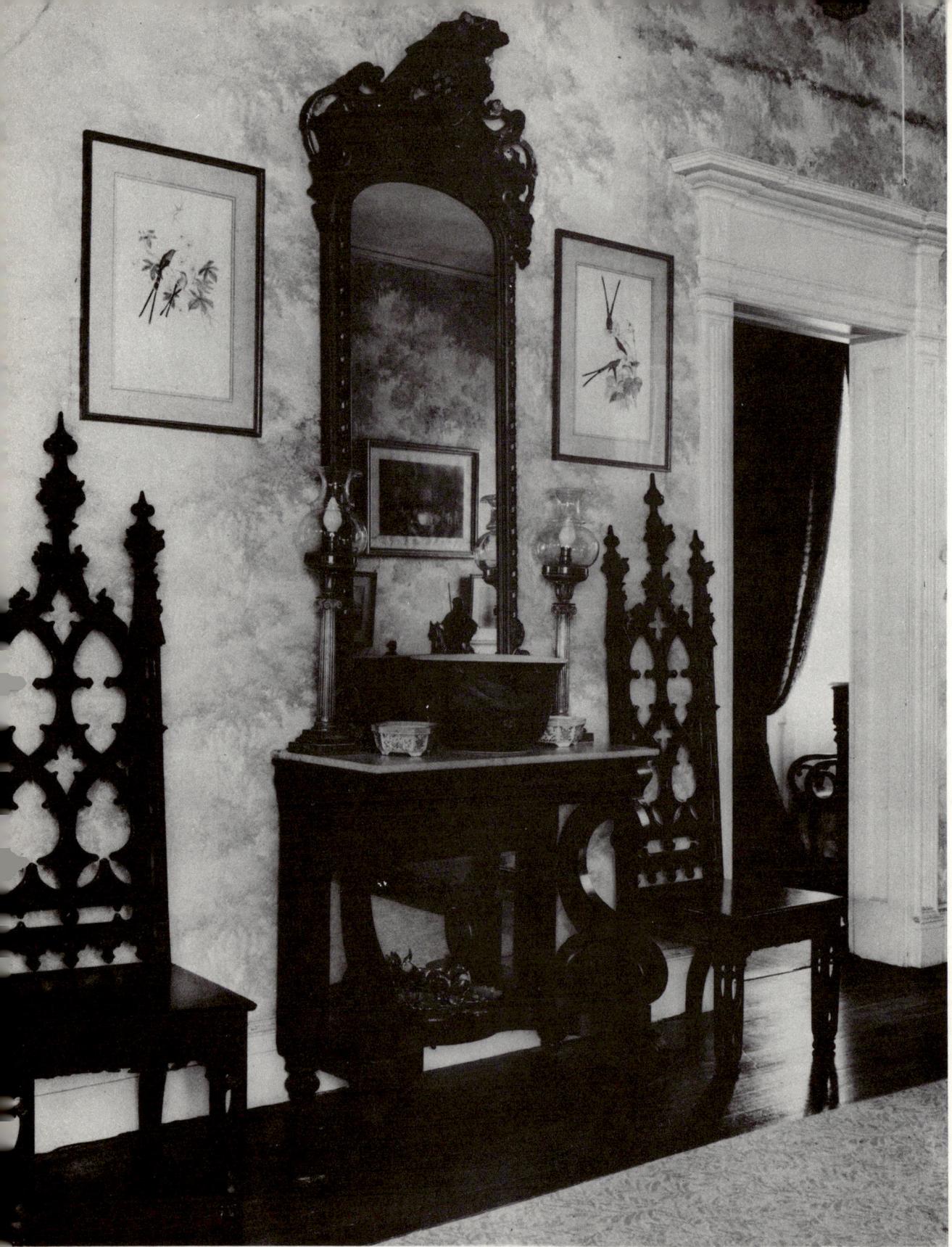

269

269. Restauration console, a replica of figure 85 in Hall's *The Cabinet-Maker's Assistant,* has a marble top, shelf base with two massive scrolls set cant-cornered at the front angles, and a mirror back. It is flanked by two tall Gothic chairs with carved peak backs, square front legs, and square ogee back legs, a style favored on Gothic chairs. The seats have hinged lids over glove compartments. The mirror with carved cresting is in the Renaissance style. (*Estate of Mrs. Hubert Barnum, Monmouth, Natchez.*)

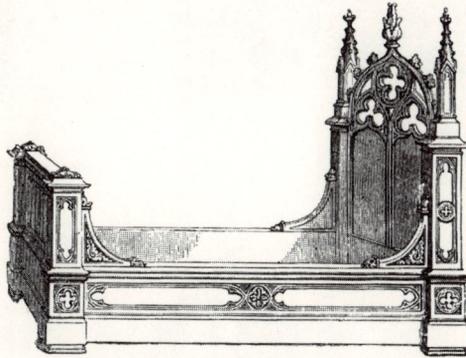

270. Bed from A. J. Downing's *The Architecture of Country Houses* of 1850.

Gothic Furniture

Gothic furniture, introduced in France in 1827, won the approval of the Duchess of Berry and became fashionable.

In America, from the 1830s through the 1850s, Gothic influence was seen chiefly in official, ecclesiastic, and academic buildings. In 1850 Andrew Jackson Downing, in his book *The Architecture of Country Houses,* referred to Gothic in architecture and furniture as an accepted fact; he illustrated two rooms, one of which belonged to J. Rathbone, Esq., near Albany, in which the decoration and basic pieces of furniture are in a restrained Gothic style. A certain amount of this Gothic furniture was made to order. Downing recommended the work of Alexander Roux and George Platt of New York. Gothic pieces of finest design and workmanship are found in some of the Natchez plantation houses. Little of it was featured commercially.

The records of the American Institute from 1829 to 1853 reveal only one Gothic rosewood inlaid table, exhibited in 1850 by W. B. and H. W. Douglass of Newark. At the New York Crystal Palace in 1853 there were a Gothic bookcase by Bulkley and Herter of 92 Mercer Street and a Gothic sideboard in oak by Ira Campbell, 37 Mercer Street, New York.

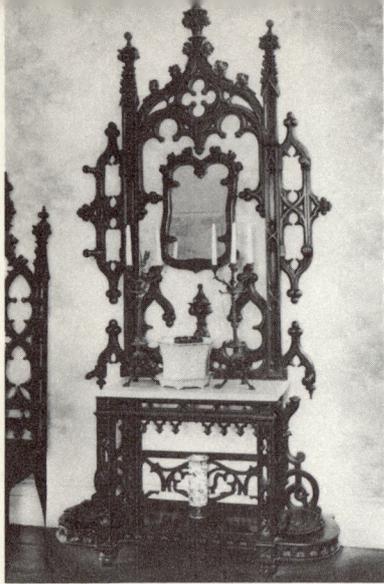

271

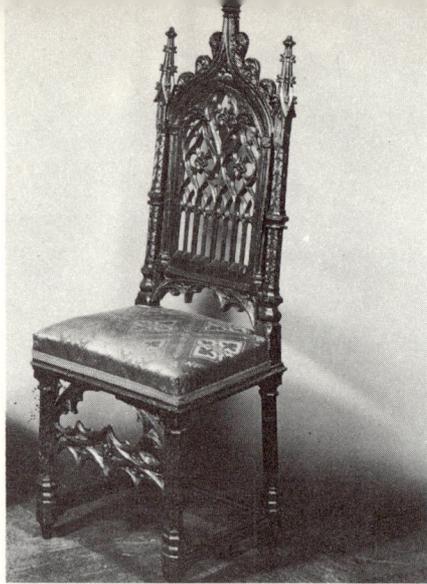

272

271. The frame of a Gothic hall stand has a peaked cresting of quatrefoil, crockets, and pinnacles. A small mirror and brackets with pegs are attached to the frame, which has a marble shelf and cast-iron drip pans. (*Estate of Mrs. Hubert Barnum, Monmouth, Natchez.*)

272. Gothic oak chair of the Louis Philippe period with upholstered seat. (*Musée des Arts Décoratifs.*)

273. The back of a mahogany Gothic chair is carved with milk thistle and has a studded finial in the form of a milk thistle bud. The chair was made by Daniel and Hitchins, Troy, New York. (*Brooklyn Museum.*)

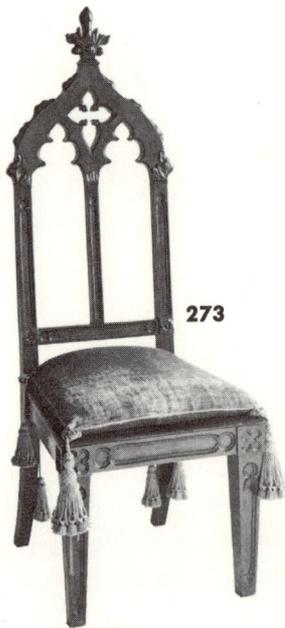

273

274, 275. An American Restauration chair and its French prototype have a Gothic arcaded back, trefoil ornament, and console front legs. Chairs identical to the American type are shown in a painting by Francis B. Carpenter of President Lincoln with his Cabinet on the occasion of the first reading of the Emancipation Proclamation. Marta Sironen, in *A History of American Furniture,* states that President Andrew Jackson commissioned Antoine G. Quervelle to make furniture for the White House. Perhaps these unusual chairs were among furniture delivered by him during President Jackson's term of office, 1829–1837. (274: *Brooklyn Museum.* 275: *Musée des Arts Décoratifs.*)

275

274

276. Study of the Milligan House, Saratoga. Gothic-head panels are used in the upper and lower sections of the secretary bookcase. A corner cupboard has Gothic-head mirror panels in the door and a graduated *étagère* with carved and pierced supports and finials. Panels of the plain pedestal desk are carved with trophies. (*Brooklyn Museum.*)

THE ROCOCO PERIOD

In France, Louis Philippe's reintroduction of the *rocaille* style of his great ancestor the Duke of Orleans, regent during the long minority of Louis XV, terminated the classic period. As elsewhere, a substantial bourgeois class had developed, and furniture departments were introduced in Paris stores to cater to their requirements. Belschmidt of the Place Royale was the leading store in the French capital. New machinery had now brought about a drastic change in production. Furniture was of more robust construction, and the use of mahogany veneer, lacquer polish, and such modern items as bookcases, wardrobes, hall furniture, and washstands produced furniture very different from the handmade prototype. Derived from the *rocaille*, the rococo style emerged as one of the main furniture trends of the nineteenth century.

In America industry as a whole was rapidly expanding and furniture-making was no exception. In 1837 an issue of the *Journal of the American Institute* reported: "A competent person should be employed to visit the principal manufactories in Europe, his time to be devoted in learning the progress of improvements and in communicating with the American Institute, transmitting drawings, models, machinery and all useful discoveries for the benefit of our citizens."

Yet 1837 hardly seemed the time for innovations. In that year the crisis caused by President Jackson's disastrous financial policy became acute. In New York, George Templeton Strong wrote in his diary: "The whole city going to the devil from a pecuniary point of view."

After the beginning of the new decade, however, the country resumed its interrupted upsurge with immense resilience. In short time the French Antique, later known as the rococo, was formulated. Its development coincided with the beginning of American machine-made furniture, which developed primarily in Cincinnati and Grand Rapids. Thomas Blanchard's profile lathe and the band saw, introduced in 1840, made light work of the intricate, asymmetrical scrolls, curves, and carving. In 1848 the Cincinnati Chamber of Commerce reported that "every description of furniture, almost from the common bedstead to the most costly articles were made in some of their extensive steam establishments." The great reduction in the price of furniture, due to mass production, attracted a large trade, particularly from the West and from the South. Mahogany, rosewood, and occasionally satinwood were used, and a new wood for furniture—black walnut, which was oiled, not highly polished.

In 1845, during his second visit to the United States of America, Sir Charles Lyell wrote that

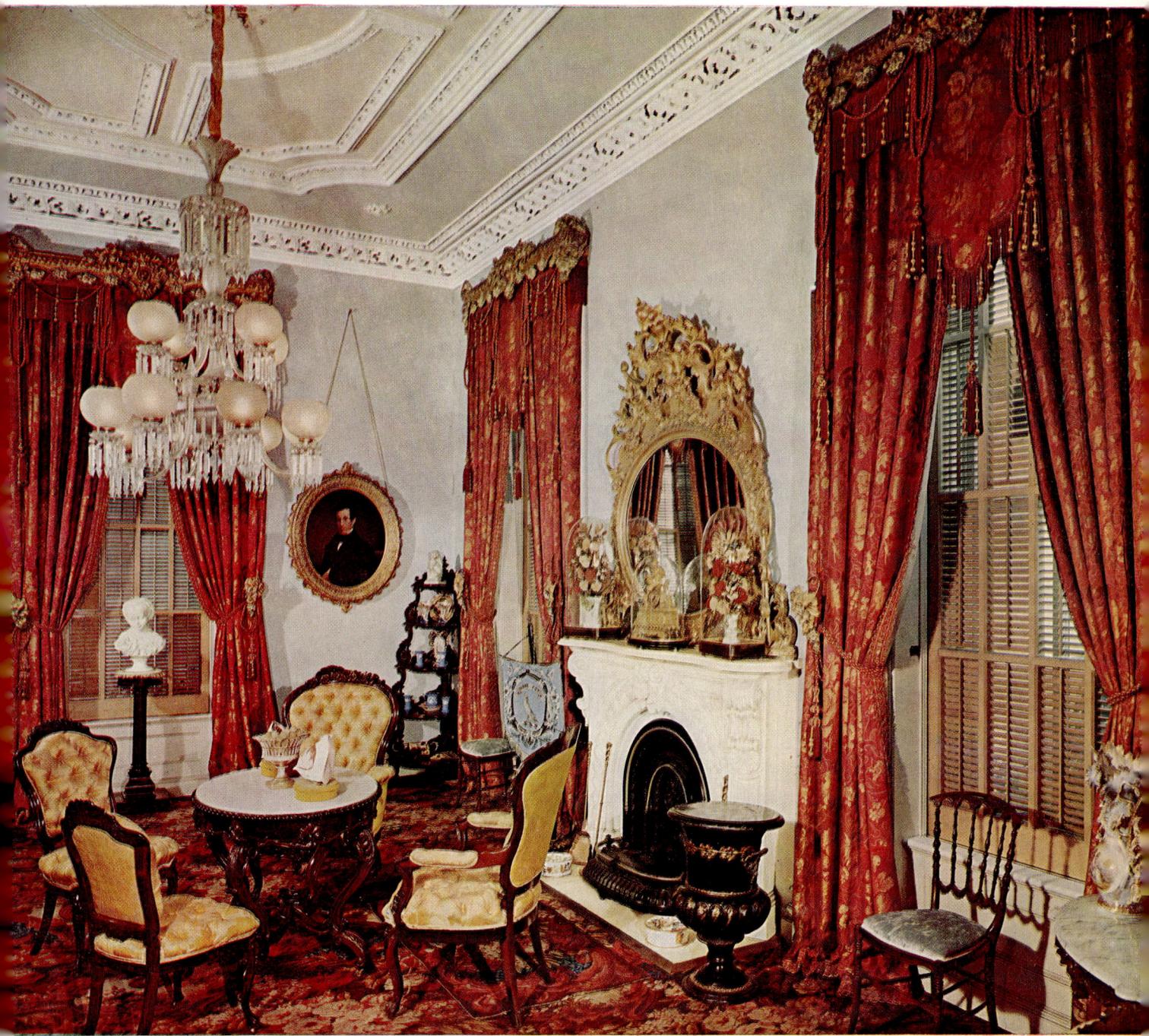

PLATE II. Parlor from the Robert Milligan house in Saratoga Springs, and now in the Brooklyn Museum. All the furniture was made in 1853 by Elijah Galusha of Troy, New York. The seat furniture is late rococo, with shield-shaped backs; the base of the marble-topped table is richly carved; the *étagère* has the customary five shelves. The handsome mantel mirror, oval with a level base, was made in 1856 by James Burton and Co., Albany. The luster gasolier, with opaque gas globes, is a rare type. (*Brooklyn Museum.*)

he saw many houses gorgeously fitted up with satin and velvet draperies, rich Axminster carpets, marble and inlaid tables, and large looking glasses, the style in general being Parisian rather than English. Sir Charles had heard it said in France that no orders sent to Lyons for the furnishing of private mansions were on so grand a scale as some of those received from New York.

John Henry Belter, established in New York in 1844, was outstanding among the makers of luxury furniture in the rococo or French Antique style. In 1856 he applied for a patent for his process of laminating thin sheets of wood, generally rosewood, and molding them by heat into the desired shape. He finished his furniture with lavish carving, beautifully designed and executed. Belter remained active until his death in 1863.

The importance of another cabinetmaker, Charles A. Baudouine, listed in New York directories from 1837, has been generally recognized since the 1960 publication by Marvin P. Schwartz of the Brooklyn Museum of a short account taken from the journal of Ernest Hagen, a journeyman cabinetmaker, in the Winterthur library, and of a full, illustrated transcript, with notes by Elizabeth A. Ingerman, in *Antiques*, November 1963. Hagen, who worked for Baudouine from 1853 until he closed down in 1856, had a happy facility for recording contemporary details. He noted that Baudouine was "at this time the leading cabinet maker of New York." Hagen also wrote that nearly two hundred employees worked for Baudouine and that he went to France every year. "Some of Baudouines most conspicuous productions were those rosewood heavy over decorated parlour suits with round perforated backs generally known as 'Belter Furniture.' . . . Baudouine infringed on Belter's patent by making the backs with a center joint. . . . He use to get 1200 a sett. . . . He also made large side tables and center tables to match with marble tops . . . very large etageres . . . and any amount of gorgeous heavy carvings."

With such an establishment Baudouine's production must have been considerable, yet at present only a pair of card tables at Fountain Elms seems to have been definitely identified. Doubtless because of similarities in construction and finish, much of Baudouine's work has been attributed to Belter. There exists, however, a group of very ornate seating furniture with complicated carving of strange stylized cornucopias and vegetable ornament in a flowing and uninterrupted line quite different from Belter's neatly banded sections. These pieces must have been made for large and elegant interiors. It is possible, in view of his reputation and background, to identify the maker, at least tentatively, as Charles A. Baudouine. The furniture is beautiful and interesting, with certain features common to all of it. The "center joint" mentioned by Hagen is on the backs of three items.

On his retirement in 1856, Baudouine invested in real estate, and from 1876 he lived comfortably at 718 Fifth Avenue, where he stabled the horses for his coach-and-four. In his will he allotted an annual income of sixteen thousand dollars to his wife, and to his daughter's son, whose name had been changed in the Court of Common Pleas from Martine to Charles A. Baudouine, Jr., he left "all my diamonds."

In the South, the cabinetmakers of New Orleans followed the French furniture prototypes closely. The two main exponents were Frenchmen — François Seignouret, who worked until 1853, and Prudent Mallard, who died 1879. Rosewood and marble were much used in their fur-

277. (OVERLEAF) Double drawing room of a house in Saint Louis, Missouri. The frames of the large mirrors are finished in gold leaf and match the design of the window cornices. The chairs and settees are framed in rosewood. (*Campbell House Foundation.*)

niture. Seignouret, forty-one years older than Mallard, produced pieces in Empire, Restauration, and rococo styles, while Mallard favored rococo and Renaissance. H. N. Siebrecht, who is also mentioned as working in this period, is recorded in *Cohen's New Orleans and Lafayette Directory, 1851/3/4/7 and 8* — "H. N. Siebrecht, Upholsterer, 41 Royal Street, d. C. Marais and Common." In *Gardner's New Orleans Directory* for 1861 he is listed as "H. N. Siebrecht, Upholsterer and Furniture, 11 Chartres Street, d. 2 res. 301 Common Cor. Marais Sts."

278. Superb laminated rosewood bed with the label of John Belter. (*Brooklyn Museum.*)

Bedroom Furniture

The main bed of this period was the sleigh bed, which was produced in many variants. In some examples the rounded corners of the Louis XV type were used. The Louis Philippe type had head- and footboards scrolled at the top, with cyma cheeks broadened at the base, a deep frame on which a square of matching width was reserved, and low flange feet. This treatment of the ends was well designed and effective.

Many of the magnificent plantation beds had carved cornices and headboards. Hagen in his journal wrote of Henry Weil, c. 1845–1853, that he "made those ugly heavy veneered 8 cornered

high post bedsteads of which you find so many down South, also large mahogany wardrobes, dressing bureaus, and other large case work." And later "Finally to New Orleans in 1857, where I worked for Sampson & Keene on Bienville near Royal Street, a furniture store who mostly got their supply from Henry Weil in New York." A new type, with a half-tester, was introduced by Prudent Mallard. Metal bedsteads began to be used at this time. In 1844 William Hawkins of New York exhibited a brass bedstead at the American Institute Fair. And in 1848 four iron bedsteads as well as a brass bedstead were shown by individual makers; in addition two spring mattresses were displayed by W. L. Branch and W. Brown of New York. The first spring bed was patented by John Putnam in 1848–1849. In *Williams' Directory* of 1849–1850 E. Rowe of Cincinnati advertised that he manufactured "bedsteads, patent and common, including trundles, $2–$20 Wholesale."

In spite of all innovations and improvements, the dressing bureau — a chest of drawers with a mirror attached — was used far more than any other type. In 1845 Joseph Walter, a freed Negro from Pennsylvania, announced in the *Western General Advertiser:* "Bureaus; Dealers in furniture and others are informed that I am manufacturing extensively Plain, Scroll and Dressing Bureaus, which I will sell at wholesale at the lowest living profit." In 1849 John Geyer of Cincinnati advertised "Fancy Dressing Bureaus."

The typical luxurious rococo dressing table had four heavy cabriole legs, one full-width drawer in the carved frieze, and a mirror in a richly carved frame. Washstands were made on the same general lines. Two- and three-door wardrobes were of more functional design, yet finely carved.

In Thomas Webster's *Encyclopaedia of Domestic Economy*, 1845, it was stated: "Wardrobes are far more convenient for keeping apparel than the chests of drawers formerly in use. In wardrobes the dresses are hung up or laid on shelves which draw out." A winged wardrobe, elegant in mahogany, had "an apparatus something like a crossbow, sliding on a rod."

As late as 1848, wardrobes were not widely used. In that year the Cincinnati Chamber of Commerce reported that seven steam-powered establishments produced annually: 4250 bedsteads, 7500 bureaus, 4500 washstands, 14,500 dozen chairs, 1560 sofas, 3500 card tables, but only 200 wardrobes.

John S. John of Cincinnati, a noted maker of fine and fashionable furniture, produced dressing bureaus, canopy bedsteads, and mahogany wardrobes, and in 1849 M. L. Duncan of Cincinnati advertised "Mahogany and Black Walnut Wardrobes."

Mirror panels on armoire doors, which were introduced in Louis Philippe's French rococo style, were adopted in the American French Antique style.

279. Sleigh bed, formerly owned by G. William Nott of New Orleans, with high paneled headboard and square posts with vase finials. (*Louisiana State Museum.*)

280. The half-tester of a rosewood bed has a serpentine cornice and colonnettes with finials at the front angles. The tapering octagonal headposts are finished at the top with carved, pierced brackets. Carved ornament is applied on the head-, side- and footboards. (*Mr. and Mrs. Hyde Dunbar Jenkins, Hawthorne, Natchez.*)

281. Rosewood night table with applied lemonwood ornament, one of a pair included in a suite of bedroom furniture made by Prudent Mallard for the bedroom of Isabel Puig in her house at 624 Royal Street, New Orleans. (*Louisiana State Museum.*)

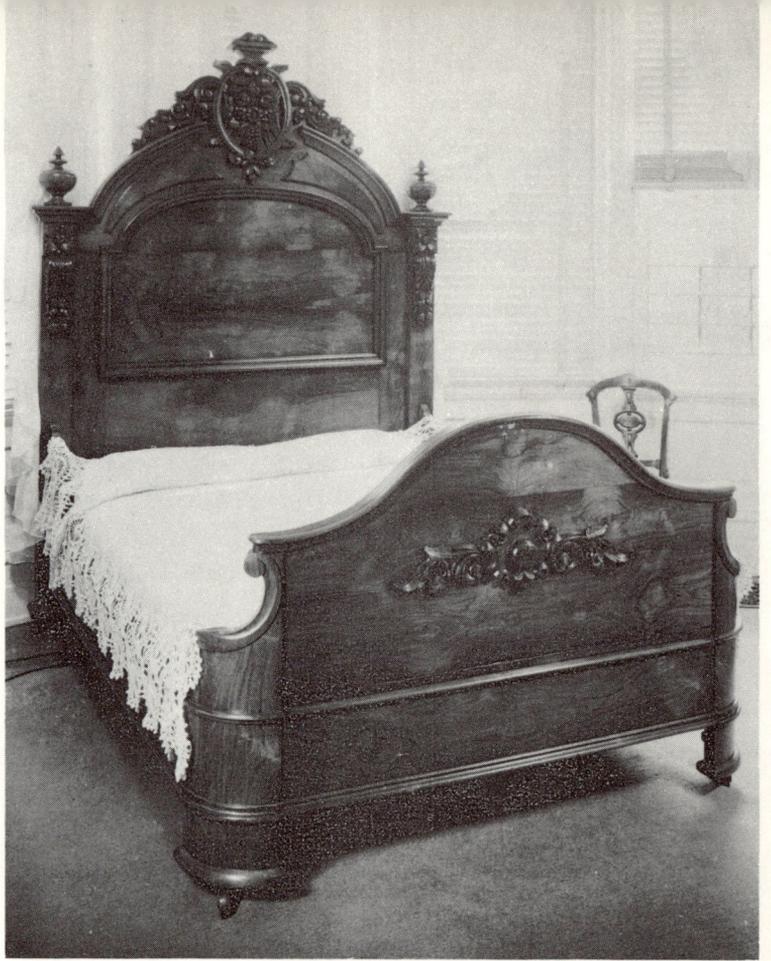

279

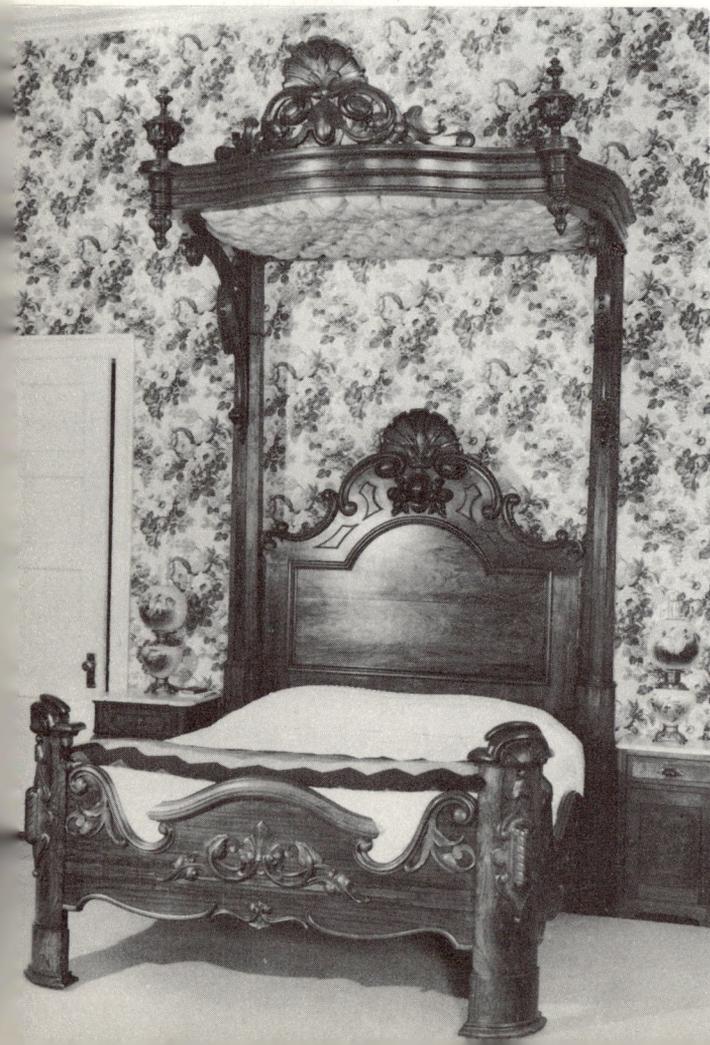

280

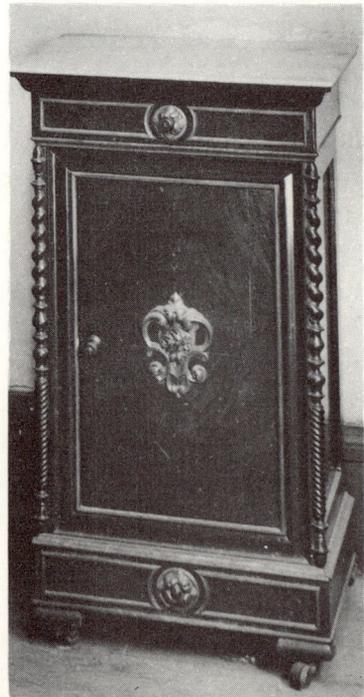

281

282. Rosewood sleigh bed made by Prudent Mallard for Felix Puig of New Orleans, with a half-tester added on posts attached to the side of the headboard. The shaped head- and footboards and side rails are embellished with applied ornament. The novel marble-topped washstand has a hinged shaving mirror set in the trellis *étagère* back. (*Louisiana State Museum.*)

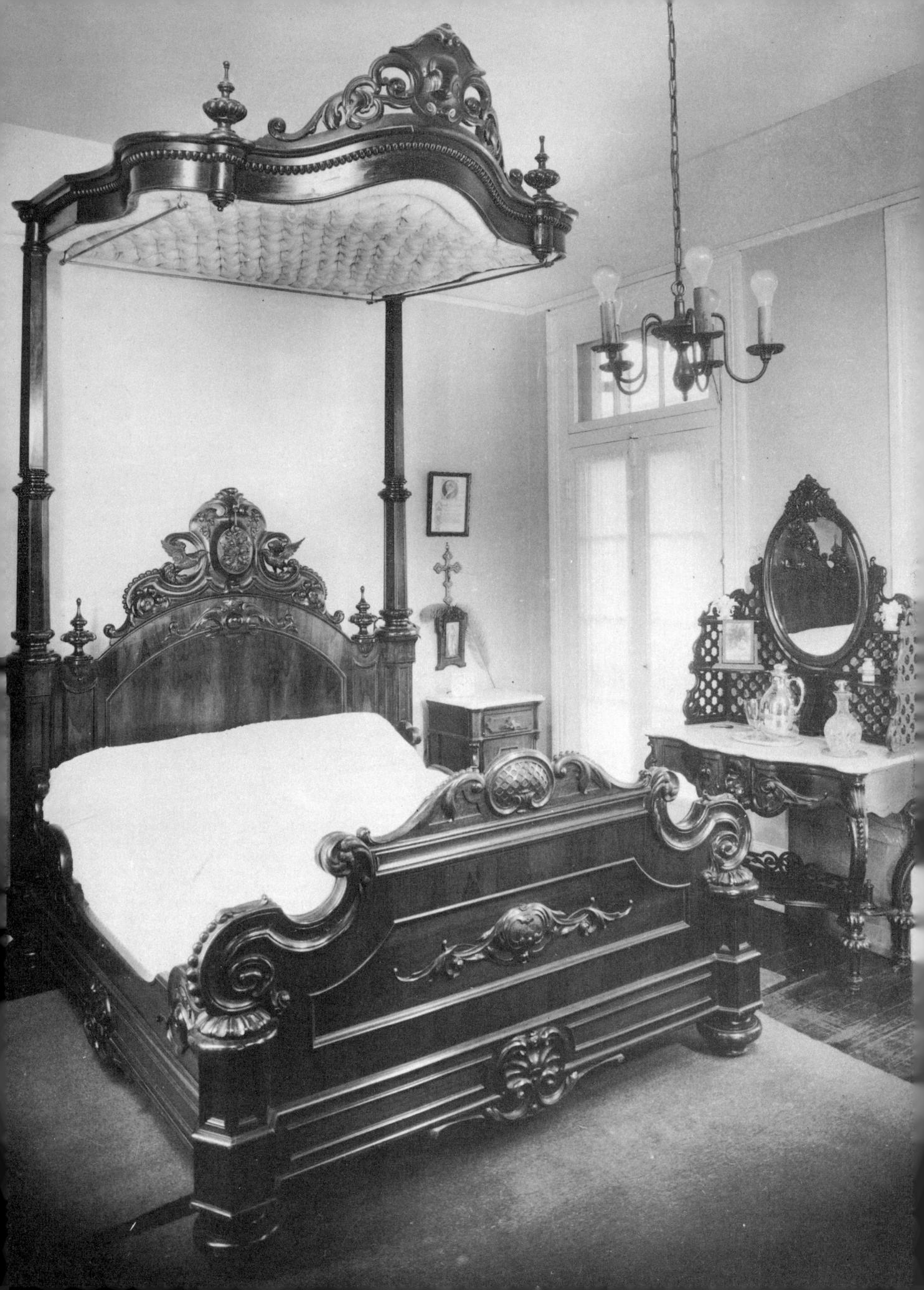

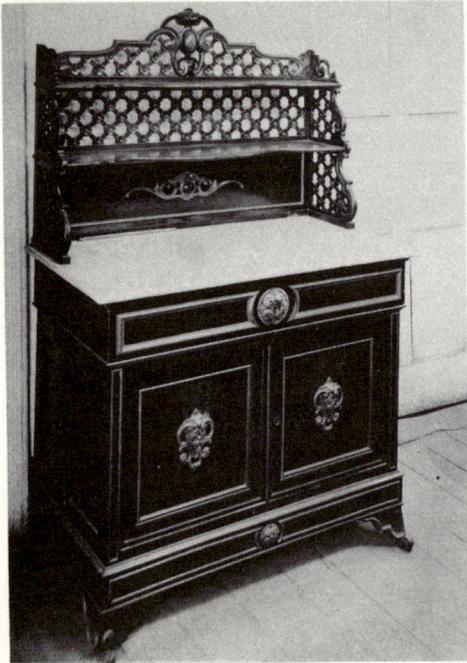

283

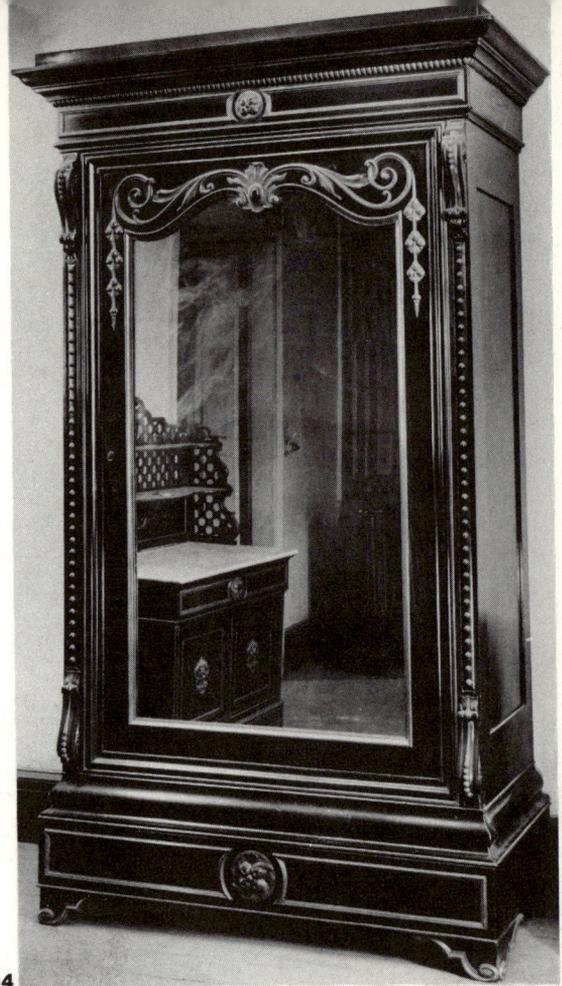

284

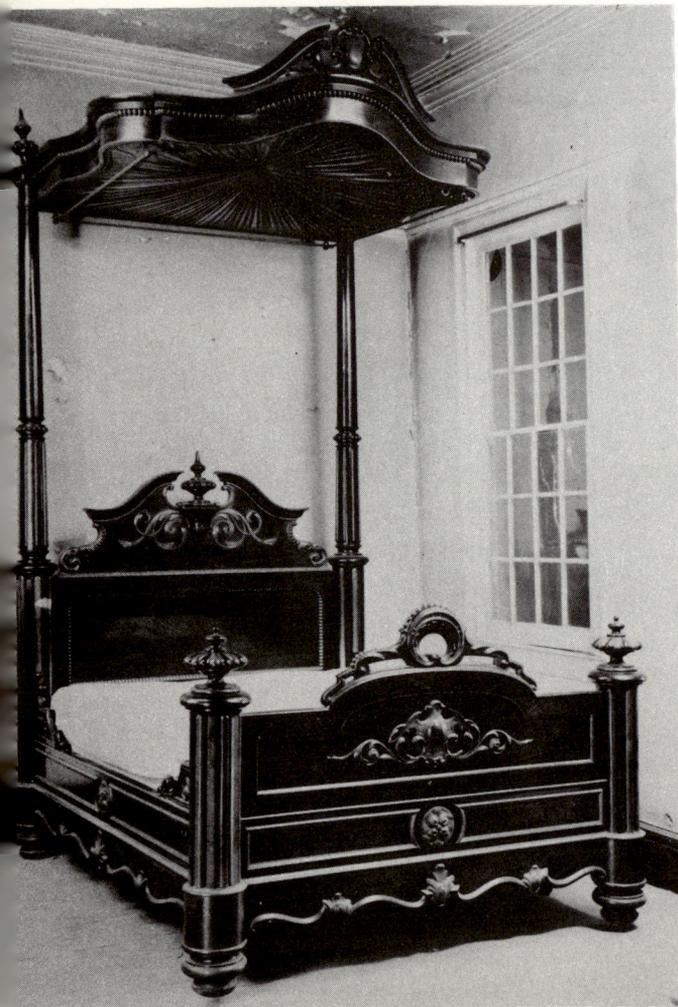

285

283–286. Prudent Mallard, French-trained cabinetmaker, was established in New Orleans in 1838 and quickly became famous, especially for his bedroom furniture. He generally used rosewood, the larger pieces being in solid wood, usually with applied carving.

This set of rococo-style bedroom furniture, made for the bedroom of Isabel Puig in the house at 624 Royal Street, New Orleans, is outstanding in quality and design. The outlines, moldings, carved applied ornament, beading, flutes, ribs, and spaced studs were made of lemonwood, which, mellowed to a soft tan, is extremely effective on the rosewood. The shaped half-tester of the bed is fitted with Mallard's special frame for the mosquito curtain. The Duchesse dressing table (286) has a gray and white marble top with one drawer in the frieze and marble-topped cases flanking the oval mirror.

The washstand (283) has a base with a drawer and two-door cupboard. The *étagère* back (above the level of the lower shelf) and the sides are fine trellis, with a dogwood patera on each cross, the cresting outlined in lemonwood. The wardrobe (284) and the night table in figure 281, each one of a pair, serve to show the basic functionalism of Mallard's construction. The applied paneling shows Renaissance influence. (*Louisiana State Museum.*)

287. Wardrobe in the bedroom of Felix Puig is plain with good detail; the cresting is formed of scrolls with a medallion and birds. The chair reflected in the mirror is a type much used, with and without framing to the back and arms. (*Louisiana State Museum.*)

288. Rosewood wardrobe is surmounted by a broken-rounded pediment, with acroteria on the corners, pierced carving on the sides, and a foliage plume rising from a square bowl in the center. (*Mr. and Mrs. Hyde Dunbar Jenkins, Hawthorne, Natchez.*)

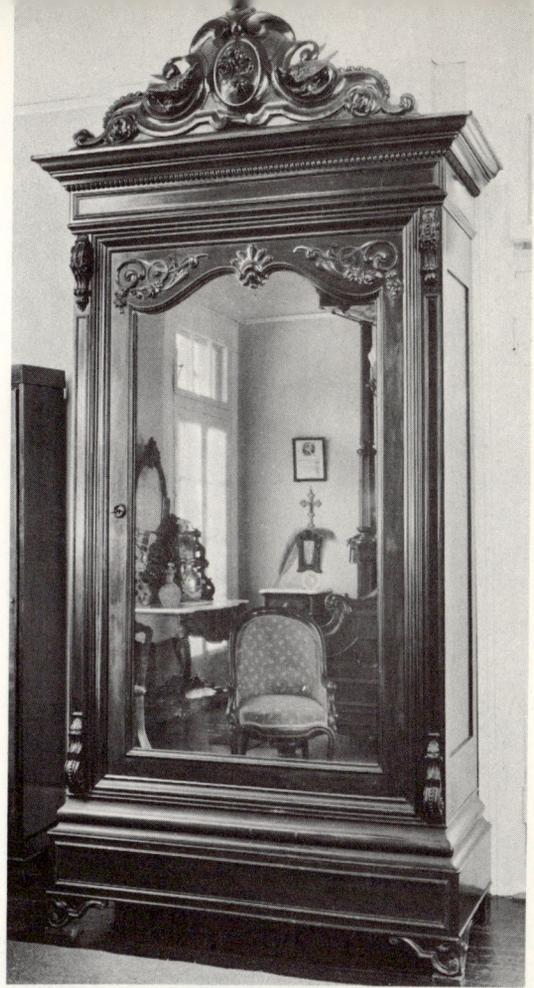

287

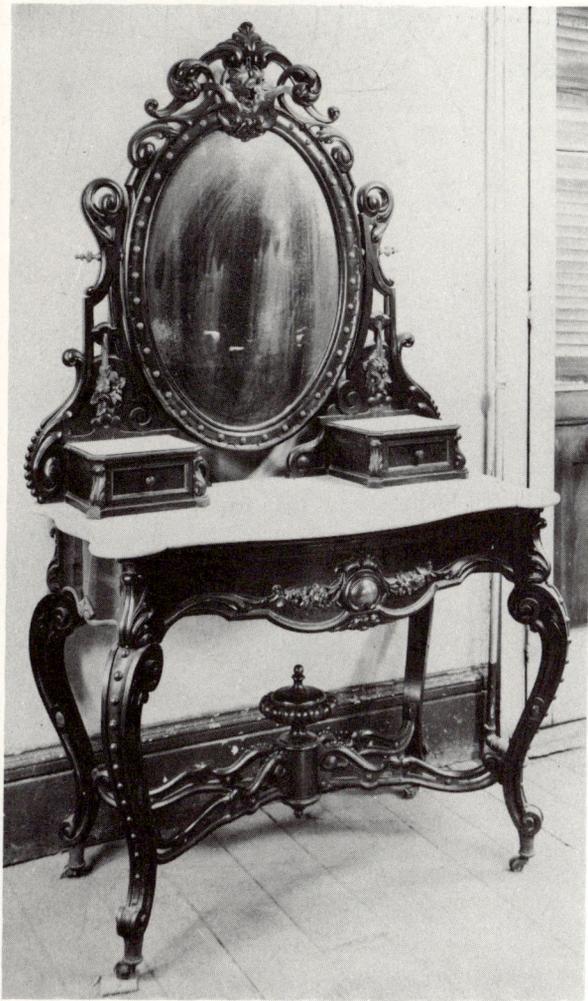

286

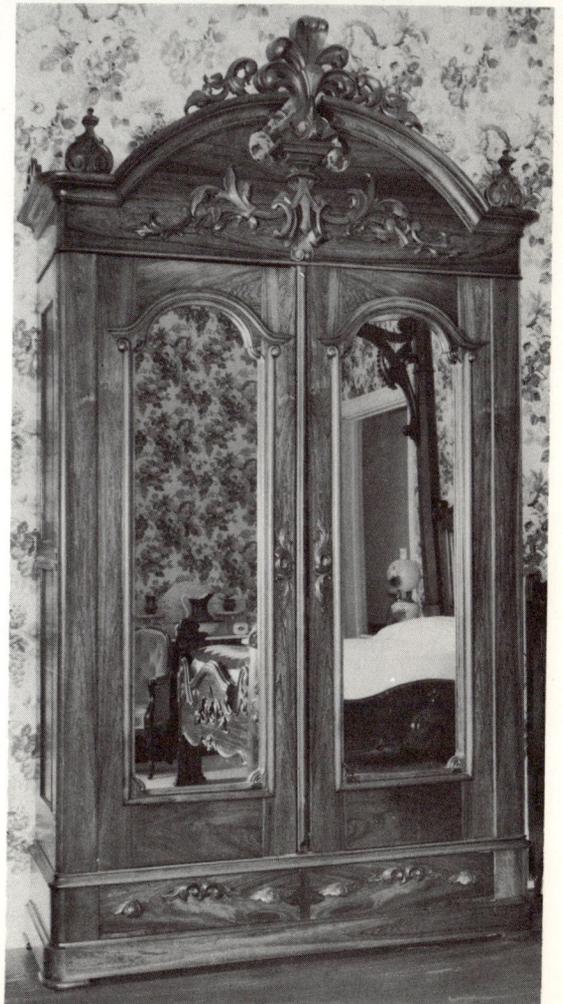

288

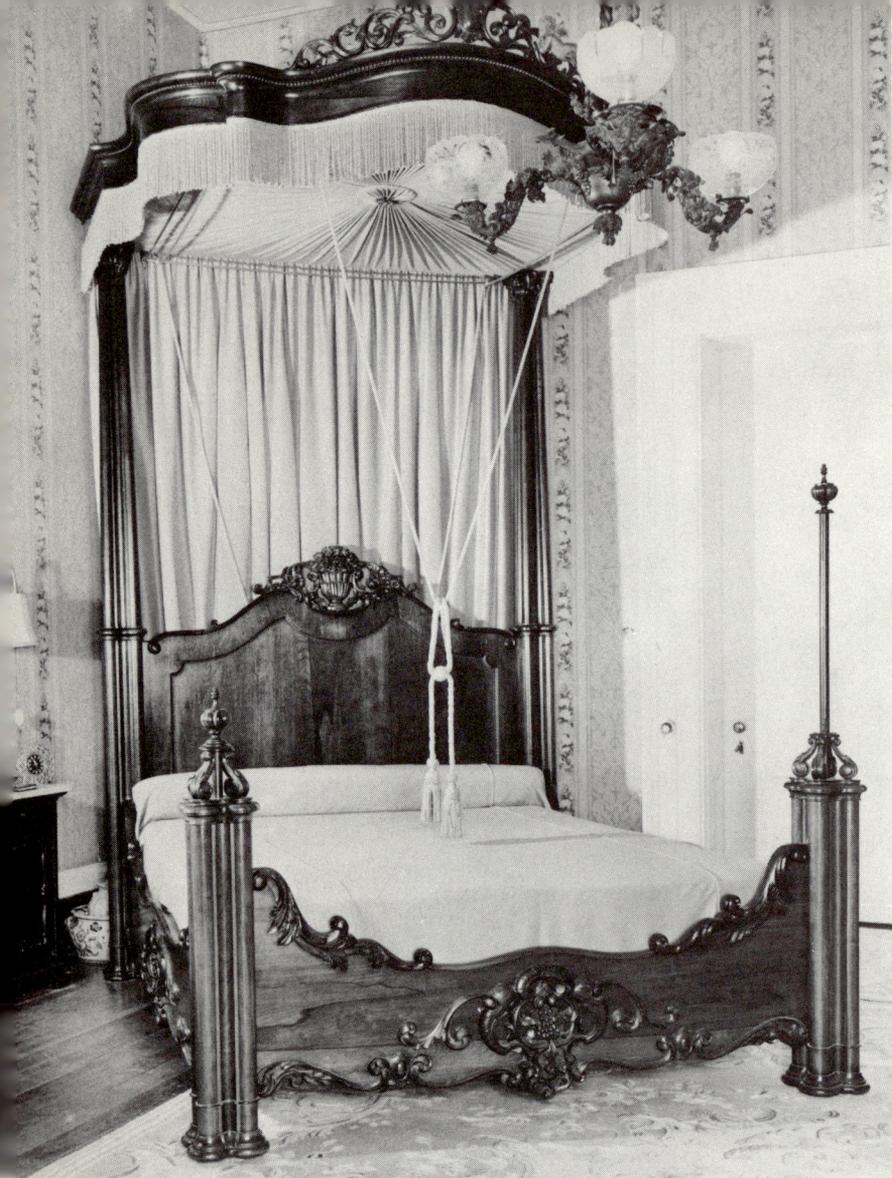

289

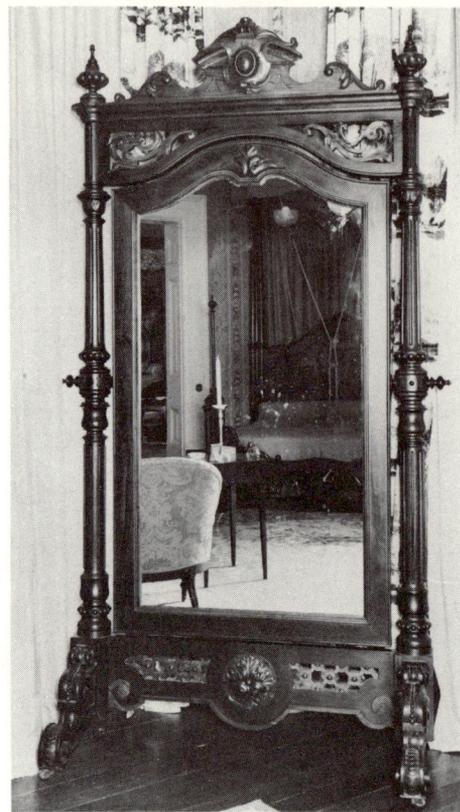

290

291

289–292. A magnificent suite of rosewood bedroom furniture was created by Prudent Mallard for Lansdowne. On the bed, called the Victoria by Mallard, the half-tester is fitted with a wire frame and cords to hold the mosquito curtain over posts at the foot; this arrangement replaces the four heavy posts previously indispensable. The Victoria was widely copied. The gasolier, probably French, was made of bronze because it was feared that gas would oxidize gilt metal. (*Mrs. Singleton Gardner, Lansdowne, Natchez.*)

The *cheval* mirror (290) has a shaped base. The roundel between two trellis panels is typical of Mallard.

The rosewood dressing table (291) has a base in the Louis XIV manner and an oval mirror with carved ornament at the top and base.

The wardrobe (292) is unusually large and commodious, with three cupboards and a full-width drawer in the base, inlaid with fine marquetry.

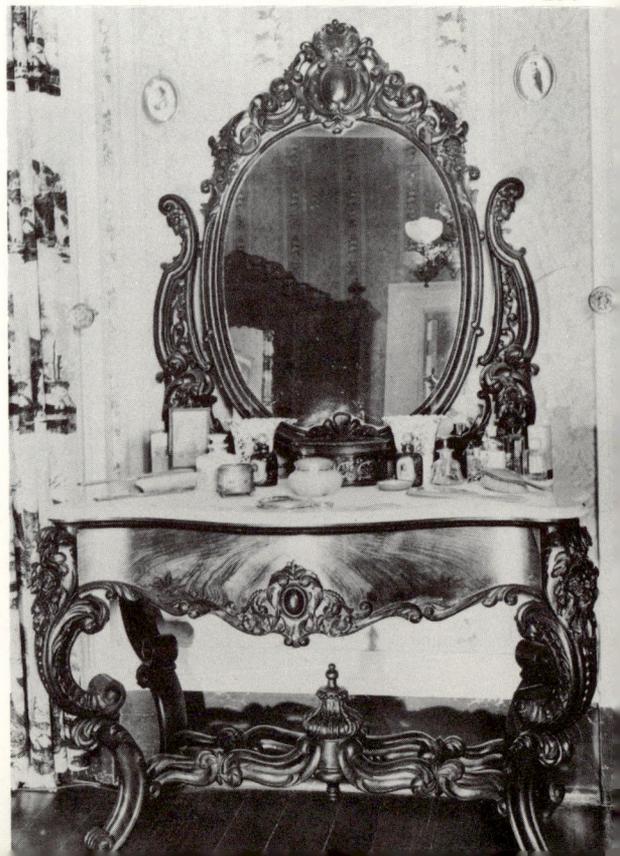

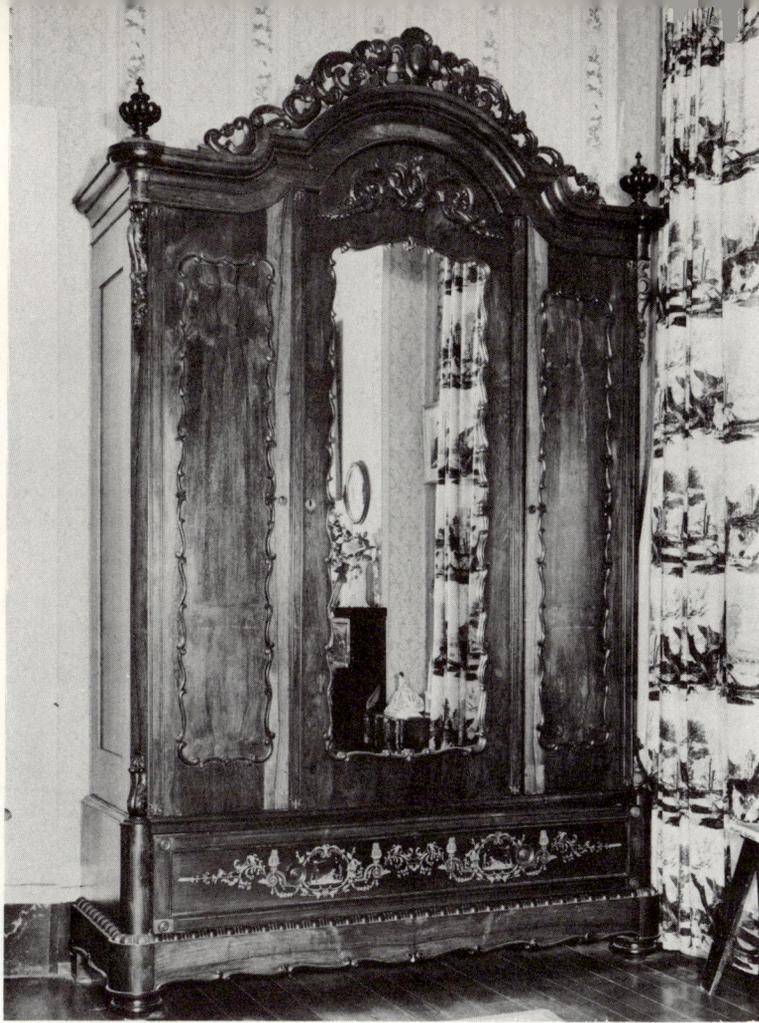

292

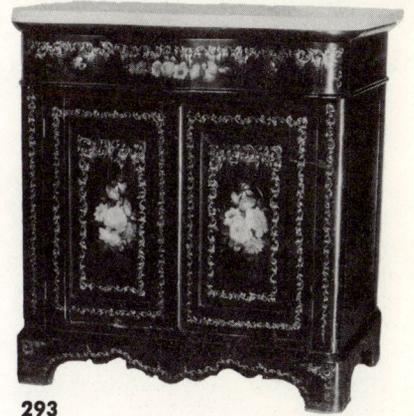

293

294

293–295. Dressing bureau, washstand, and night table
with white marble tops made by Hart, Ware and Co.,
280 Chestnut Street, Philadelphia. All are decorated with
flowers painted on a black ground, framed in gilt scrolled
ornament, a feature of the Louis Philippe style.

An enameled and richly ornamented cottage bedstead
exhibited in 1853 at the New York Crystal Palace by
Hart, Ware and Co. of Philadelphia, may have been in
the style of these three pieces. (*Philadelphia Museum of
Art.*)

295

296

296. Simple, functional cabinet by Prudent Mallard with ornamented corners and one transverse astragal in the glazed doors. A shaped apron unites with cylindrical feet beneath the low, projecting two-drawer base. (*Mr. S. B. Laub, The Burn, Natchez.*)

297. Curves, scrolls, and flowers form the main stem of a cast-iron hatstand and frame a small oval mirror. Foliate scrolls embellish the drip pan in the base. (*Sleepy Hollow Restorations.*)

298. Large rosewood mirror *étagère* with a marble-topped base. *Étagère* sections flank a triple arched center of the mirror back (*Rosalie, Natchez. State Shrine of Mississippi D.A.R.*)

297

298

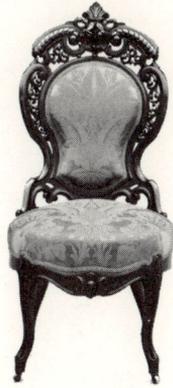

299. Rosewood side chair attributed to John Belter. (*Metropolitan Museum of Art.*)

Chairs

Chair styles changed rapidly under the impact of the rococo fashion. *Chaise, fauteuil* and *bergère* were adopted for parlor chairs, all with padded back panels.

John Henry Belter produced chairs that were a marvel of elegance and comfort. They had curved backs and large rounded seats. The backs, finished with wooden facings, were carved and pierced and were made both with and without a central upholstered medallion. Ornament on seat rails was limited to slight carving, frequently an escutcheon, on the center front and the groove where front cabriole legs were united with the rail.

In dining chairs there seemed to be a preference for a wooden-backed chair. A balloon-backed chair, with stay rail and carved cresting, had been illustrated in 1836 in the Cincinnati *Book of Prices*. This wooden balloon back, set on the rounded, upholstered seat and cabriole leg of the rococo style, resulted in the outstanding dining and occasional chair of the period. Elijah Galusha of Troy, New York, made a number of interesting variants of this type.

The rococo easy chair closely resembled the French *bergère*. Its low seat and arms were united with a high back, and it was upholstered inside and out within the rococo framing. The matching lady's chair had braces instead of arms.

In 1846 a Cincinnati advertisement indicated expansion: "Chairs! Chairs! Jonathan Mullen: Wholesale and Retail, Chair Factory, 132 Sycamore Road, Cincinnati, continues to manufacture and keep constantly on hand, at very reduced prices, Mahogany, Black Walnut, Ash and Maple Chairs, Settees, etc., of every variety of pattern, which he warrants equal in workmanship and material to any manufactured in the Western country." In 1849, C. D. Johnston, employing one hundred sixty hands, sent chairs to the Ohio and Mississippi Valleys and all important cities in the South and West.

137

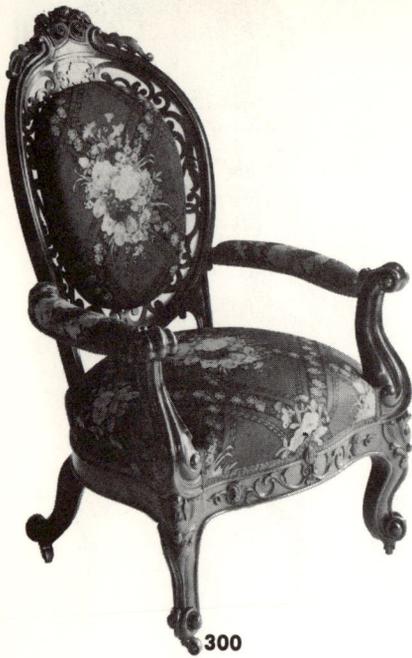

300

300. Open-arm chair with upholstered oval back surrounded by fretwork tracery. (*Brooklyn Museum.*)

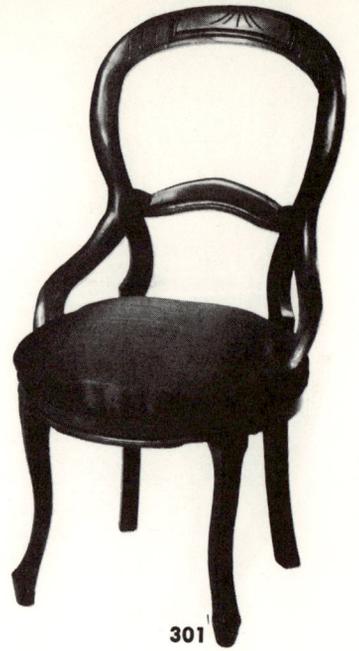

301

302

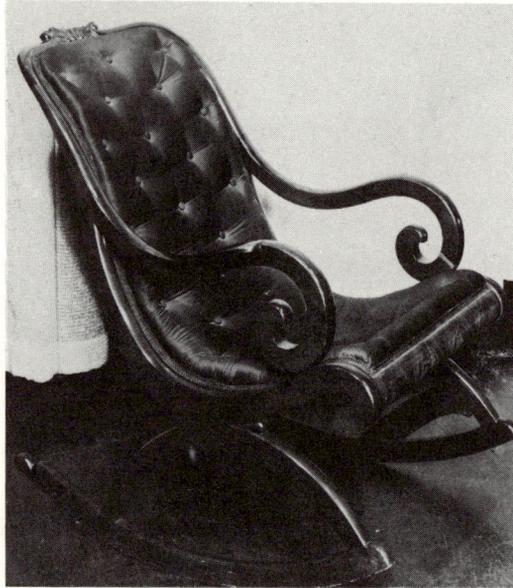

301. Braces are added to this simple version of the balloon-backed dining or occasional chair with a rococo base. The curved front seat rail unites with grooved legs. (*New-York Historical Society.*)

302. Contour rocking chair with mahogany frame and black horsehair upholstery once belonged to Washington Irving. (*Grand Rapids Public Museum.*)

303. Walnut balloon-backed chair with paired scrolls set as a vertical splat on the stay rail. (*Henry Ford Museum, Dearborn.*)

304. A low-seated chair by Belter, a variant from his usual style, with the rounded band frame of the back enclosing carving of paired, bound, stylized scrolls. (*Sleepy Hollow Restorations.*)

303

304

305, 306. Modified versions of rococo parlor chairs retained certain distinctive features — rounded framing with a protruding center flanked by bands; backs generally oval with supports reduced to simple extensions of the back framing. On a parlor chair and a lady's rocker, the carved cresting is reduced to foliate tendrils on the shoulders, the center of the framing "stopped" above and below. (*Henry Ford Museum, Dearborn.*)

305

306

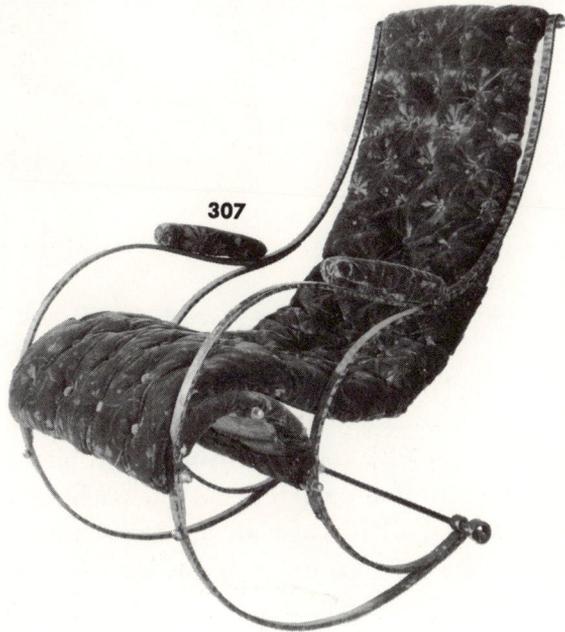

307

307. The metal frame of Peter Cooper's chair is painted to simulate tortoise shell. An identical chair was illustrated in the 1845 American edition of Thomas Webster's *Encyclopaedia of Domestic Economy* among the "Notes and Improvements" added by E. Meredith Reese, American Editor, with the caption: "A rocking chair for exercise. It is made wholly of iron with a stuffed covering, but not very heavy." (*Cooper Union Museum.*)

308

308. Upholstered open-arm chair with vertical medallion back panel resting on two waisted supports at the back of the seat. The use of casters only on the front legs is typical of American rococo furniture. (*New-York Historical Society.*)

309. Parlor chair with an unusually complicated back. A capped oval panel, flanked by scrolls, is framed by an oval hoop. (*Cooper Union Museum.*)

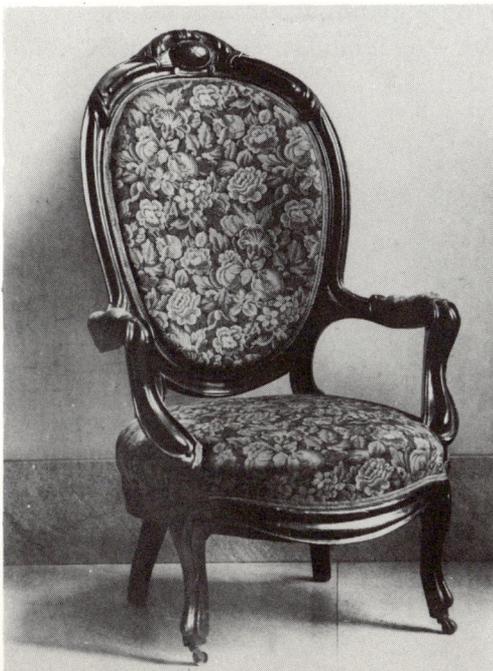

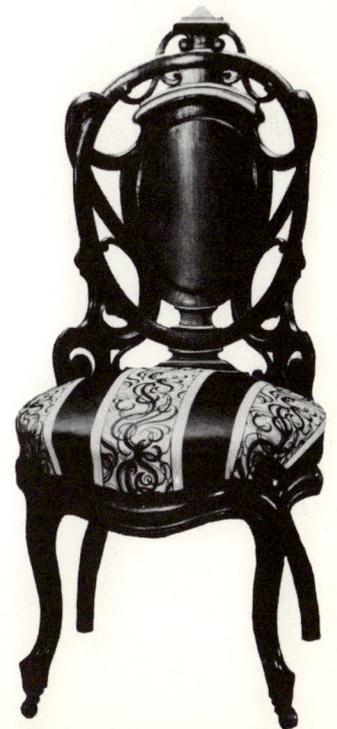

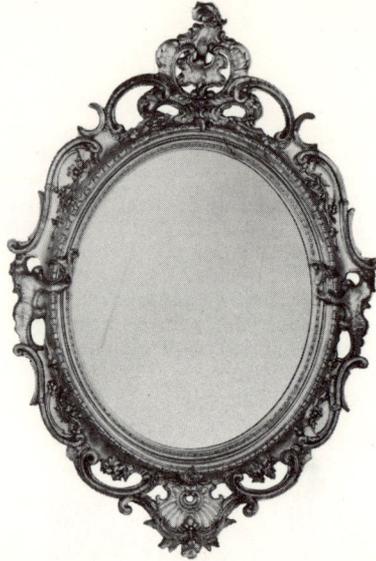

310. Hanging mirror, formerly the property of Frederic de Peyster. (*New-York Historical Society.*)

Mirrors

Rococo hanging mirrors were predominantly vertical and oval, the glass surrounded by plain or ornamented moldings. On the outside edge rococo ornament was pierced and carved in varying degrees of elaboration, frequently with some small detail encroaching on the sides of the frame. A novelty was the use of round or oval mirrors as mantel mirrors, the scrolled and pierced frame expanded to a level base that rested on the mantel. Some overmantel mirrors were very large and of quadrangular shape. The tops of these were slightly arched, with scrolls at the corners, an imposing cresting generally incorporating those at the top. Frames were predominantly gilt.

A narrow rectangular mirror was designed to rise nearly to the ceiling from a low console or jardiniere base. These tall mirrors were sometimes placed between windows, and, for the New York brownstone house with windows only at the ends of its living rooms, this treatment was especially suitable.

In the Cincinnati directory of 1846 under the heading "Steam Power Looking Glass Manufactory," Ebenezer Wiswell, of 117 Main Street, announced: "The subscriber has commenced the manufacture of Looking Glass, Portrait and Picture Frames of every variety of pattern by Steam Power."

In the New York Fair of the American Institute in 1842, H. V. Sigler, of 31 Ann Street, exhibited a looking glass, and about 1850 in his advertisement for the Eagle Mirror Works, 215 Centre and 221 East Twenty-third Street, as "Manufacturer of Looking Glasses and Picture Frames," he used a rectangular, scroll-framed mirror as the illustration.

140

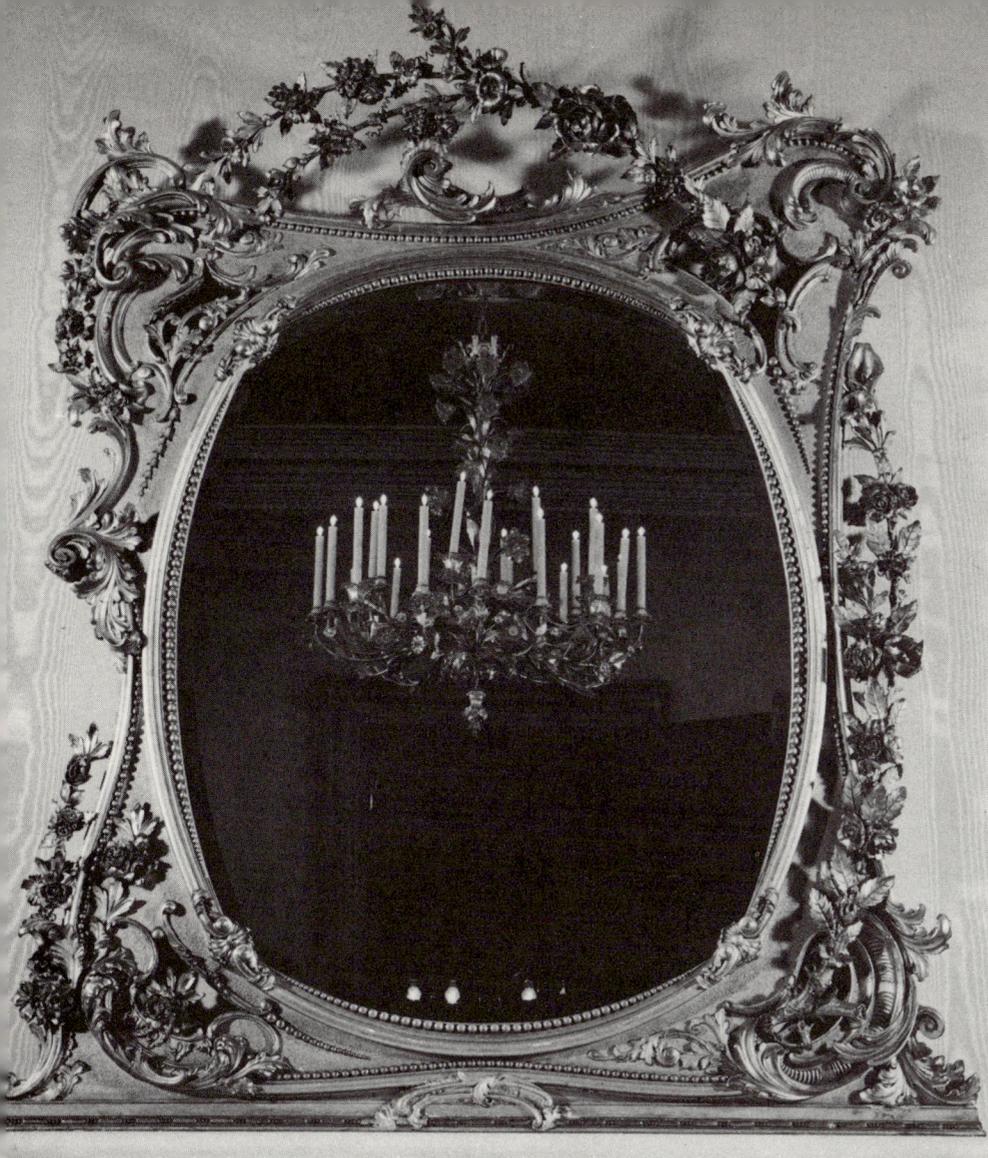

311. Distinctively American mantel mirror with a level base. Except for the four details on the molding surrounding the glass, the whole design is asymmetrical, executed with great skill, fully equal to that of the eighteenth-century *rocaille*. The unusual string beading appears in three variants — plain with tapered ends, knotted, and spaced. (*Munson-Williams-Proctor Institute.*)

312. Small cast-iron oval table mirror is held by crinoline figures poised on olive branches sprouting from an obelisk flanked by the American flag and a trophy. (*Sleepy Hollow Restorations.*)

312

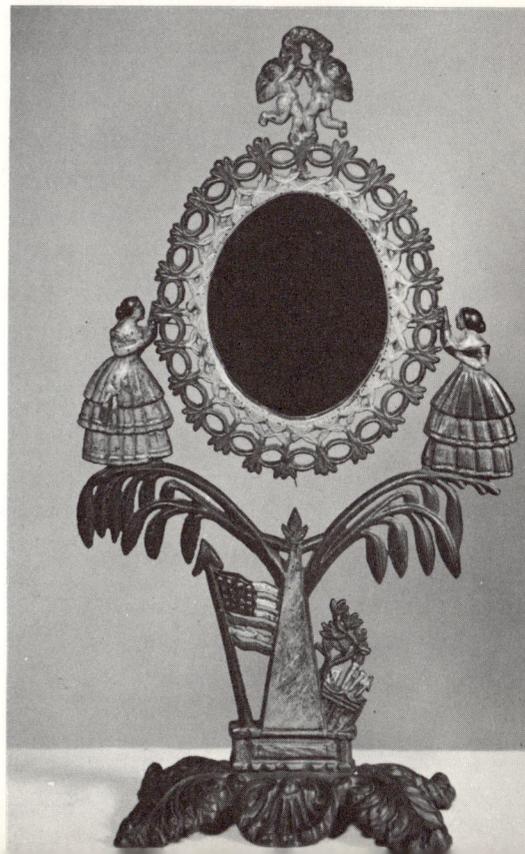

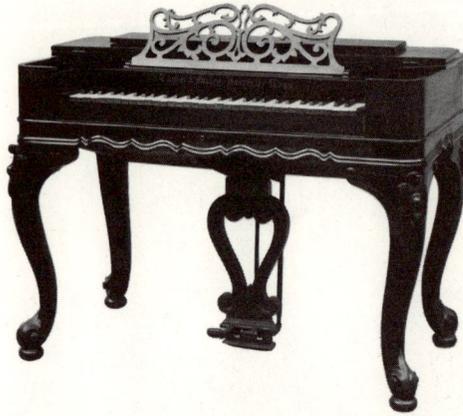

313. Harmonium with rosewood case made by Taylor and Farley, Worcester, Massachusetts. *(Metropolitan Museum of Art.)*

Musical Instruments

The piano and guitar were still the favorite musical instruments in America. Many instruments were imported and the cases for them made by American cabinetmakers. With ingenuity, American craftsmen reacted to the challenge, and Conrad Meyer of Philadelphia produced the first square piano. The question of how best to use iron in piano construction was solved by Alphaeus Babcock, who invented a single casting that was successfully adopted in America by Meyer in 1833 and later improved by John Chickering of Boston, who applied it to the grand piano.

In 1840 there were three manufacturers of pianos in Cincinnati. T. B. Mason advertised that he kept constantly for sale an extensive assortment of pianos from all the most celebrated manufacturers in the United States.

Exhibits at the American Institute Fair in New York in 1848 included: "A Grand Piano with novel improvements and a Square Piano with new Leaf Turner" by J. H. Schomaker and Co., Philadelphia; "A Piano Forte in an oak case" by G. F. Holmes, Third Avenue; one pianoforte each by Hy. Ockerly and Co., C. T. Holden, William Compton, Thomas J. Doyle, all of New York.

In 1853 at the New York Crystal Palace, "Grovesteen and Co., Manu. of 48 Broadway, N.Y.," exhibited two pianofortes in rosewood and papier maché.

Rosewood, sometimes ebonized, was frequently used for rococo piano cases, which were generally designed with four massive and elaborately carved cabriole legs.

142

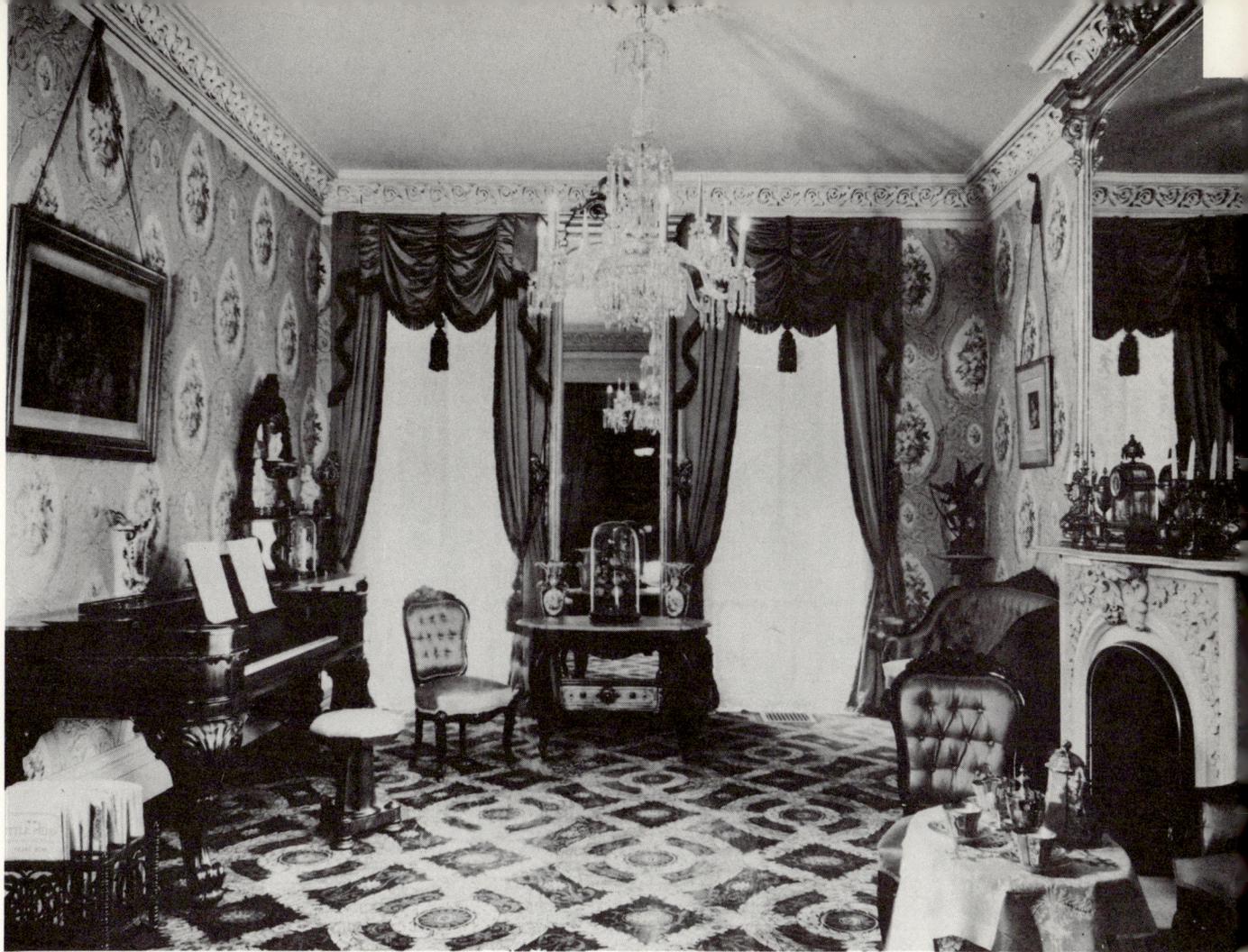

314

314. A tall mirror and a console table between windows with ornate draperies dominate the parlor in the Manhattan house of Theodore Roosevelt. The plain framed chairs match the unusual settee. The oval-topped table in front of the mirror has a shaped frieze. The piano has heavy cabriole legs; the stool is set on a cluster-column base.

315

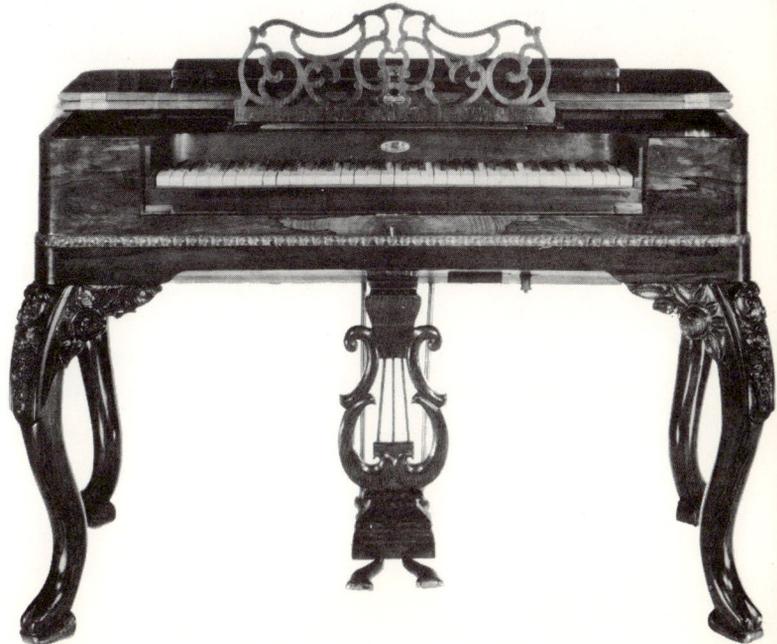

315. Melodeon made by H. Spang of Syracuse, New York, with a hinged cover. Cabriole legs, carved with sheaths and roses, end in two-lobed toes on wedge-shaped pads. *(Henry Ford Museum, Dearborn.)*

Secretaries

The library type of secretary bookcase does not seem to have been susceptible to rococo influence; in rooms with rococo furniture it was frequently uncompromisingly plain and functional, as in the Theodore Roosevelt parlor. John Hall illustrated this type of secretary with large scrolls on the stiles and as feet.

A type advertised by John Geyer in Cincinnati as "Ladies Cabinet and Writing Desk" was a small writing table with rococo frieze and legs and a recessed *cartonnier*. Its low trellis back was sometimes expanded into an *étagère*.

Flat writing tables on four legs or a *cheval* base, with leather tops and drawers in the frieze, were much used. Adjustable reading and writing boards were frequently added. For libraries, pedestal desks were popular.

Settees

Some rococo settees were made in the Louis XV style, with low seats, rococo frames, simple arched backs, and sparse carving.

Distinctive small sofas were evolved *en suite* with the medallion-backed chairs. The ends of the sofa seat were rounded at the back; on each a chair-back with one arm was set canted, a simple lower section uniting them. These were the original *tête à têtes*, a type that developed into a three-seated rococo settee, with low short arms and a high padded back, divided into three crestings.

The rococo version of the *méridienne* was a short sofa, with one chair-back set canted and one arm extending to the front. The back extended two-thirds of the length of the seat — legs being set at this level, leaving the rounded end projecting. In Vienna this type was called a "Balzak."

When suites began to be made in the 1850s, *méridienne* and settee were generally included for the parlor.

Window benches were made, chiefly in the South, for the bays of large windows. They had an ottoman-type seat without arms, a narrowed back, and bulb or low rounded bracket feet.

Upholstery, when not of horsehair, was elaborate and sometimes of costly fabrics; backs, seats, and the insides of arms were frequently buttoned.

In 1846 John Geyer of 8 East Fourth Street, Cincinnati, offered a general assortment manufactured by himself, "faithfully made and of the most modern style consisting of Sofas, sociables, Divans, Tête à Têtes, Ottomans, Reclining Chairs." In 1849 Archibald Armour added couches and lounges — John Hall types — to the styles available — "every variety at the lowest possible prices, wholesale and retail."

316. New Orleans plantation writing table of good, practical design. The writing slope lifts up over a center compartment in the spacious table; the kneehole space is flanked by two drawers. (*Louisiana State Museum.*)

317. Fall-front secretary attributed to John Belter, with full-width drawer above the secretary and a two-door cupboard base. Carving embellishes the chamfered cavetto stiles. Panels on the fall front and on the cupboard doors are outlined by slender paired scrolls. (*Museum of the City of New York.*)

318. Lady's *étagère* writing desk with a serpentine front and a *cartonnier* recessed on the top. Hall's influence is evident in the paired scrolls and arched stretcher rails of the *cheval* base. (*Grand Rapids Public Museum.*)

317

318

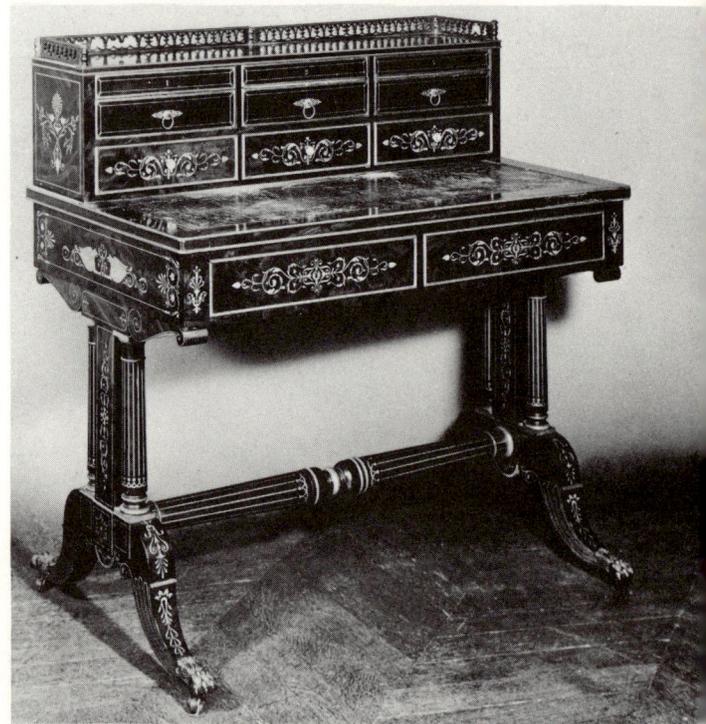

319

319. Mahogany French *secrétaire* inlaid with lemonwood, following the Louis Philippe fashion for dark woods inlaid with light. The *cartonnier* is recessed, with three tiers of triple drawers. The *cheval* base has a paired baluster stretcher. (*Musée des Arts Décoratifs.*)

320. Settee in simplified rococo style. The space between the canted chair-back ends is filled with a horizontal oval panel. *(Henry Ford Museum, Dearborn.)*

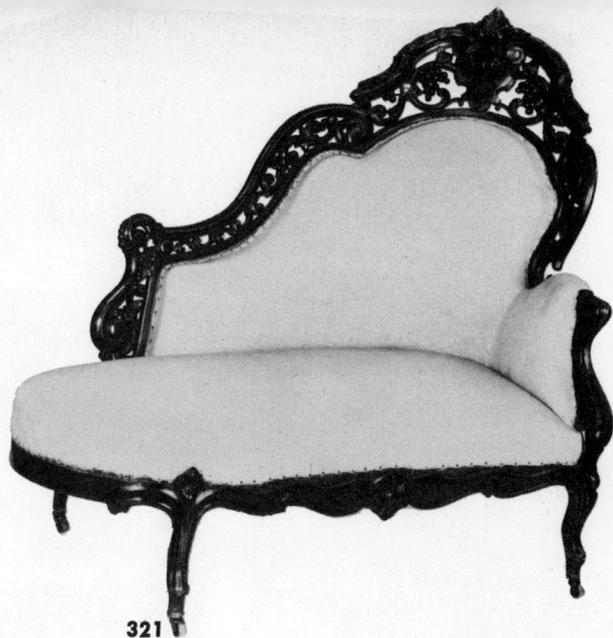

320

321

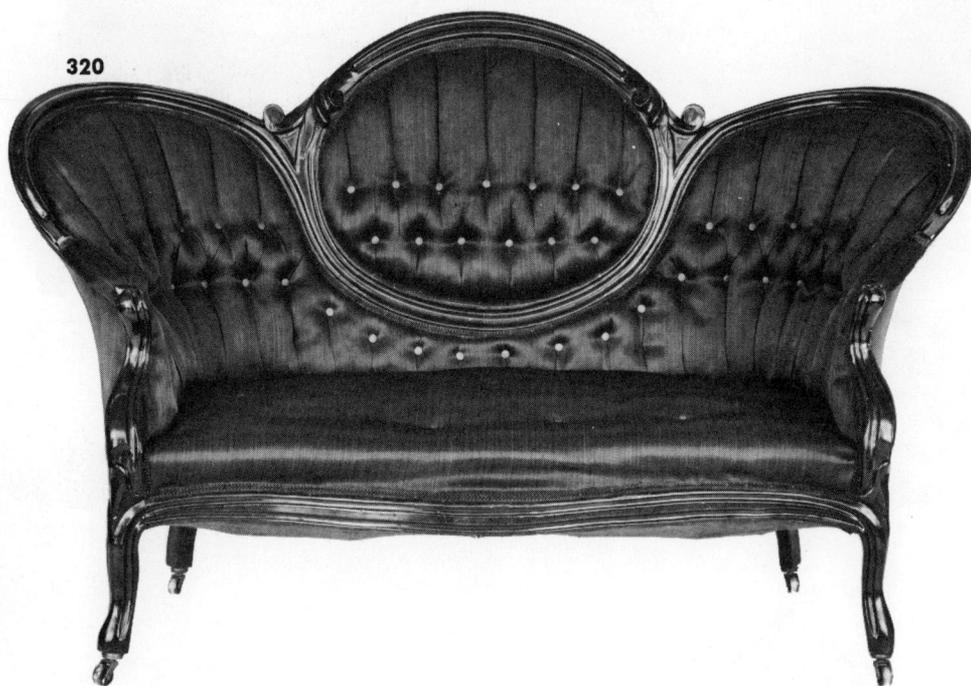

321. *Méridienne* included by John Henry Belter in a set of parlor furniture sold by Mrs. Abraham Lincoln in Chicago. The legs are set so that the rounded foot projects, a typical rococo feature. *(Henry Ford Museum, Dearborn.)*

322

322. *Méridienne* with kidney-shaped seat, developed from one of the low-backed window benches frequently found in Natchez; the back has a peaked corner head and cresting. *(Mrs. Joseph B. Kellogg, The Elms, Natchez.)*

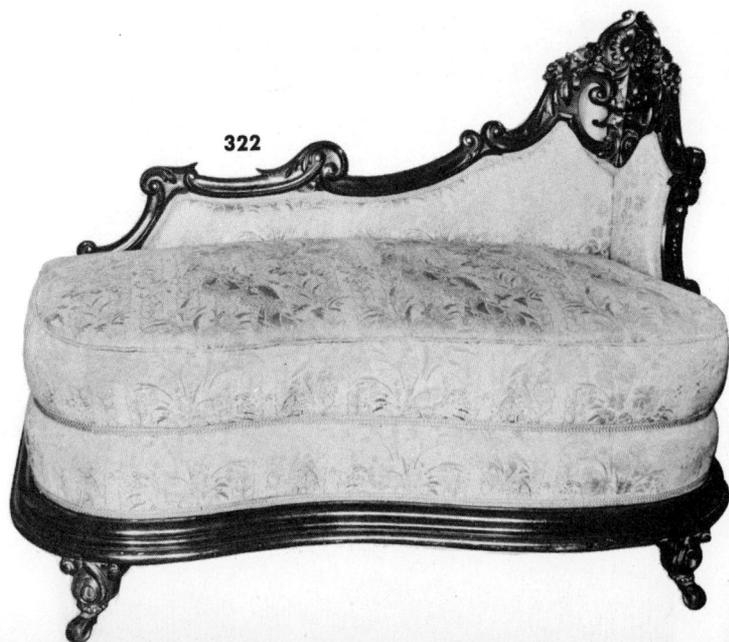

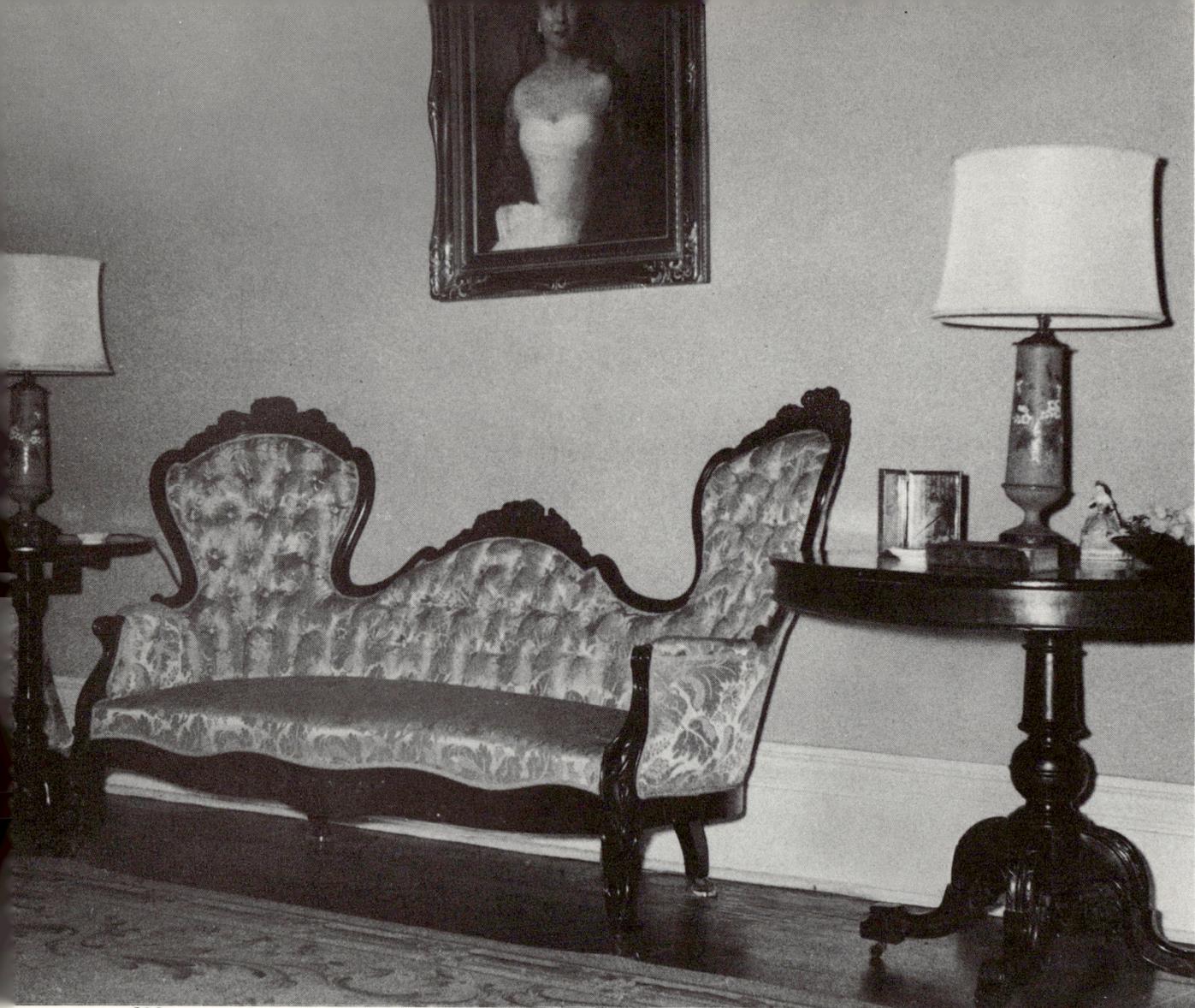

323

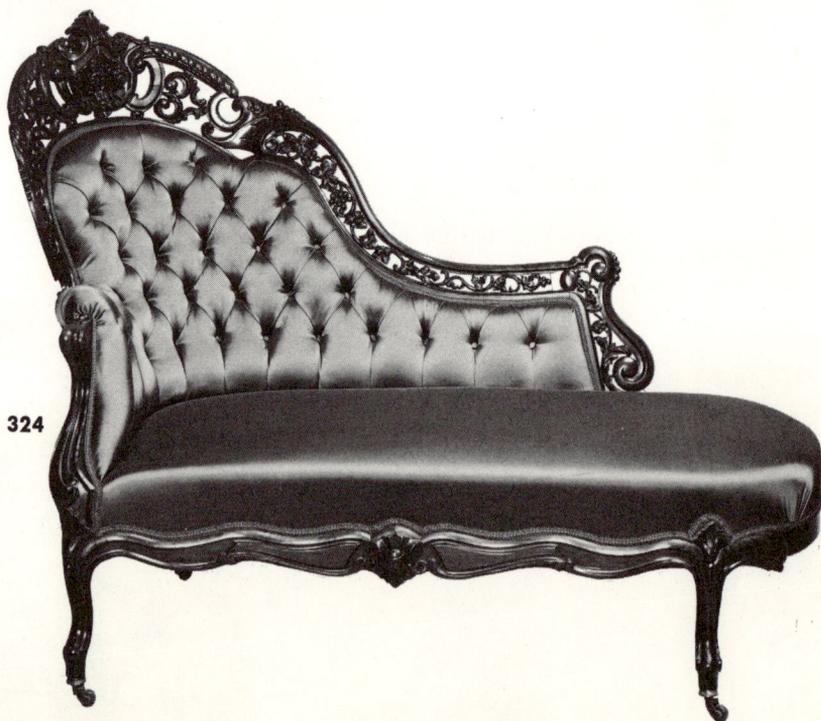

323. A French prototype of the American rococo settee is similar in design, but the back is higher and more strongly raked; padded armrests are curved around the end in the Louis XV manner and front legs and facings of arms are united and carved. (*Mr. and Mrs. Charles J. Byrne, Cherokee, Natchez.*)

324. A *méridienne* in typical rococo style, with carving of scrolls and grapes enclosed within bands. (*Brooklyn Museum.*)

324

325. Small *méridienne,* part of the furniture in a bedroom in Sunnyside, Hudson River home of Washington Irving. *(Sleepy Hollow Restorations.)*

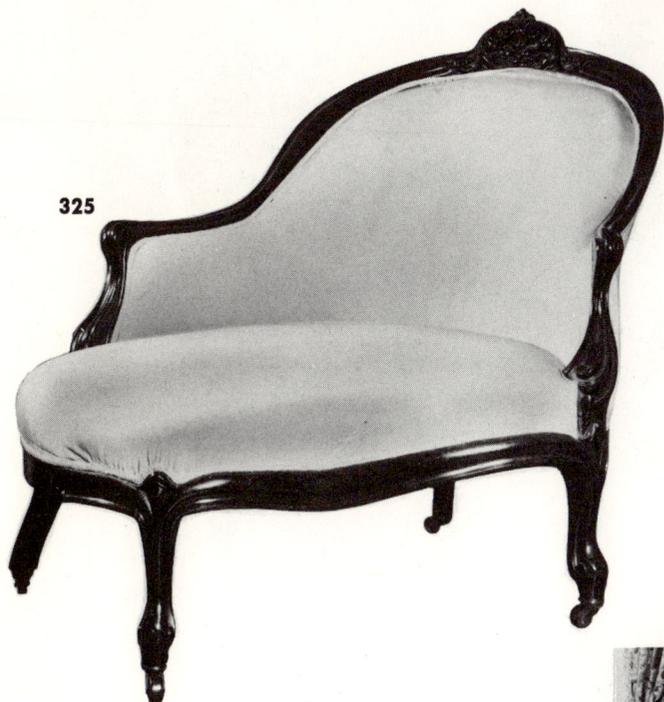

326

325

326. Settee with pierced and carved triple chair-back cresting, low arms, and short cabriole front legs. *(Metropolitan Museum of Art.)*

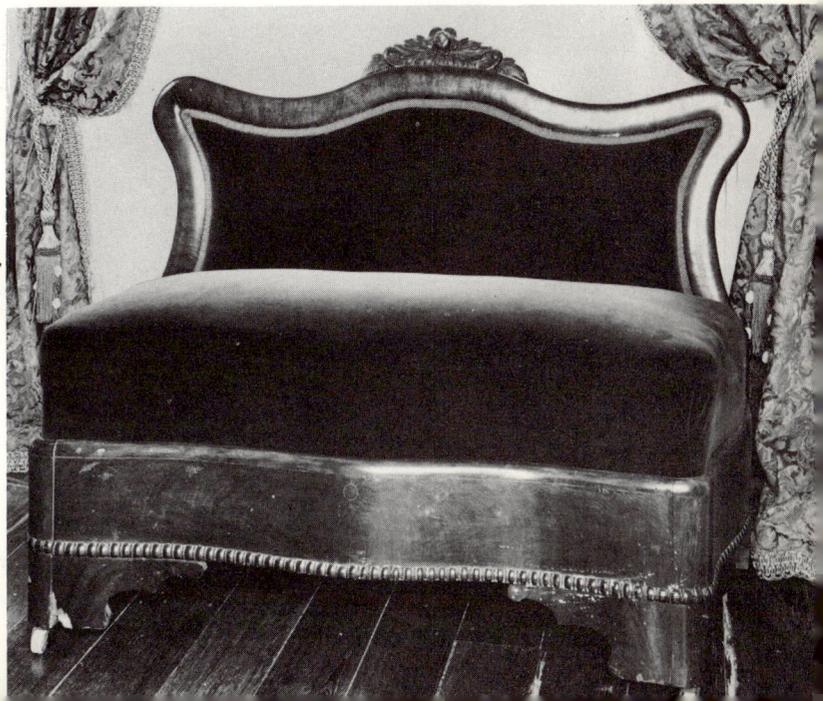

327. Simple ottoman window bench with a padded seat in a deep, gadroon-edged frame. A plain rounded band with a carved foliate cresting frames the low back. *(Mrs. Joseph B. Kellogg, The Elms, Natchez.)*

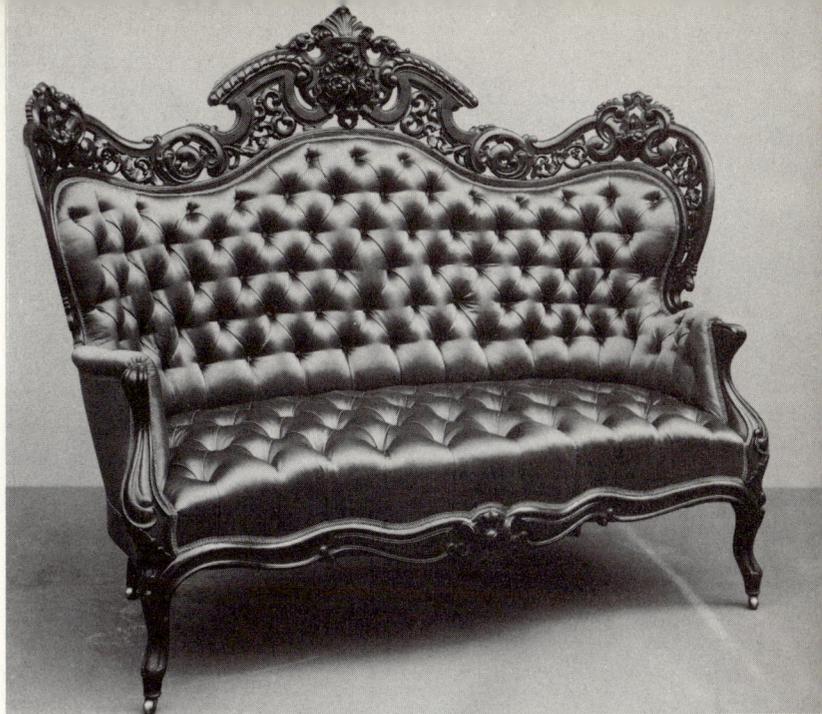

327

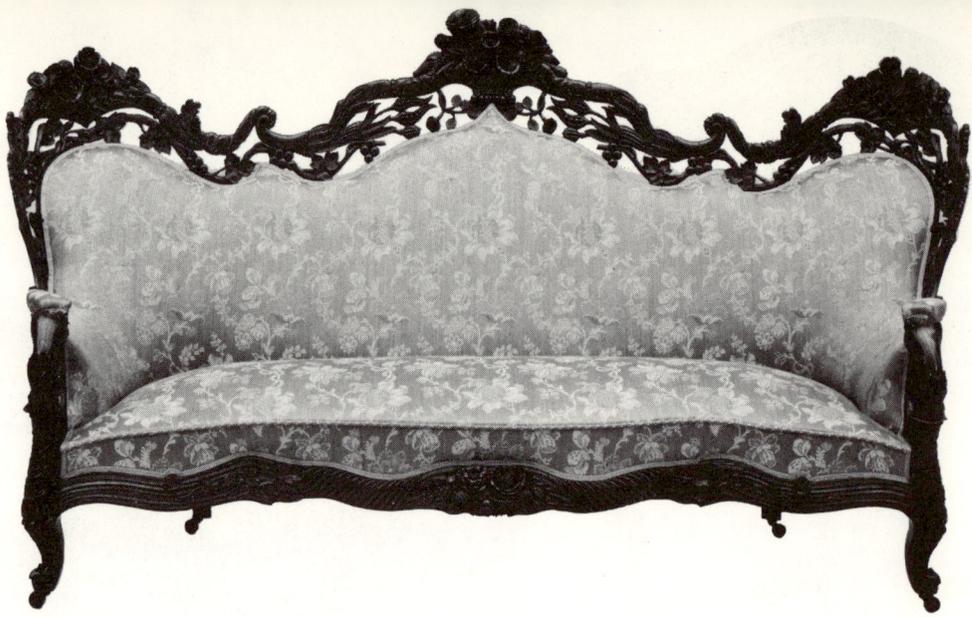

328

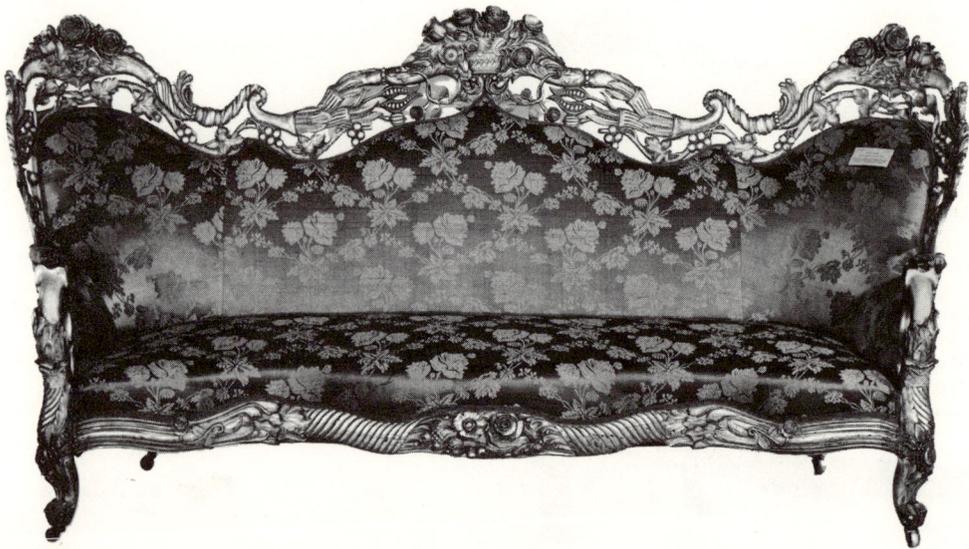

329

330
331
332

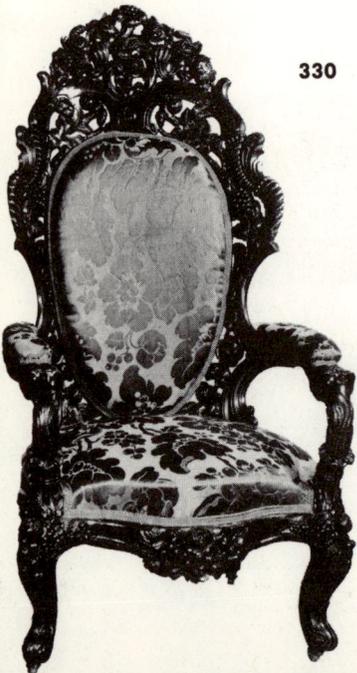

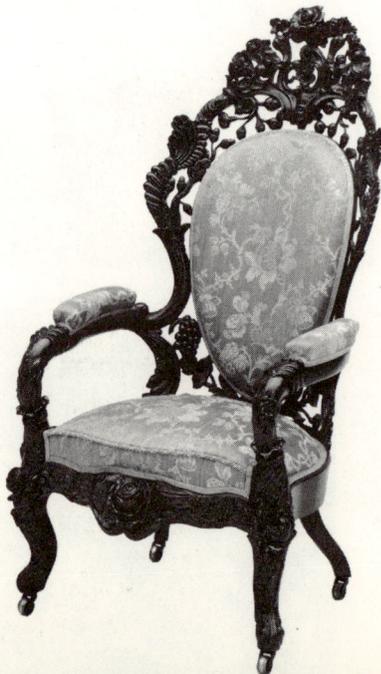

FROM
C. A. BAUDOUINE
—335—
BROADWAY
NEW YORK

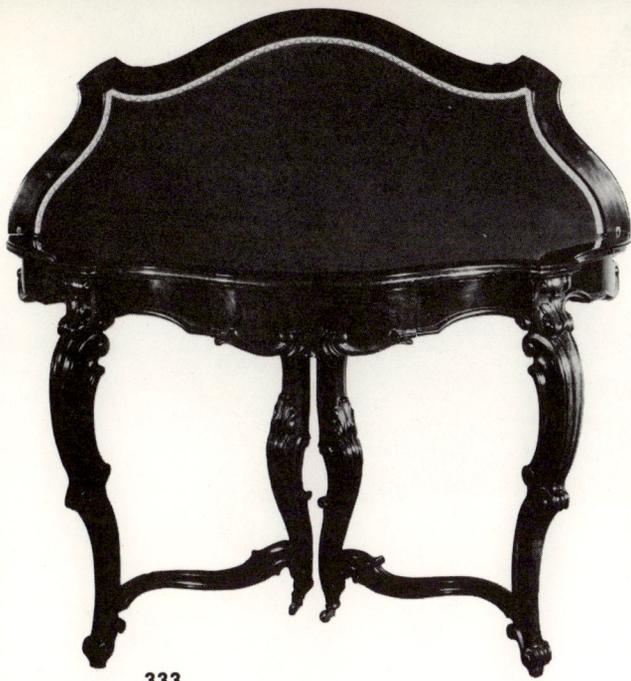

333

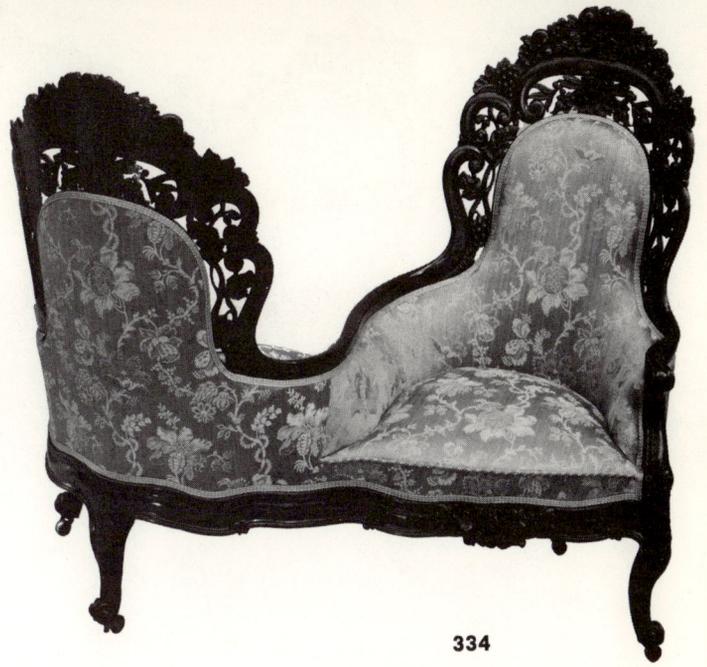

334

328–336. A number of fine pieces of furniture in the rococo manner, all in laminated rosewood, the wooden backing on some of the chairs and settees curved by steam, and with extremely fine and distinctive carving, are in various collections. Of the three settees illustrated, 328 is in the Metropolitan Museum of Art, 329 in the Virginia Museum, and 335 in the Museum of the City of New York. In each, the design and detail of the cresting on top of the back is markedly similar; the top of the upholstered back is finished in five points; the low arms, united with the front legs, are identical in design with the detail shown in 336. The conversational (334) and the easy chair (331) are *en suite* with the settee in 328. The easy chair in 330, *en suite* with the settee in 335, is part of a set with four parlor chairs in the Museum of the City of New York. The card table (333), one of a pair with the label of Charles A. Baudouine, is in the Munson-Williams-Proctor House in Utica.

335

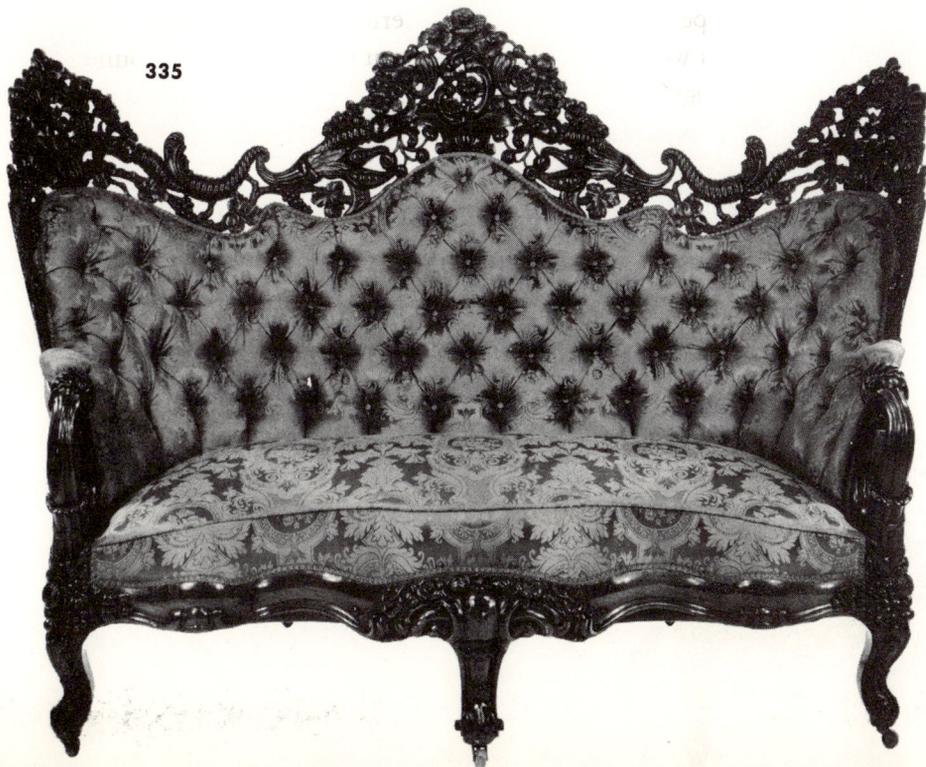

336

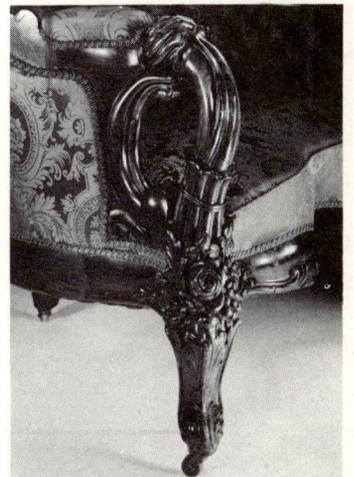

Sideboards and Tables

Louis Philippe's rococo style provided no prototype for sideboards. The movable French *desserte*, with three open shelves for the removal of dishes and tableware, was retained, but developed into a stable item, on a plinth base, with mirror back and carved and pierced ends.

Although the American sideboard continued its traditional function, French influence is seen in the introduction of mirrors and carving. Specimens are rare, and in Cincinnati furniture advertisements for the decade 1840 to 1850 sideboards are practically nonexistent.

About 1840, when rococo furniture with its rich, carved ornament was introduced, tables immediately underwent a radical change. Center tables assumed importance, and tops, frequently of marble, were made in circular, lozenge, oblong, and oval shapes, much work being expended on the frieze and base. John Henry Belter introduced the Louis XIV base, which consisted of four heavy cabriole legs joined by an elaborate arched, crossed stretcher with a sizeable urn on its apex. This type was widely adopted in America.

Dining tables were of the extension type, round or oblong, with rounded ends, on a pillar with two extra legs.

The use of marble became increasingly popular, and an abundant supply of white and finely variegated types was available at this time from Lanesborough, Connecticut. In 1842–1843 marble worth more than two hundred thousand dollars was shipped from Lanesborough to New York, Philadelphia, Boston, and the West.

In 1848 S. S. John advertised that there were no finer articles made in Cincinnati than his pier and sofa tables. These were covered with black Egyptian marble, which was noted for its fine, gold-colored veining. From 1849 to 1851 John Geyer advertised Italian-marble-slab and mahogany work tables, with fancy baskets around the pedestals.

In 1850 Downing, after a lengthy description of various types of tables in *The Architecture of Country Houses* added that "all tables depend on drapery or cover . . . concealing all but the lower part of the legs." He also commented that the center table had given place to sofa tables.

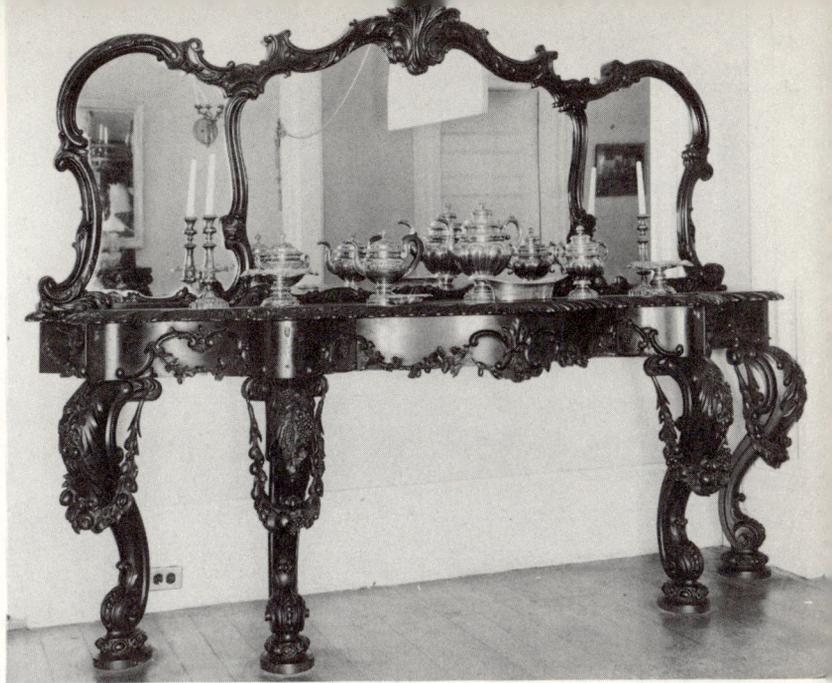

337. A small rosewood sideboard or cabinet made by Elijah Galusha of Troy, New York, with a full-width drawer in a two-door cupboard base. Four colonnettes on projecting blocks are canted on the front angles. Two graduated shelves are set on the mirror back. *(Munson-Williams-Proctor Institute.)*

337

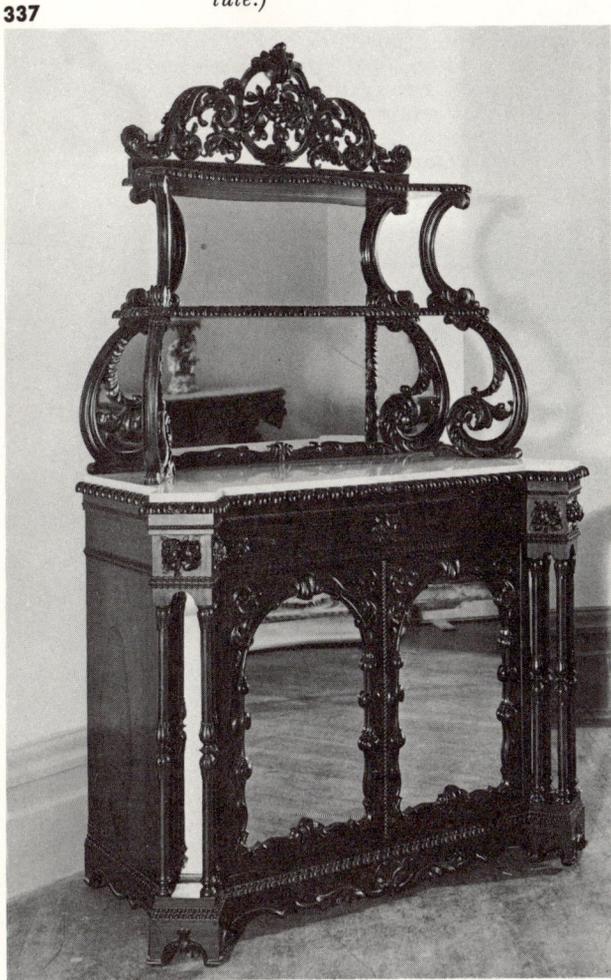

338. Large rosewood sideboard. The serpentine front has a gadroon edge and drawers in the carved frieze. Four massive cabriole legs with fruit and foliage swags, each with a different design carved on the knee, are set under the convex sections of the frieze. *(Mr. and Mrs. Douglas H. McNeill, Elmscourt, Natchez.)*

339

339. Three-shelf construction is retained in this French *desserte* of the rococo period, but a solid plinth base, a mirror back, and carved panels enclosing the ends have been added. *(Musée des Arts Décoratifs.)*

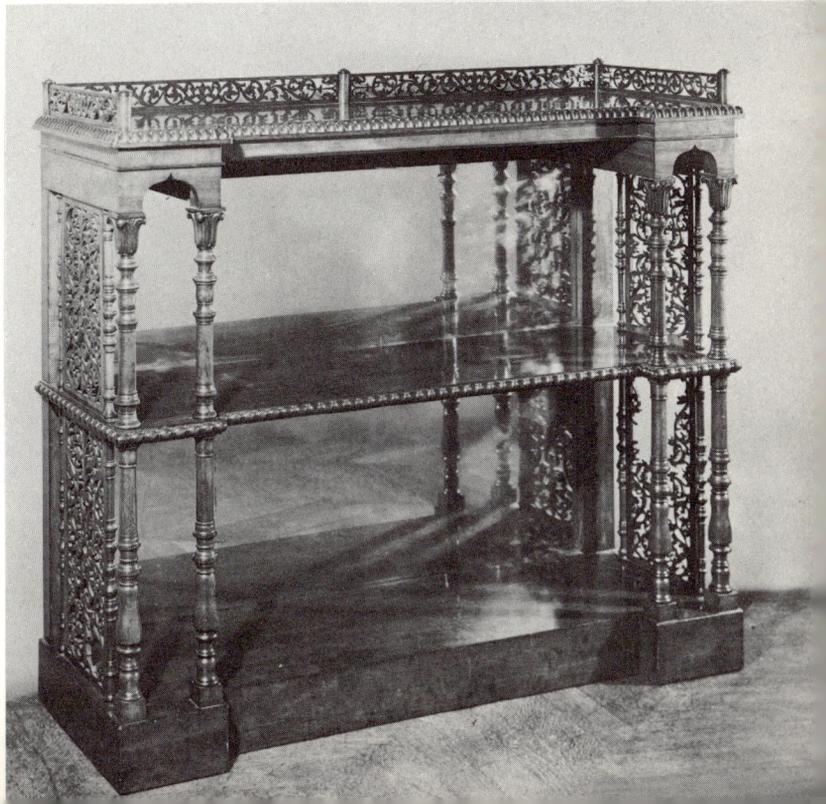

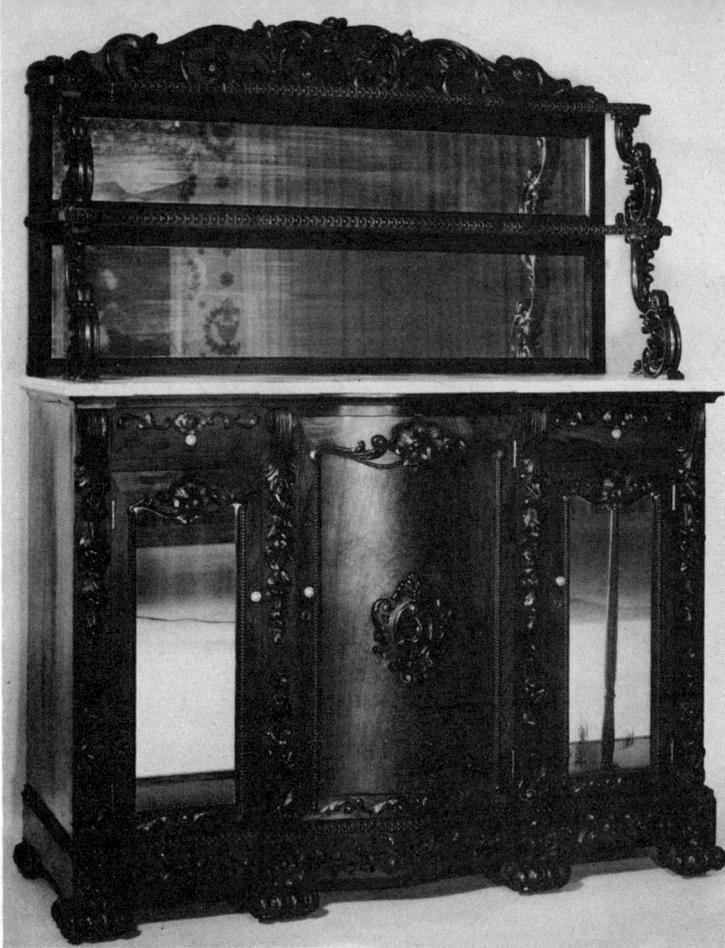
340

340. Sideboard with a three-cupboard base, the ends with mirror panels; marble top; and graduated shelves on the mirror back. A similar small sideboard is illustrated in the *House Decorator and Painter's Guide* by W. H. and A. Arrowsmith, Decorators to Her Majesty, 1840. *(Newark Museum.)*

341. Rosewood center table made by François Seignouret of New Orleans with a bold gadroon edge and beaded frieze. The vase pillar with cylinder base and four foliate-carved legs with hoofs, may have been inspired by a Louis Philippe writing table that had lotus and leaf-carved deer legs. *(Louisiana State Museum.)*

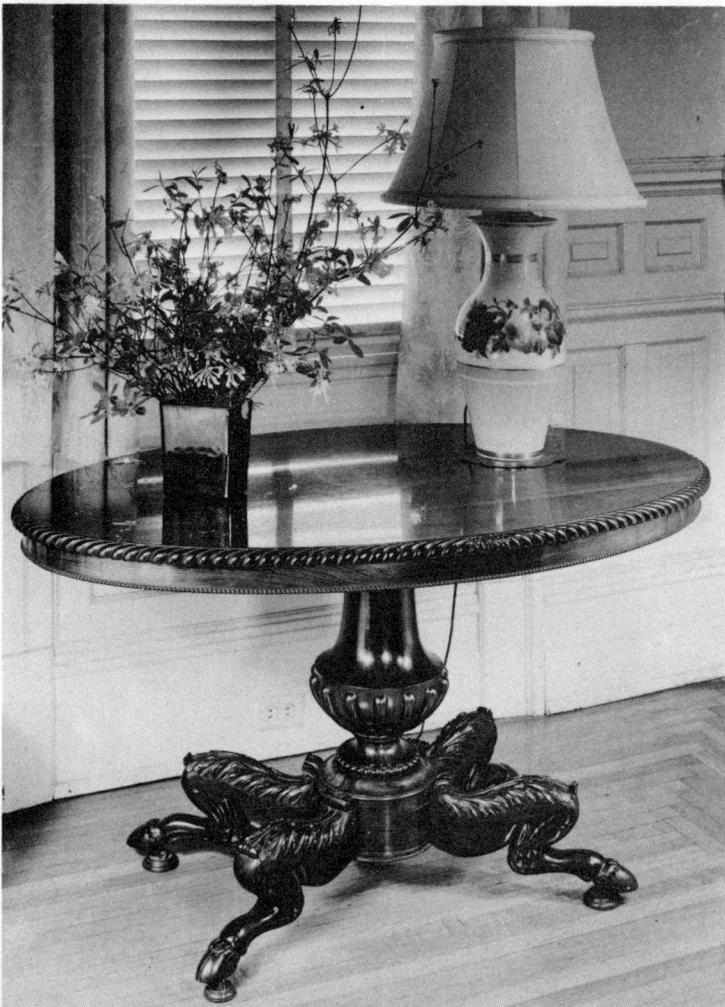
342

342. In a simplified version of the Louis XIV center table a white marble top overlaps the molded frieze with fruit-carved pendants in the center of the sides and ends. The accentuated cabriole legs are carved on the knees and joined by an arched, crossed flat-section stretcher, with covered urn and pendent finial. *(Mr. and Mrs. Hyde Dunbar Jenkins, Hawthorne, Natchez.)*

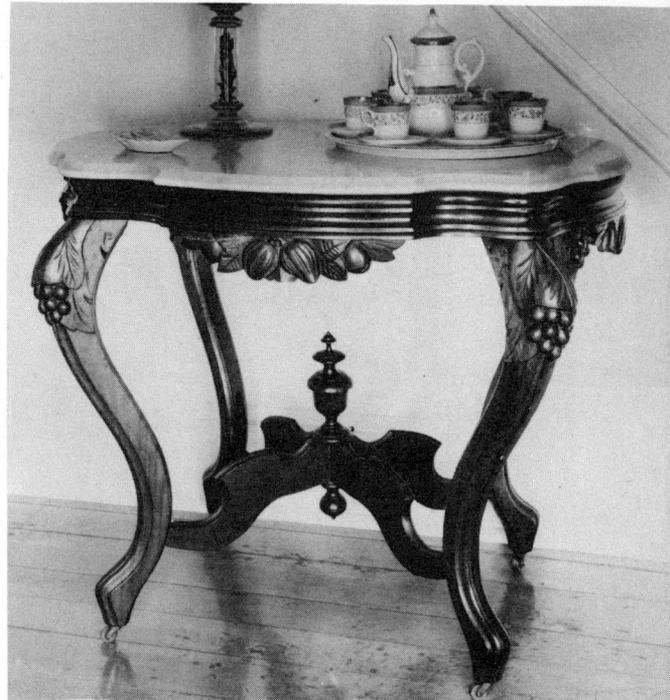
341

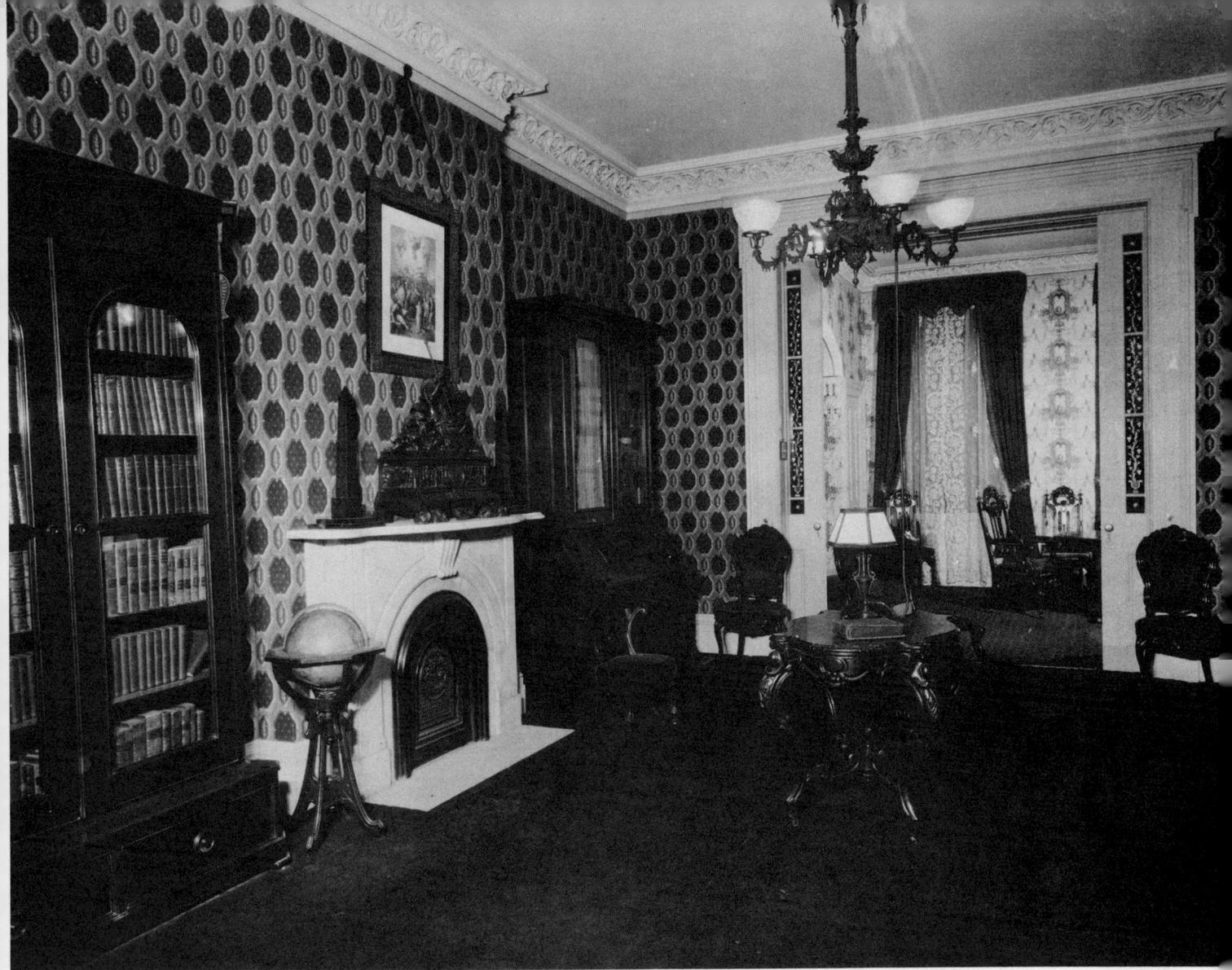

343

343. A room in the Theodore Roosevelt house at 28 East Twentieth Street, New York City, is furnished in modified rococo style. It contains upholstered horsehair chairs with shield-shaped backs and a marble-topped center table in Louis XIV style. The bookcase has a projecting base with drawers. The slope-front secretary with recessed bookcase is decorated with applied panels framed in moldings.

344. American console *étagère*, with bowed front and substantial cabriole legs united by a Louis XIV stretcher. A female head is carved in relief on the cresting of the mirror-backed *étagère*. (*Cooper Union Museum.*)

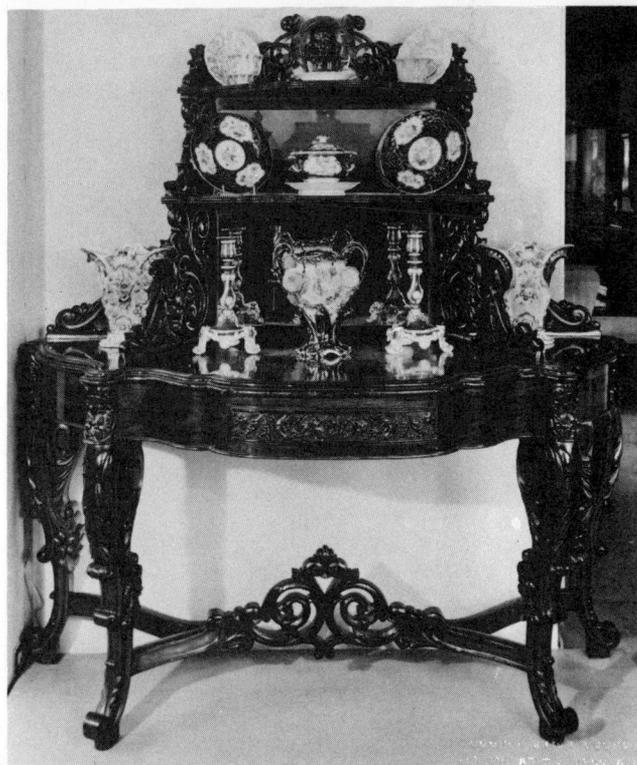

344

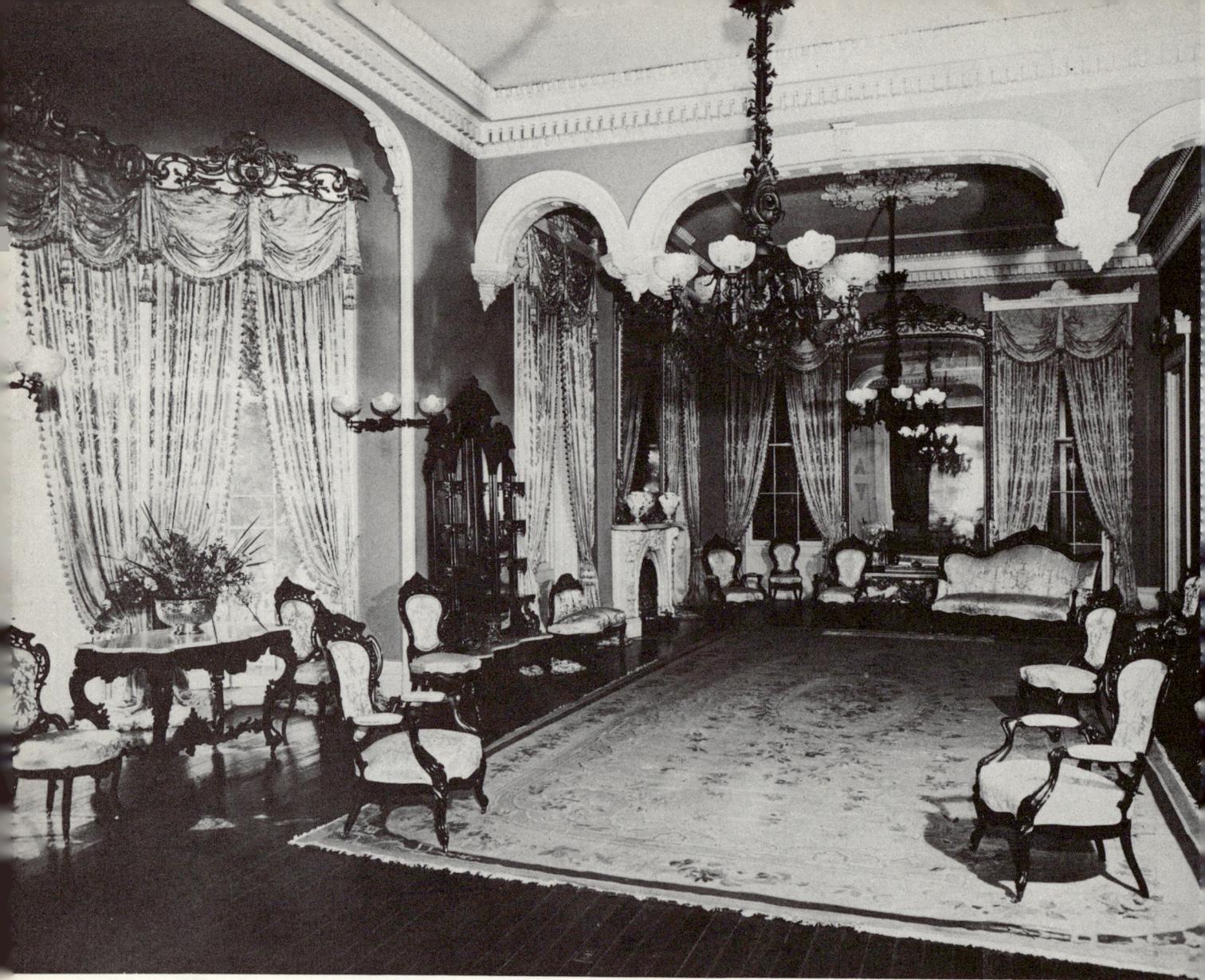

345

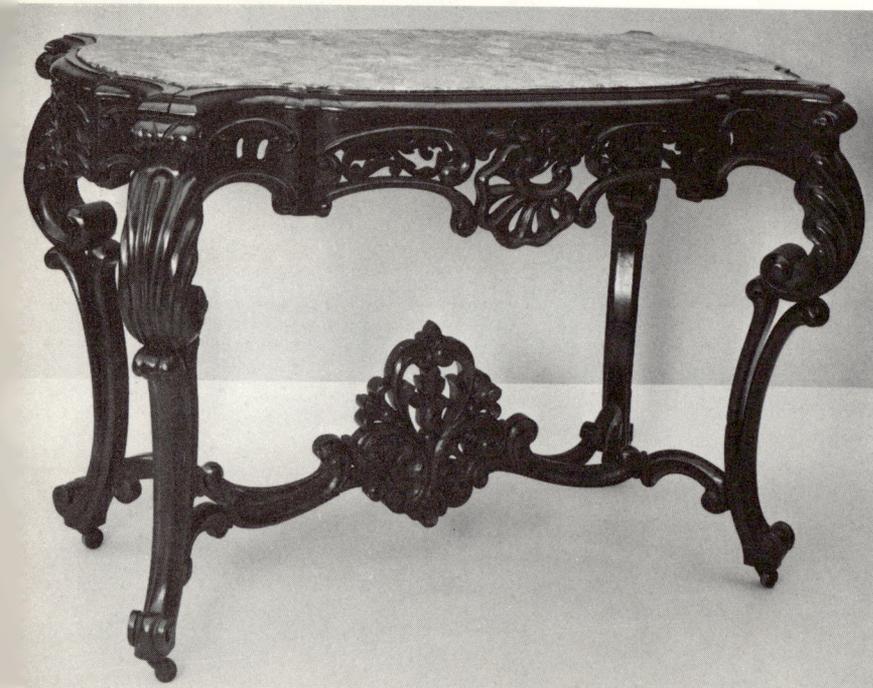

346

345. Double drawing room, seventy-two feet long, in Stanton Hall, built in 1851. The double set of Belter parlor furniture includes an *étagère,* a window bench, a marble-topped table, chairs, and settees. The large mirrors, marble fireplace, and bronze chandeliers were imported in chartered vessels. (*Stanton Hall, Natchez.*)

346. Console table, part of a parlor suite attributed to Belter, shows the attention paid by him to the design of the legs in cabriole outline — a shell resting on a split scroll with a volute foot. Table corners are expanded to cover the top of the shells. (*Metropolitan Museum of Art.*)

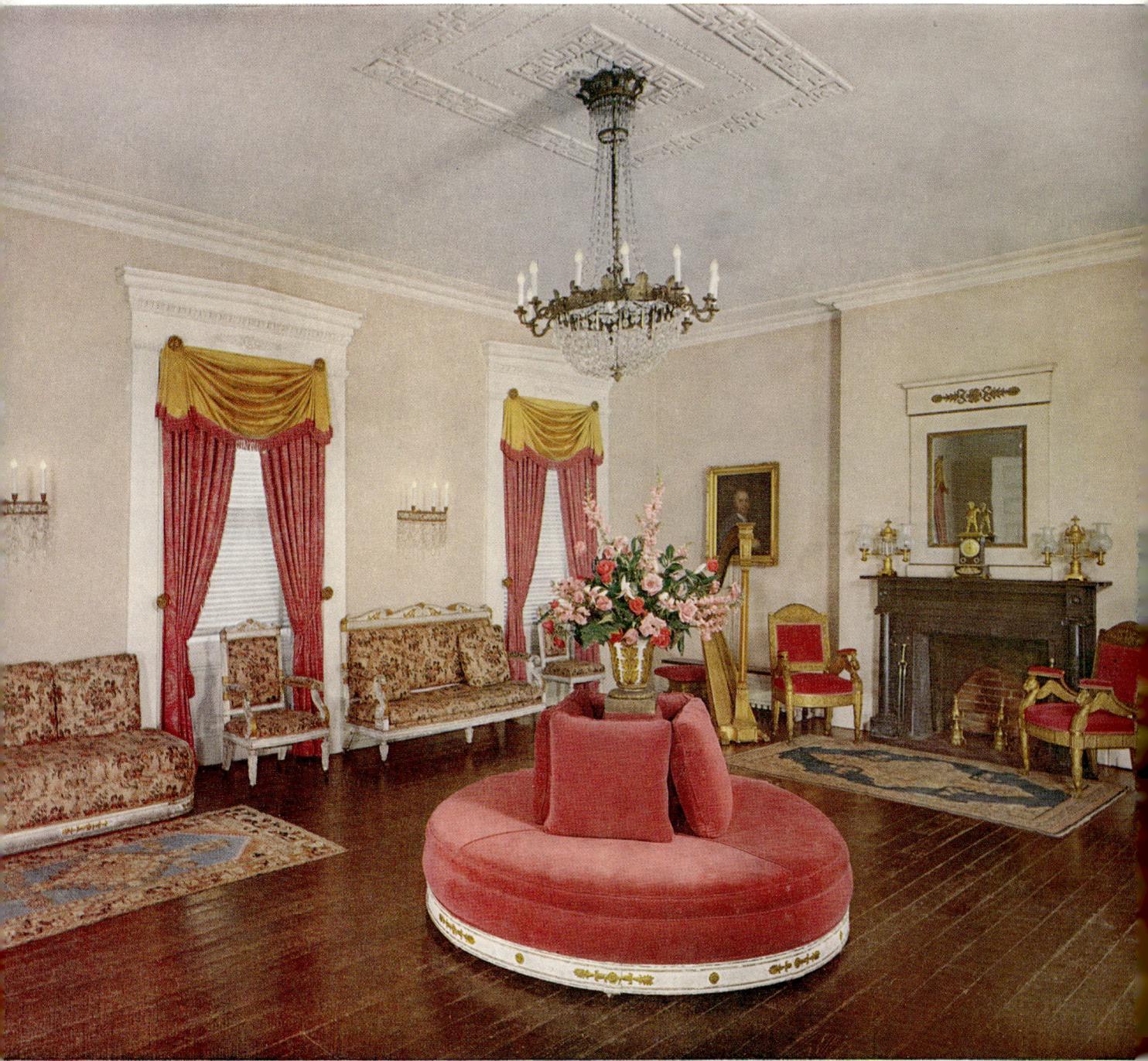

PLATE III. In the music room in Strawberry Mansion, Fairmount Park, there is a set of white and gold cottage furniture — two settees, one a three-back divan type and the other in the French style; two matching chairs; a center ottoman; and a mantel mirror. The carved ornament on the white frames is applied and gilded. *(Philadelphia Museum of Art.)*

347. Marble-topped rosewood table bearing the label of John Henry Belter. The apron below the frieze is composed of four sections of balanced design. The stretcher rails are scrolled, with a central bouquet of fruit, foliage, and flowers. The slender reinforcing on the legs is Belter's ingenious method of lightening the substantial cabrioles necessary to support the heavy marble top and framing. The carving of the fruit and flowers and the carefully arranged tracery in the apron are typical of Belter's beautiful work. *(Henry Ford Museum, Dearborn.)*

347

348. A circular table with wave-molded rim, carved and pierced frieze, and an unusual three-legged base; the strange stretcher rails, composed of scrolls and stylized cornucopias, and certain details in the ornament, seem to be reminiscent of the seat furniture tentatively attributed to Charles A. Baudouine. *(Metropolitan Museum of Art. Gift of Miss Mary E. Steers.)*

349

348

349. French Louis XIV table, carved and gilded; the style of the base resembles that used by John Henry Belter on many of his tables. *(Musée des Arts· Décoratifs.)*

Elizabethan and Cottage
Furniture

In England, between 1837 and 1840, when Victoria reigned as an unmarried woman, Elizabethan furniture suddenly developed into a rich and decorative style that conquered the market. It was derived from the Palladian Renaissance, originally introduced into England during the reign of Elizabeth I by Inigo Jones, who was known as the English Palladio. With the aid of new machinery the enrichment of the earlier furniture was not only equaled but surpassed.

In America the Elizabethan style encroached on the rococo. Thomas Webster's *Encyclopaedia of Domestic Economy*, circulated in 1845, refers to Elizabethan as "a fashion now at its height."

In 1850, Andrew Jackson Downing wrote, "Economically considered, Elizabethan furniture has hitherto been more expensive than any other." It developed in America as a luxury style, identifiable by its spiral supports, lavish carving, rich fabric upholstery, and fringe.

In 1851, Wm. Cremsey of Cincinnati advertised parlor, rocking, and Elizabethan chairs. At the New York Crystal Palace in 1853 one of the items was a rosewood billiard table, elaborately carved in the Elizabethan style, with patent cushions — "Ab'm Bassford, pat. and manu. 8 Ann Street, N.Y.C." And as late as 1878, Harriet Spofford mentions Elizabethan chairs, evidently still in favor.

The fashion for a specific type of cottage furniture began about 1845, and in the 1848 Fair of the American Institute, cottage chairs were shown by five different exhibitors.

In 1850, Andrew Jackson Downing dealt with cottage furniture as an important novelty, "now offered in all our principal cities, of pretty forms and at moderate prices."

As in France and England, the resort cottage demanded more than a suite. In 1852 Mr. Godey wrote in his magazine: "Hart, Ware and Co. have a most splendid display of their furniture in their repository, No. 280 Chestnut Street. We would call particular attention to their cottage furniture which is now in general use." In 1853, at the New York Crystal Palace, highly ornamented cottage chamber suites were shown by John Gschwind of New York, enameled in deep rich color, with warm tinted marble and buff brocade. Matthews and Stacy exhibited rich, ornamental cottage furniture in white and gold enamel; other examples in the same class were shown by Briggs and Vickers and S. W. Warwick.

This style became an established part of furniture production. Meeks's advertisement, c. 1860, included an assortment of superior cottage furniture; and in 1876 "Horace J. Farrington of New York (established 1848) . . . Maker of Enameled Furniture," advertised "Cottage Suits from $21.33 to $166.66."

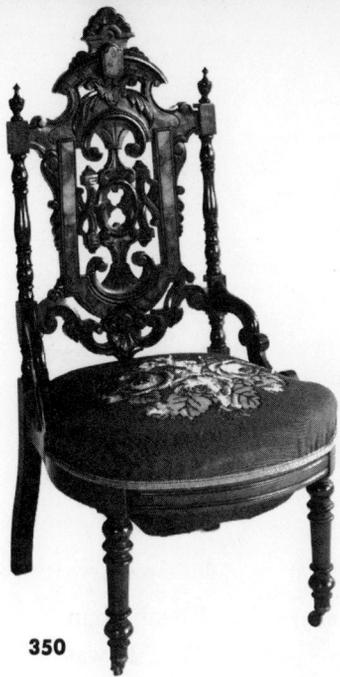

350. Elizabethan chair with a low, deep seat; the front legs are turned with annulets and bulbs. The back is a tall carved and pierced panel with arched cresting and baluster uprights. Chairs of this type, with variants, were made for decades. Downing illustrated Elizabethan chairs in 1850, with the caption: "Chairs of this style, but of a great variety of designs and highly elaborate carving, may now be found in the principal warehouses in our largest cities . . . usually made of rosewood or ebony, sometimes relieved by gilding." (*Brooklyn Museum.*)

351. Set of bedroom furniture illustrated in the 1853 edition of Downing's *Cottage Residences and other similar Works*: Bobbin turning was widely adopted for lower-priced furniture, chiefly for the bedroom. The Salisbury Furniture Corp., now the Randolph Furniture Corp. of Vermont, made it by mass production. It retained its popularity, and the style spread to better quality items, including parlor furniture.

352. Small occasional table at Sunnyside. (*Sleepy Hollow Restorations.*)

353. Bobbin-turned walnut armchair. (*Mr. and Mrs. J. Balfour Miller, Hope Farm, Natchez.*)

354

354, 355. This enameled cottage furniture in Sunnyside may have been made by Hennessey of Boston. The French bedstead is in the Louis Philippe style; the cane-seated chair, small oblong table on *cheval* base, and four-drawer dresser are all practical and well designed. The mirror frame and supports are in the peculiar flat-section wavy style used on Second Empire French enameled furniture. (*Sleepy Hollow Restorations.*)

355

356. In 1850 Downing illustrated "Furniture for bedroom or Chamber; got up at the Manufactory of Edward Hennessey, 49-51 Brattle Street, Boston.... Mr. H's prices are moderate and the design and finish of the articles so good, that his reputation is an extended one and he supplies orders from various parts of the Union and the West Indies. This furniture is remarkable for its combination of lightness and strength and its essentially cottage-like character."

This illustration shows one of the complete, practical sets — a French bed in the Louis Philippe style, with decorated ends; dressing bureau with case drawers and oval mirror; washstand; towel rail; and night table; to which were added an oblong occasional table on a cheval base and four caned chairs.

356

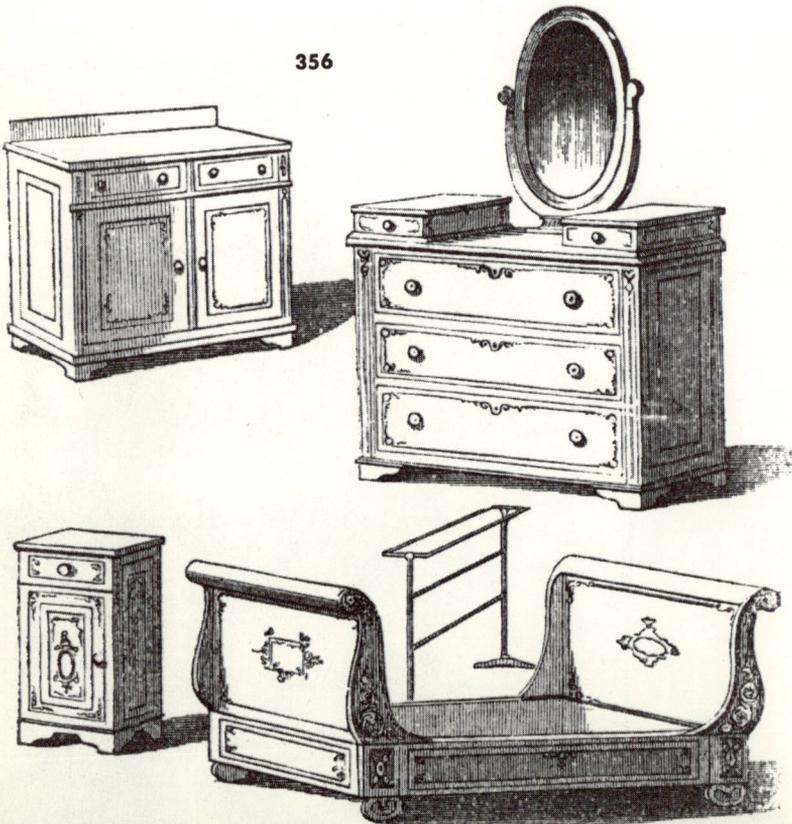

357. Mantel mirror in room at Andalusia, residence of Mr. and Mrs. James Biddle, has a white enameled frame embellished with applied, carved, and gilded ornament, in the style made for the *cottage orné*. (*Photo: Cortlandt V. D. Hubbard. Courtesy Antiques Magazine.*)

357

358. French state bed made for Eugénie's apartment at Saint Cloud in white and gold in the style of *Louis XVI à l'Impératrice*. A cartouche with the initial "E" on the front of the canopy is supported by winged *amours* and decorated with pendent swags of natural flowers. (See Fig. 360) (*Musée de Compiègne. Photo: Giraudon.*)

359

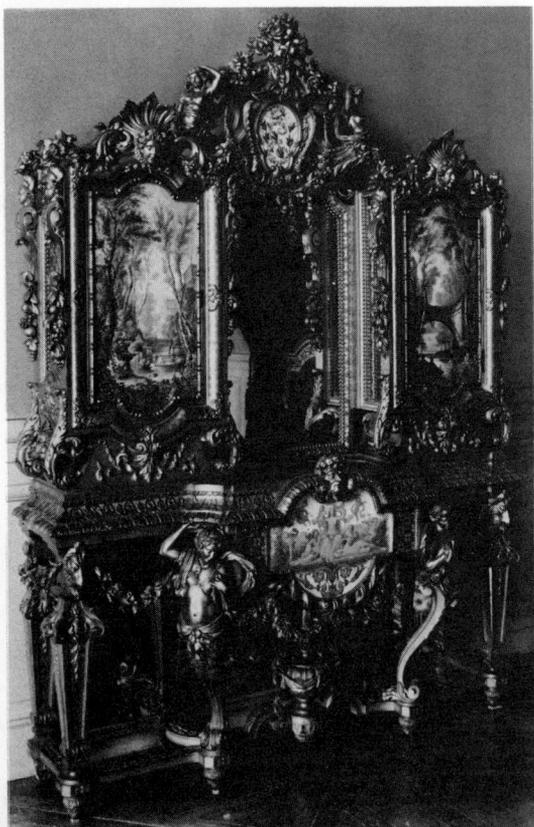

359. The jewel cabinet of the Empress Eugénie at the Palais de Compiègne, of carved and gilded wood, is adorned with mirrors and plaques of Sèvres porcelain. (*Photo: Giraudon.*)

THE RENAISSANCE PERIOD

When Louis Napoleon was proclaimed President of the French Republic in 1848 a change in furniture design was inevitable. Henri Fourdinois, France's leading cabinetmaker, was devoted to the Renaissance, not of the Vitruvian classic orders but of the *Rinascimento* introduced by Palladio in Italy in the sixteenth century. By 1851, at the Great Exhibition in London at which not only French cabinetmakers but also those of other countries exhibited Renaissance furniture, the style had already been formulated.

After 1852, with Napoleon and Eugénie as Emperor and Empress of France, much redecoration of the royal palaces took place. Charles Garnier was the appointed architect and Fourdinois the supplier of furniture. Eugénie cherished an affinity with Marie Antoinette, and she adopted the style of Louis XVI, favoring white and gold furniture with painted panels and ornamentation. The examples produced for her taste were, however, more in the style of Boucher than in that of classical design, and the type became known as *Louis XVI à l'Impératrice*. Eugenie preferred comfort and glamour to the discipline of the classic. Octave Feuillet, whose comedies she enjoyed, described her rooms in a letter he wrote to his wife: "The suite of the Empress consists of two rooms united by a sort of arcade — a dream. . . . Paintings, Flowers, artistic treasures, little corners, niches, retreats, grottoes concealed by drapery behind screens of foliage and flowers, with lamps among the branches."

Eugénie's revolutionary scheme of interior decoration went still further as she introduced *"confortables"* — large settees, easy chairs, and pouffes, thickly padded and upholstered, with no wood showing. With these seating arrangements and many light chairs — *Chaises Volantes* — and tables she produced informal groups, hitherto unknown in royal apartments.

French cabinetmakers — among them Jeanselme, Quignon, and Charles Grohé — made a quantity of Louis XVI furniture during this period. In addition, Renaissance cabinets and commodes — many in ebony inlaid with semiprecious stones — large mirrors, and extremely fine bronze and sculptured lighting standards such as those made by Barbédienne et Cie., contributed to the background of magnificence which set a standard for wealthy Americans who were received and made welcome at court.

The arrival of the new Renaissance style in America was not delayed. In 1850 Andrew Jackson Downing repeatedly referred to it in his *Architecture of Country Houses*. He said, "The French, in their Renaissance style, at present in high favor on the Continent, offer the best

165

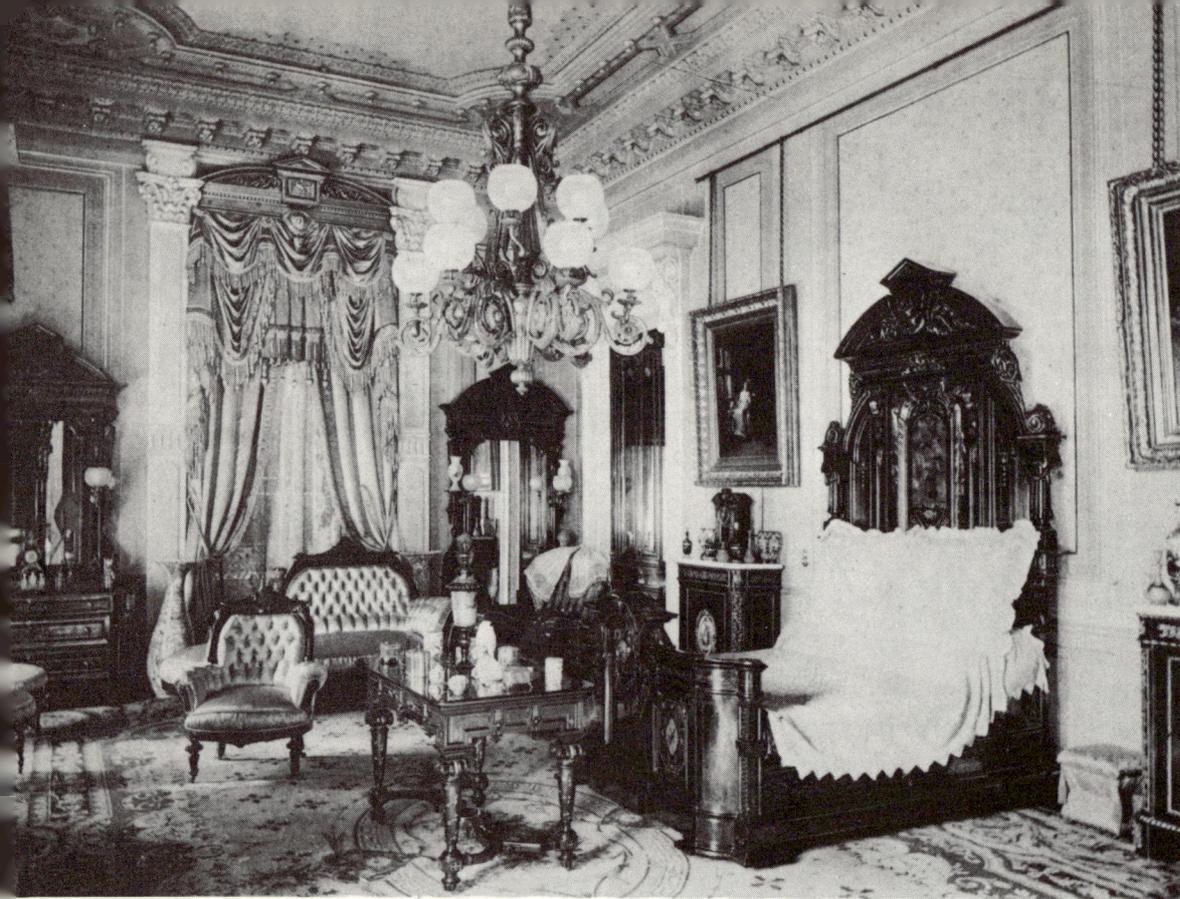

360. Bedroom of the A. T. Stewart house on Thirty-fourth Street. The bed is typical of the Renaissance period. The dressing bureau had drawers and gas brackets; the dressing table was of the Princess type, with a long, low mirror. Marble-topped Boulle cupboards were decorated with porcelain plaques. The American-style chair and chaise longue had carved wooden frames and Pompeian front legs.

361

361. Renaissance bedroom furniture of Napoleon III shown in the Paris Exposition in 1900. The bed, with a separate half-tester attached to the wall, had curtains and coverlet of lace. An "N" and eagle are inlaid on the headboard and classical scenes on the footboard. The French fashion for lace draperies was quickly adopted in America. (*Photo: Giraudon.*)

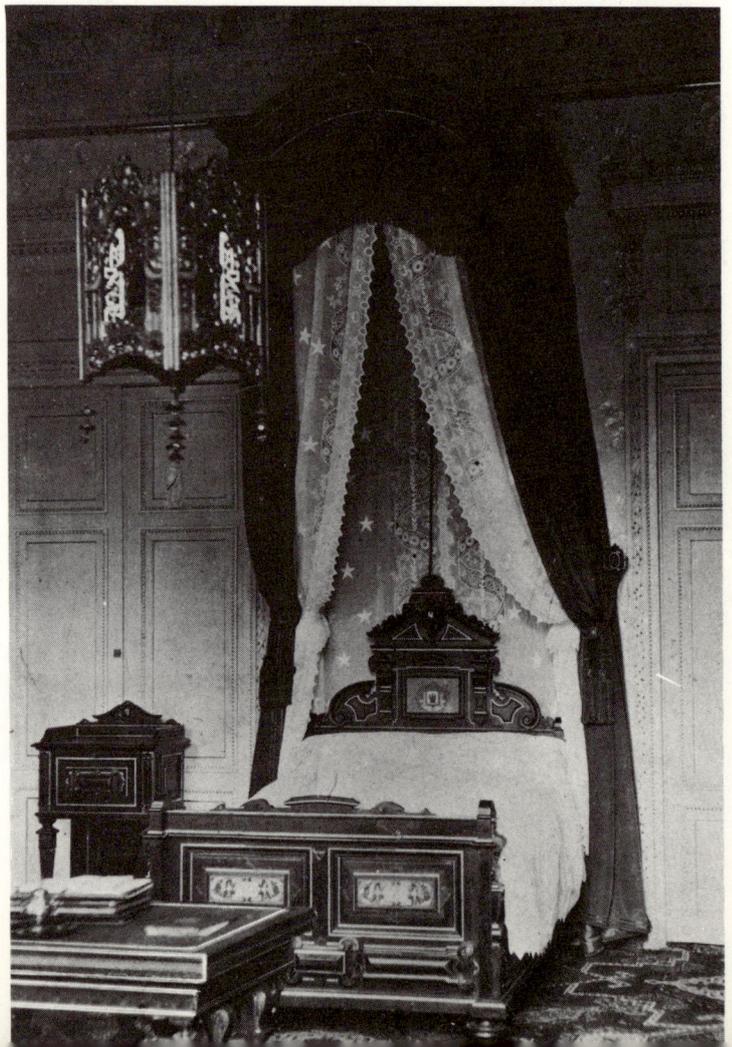

example of it as applied to modern uses. ... French furniture in the same plain modern classical taste is almost universally preferred in this country."

In American Renaissance furniture certain features hardened into a style. Sculptural carvers were not available in sufficient numbers to emulate the French models and so, as a substitute for carvings, panels in burl walnut and machine-carved moldings and ornament were applied. The construction of furniture was rectangular, with arched top, broken pediment, and prominent cresting. There was much use of incised lines, angular scrolls and pilasters, and chamfer stops, as well as fancy columns, colonnettes, and legs of Pompeian style. Oak was used at first, but black walnut was favored throughout the whole period; and as late as 1876, in the Philadelphia Centennial Exposition, some of the outstanding furniture exhibits were still of Renaissance design in black walnut. As in France, many rococo pieces were still made in America during a transition period lasting ten years or more, and ending about 1860.

Among the producers of good furniture in the Renaissance style were the Berkey and Gay Company of Grand Rapids, Michigan, the brothers Christian and Gustav Herter of New York, who specialized in fine carving, and Thomas Brooks and Company of Fulton Street, Brooklyn.

In 1851 the American Institute awarded Charles Volkert a "Diploma for Very Superior carved molding and inlaid work." Two years later numerous entries in the Crystal Palace Exhibition in New York show the new Renaissance trend. Among these examples were a carved oak buffet by Alexander Roux and a sculptured marble mantel by A. Eliaers of Boston. Other "Renaissance" buffets included one designed by Herter and made by T. Brooks and a magnificently carved example by Bulkley and Herter. The trend toward carved decoration is also apparent in an 1853 announcement by F. William Beechmann of Cincinnati, who manufactured "Every Description of Mouldings for Cabinet Makers: Ornamental Sawing: Mouldings worked in Mahogany, Rosewood, Walnut and all fine woods," and again in an advertisement of H. and W. Fry, who offered "Carvings of every description, patterns for Stucco, Cabinet Work, etc."

362

Bedroom Furniture

The Renaissance bed was a welcome change from the French sleigh bed, which had been almost universally used. Characteristic of its design were straight outlines, a headboard with built-up cresting; a low, level footboard; and side boards just off the ground. In New Orleans half-testers, magnificently carved, were introduced by Prudent Mallard, and in New York John Belter introduced Renaissance details into his pierced carving. Manufacturers evolved modified, practical types, and at this time spring mattresses began to be used.

Mr. Godey wrote in his *Lady's Book* in 1852: "There are 2 kinds of bed chambers now in vogue; North, where curtains are not indispensable, low French or couch bedsteads. . . . South, where mosquito bars become a necessity, heavier furniture more frequently found; high posts, finely carved and supporting a cornice of corresponding workmanship."

In 1850 William Clawson and Enoch Mudge, a large, established bedstead factory in Cincinnati, were producing ninety-five varieties of the Renaissance bed, with wholesale prices ranging from $1.35 to $75.00 each. They used black walnut, mahogany, and rosewood for the expensive types; headboards were not mortised with the posts but attached by iron hooks. This factory supplied the principal hotels of Nashville, Memphis, Mobile, and New Orleans.

In 1850 Downing wrote: "Iron bedsteads are now to be had in New York in great variety of patterns, some of beautiful designs. The latter are as dear and not so satisfactory as wood. But simple forms are offered at low prices." At the American Institute Fair in 1851, Hutchinson and Wickersham of 312 Broadway, New York, were awarded a premium for iron beds. At the 1853 Crystal Palace Exhibition an iron bedstead was shown by T. S. Gillies of 308 Broadway, and at the American Institute Fair in 1859, Geo. Schott and J. Lippincott, both of Broadway, won first and second awards for "Sprung Bed Bottoms."

363. Bedstead in Washington Irving's home, Sunnyside, with handsome iron frame cast in a bold design of scrolls, palmetto tendrils, and quatrefoil pierced bands. *(Sleepy Hollow Restorations.)*

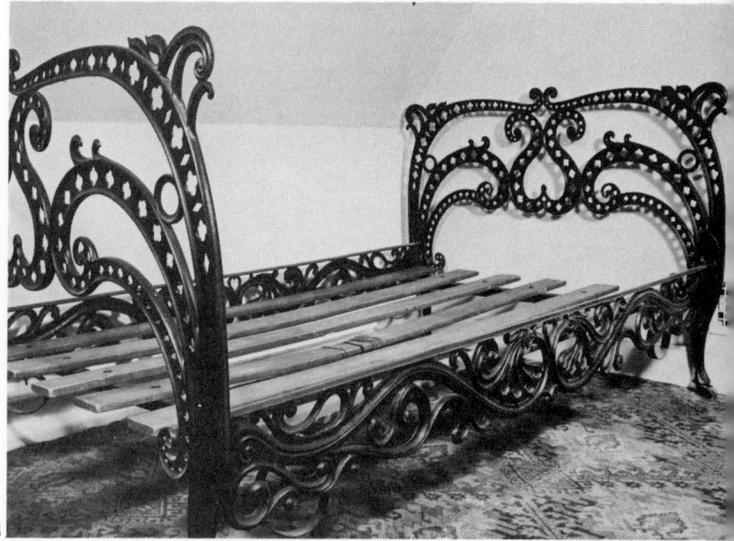

363

364. Four-post bed in rosewood with a full tester and a three-panel headboard. Slender shaft posts are set on short vase and bulb legs. *(Mr. and Mrs. Hyde Dunbar Jenkins, Hawthorne, Natchez.)*

365. Plantation bed with a full tester supported by plain posts with ring and vase sections and heavy legs with Gothic-arch panels. The trundle bed is bobbin-turned. *(Rosalie, Natchez. State Shrine of Mississippi D.A.R.)*

364

365

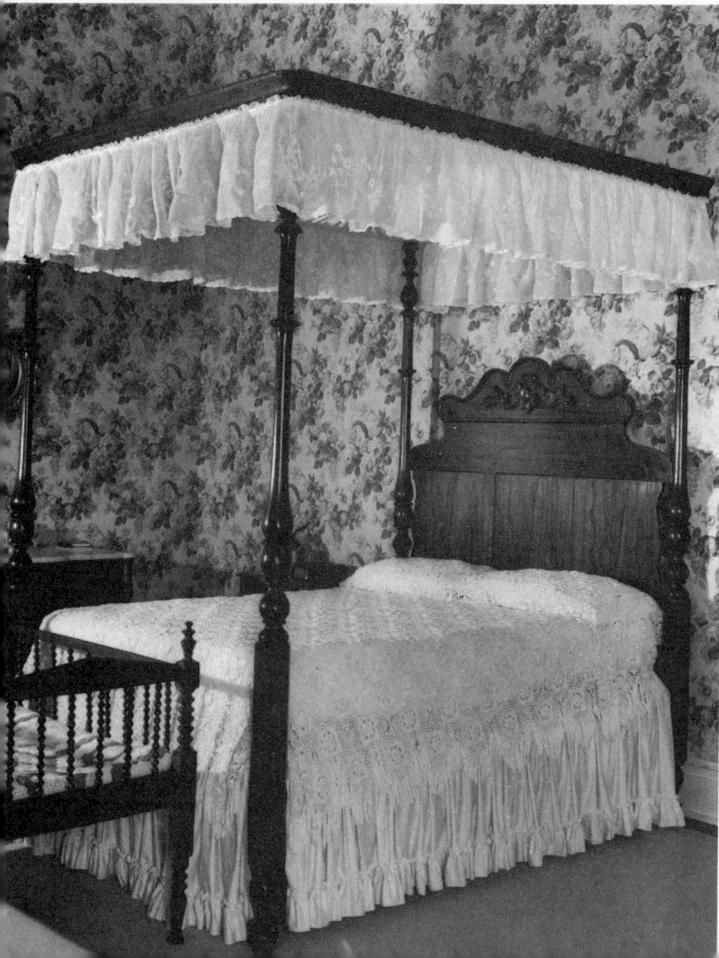

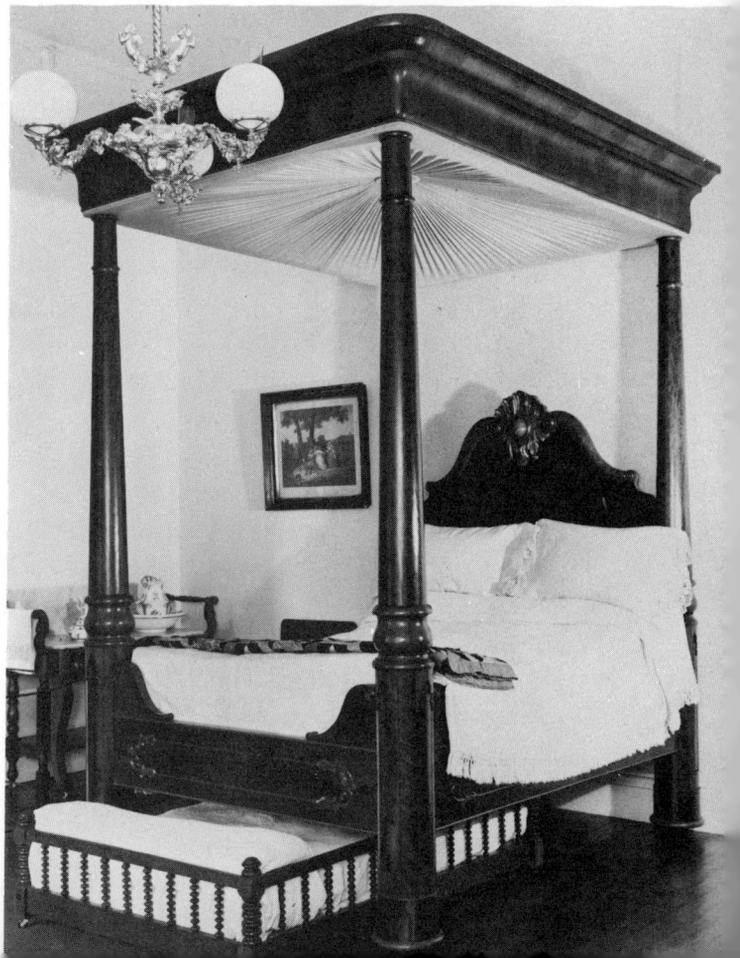

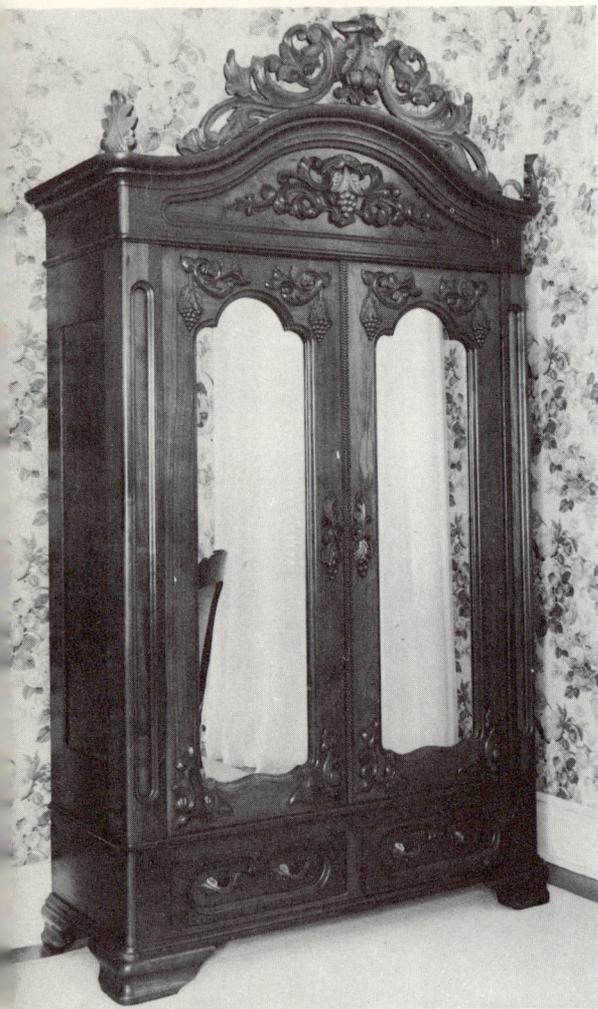

366

366. Two-door wardrobe with carved grip handles, pomegranates carved in the center of the cresting, pineapple finials on the angles, and shaped mirror panels. *(Mr. and Mrs. Hyde Dunbar Jenkins, Hawthorne, Natchez.)*

368

367. Dressing bureau, a good example of American ornate Renaissance style, with pierced and faceted carving and lamp roundels on the mirror frame. The marble-topped base has carved angular pilasters on chamfered corners; applied moldings form panels on the drawers. Carved grip handles were much favored during the 1870s. An 1876 catalogue of Nelson and Matter of Grand Rapids illustrating furniture obviously intended for an expensive market included eighteen variants of carved wooden handles. *(Mr. and Mrs. Hyde Dunbar Jenkins, Hawthorne, Natchez.)*

367

368, 369. Two Andrew Jackson Downing illustrations showing the French style of placing a corona high on the wall with ample draperies to fall over the head- and footboards of a bed placed sideways beneath it.

369

370. Renaissance room with furniture made by Thomas Brooks and Co. of Brooklyn, c. 1870. The bedroom items comprise a large, marble-topped dressing bureau with a practical low mirror, a washstand with drawers and cupboards, a shaving stand and a towel holder of Gothic simplicity. The small cabinet in papier maché is English. The chair is the same as figure 385. The beaded edging to the mantel board and macramé valance and antimacassar are typical of the period. *(Brooklyn Museum.)*

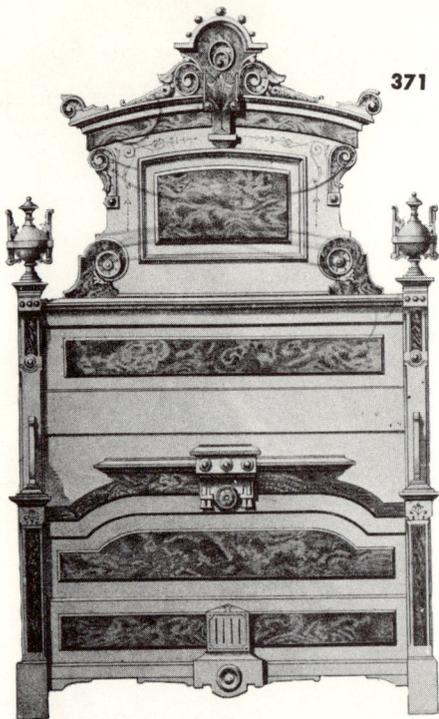

371

372

371. Bed representative of an established good type of commercial American Renaissance furniture; the plain construction is emphasized by applied burl walnut panels, and elaborate pediment and cresting are built up on a capped molding with scrolls and central cartouche. One of a series of advertisements published by Kimball, 1876.

372. Pierre Antoine Bellangé, who specialized in French Renaissance designs, was awarded a medal at the London Exhibition of 1851 for an ebony commode with a marble top, ormolu mounts, and octagonal pilasters on the front angles. Inner corners of the panels on the cupboard doors are broken to form an octagon framing an ormolu panel with a female figure repoussé. (*Musée des Arts Décoratifs.*)

373. Washstand made by Thomas Brooks and Co., with projecting marble top, rounded front angles, and a full-width drawer in the frieze. Molding frames the grapes and vine leaves applied on the recessed panels of the cupboard doors. (*Brooklyn Museum.*)

374. Washstand with applied burl walnut panels on drawers, door, and stiles, and chamfered corners with angular "stops." (*Mr. and Mrs. William E. Herrlich.*)

375, 376. Two pieces of a relatively austere bedroom suite presented by Andrew Jackson Downing. "To show how chaste and beautiful even this style becomes when treated by artists of taste, we give the three accompanying designs, which are excellent specimens of the modern Renaissance school of design." The bed in Figure 362 completes the set.

373

374

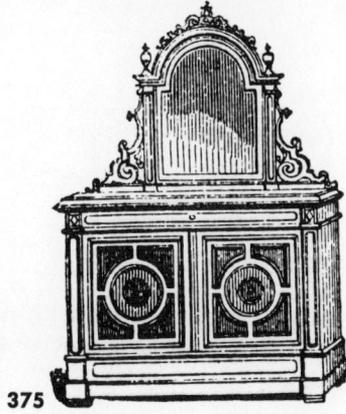

375

377. Jasper-topped walnut dresser, part of a suite made by Berkey & Gay which won a high award at the Philadelphia Centennial Exhibition in 1876. Paneling of the full-width drawers is divided by elaborate escutcheons with depressed circular centers incised with gilt lines. There are attached colonnettes at the front angles; small case drawers extend from front to back. The mirror frame, with roundel lamp brackets, is carved and inlaid with marble. The dentiled pediment is broken by a built-up, carved cartouche and has crossed finials. (*Grand Rapids Public Museum.*)

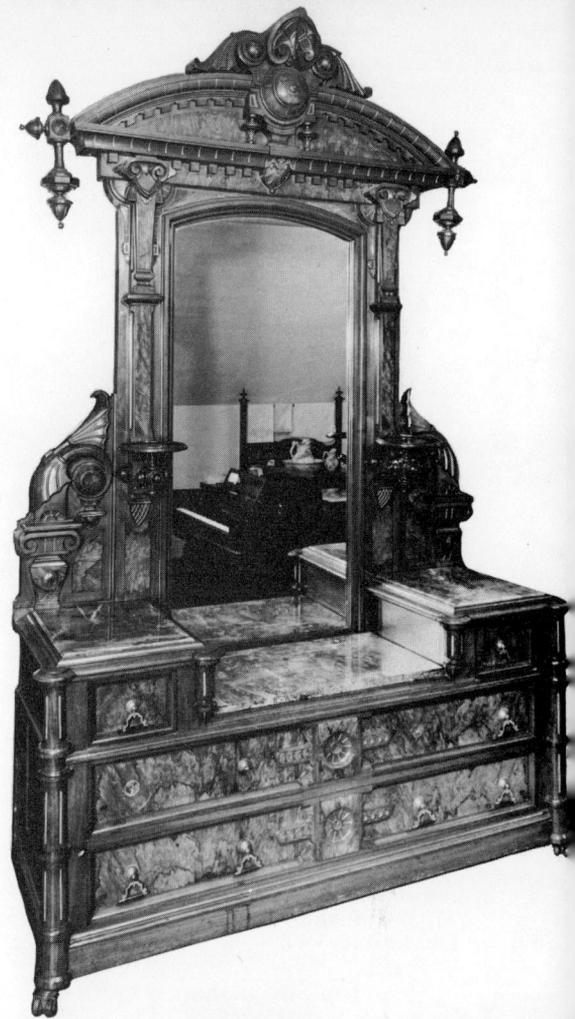

377

378. Two-door wardrobe, with Renaissance features, attributed to François Seignouret, is from the house of F. William Nott of New Orleans. The shaped, peaked pediment has gadroon molding and a scrolled escutcheon in the tympanum; door panels and closing stile are in braid molding; cylinders on the angles of the base are graduated. (*Louisiana State Museum.*)

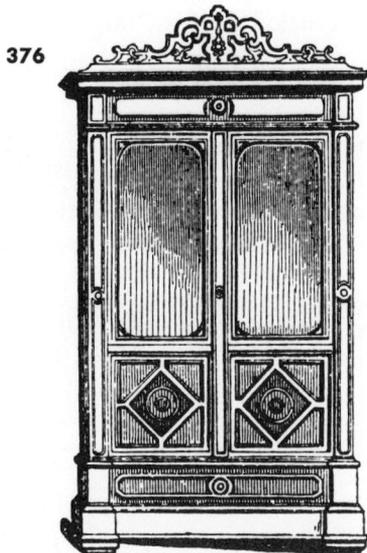

376

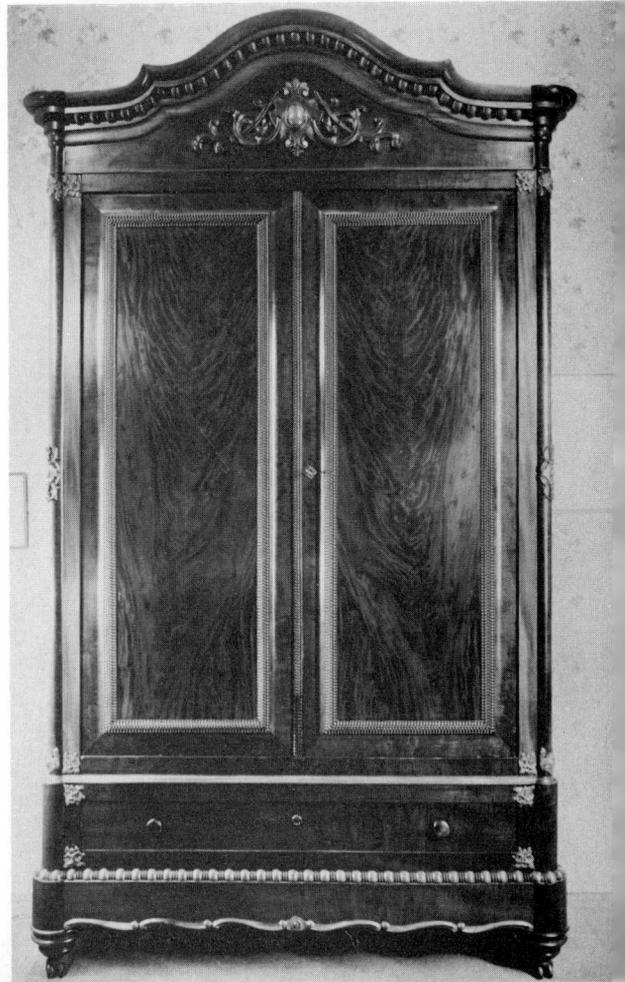

378

The Boulle Style

André Charles Boulle, the great cabinetmaker of Louis XIV, created furniture with metal and tortoise-shell marquetry that has remained unsurpassed. Louis Philippe so favored it that he had a great number of copies made, the best being by Monbro Aîné, who, however, used marble tops. Other versions were chiefly one-door dwarf cabinets with gilt mounts and gilt-framed painted porcelain plaques. During the Second Empire this type was still made, but an improvement is seen in one-door cabinets in dark wood, with marquetry in light woods.

Chairs

Renaissance chairs were generally made with angular backs and U-shaped seats. The front legs were frequently turned posts, but more usual was the Pompeian type that had tapering shanks, either plain or with incised lines, with exaggerated roundels at the top and rings above the toes. Backs were frequently padded, upholstered, and framed with slightly expanded angles at the top and a shaped cresting with some elevation placed in the center. Low brackets from back to seat are frequently seen, as well as armrests of normal height. Wooden backs were generally open with a vertical decorated splat between the stay rail and tablet. On some rounded seats flat bands replaced the usual frame. Apron tabs were much used on the front seat rail. A number of chairs with one low arm were made. The contour chair persisted.

American rocking chairs were exhibited in the Paris Exposition of 1867 and immediately adopted for elegant salons. In 1876 J. Wayland Kimball wrote: "Foreigners call the Rocking Chair a peculiarly American luxury, yet the necessary length of the rocker causes this favorite chair to be occasionally in the way ... certain makers ... built them so that there is no rocker on the floor.... Three firms may be mentioned — M. Schrenkeisen, Frank Rohmer and Co., and Palmer and Embury." Schrenkeisen's advertisement called attention to his "improved patent Rocker ... in various styles, from a low price Ladies' Sewing Chair to the most elaborate Turkish."

George Hunzinger, "Manufacturer of Fancy Chairs, Folding and Reclining Chairs and ornamental Furniture, 141 and 143 Seventh Avenue, New York," illustrated in Kimball's *Album of Designs,* 1876, a "Carved Reclining Chair, frame walnut and gilt, Tufted in Muslin, $44.00. Tufted in Terry, with Marquette or fine Tapestry stripe, $53.33. In Satin with Satin Stripe, Silk fringe in front, $72.00."

A new trend in upholstery is seen in the advertisement of Charles B. Yandell and Co., 744 Broadway, New York, "Art Leather Manufacturer" who received at the Philadelphia Centennial the highest award for "figured leather Work and figured Plush and Velvet."

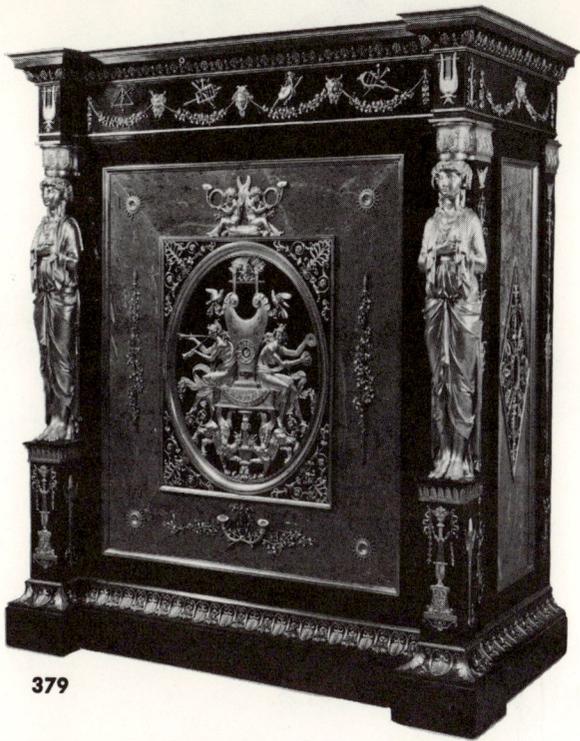

379

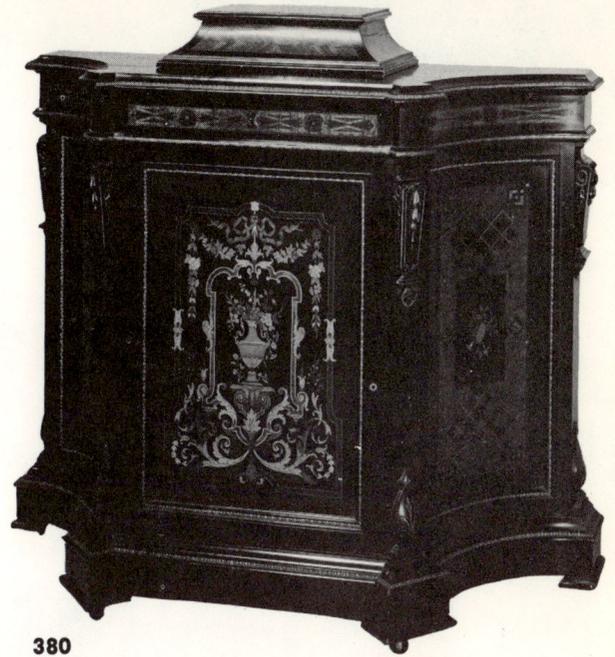

380

379. French nineteenth-century *meuble d'appui* in ebony, with marble panels and ormolu mounts, probably made during the reign of Louis Philippe. A special company of cabinetmakers under the direction of Belfort was employed to repair and copy furniture for the royal rooms. (*Victoria and Albert Museum, London.*)

380. Nineteenth-century American dwarf cabinet of ebonized walnut designed in the Boulle manner. A one-door cupboard with concave ends forms a projecting front. Satinwood marquetry panels are outlined by ornamental metal strips. (*Brooklyn Museum.*)

381. Walnut dwarf cabinet. The door is glazed in four panels, with a wooden roundel carved with a fruit border and a female head superimposed on the center. Shaped panels are applied on the ends of the cabinet. (*Philadelphia Museum of Art.*)

382. French dwarf cabinet inspired by those made by André Charles Boulle, with diagonal veneer in palisander and lemonwood marquetry, in the Renaissance style of Napoleon III. (*Musée des Arts Décoratifs.*)

381

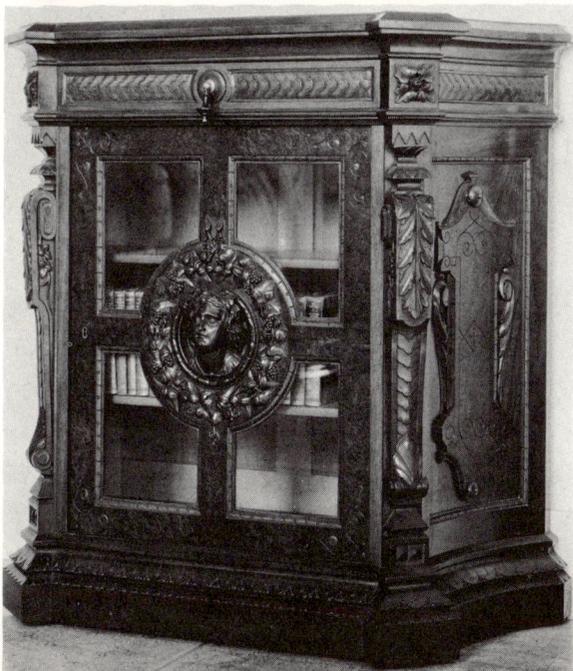

382

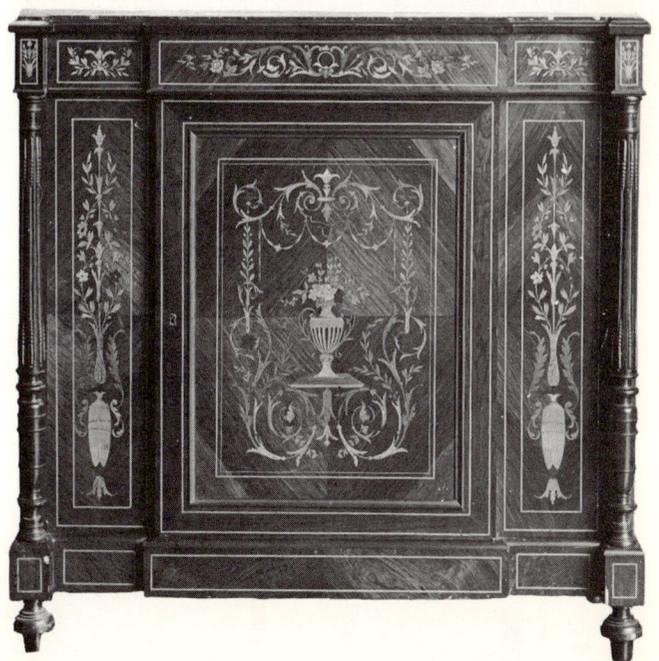

383

384

385

383 and 387. Easy and side chairs made in walnut by Thomas Brooks, 1872. The back framing is plain with scroll-carved uprights, its cresting a roundel and escutcheon flanked by dolphins. The front seat rail is divided short of center with patera-carved roundels. Upholstery is deep and the sides of the boxed seats and arm rests "puffed," a term used by Kimball in his advertisements. (*Brooklyn Museum.*)

385. Typical Renaissance side chair with incised and carved ornament, a hooped back, expanded corners, and a vertical splat with a roundel center. The seat rail has a central ornament, and the front legs are Pompeian. (*Mr. and Mrs. William E. Herrlich.*)

384. French Second Empire prototype of this low, velvet-covered chair had the same deep seat and padded panel on top of the uprights but was without arms and the spindle stay rail. (*Brooklyn Museum.*)

386. On a Renaissance cane-seated walnut chair, made by Thomas Brooks and Co., the back uprights are angular, and a panel set high between them has a shaped grip cresting. (*Brooklyn Museum.*)

386

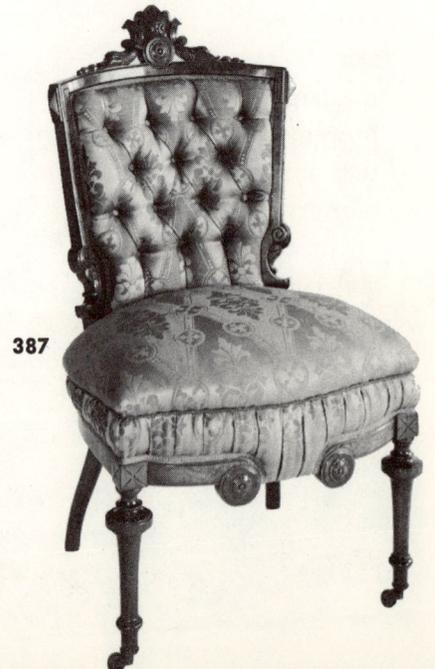

387

388. Gilt mirror framed in a congeries of moldings. (*Brooklyn Museum.*)

Mirrors

After the lavish use of large mirrors in richly carved frames during the rococo period, the tall, narrow, severely rectangular console and pier type of Renaissance mirror seems almost austere. Console and pier tables were frequently diminished to small shelves, about a foot from the ground. In the hall or stairway a jardiniere trough was sometimes used.

Overmantel mirrors were full width, proportionately high, and were frequently enclosed in an architectural framing.

Oval mirrors were made in great quantities, the frames ranging in elaboration from plain moldings with slight ornament to a congeries of moldings, some carved with sprays of natural flowers and leaves. Walnut and rosewood — real or simulated — were used, but most frames were gilded over gesso. Some of the large gilt oval mirrors were hung horizontally.

In 1853, mirrors in cast-iron frames were advertised.

In 1855 S. J. Sigler, 67, 69, and 71 Forsyth Street, New York, advertised in the *Price Current Weekly* of Cincinnati: "Looking Glass and Picture Frame Manufactory; being probably the largest and most extensive establishment of the kind in this country, with the many improvements recently made in his machinery, enable him to sell his articles at less prices than that of any other manufacturer . . . On hand Rosewood, Walnut, Mahogany and Gilt Mouldings of every description."

In 1863 the following advertisement appeared in Williams' Cincinnati directory: "Holstein and Hammer, Manufacturers of Oval frames, suitable for cabinet makers and others, which we are making on our improved Oval Machine, for which Letters Patent were granted on the 11th day of March, 1862, to Holstein and Hammer, the inventors thereof. 31 Smith Street, Cincinnati, Ohio."

389

391

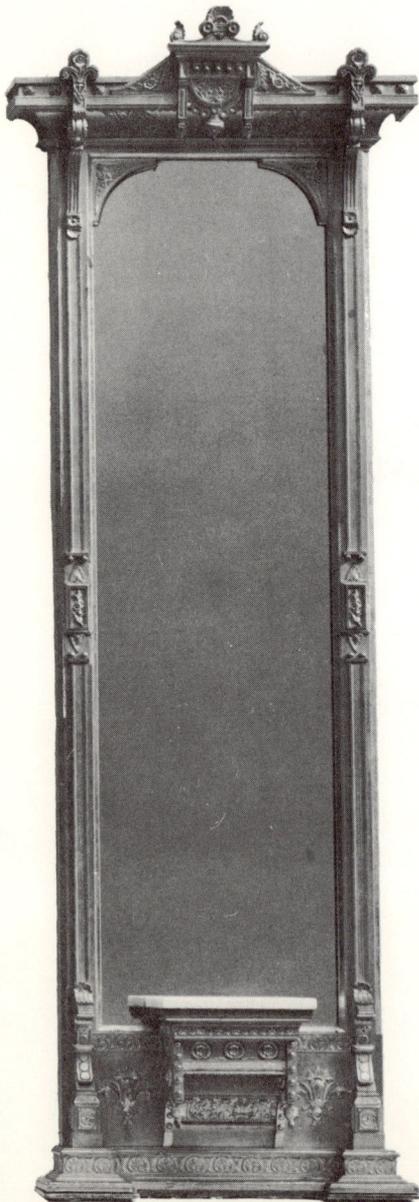

390

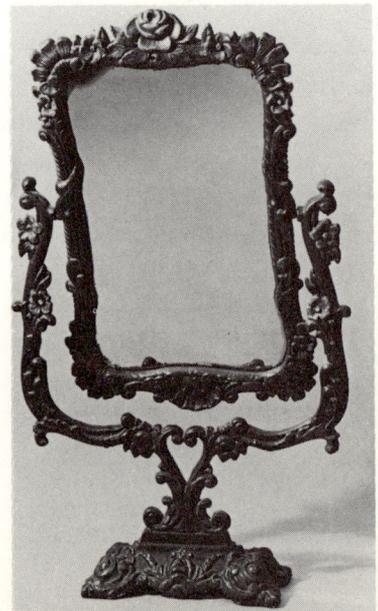

392

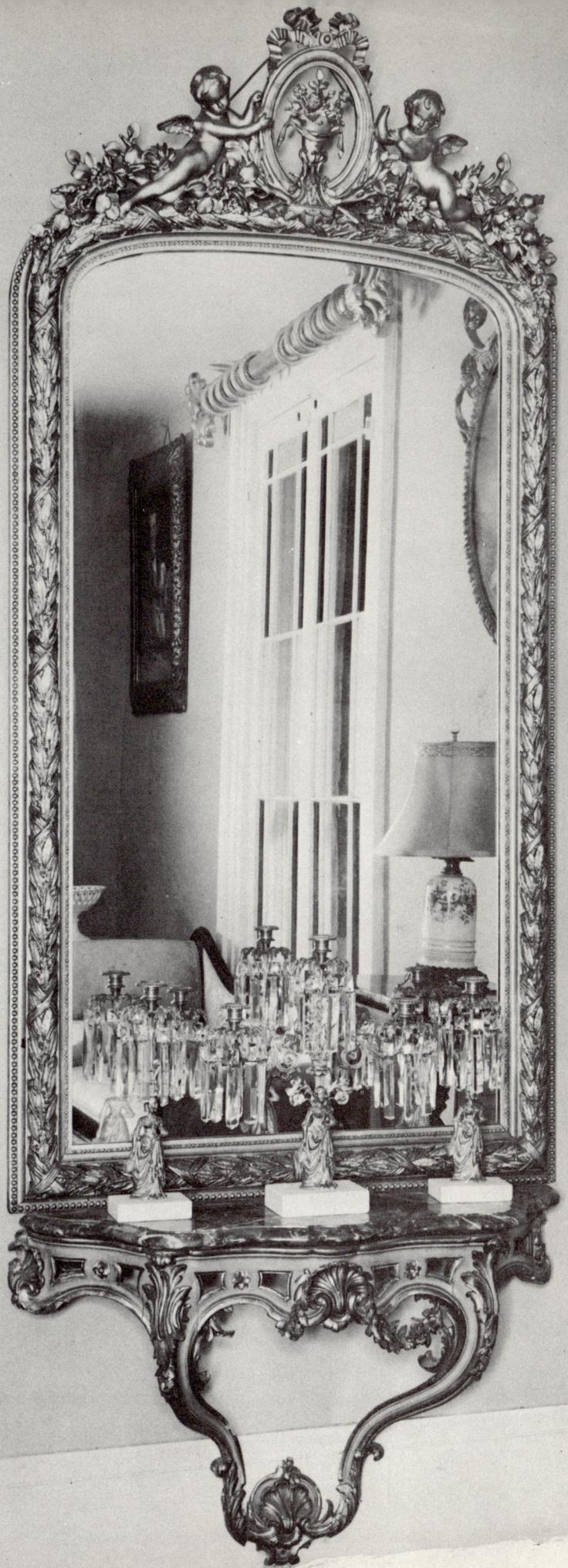

389. Small octagonal wall mirror with a frame composed of plain beveled panels alternating with panels finely painted with birds, flowers, and foliage. A mirror of this type was exhibited by Barbédienne of Paris at the Great Exhibition in London, 1851. (*Philadelphia Museum of Art.*)

390, 391. Two examples of the Renaissance console mirror, each tall and narrow. The stiles are ornamented at top, bottom, and center; a panel at the base rests on a stepped plinth. In the mahogany example (391) at the Brooklyn Museum, ornament is chiefly incised lines, gilt, and the cartouche cresting has broken-rounded capping. On the Metropolitan Museum gilded mirror (390) ornament is confined to details carved in low relief.

392. Dressing mirror at Sunnyside. The painted cast-iron frame is set on a domed oblong base with boss and cartouche corners in the Renaissance manner. (*Sleepy Hollow Restorations.*)

393. Arch-topped mirror hung over a marble-topped wall console supported by a white and gold bracket, paneled in the Renaissance manner. A cresting composed of natural cherubs, flowers, and ribbon, in the style of *Louis XVI à l'Impératrice*, crowns the mirror frame. A similar bracket shelf and a shelved *encoignure*, both attached to the wall, made by George Platt of New York, were illustrated by Downing in 1850. In 1878 Williams and Jones described a "Pier table — now superseded by the mirror bracket, gilded and marble topped." (*Mrs. Joseph B. Kellogg, The Elms, Natchez.*)

393

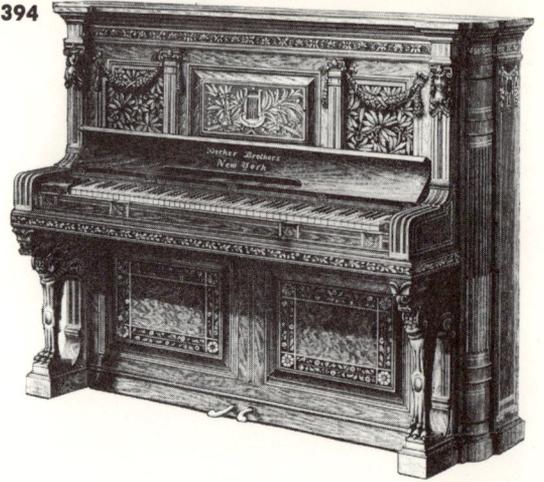

394. Decker Brothers, among the foremost piano makers of New York, exhibited this piano at the Centennial Exposition, 1876. It provides a good example of the manner in which American manufacturers modified Renaissance design and construction. The frame is basically simple, with pilasters, stylized monopodium supports, and restrained carving. Fine marquetry is shown in the banding and the panels of walnut, white holly, and satinwood.

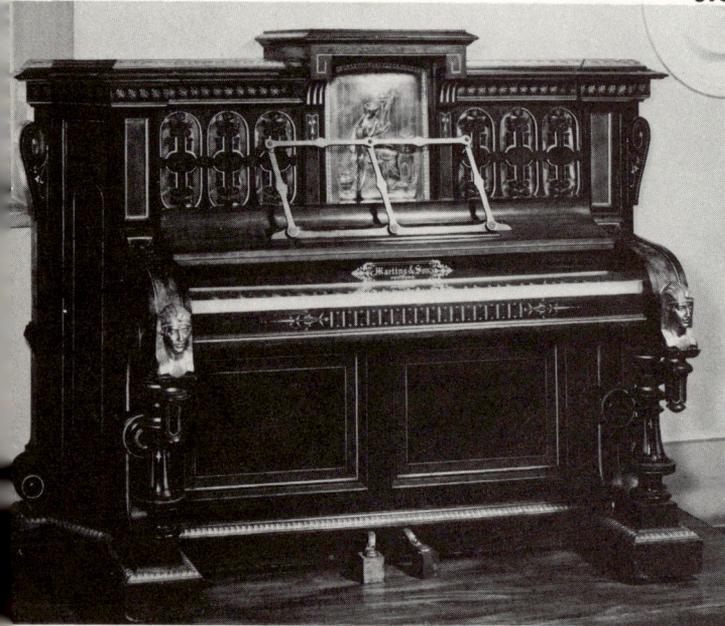

395. Striking and original design for an ebonized piano case with panels of burl walnut was used by Martins and Son, New York. Over the keyboard is an adaptation of the Renaissance linked ellipse; in the center, its top elevated and capped, is a metal panel repoussé with the faithful Penelope unraveling her weaving. The base has two plain panels, with the end section of its gadroon-edged plinth providing a base for Renaissance baluster legs. (*Brooklyn Museum.*)

Musical Instruments

In 1850 Andrew Jackson Downing wrote, "The piano forte is universal in the American drawing room or parlor." A year later, an improved patent piano melodeon, made and patented by George A. Prince and Co., was on sale in New York, Buffalo, and Cincinnati, where Colbourn, Field and Swett, and Baker and Co. advertised pianos and musical instruments. In 1853 Steinway and Sons established their firm in New York.

At the Crystal Palace Exhibition in New York in 1853 there were numerous pianos, all apparently in carved rosewood cases with the exception of a "magnificent piano-case in mottled oak with a richly carved plinth" by Wm. Hall and Sons. One, made by Jean Laukota, had keys of mother-of-pearl and tortoise shell. Makers included Hallet, Davis and Co., Grovesteen, J. Ruck of Boston, and Hazelton Brothers and McDonald, who introduced a new reed arrangement called the "Euterpean Attachment." There were various types of musical instruments — viols and violins, clarionets, banjos, guitars from Pennsylvania, and flutes.

The Grovesteen family is notable in American piano manufacture, the name being mentioned at intervals from 1838 to 1870, sometimes with associates. Their entry in the Crystal Palace Exhibition was "2 piano fortes in Rosewood and Papier Maché, by Grovesteen and Co., Manu. 48 Broadway."

396. The rosewood case of a grand piano by R. Nunns and Clark, New York, 1838–1858, carved with ornament and cupids, each corner being decorated with a vase of flowers in full relief. The legs are massive Renaissance cluster columns. The keys are of mother-of-pearl and tortoise shell, and the pedals are silver. Inside the cover there is a small medallion portrait of Victoria and Albert, probably added for the London Exhibition of 1851, at which this instrument was awarded a prize. (*Metropolitan Museum of Art.*)

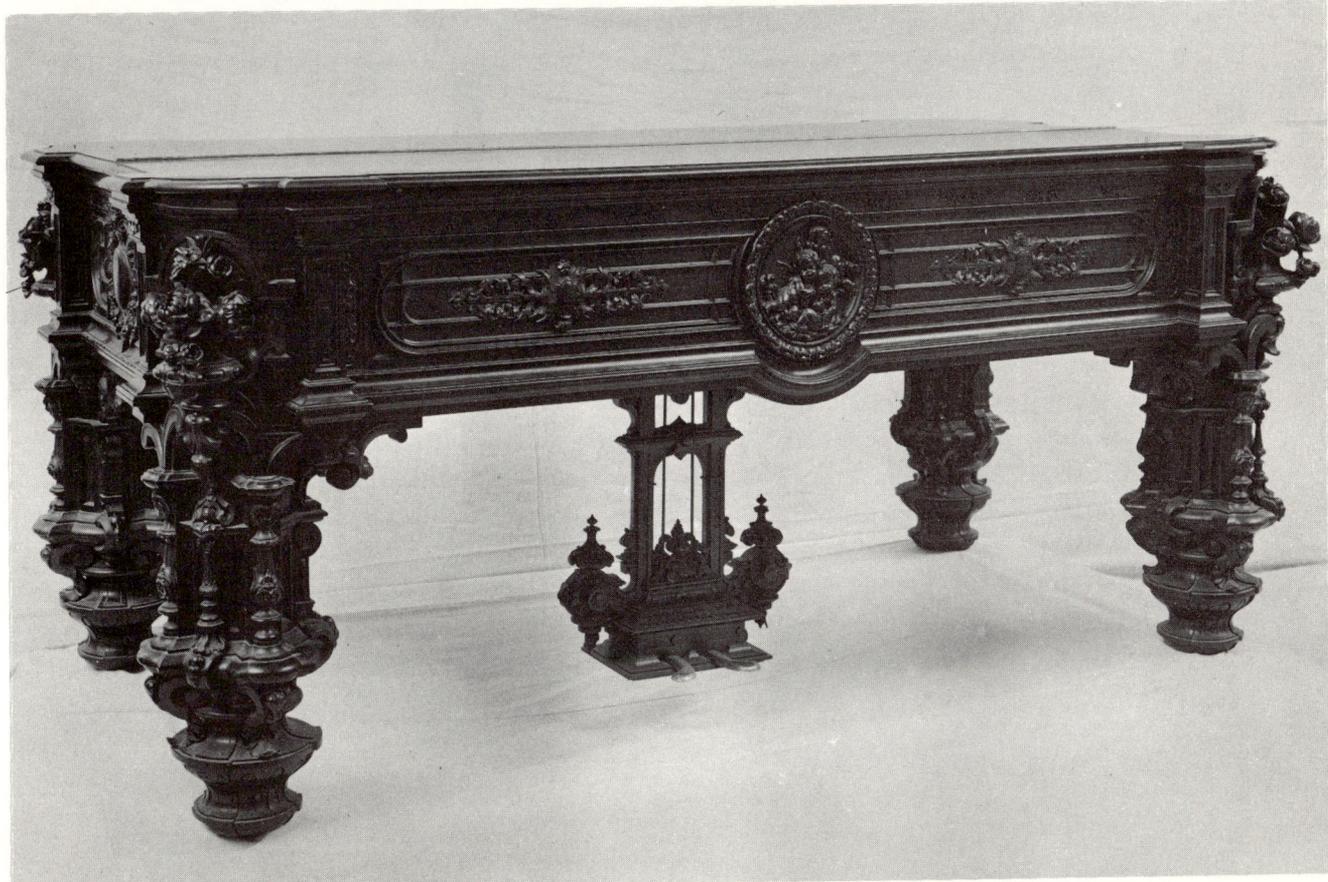

Secretaries and Desks

The secretary bookcase seemed to revert to the old type of slope-front desk, but on a two-door cupboard base instead of drawers; or it was a fall-front desk over a cupboard base. The bookcase was introduced as a separate item.

Flat-topped writing tables were much used, the top covered in cloth or leather, banded with wood. In France, the successful author, Augustin Scribe, whose decoration and furniture caused a sensation, had a large and massive study table, "like that of a lawyer."

In 1876 J. Wayland Kimball of Boston advised that a library table to be covered in cloth might have tiles made by C. R. Yandell and Co. in four different patterns inserted at the corners, the usual finish or bordering of narrow leather carried around the whole.

For ladies davenports were introduced — small, sloping desks on a pedestal of drawers, generally in walnut or rosewood.

Settees

The Renaissance settee was rectangular with a straight back and seat and lower, shaped arms set at right angles to it. The framing of the back was an adaptation of a chair back, and the four legs were turned posts or Pompeian.

The *méridienne* disappeared and was replaced by conversationals and by one-armed chairs — a new feature, taken from French models. Ottomans were preferred; the center ottoman replaced the center table; settees were placed with small tables and chairs in informal groups.

As seat furniture became increasingly opulent, upholstery was made in complicated designs trimmed with gimp and fringe and with elaborate "puffing" on open arms and seat rims. Seats were generally plain.

In 1856 F. A. Vrede and B. Kippert of New York advertised themselves as the "Largest Establishment of its kind in the City — Chairs and Sofas for the trade in the U.S."

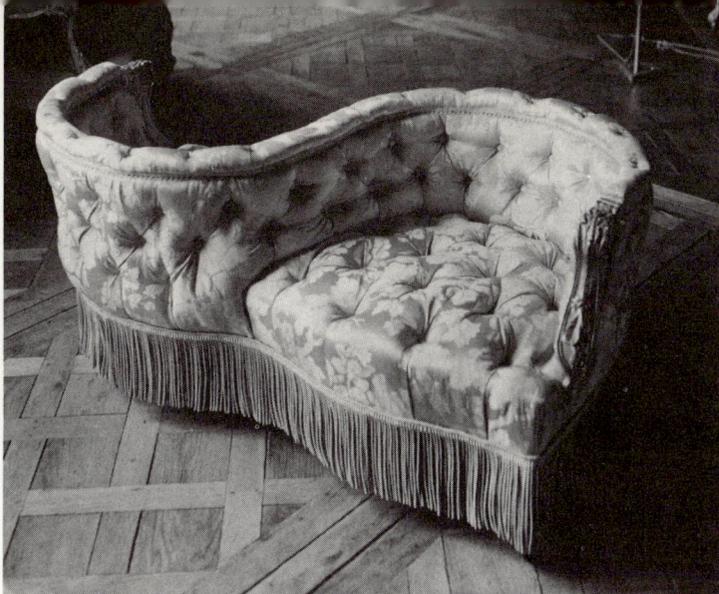

397

397. Conversational in the style of Eugénie's *"confortables."* The only wood showing is the carved facings on the arms. (*Palais de Compiègne.*)

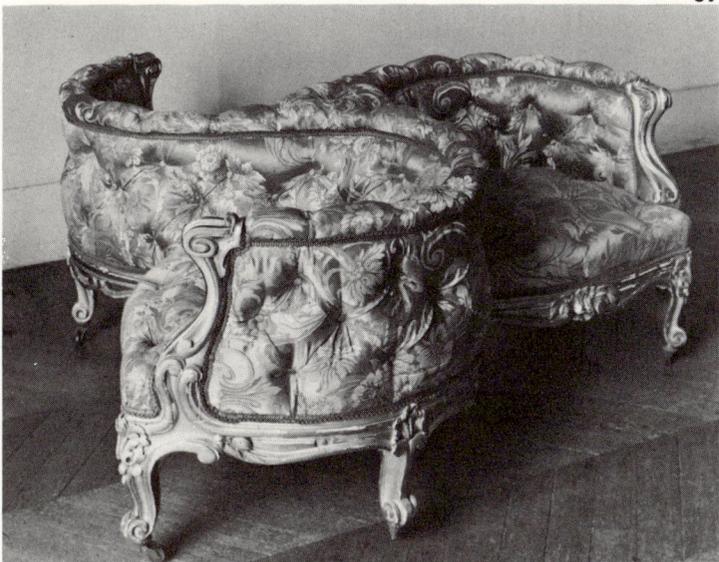

398

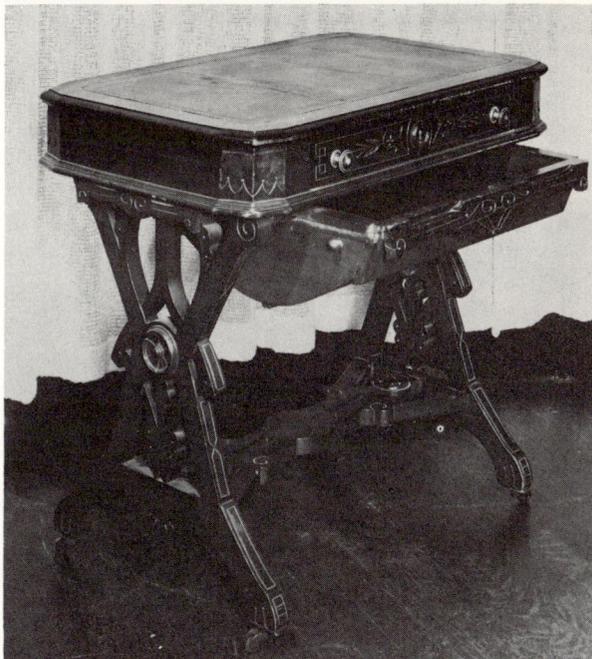

399

398. The *"indiscret,"* a new type of conversational ingeniously seating three, was included among Eugénie's *"confortables."* (*Musée des Arts Décoratifs.*)

399. Small combined secretary and sewing table with a writing drawer in the frieze above a slide holding a wooden trough for sewing materials. The *cheval* base is in typical angular Renaissance design, with applied burl panels and complicated flat-section standards and stretcher. (*Grand Rapids Public Museum.*)

400

400. Settee, heavily padded and upholstered, showing no wood except the carved supports of the back, is in the typical Second Empire manner. The edge of the seat is "puffed" and finished with fringe, gimp, and tassels. (*Grand Rapids Public Museum.*)

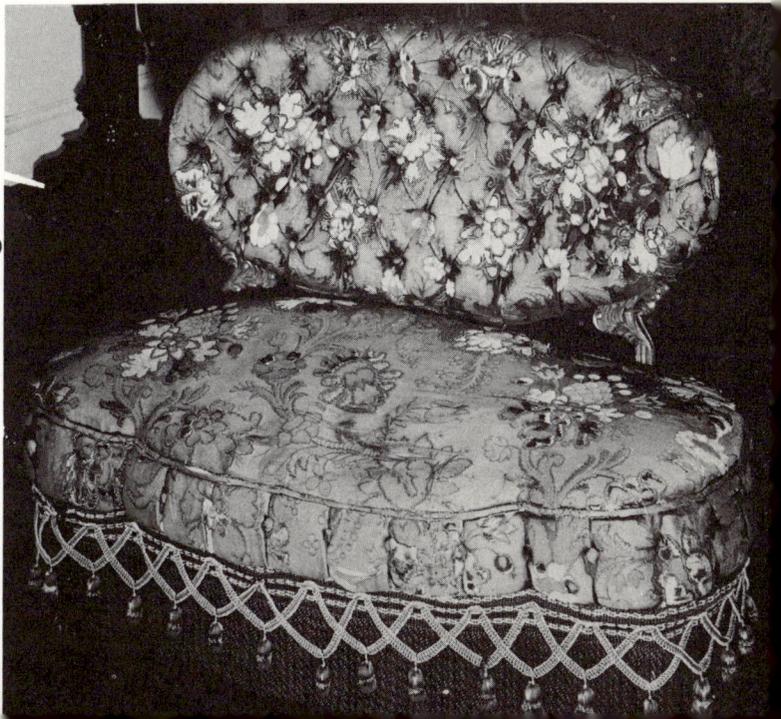

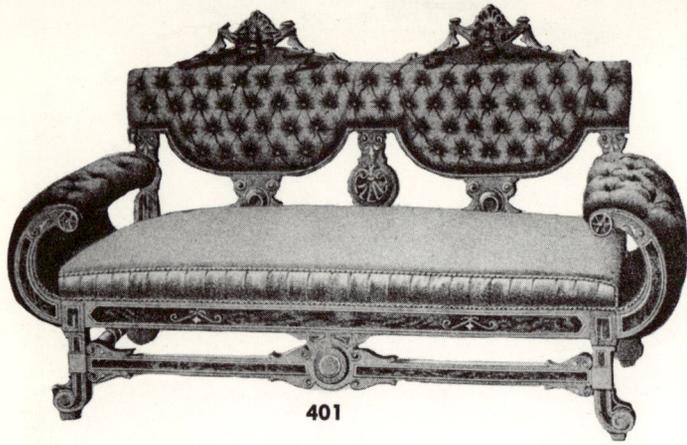

401

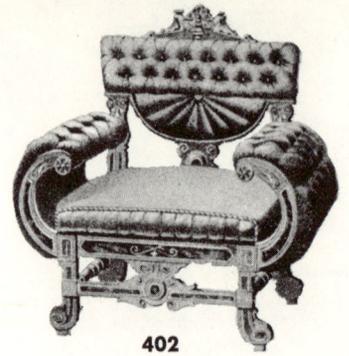

402

401, 402. Illustrations from Plate 4 of J. Wayland Kimball's *Album of Designs*, 1876. Specifications for the chair by George Hunzinger were: "Chair in Walnut, $18.67. Upholstered with Star in different color Satin, $40." The back of the settee is an adaptation of the back of the easy chair, with angular facings to the arms, seat rail with pendent tabs, and Pompeian front legs.

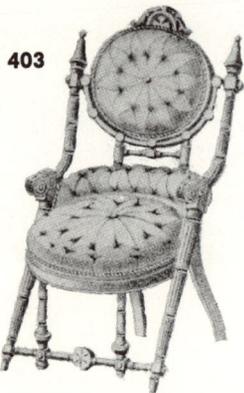

403

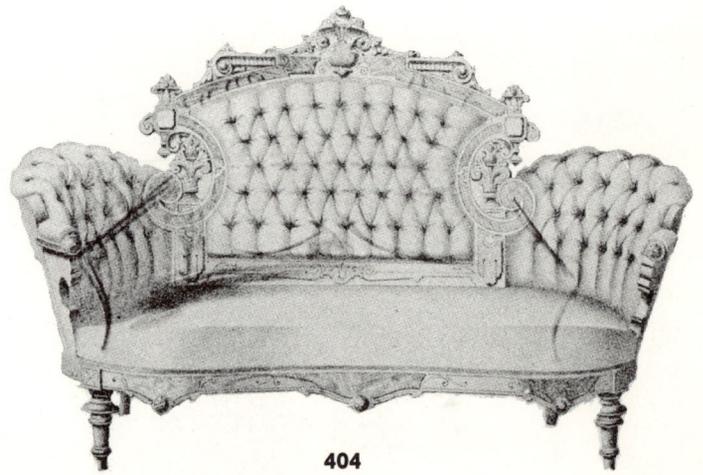

404

405

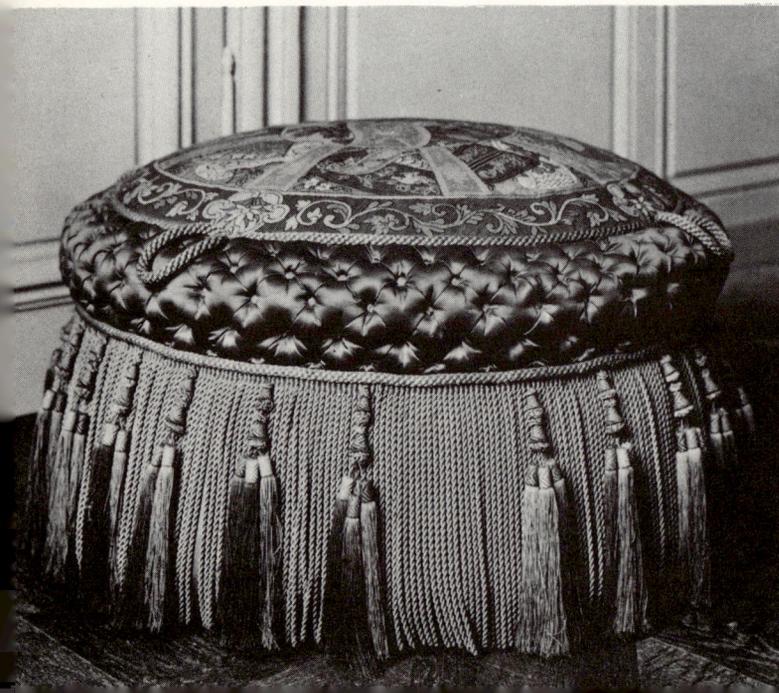

403, 404. Settee and arm chair from a "Parlor Suit" advertised by Barmitz & Diehl, 80 Broadway, New York, in Kimball's *Album of Designs*, 1876. Upholstery could be in terry, plush, or coteline.

405. A typical specimen of the *confortable* pouffe introduced by Eugénie to allow crinolines full play. (*Palais de Compiègne.*)

406. Wicker chairs were introduced at the French court for use in Eugénie's informal furniture arrangements. On this beautifully woven French chair — a diminished *méridienne* — a substantial apron shows Second Empire influence. (*Mrs. Bertha Hinshaw, Lake Wales.*)

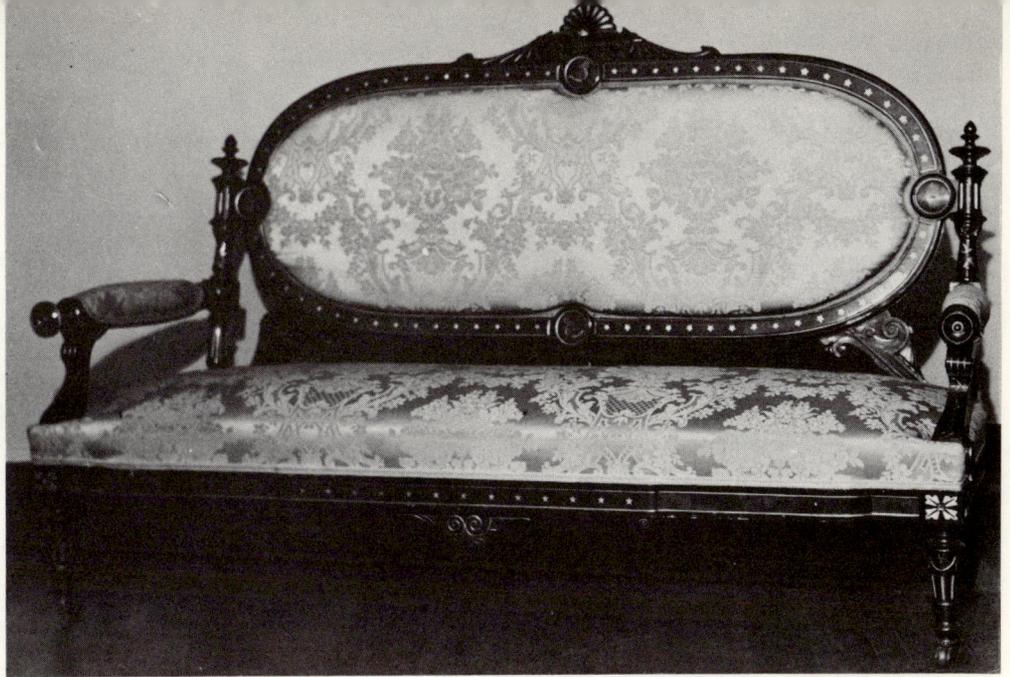

406

407

407. Settee, part of a set with a table and four chairs, made in 1875 by Léon Marcotte for John Hill Morgan of Brooklyn and awarded first prize at the Philadelphia Centennial in 1876. Amboina bands on the mahogany frame are inlaid with mother-of-pearl stars and slight details in marquetry. Butterflies matching those on the chairs are inlaid in colored wood on the four roundels on the elliptical frame of the back. Butterflies and mother-of-pearl stars are said by Edith Hall Bjerkoe to have been used by Léon Marcotte. (*Museum of the City of New York.*)

408

408. Settee showing the typical treatment of a chair-back used in the center of the back. The front seat rail has a pendant, and the legs are Pompeian. (*Mrs. Bertha Hinshaw, Lake Wales.*)

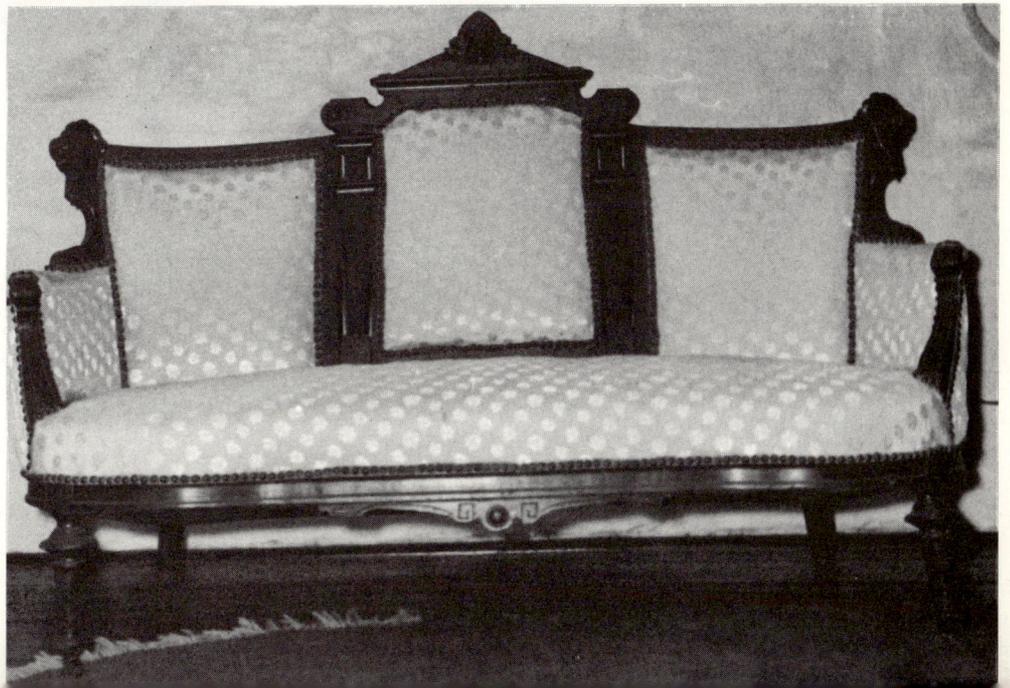

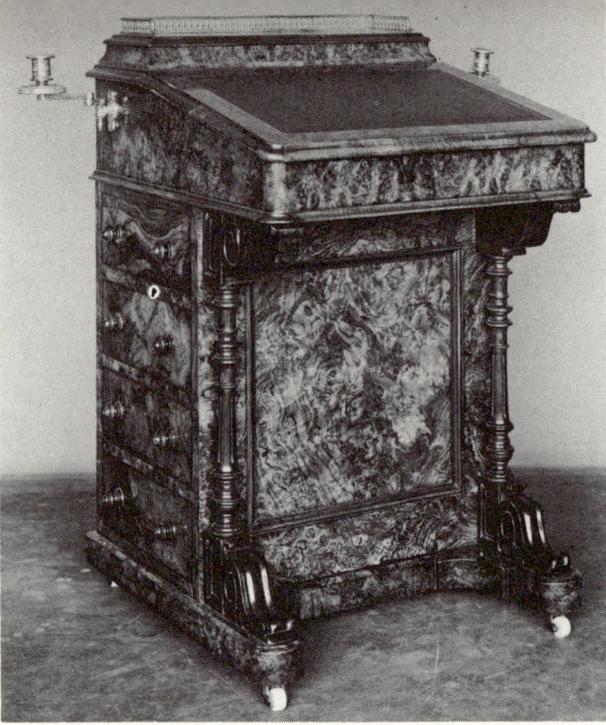

409. Typical English davenport in veneered walnut construction. Colonnettes with scrolled brackets at the top and base support the writing section. (*Victoria and Albert Museum, London.*)

410. Fine quality fall-front French *secrétaire* designed in the style of Louis XVI, adorned with ormolu plaques and mounts, has a marble top and is signed F. Piret — a nineteenth-century cabinetmaker. (*Victoria and Albert Museum, London.*)

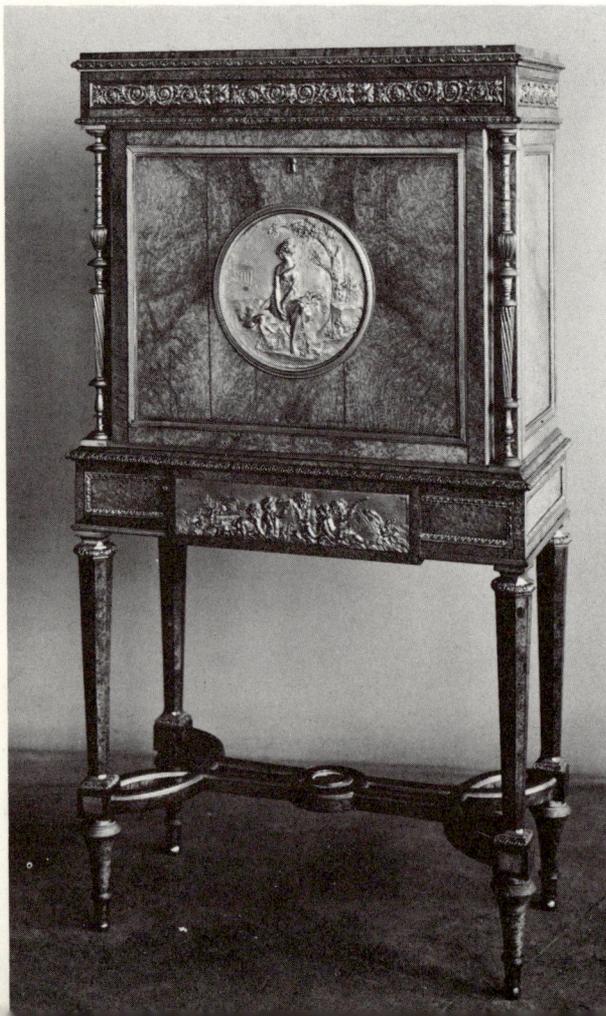

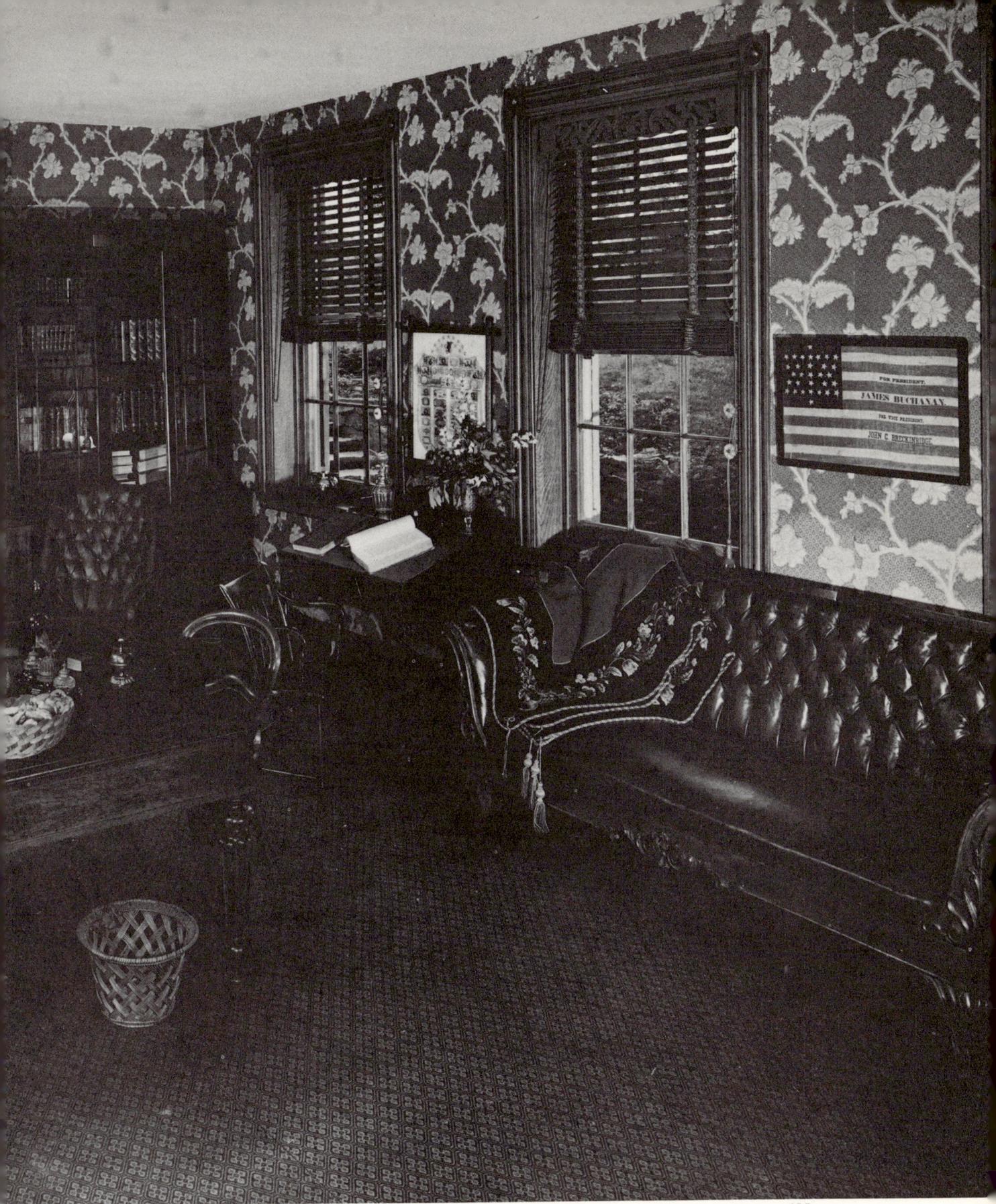

411. Study of President James Buchanan at Wheatland. The writing table with drawers in the frieze and sturdy tapered legs with vase feet, was a popular type; the top, banded with wood, is upholstered with leather. The convenient, slope-topped desk is covered with felt. (*James Buchanan Foundation, Lancaster, Pa.*)

Sideboards and Tables

American Renaissance sideboards are generally practical and of good design and far removed from exhibition monstrosities, although in the 1853 Crystal Palace Exhibition Bulkley and Herter's magnificently carved oak buffet inspired the official comment, "space sacrificed to show."

The developed commercial type was fitted with two or three drawers in the frieze above two or three one-door cupboards resting on a plinth; wooden backs were paneled, with a shelf or shelves and a broken pediment and cresting.

In Kimball's *Album of Designs*, 1876, some makers included in their dining-room furniture the equivalent of the French *desserte* — a set of open shelves with corner posts — as a "dinner tray" or "side table." In England it was called a "dinner wagon" and became a staple in restaurants. In the same issue Kimball notes with regard to marble tops on sideboards: "It is much the best way to finish sideboards in wood. Marble is uninviting and cold in appearance, besides being a constant source of noise and danger to crockery and glass, unless these are placed with utmost care."

The construction of tables supported by a pillar base changed considerably. Tops were generally circular or shaped oblong; the pillar base was set on a cross with four supports rising from its points to the table; or there were four flat-section curved legs attached to the pillar and four corresponding supports. A change is seen in the use of the short pillar with pendent finial. In 1876 Kilian Bros., 157 and 159 West Thirty-second Street, New York, advertised a great variety of inlaid tables. "By direct importation we are enabled to furnish a large assortment of inlaid tops of new and attractive designs which we can offer at very moderate prices."

412. An oval marble-topped table made by Thomas Brooks is set on a short baluster pillar resting on a square block with a pendent finial. Shaped angular sections attached to the block form legs and supports. (*Brooklyn Museum.*)

413. Carved oak sideboard shown by Jackson and Graham at the Great Exhibition in London in 1851 is the English version of the Renaissance style, derived from the Elizabethan interpretation of Palladian design. The carved trophies of fish and game on the doors were often favored for Renaissance sideboards. Jackson and Graham were in the first rank of British cabinetmakers: in the Paris Exposition of 1867 "honors [were] divided between Fourdinois and Jackson and Graham of London; never had marquetry been brought to such perfection." (*Victoria and Albert Museum, London.*)

413

412

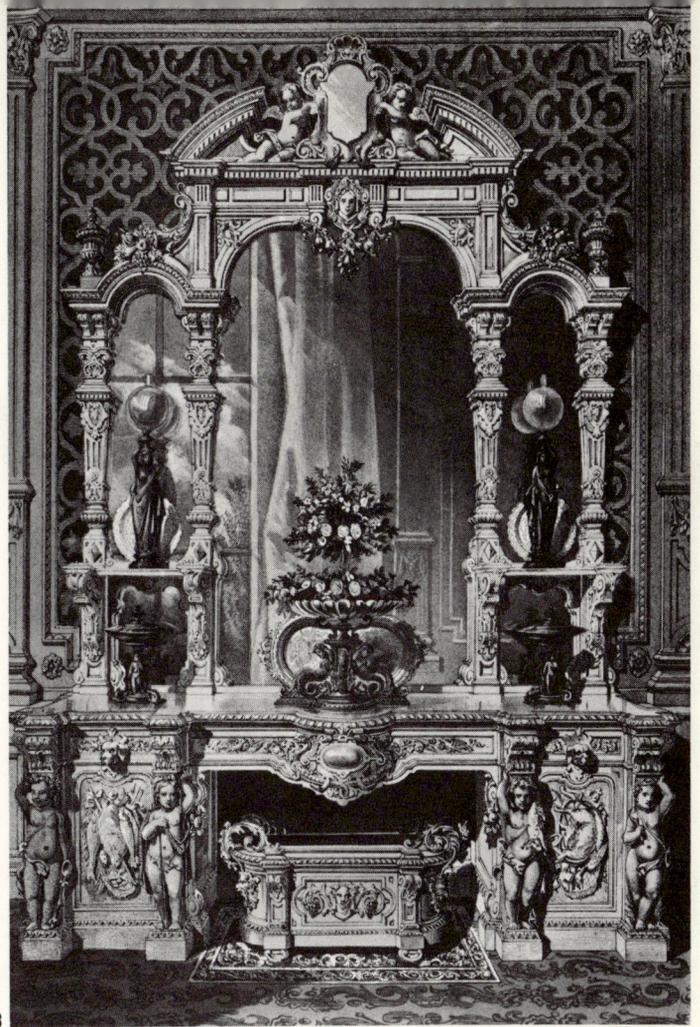

414

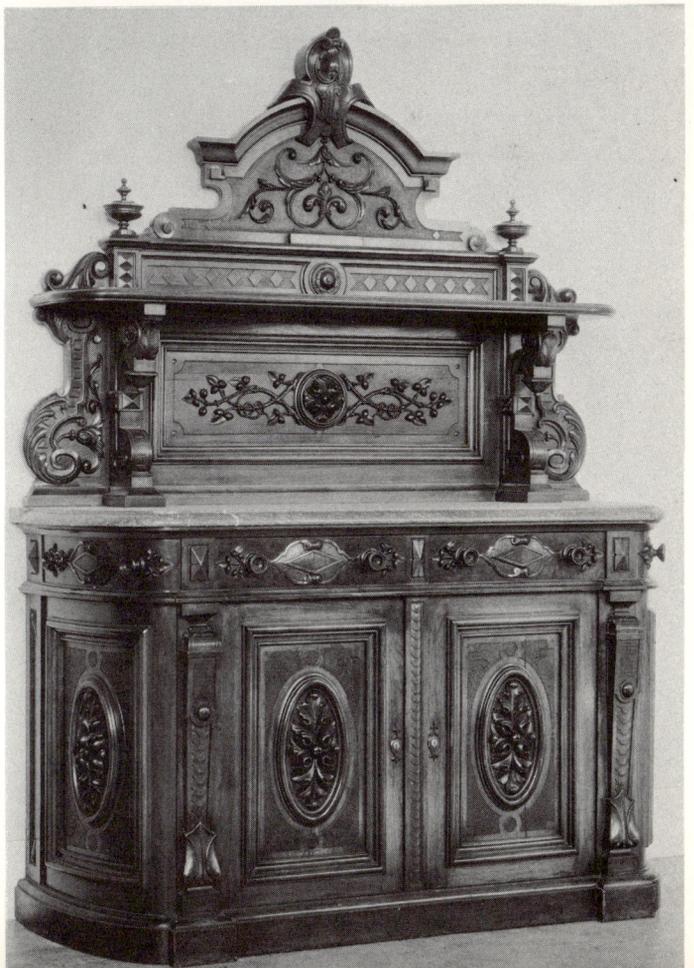

414. A good American sideboard, made by Daniel Pabst of Philadelphia in 1869, had a marble-topped cupboard base with rounded ends and a small shelf projecting from its paneled back, probably inspired by Eastlake's suggestion that this would be suitable for the placing and grouping of art objects. (*Philadelphia Museum of Art.*)

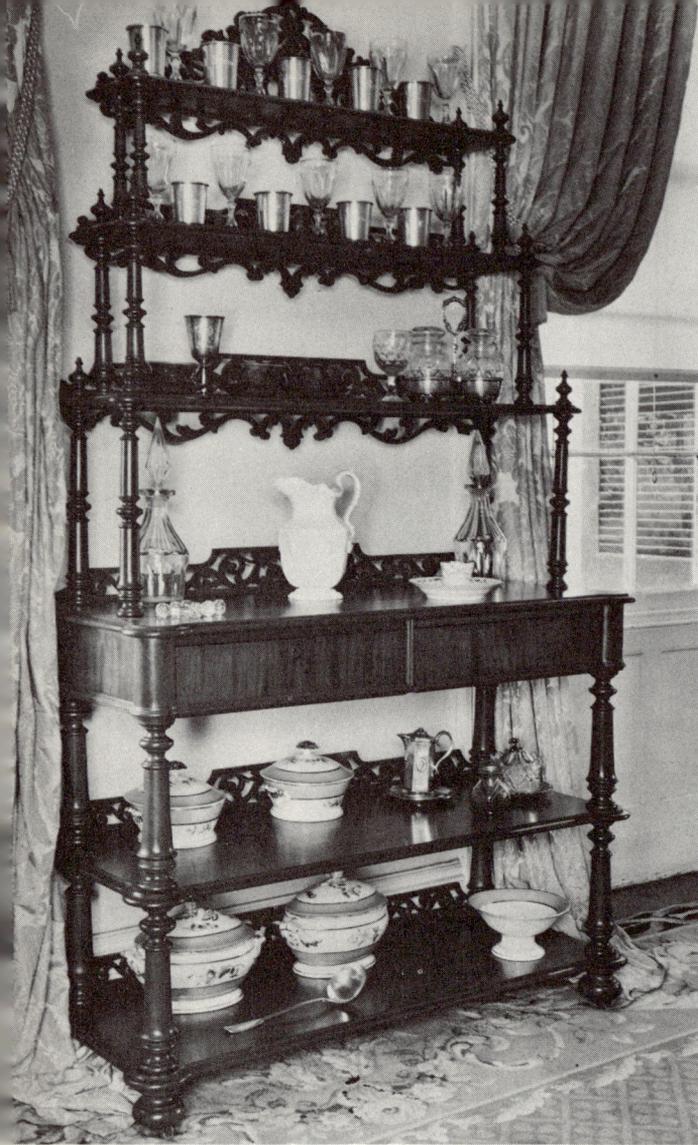

415. Buffet *étagère*; two half-width drawers are set in the frieze above two full-width shelves. The colonnette supports show Renaissance influence. (*Rosalie, Natchez. State Shrine of Mississippi D.A.R.*)

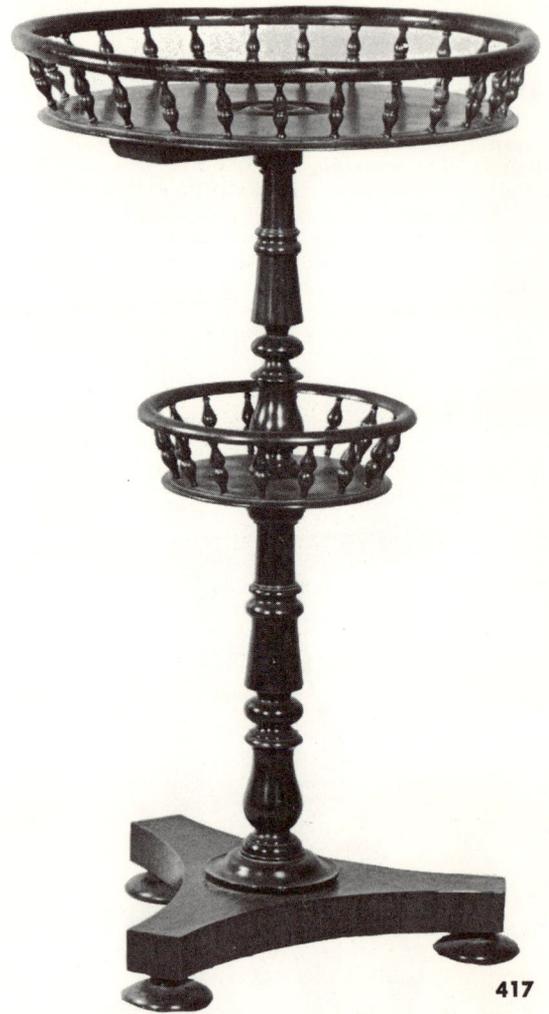

416. Small stand of fine design. The top and the two shelf brackets are onyx, and the four square legs end in dolphin heads. The lower shelf of beveled plate glass is framed in a metal band. (*Grand Rapids Public Museum.*)

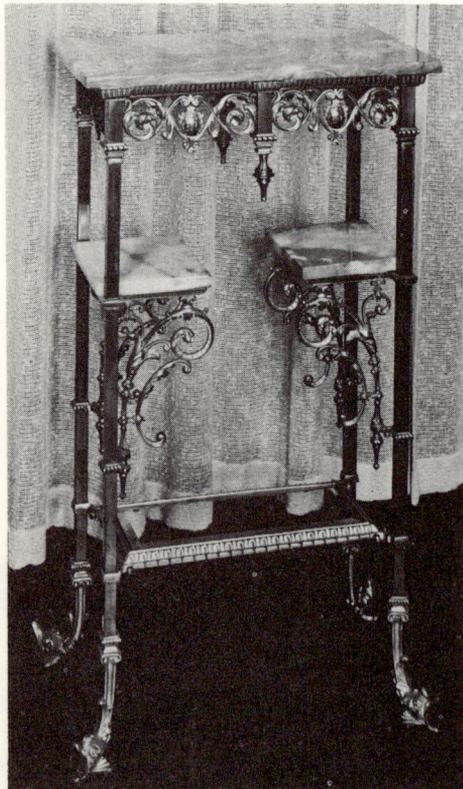

417. In 1850 A. J. Downing illustrated two workstands of this type. "These are made in various modes, either very tastefully and fancifully of rosewood or mahogany, curiously carved, for the villa: or of rustic work, varnished in the Swiss manner; or of bamboo, after the Chinese fashion for the cottage." (*Sleepy Hollow Restorations.*)

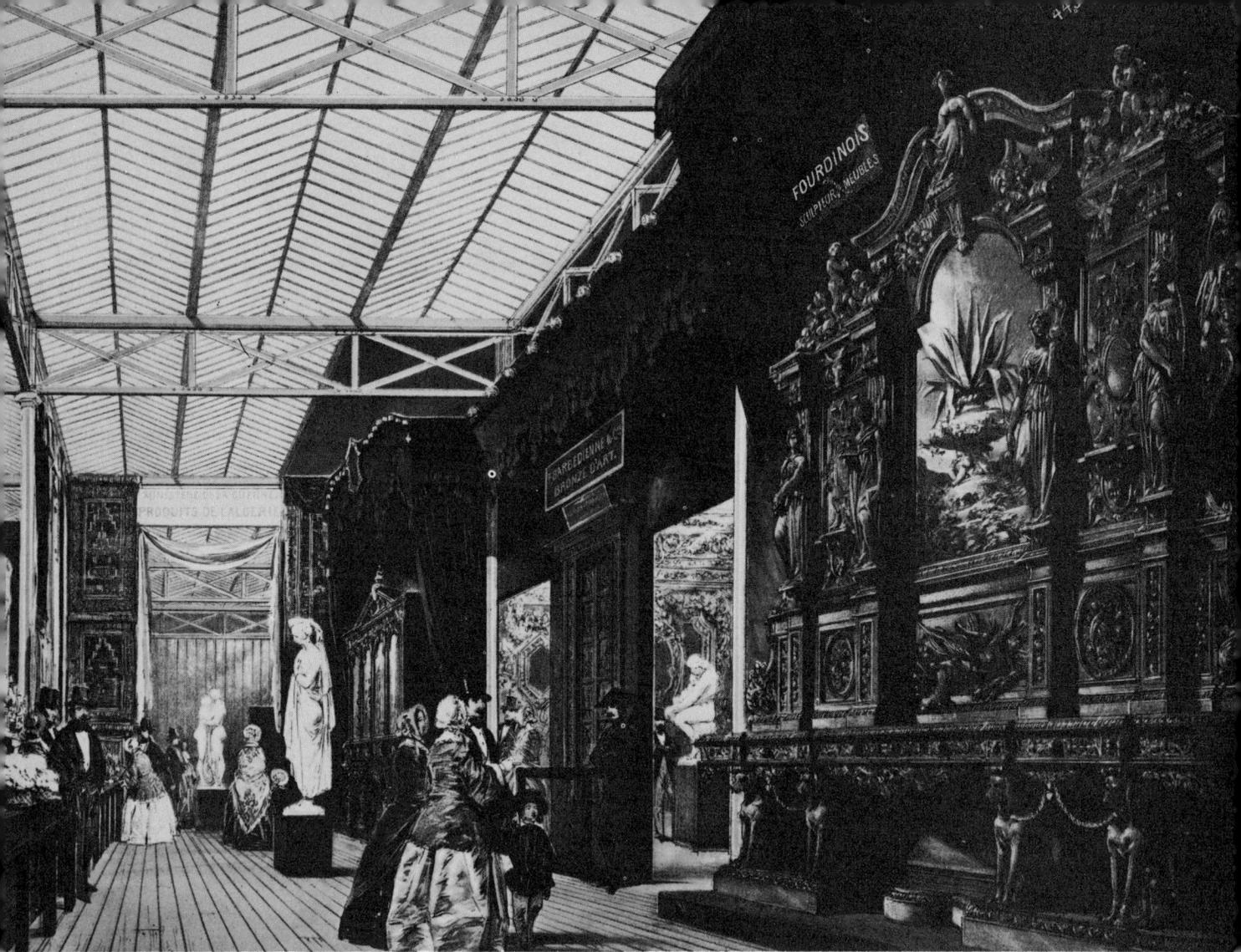

418

418. Henri Fourdinois, foremost Parisian cabinetmaker, exhibited this gigantic sideboard at the Great Exhibition in London, 1851, although they were not generally used in France. The four main figures represent Tea, Coffee, Wine, and Dessert; the main panel in the center is painted; and the supports are four chained, seated hounds. This was not the only overlarge, overdecorated piece of furniture in the Exhibition. The official report commented: "This magnificent display gave birth to one legitimate regret . . . so few specimens of ordinary furniture for general use." The adjoining court at the Exhibition was that of Barbédienne et Cie., of Paris, showing mirrors, sculpture, and bronzes, for which the house was famed; some of their standard lighting fixtures are still among the glories of the Second Empire. (*Victoria and Albert Museum, London.*)

419

419. Small stand of ebonized wood. Four supports and four angular splayed legs on hoof feet are attached to the pillar and cross of the base. The removable tabletop is painted with pelargoniums. (*Brooklyn Museum.*)

420

420. Corner *étagère* with short post legs and five shaped and graduated shelves connected by turned colonnettes and spindles. *Étagères* did not persist; various types of stands were introduced to replace them. (*Mr. and Mrs. William E. Herrlich.*)

421. Sideboard made in Grand Rapids in 1856 by George M. Pullman. Detached colonnettes embellish the chamfered front corners; panels are reserved by applied line with corner and center ornament. (*Grand Rapids Public Museum.*)

421

422. An ebony cabinet, shown by Henri Fourdinois in the 1867 Paris Exposition, was awarded the Grand Prix. The carving of groups and figures was executed separately in boxwood; the superb inlay was chiefly of box and pear. (*Victoria and Albert Museum, London.*)

422

423, 424. Plate 9 of J. W. Kimball's *Album*, 1876, illustrates unpretentious, practical designs of dining-room furniture showing characteristic Renaissance features. This extension dining table has finials and roundels on the angular flat-section legs. The matching side table is an American version of the French *desserte*.

425. Oval center table, possibly made by Léon Marcotte, with narrowed ends. The cabriole legs are joined by crossed stretchers capped by an urn finial. The top is finely inlaid with a panel of flowers and stars. (*Museum of the City of New York.*)

426. A Renaissance table by Marcotte, formerly owned by John Hill Morgan. At the French Exposition of 1878 Léon Marcotte was awarded a Gold Medal for a piece of furniture which, "assimilating the styles of old Europe, had the effect of an original composition." This table has light marquetry on its top rim, Corinthian columns for legs, and a flat stretcher with curved ends and a covered vase as a finial. (*Metropolitan Museum of Art.*)

427. Small table, with a base composed of a pillar and cross, with angular braces and supports, is typical of the American Renaissance style. The top is inlaid with colored woods. The table was made by Berkey and Gay, Grand Rapids, c. 1880. (*Grand Rapids Public Museum.*)

423

424

425

426

427

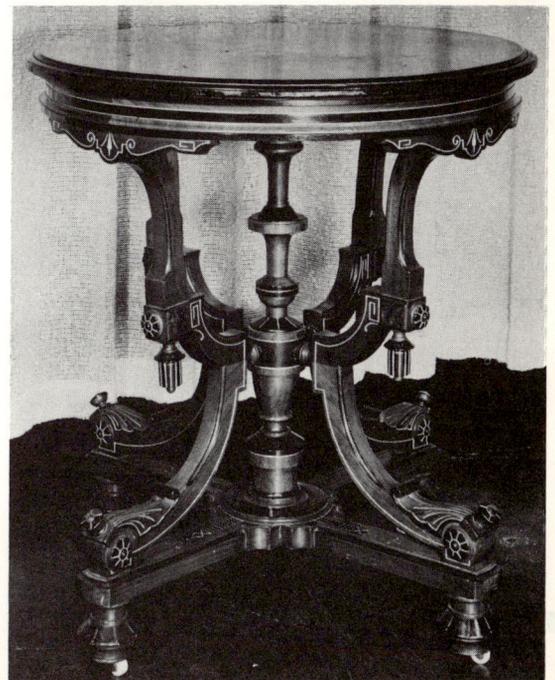

Papier Mâché Furniture

At the Great Exhibition in London, 1851, papier mâché furniture was shown in an astonishing degree of variety and perfection. It was also made in America, but not to a great extent.

In 1852 Mr. Godey drew particular attention to "tables and stands, finished in papier maché, worthy the reputation of American artists," made by Hart, Ware and Co., Philadelphia. At the New York Crystal Palace Exhibition, 1853, in Class 26 — Papier Maché, Paper Hangings and Japanned Goods — there were only three items in papier mâché out of 91 exhibits: "Dressing Tables, bronze and gilded work, finished in papier maché, J. L. Hyde, Manu., N.Y.C."; "Papier Maché Book-case, work table, desk, chairs, music-stand and other furniture, Evans and Millward, Manu. N.Y.C."; "A Variety of Chamber Furniture in papier maché," made by Ward: "one case papier maché, profusely decorated painting and mother of pearl."

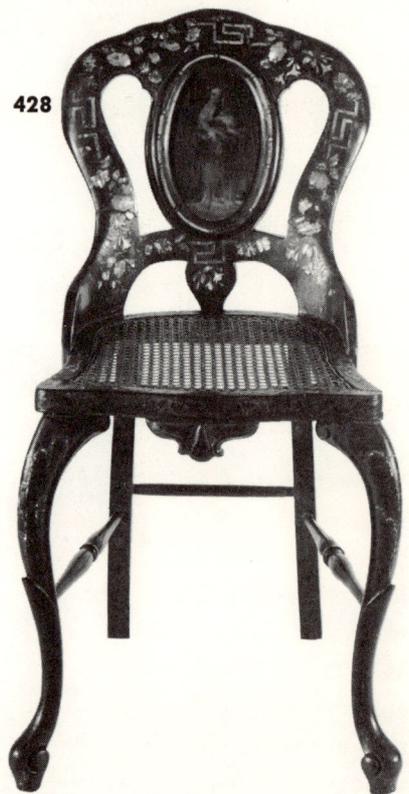

428. Chair, its papier mâché frame japanned black and inlaid with mother-of-pearl, typical of the American Renaissance, is balloon-backed and has a vertical splat in the center and a pendent tab under the front seat rail. (*Museum of the City of New York.*)

Papier mâché seemed, however, to develop for architectural ornament. In 1861 H. B. Mudge of Cincinnati advertised as "Important to Builders — Papier Maché Carved Ornament.... Centre Pieces for Ceilings, Caps, Capitals, Consoles, Trusses, Modillions, Brackets, Rosettes, Patterns, Pinnacles, Fineals, Crocketts, Ornamental Door or Window Heads. Mouldings...can be Sawed, Bored or Planed and put up by any Carpenter."

Bowler, Tileston and Co., Papier Maché Manufactory, Boston, announced the availability of "Modern and Antique Ornaments for Building, Ship Cabins, Oval Frames, Mirrors, Picture Frames, Ladies' Work Boxes and all kinds of Cabinet Work. . . . It has already in the City of Boston, been put as carved work on rosewood and Black Walnut furniture."

Machine-Made Furniture

Disparaging remarks are sometimes heard about nineteenth-century machine-made furniture, but the term "machine-made" is comparative. In 1859 Mitchell and Rammelsberg, among the foremost manufacturers of Cincinnati, claimed that they made almost every design of cabinet ware and chairs; "two-thirds cabinet ware; the rough work performed by machinery; finishing, as in other furniture shops, executed by competent and skilful workmen." Lengths and shapes, cut out by circular steam saws, then proceeded from story to story until, on the upper floors, they received final dressing and finish for the market. This company patented a bedstead in which rails were dovetailed to the posts, eliminating screws. At the same time George W. Coddington's six-story factory had two steam-driven engines, each of twenty horsepower, and a concave saw of great ingenuity to cut out chair tops in circular form and uniform thickness.

In 1873 Kreimer and Bro., Cincinnati, founded in 1856, who employed three hundred workmen, had "the latest machinery driven by an engine with 125 H.P."

Mayer and Merkel Mfg. Co., Manufacturers of Fancy Furniture, founded in 1872, described their facilities: "Machinery is all late and desirable . . . the propelling force is furnished by an engine of ample power, 40 workmen employed."

Paris Exposition 1867 and the Second Empire

The 1867 Paris Exposition was announced in 1863 to give exhibitors ample time for preparation. In 1866 George T. Strong wrote, "Everyone going to Paris," with pithy remarks directed at "Napoleon III that Imperial Barnum," but nothing stemmed the tide.

The timing could not have been better. Contrary to expectation, the Civil War had not caused widespread financial depression. Already·in 1863 a report to the Cincinnati Chamber of Commerce disclosed: "The whole people in the Loyal States are rich beyond their anticipation and they feel it, and are extravagant beyond precedence. . . ." An 1865 report noted: "Furniture: During the past year furniture dealers saw their customers selecting Tables and Chairs, Book Cases, Bedsteads and Sofas, not because of their intrinsic beauty, but because they cost round sums. High prices were an inducement and prices were much higher than ever before."

In Paris Napoleon III had attained an unexpected peak of power and prestige, and the background and surroundings of court entertainments were impressive. The Renaissance style of Fourdinois was not new to Americans; they had used it for more than fifteen years; but Eugénie's beauty and luxury and the marvelous appearance of her circle of ladies were overwhelming. Around them were scattered priceless cabinets, paintings, statuary, bronzes, crystal, rarest rugs and embroideries.

The impression made on Americans by the Exposition was equaled by that made on the Exposition by the Americans. A *Harper's* reporter saw on a fine display of goods, *"Qualité extra-sublime fabriqué spécialment pour l'Amérique."* He asked whether the proprietor thought that Americans generally liked extra-sublime goods and was answered: "I do; we can hardly procure goods splendid enough for the American market and expense seems to them no consideration at all."

Antique shops proved an irresistible attraction to American visitors; the pursuit of bargains was a large part of their enjoyment, and the seed was sown for the annual pilgrimage to Europe that was to afford so much satisfaction to art dealers. Many purchases formed the nucleus of a completely new style of furnishing in America. Eugénie's arrangements of different types of furniture, her countless rare and beautiful bibelots, some on plush-covered tables, planted ideas

that would develop into a taste not only for luxury and extravagance, but also for Culture — an important word in the vocabulary of the seventies.

In June 1873 George Templeton Strong wrote in his diary, "Visited this afternoon the Metropolitan Museum of Art in the late Mrs. Douglas Cruger's palazzo on West Fourteenth Street. . . . Art treasures (so called) are evidently accumulating in New York, being picked up in Europe by all our millionaires and brought home. The collection promises very well indeed."

The American Louis XVI Style

Eugénie's preference for Louis XVI was reflected in America, where there was a widespread and long-lasting use of the Louis XVI style for parlors and bedrooms. American carving had greatly improved; in 1878 Harriet Spofford wrote, "At present the Louis XVI furniture is made in America with a nicety and a purity equal to that which characterises the best examples and its wonderfully beautiful carving is unrivalled by any that comes from abroad."

There were several French firms in America active in cabinetmaking: Alexander Roux, who showed furniture at the Crystal Palace in 1853 and redecorated the Havemeyer house at Orange, N.J., in the 1880s; and Léon Marcotte, who arrived in 1854. Auguste Pottier and William Stymus of Lexington Avenue had a good reputation, not only for furniture but also as interior decorators. German cabinetmakers were traditionally good carvers, and representative of this group were George H. Henkel of Philadelphia, the Herter Brothers of New York, and Henry Weil, much of whose production was sold in New Orleans.

American exponents of the Louis XVI style included George Platt of Broadway; Thomas Brooks of Brooklyn; William Pretyman of Chicago, who used a Louis XVI theme for Mrs. Potter Palmer's bedroom; John Jelliff of Newark, N.J.; D. S. Hess and Co. of New York.

In the Cincinnati business directory, 1886, an advertisement appeared: "Art Joinery. Dannenfelser. Timmich and Biemann: Hand Made Furniture. All skilled wood carvers and cabinetmakers of Years' experience. The firm makes to order all kinds of carved antique and modern furniture."

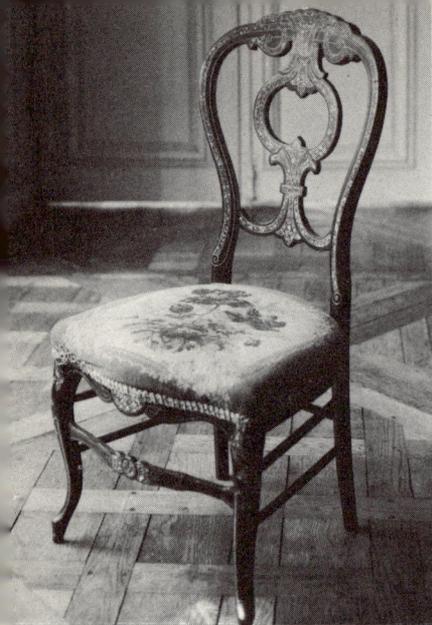

429. Black chair with painted ornament and mother-of-pearl inlay made by Burgot. Light chairs, of a type called *chaise volante*, were used in quantity by Eugénie for her informal salon arrangements. (*Palais de Compiègne.*)

430. Sewing table representative of a much-favored simpler type of furniture introduced in the reign of Louis Philippe. The black japanned frame is painted with rose sprays and gilt ornament. Renaissance features are the pendent tab and small stretcher shelf attached to the legs with tenons. Second Empire flat-section wavy supports were adopted in American furniture. (*Musée des Arts Décoratifs.*)

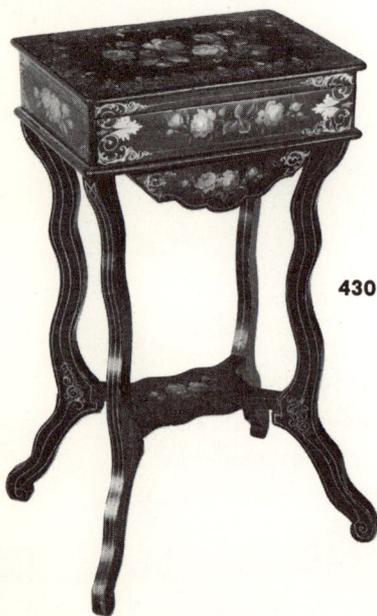

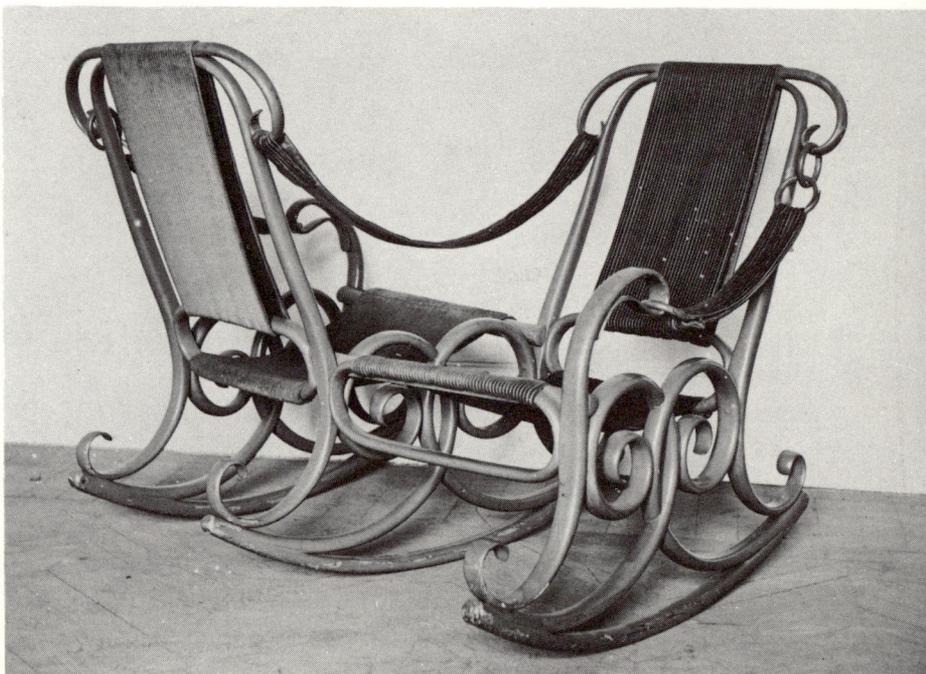

431. Rosewood occasional chair with the open panel back characteristic of the Second Empire. (*Musée des Arts Décoratifs.*)

432. The Goncourt brothers, famous authors, had a metal-framed "conversational" rocker made for their comfort and convenience. In 1867 they described the Universal Exposition as: "the final blow leveled at the past, the Americanization of France, industry lording it over art, the steam thresher displacing the painting." (*Photo: Bulloz.*)

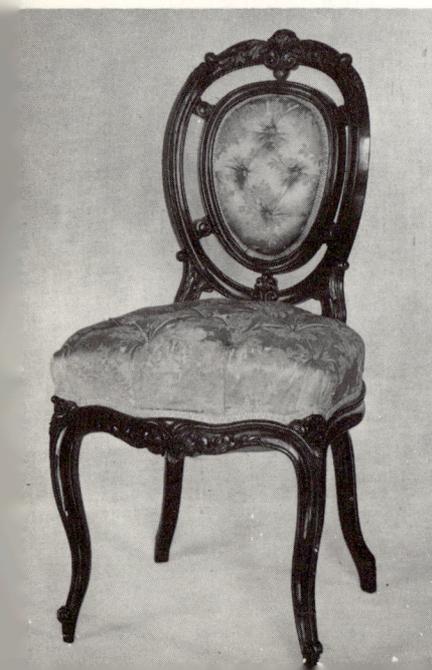

433. French Renaissance console supported by two realistic kneeling figures in bronze was made by Dalou in 1864. (*Musée des Arts Décoratifs.*)

434. At the Palais de Compiègne this Blue Salon was set aside for small official receptions during the Restauration, 1815–1830; the settee with footstools, the armchairs, side chairs, and tabourets were allotted according to rank. The majority of the guests stood. The strict etiquette of the Bourbons was abandoned by Eugénie in her informal arrangements. (*Palais de Compiègne.*)

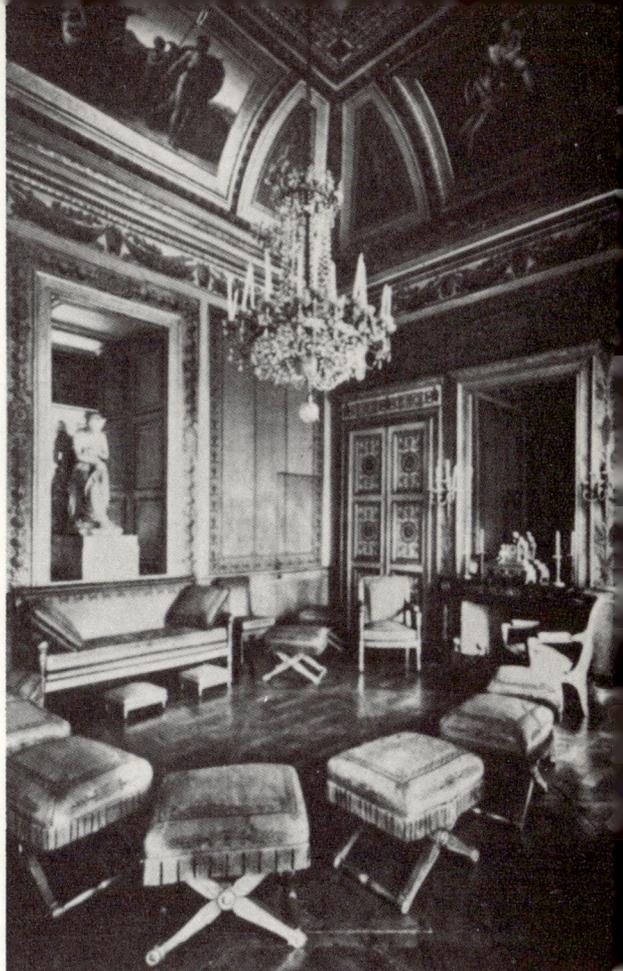

434

433

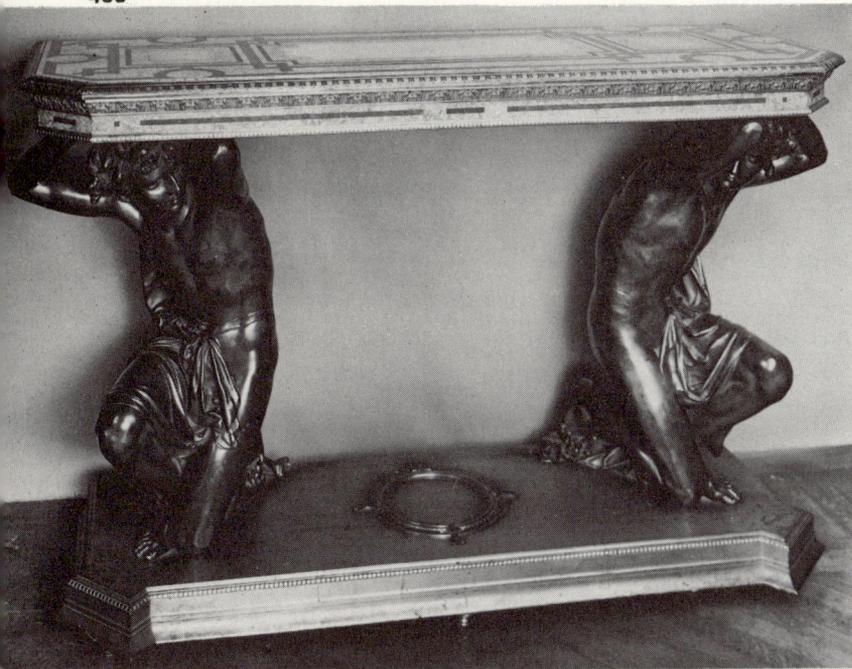

435

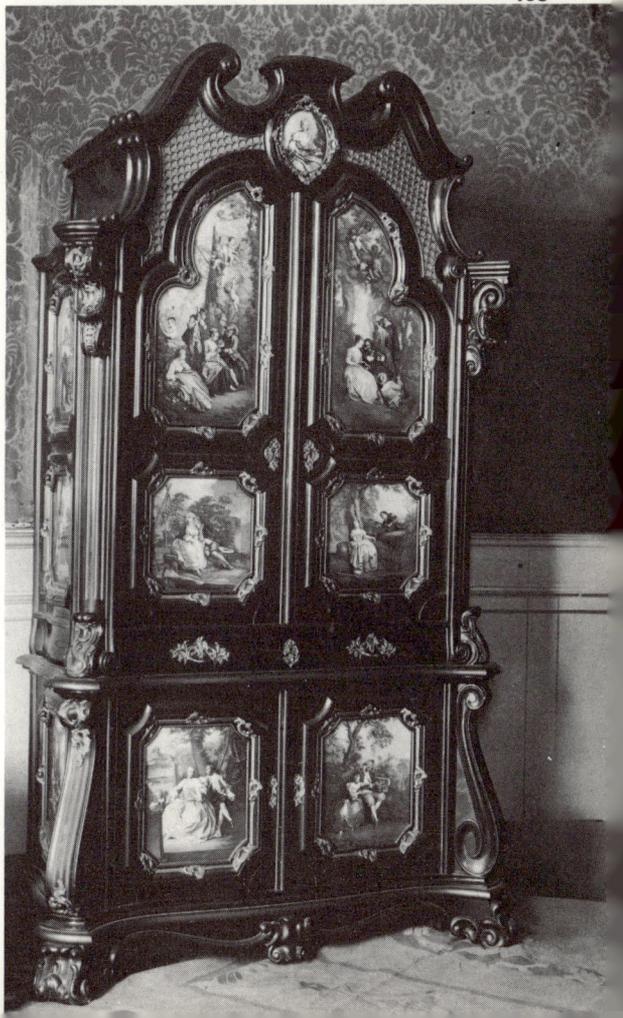

435. Second Empire cabinet in black wood, constructed in two sections. The top is arched, with front and sides divided into panels of painted porcelain framed in moldings. The use of porcelain plaques on American furniture is reflected in Kimball's article on pottery for decoration, 1876: "Indeed the new forms of furniture require the use of tiles or painted china plaques or tablets in their construction." (*Palais de Compiègne.*)

Eastlake Furniture

Hints on Household Taste by Charles Locke Eastlake appeared in England in 1868. It met with astonishing success in America and was published in Boston in 1872. Eastlake was an architect and made little pretension to constructive furniture design. His language is untechnical: "Never buy shaped chests of drawers — i.e., those which bulge out in front. If they must be stained at all let them be stained black." This pronouncement caused the introduction of the use of ebonized wood, with ebonized cherry the luxury version in America. "An Indian ginger-jar, a Flemish beer-jug, a Japanese fan may each become a valuable lesson . . . a set of narrow shelves at the back of a sideboard a good place": two hints that were widely adopted. "Pictures separated in drawing-room by small objects" introduced a vogue for small brackets, shelves, and carvings that accounted for the growth of a separate branch in the American furniture industry.

In 1870, when Napoleon III was taken prisoner by the Prussians and the Third Republic was proclaimed, France ceased to be a leader of fashion. American manufacturers probably experienced a hiatus; the Renaissance style had been in fashion for twenty years. From Eastlake's few vague illustrations and hints American makers built suites of furniture and launched an Eastlake style — plain construction, generally of oak, with panels composed of slats; ornament of tiles and wrought metal mounts; chamfered and serrated edges; gouging; incised lines and sparse inlaid details. Legs, supports, and posts were substantial and straight, either turned or square, and bulb feet and finials were of matching proportions. There was no Eastlake furniture style in England.

Among the advertisements in Kimball's *Album of Designs*, 1876, Eastlake furniture is shown in many variants. John Clark of Boston concentrated on a beautiful "Eastlake Chamber Suit, thoroughly made and finished in every detail. Bedstead, bureau and washstand, inlaid tiles and marqueterie. Bureau with marble top and French Plate glass, its top drawer lined bird's eye maple and varnished. Washstand with Marble Top, ends of drawers of cherry."

M. and H. Schrenkeisen of New York advertised an Eastlake Suit of seven pieces: "Sofa, 2 arm chairs and four small chairs, framed in wood, in Plush, Cotoline or Silk Terry, $156." Eastlake had mentioned "a German invention . . . a mixture of silk, wool, and cotton, called Cotelan, in diaper patterns of excellent design . . . one of the most artistic modern fabrics."

Other Eastlake items mentioned were jardinieres, dining and easy chairs in walnut or ash, a Ladies' parlor desk in walnut and gilt, and square cane-seat chairs.

Warren Ward and Co., Cor. Spring and Crosby Streets, advertised in *Harper's Weekly*, 1876, among "Bargains in Furniture": "Enameled Cottage Suits, $25 up," and "Furniture in Eastlake's Designs."

436

439

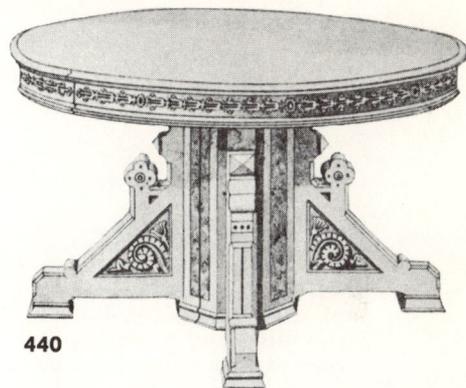

440

437

436–440. Eastlake dining-room furniture illustrated in Kimball's *Album of Designs*, 1876. Two chairs (436 and 437) have peaked panels squared at the base. A square extension table (438) and a round one (440) reveal distinguishing characteristics of Eastlake design in the angular treatment of the central pillars and the flat leg sections. The sideboard (439) exemplifies a typical use of lath panels, serrated edges, and simple ornament.

441. Eastlake hall stand, with a complicated cresting including a row of spindles above the missing mirror, pegs on the side sections, and inlaid panels and flat-section brackets at the base. The drawer — its top probably once tiled — is flanked by umbrella holders. Identifying features are the serrated edges and gouged carving and a lath panel behind the low stretcher shelf. (*Grand Rapids Public Museum.*)

441

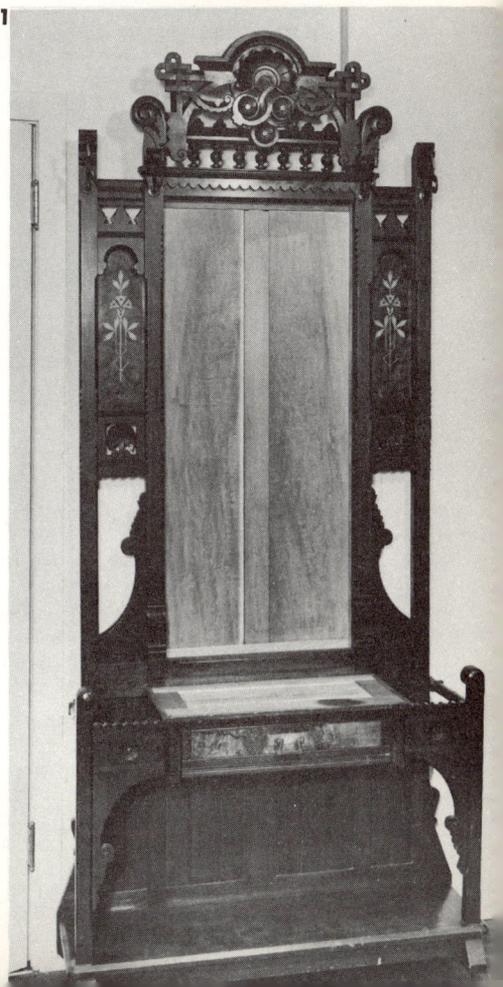

438

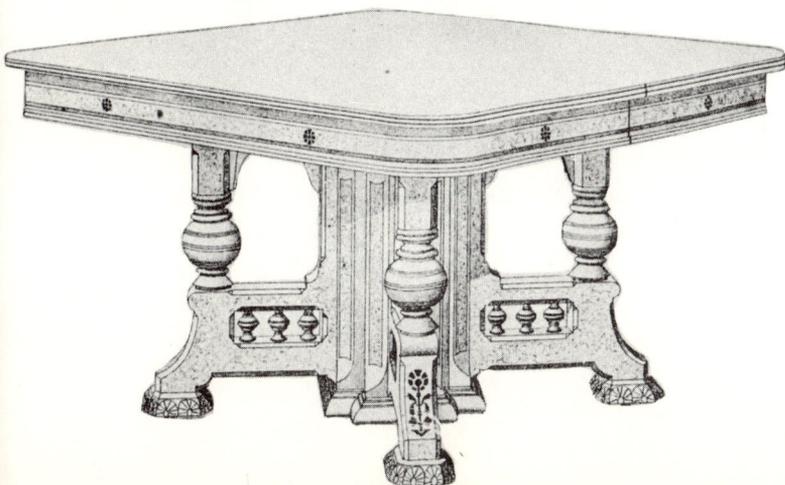

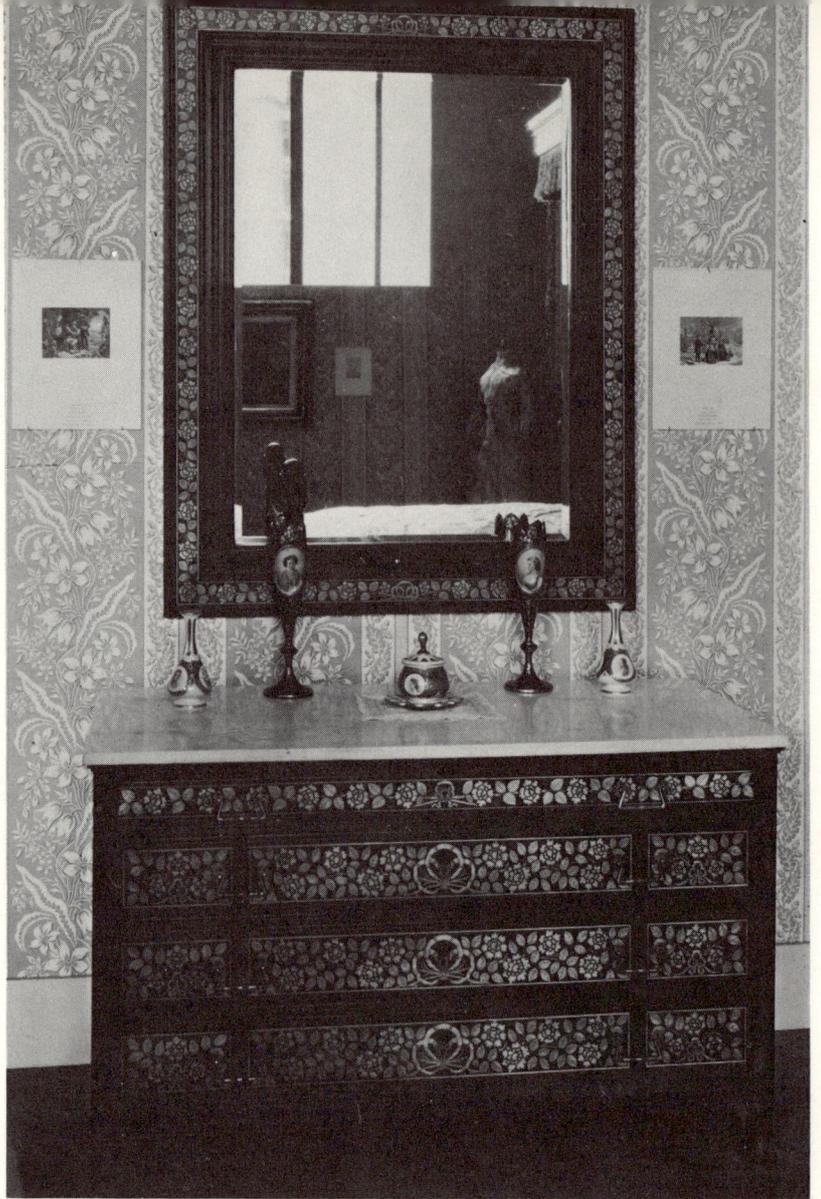

442–445. In a set of bedroom furniture made by Herter Brothers in 1876 for William T. Carter of Philadelphia, the simple design of the ebonized frames is relieved from heaviness by the insertion of vertical spindles on the panels of the bed and chairs. All panels are beautifully inlaid with natural flowers and foliage in light wood on mahogany — an elaborate and costly example of the Arts and Crafts principle of plain construction with surface decoration. *(Philadelphia Museum of Art.)*

442

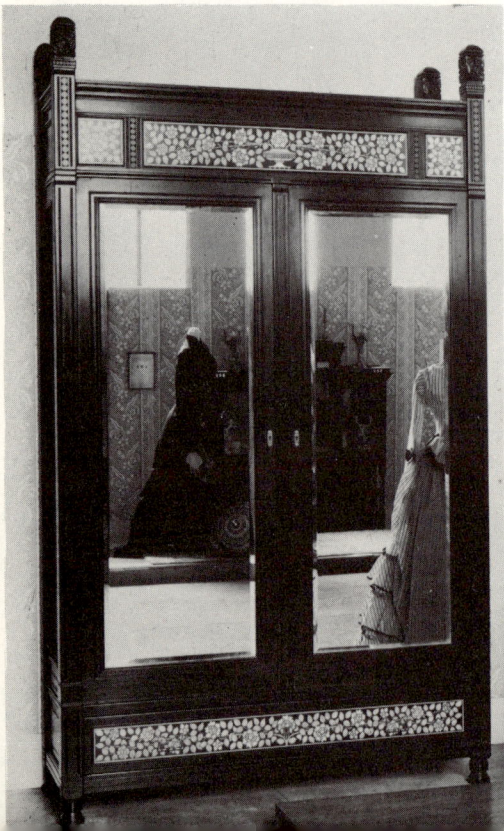

443

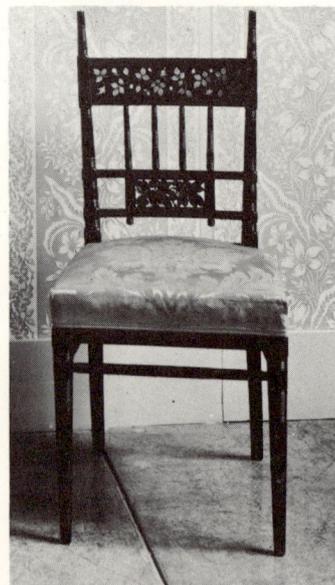

444

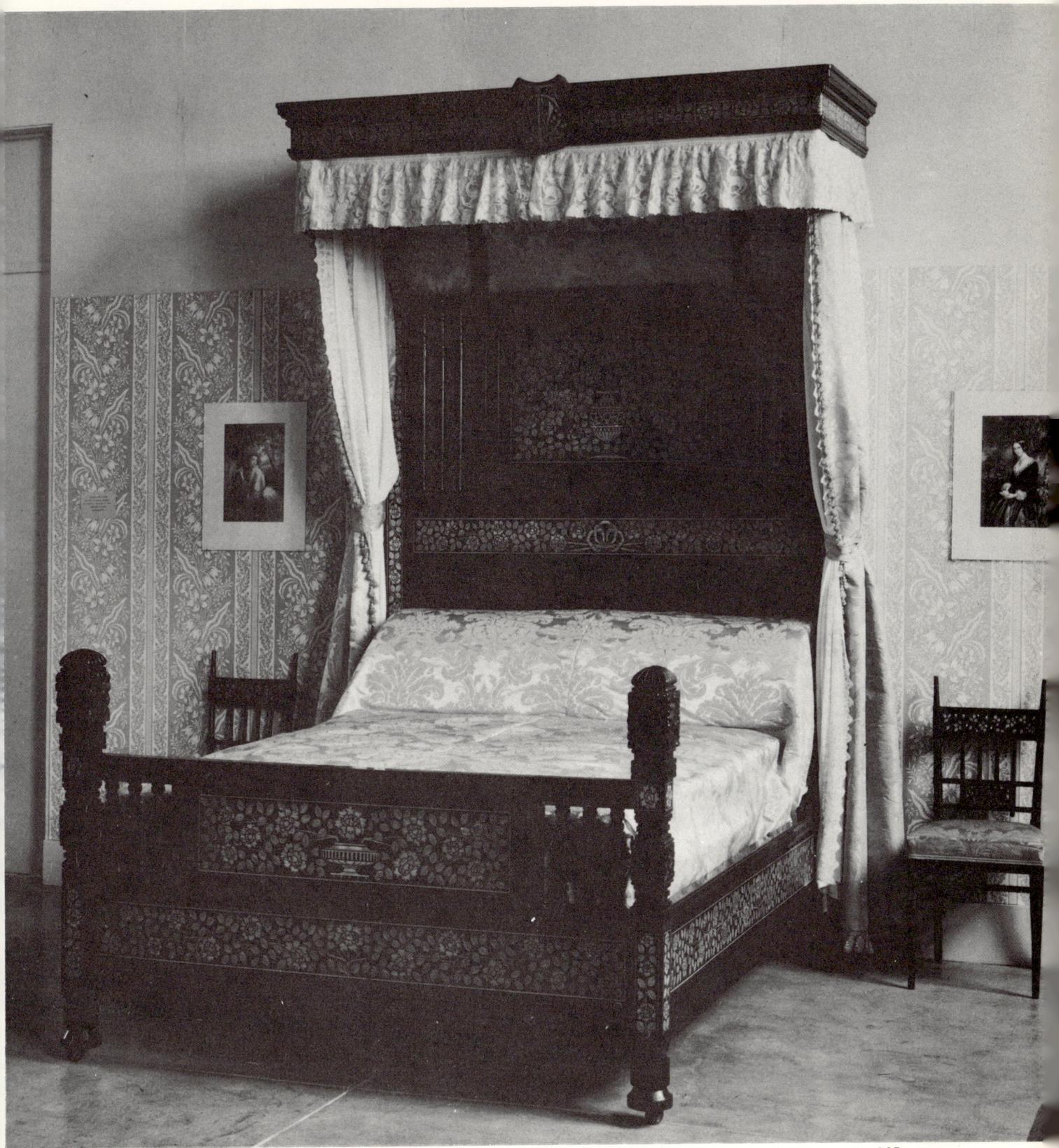

Queen Anne Furniture

Of universal interest was the Philadelphia Centennial Exposition of 1876, opened by President Grant and the Emperor of Brazil. The main building, with twenty-six miles of promenade, was the largest in the world, and the catalogue was printed in English, French, German, and Spanish. As far as American furniture was concerned, the main influence in the exhibition was still Renaissance. Individual items of Eastlake were novel but unattractive. The Gothic style was shown in rooms; not accurately but as comfortable drawing-room furniture, in costly materials, with much gilding.

A new style — Queen Anne — was shown in the British furniture section — the first new style from England since Sheraton and Hepplewhite. Norman Shaw, a British architect, had successfully introduced — in opposition to Renaissance and Gothic — Queen Anne houses, which were simple, well-proportioned, and built in red brick. The English Queen Anne furniture style was based on the principles of William Morris and the Arts and Crafts movement — plain construction with surface decoration. Adapted by commercial designers, a new and distinctive style was evolved. This was shown at Philadelphia by several of the foremost British cabinetmakers. Execution and finish were of highest quality. A cabinet by Collinson and Lock was described by *Harper's Weekly* as "very elegant and artistic, one of the finest specimens of the furniture designer's Art." The reporter also said of an oak fireplace beautifully inlaid with walnut, "it was done by a process patented by Howard and Sons of London, marvellously cheap." A great deal of marquetry in intricate patterns appears on English and American furniture from about this time.

Straight turned legs of the Arts and Crafts type were largely used on Queen Anne as well as on Gothic and Eastlake furniture. The *Furniture Gazette* noted in connection with this type: "richness can be attained by a multitude of horizontal lines, clusters of small, fine fillets, rolls, channels, flutings." These were all used.

Harriet Spofford wrote in 1878: "The Queen Anne met with opposition and allegation that Pre Raphaelites had made it up; it seems to be the very style to reward the search of the nineteenth century for something natural, beautiful, suitable and convenient."

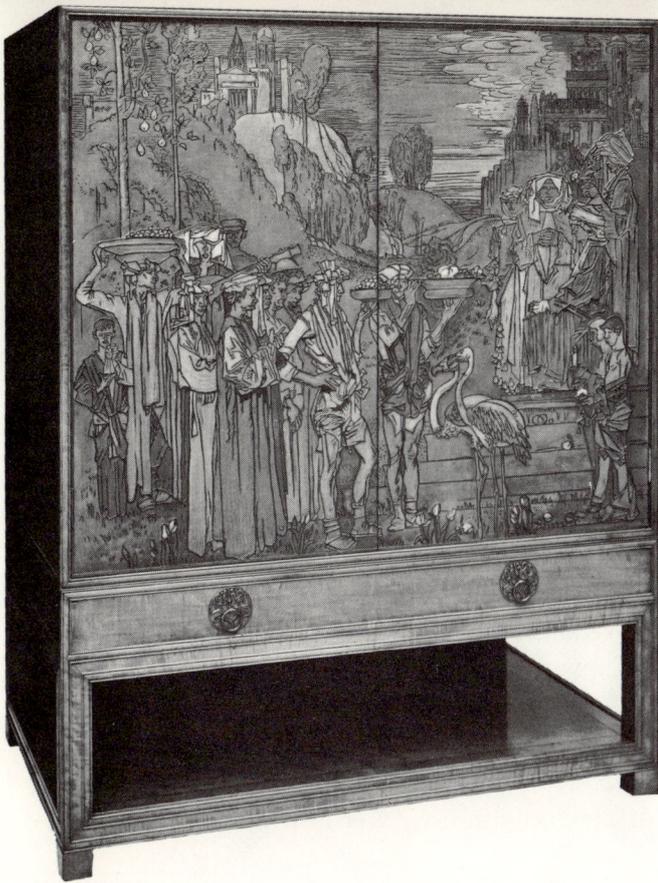

446. English Arts and Crafts cabinet — an example of plain construction with surface decoration — was designed by Frank Brangwyn and made by Paul Turpin. (*Victoria and Albert Museum, London.*)

447. Queen Anne cabinet, designed by T. E. Colcutt, made in ebonized mahogany by Collinson and Lock of London, exhibited at the Philadelphia Centennial in 1876, was designed on the Arts and Crafts principle with plain construction and surface decoration. The cornice, coved in the center, is groined at the ends. Small panels were painted with arabesques and single details by Albert Moore. This seems to be the first English style introduced in America during the reign of Victoria. (*Victoria and Albert Museum, London.*)

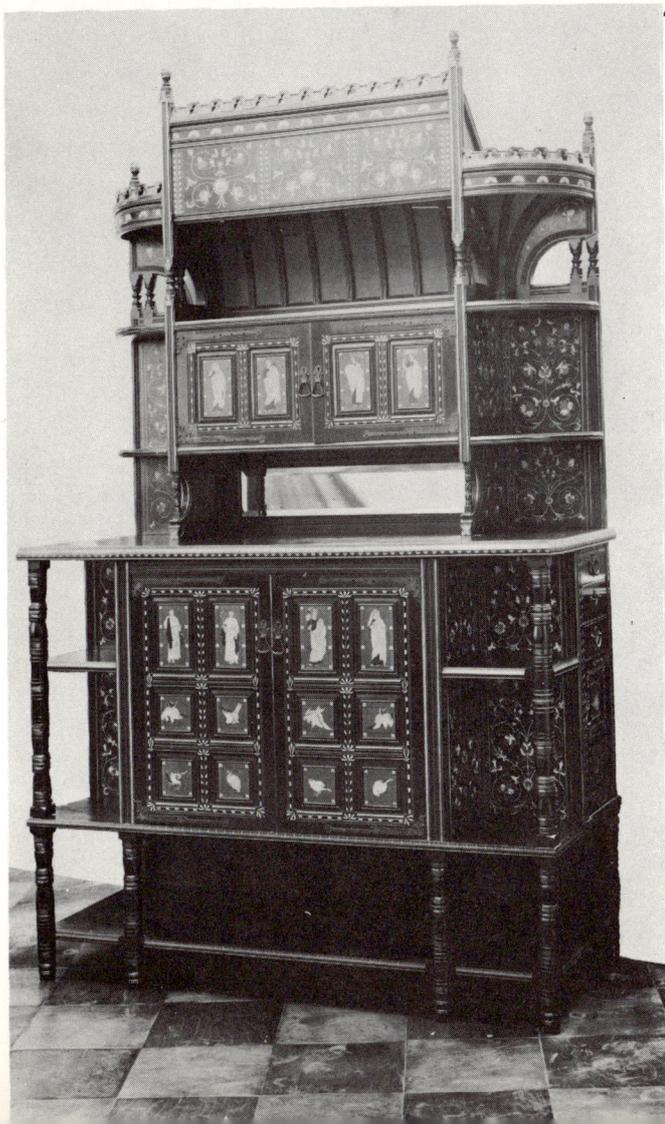

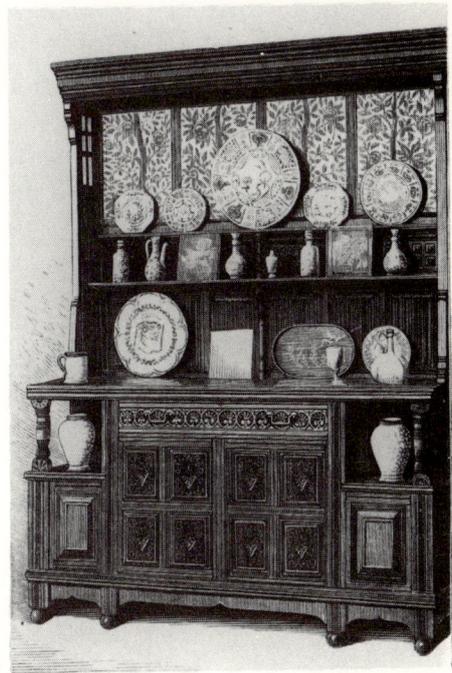

448. Harriet Spofford illustrated a Queen Anne cabinet in 1878. The base is composed of drawers, cupboards, and display spaces; the high back, fitted with two plain shelves, is paneled — its lower section carved, its upper painted.

Style in Chicago

The furniture industry does not seem to have flourished in Chicago. Wealthy residents imported their purchases from New York, Europe, and England. Leading manufacturers in Grand Rapids and Cincinnati established branches in Chicago and all qualities and styles were available at prices against which smaller firms would not have been able to compete. Designers who studied in the offices of Chicago architects were lured to Grand Rapids.

Charles Tobey, who went to Chicago in 1855, was an exception. After many vicissitudes he and his brother Frank developed a Hand Made Custom Shop that was foremost in Chicago; the John A. Colby Company's Retail Store was another successful establishment that persisted there.

After the Great Fire in Chicago in 1871, the manner in which its people accepted the challenge of their desperate situation aroused universal admiration. Reconstruction was achieved with incredible rapidity.

Great architects were employed for fine houses — William Morris Hunt and H. H. Richardson among them. Frescoes on frieze and ceiling were very fashionable; one of these, painted by John Elliott in Mrs. Potter Palmer's house on Lake Shore Drive, depicted the History of the Vintage. She had a Louis XIV drawing room, an English dining room, a Spanish music room, and Turkish, Greek, and Japanese parlors. Her Louis XVI bed was ten feet high. She was the uncontested leader of Chicago society, collected French Impressionist paintings, and wore masses of large jewels. Her entertaining in Europe and London was so sensational that the prestige of Chicago was greatly enhanced.

Harriet Hubbard Ayer was another noteworthy Chicago woman. For a new house, built in 1876, she bought furniture from Sypher and Co., antique dealers and decorators in New York; her dining room, designed to accommodate forty guests, was paneled in English walnut.

449

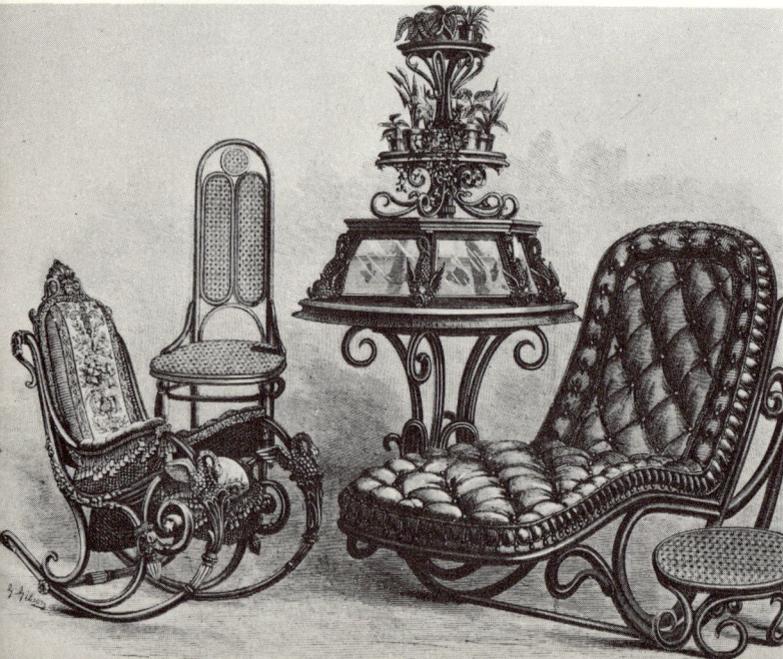

449. *Harper's Weekly* illustrated bentwood furniture in 1876 from the handsome displays of Thonet Bros. and Jacob and Joseph Kohn of Vienna at the Centennial Exhibition, 1876. The frames were of highly polished beechwood. Thonet Bros. opened a store on Broadway; Kohn established a firm in England. Bentwood furniture with elaborate frames became fashionable and was introduced into luxurious apartments. The vogue lasted until the end of the century, after which it was reduced to utility types. (*New-York Historical Society*.)

450. The drawing room in Jacob Rupprecht's Renaissance brownstone house in Chicago was typical, fashionable Louis XVI. The low, ivory-colored wainscotting was embellished with papier maché ornament in red and gold, and the walls were covered with soft pink Louis XV damask. The Louis XVI pieces visible in the photograph are two light-enameled occasional tables, two parlor chairs, and a three-section console — the ends higher than the center — with a large vertical rectangular mirror. The house was decorated by Herter Brothers of New York. (*Illustration from* Artistic Houses, *1884*.)

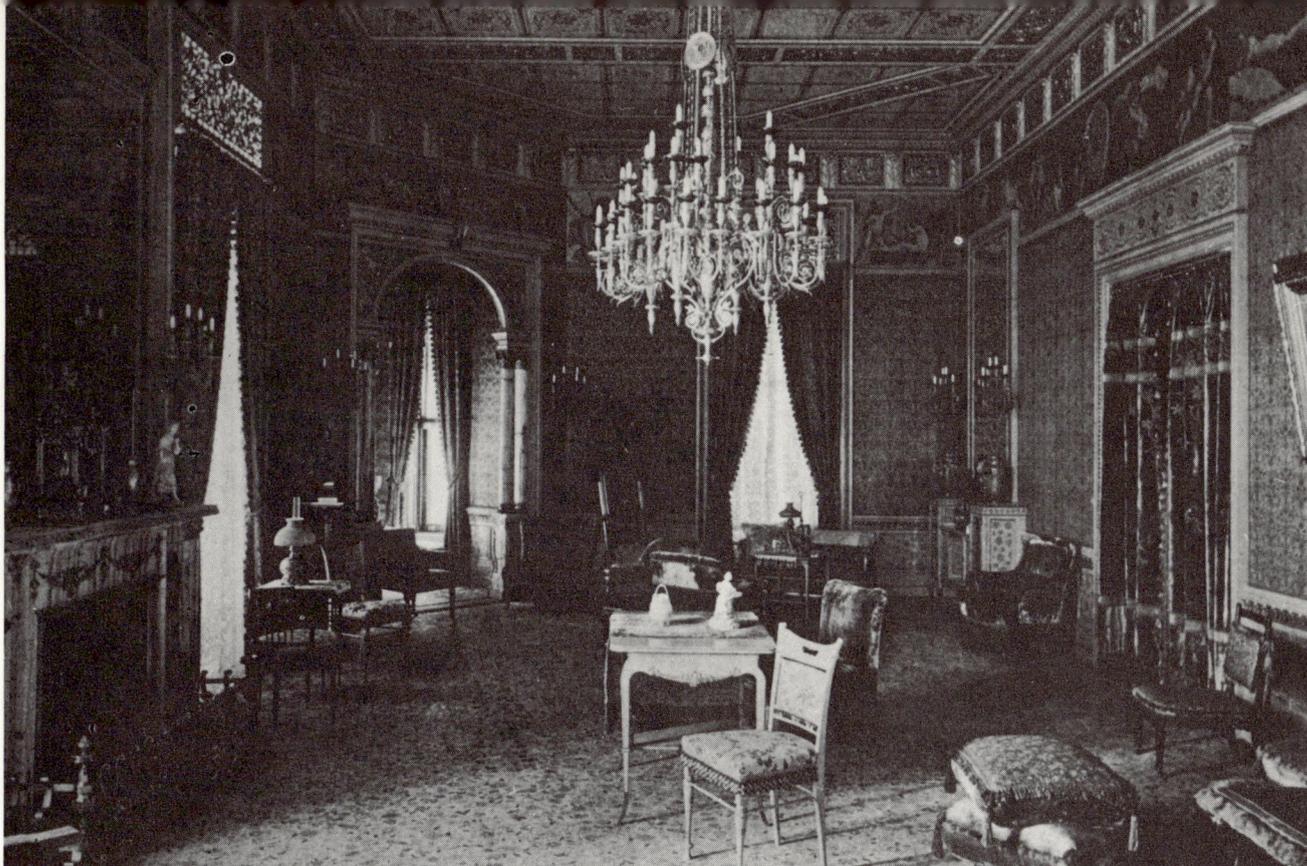

451. Library in Marshall Field's house in Chicago designed by William Morris Hunt. Low bookcases are set along the walls. An elaborate hooded fireplace is decorated with tiles and a stained-glass panel. Chairs include a Renaissance easy chair, two armless Second Empire chairs, and a large, plush-covered Turkish easy chair. Oriental rugs are scattered on the parquet floor — a fashionable trend. The whole house was lighted by electricity, the first in Chicago, powered by a plant in the stables of Mr. J. W. Doane, a neighbor. (*Illustration from* Artistic Houses, *1884.*)

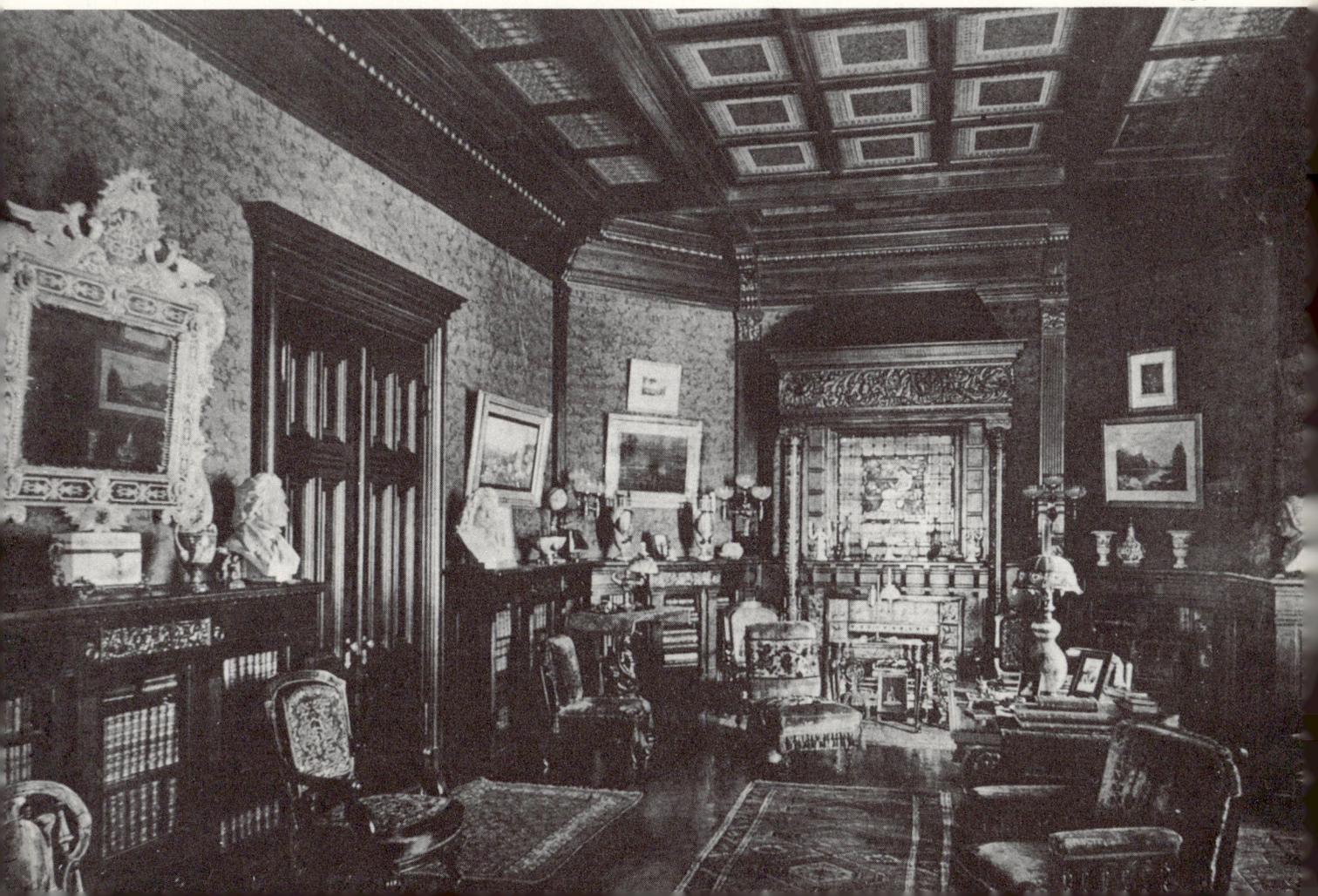

THE EIGHTIES AND NINETIES

During the last two decades of the nineteenth century society, especially in the big cities, developed certain standards and a more formal way of living.

Professor Walter Smith, in his report on the 1876 Centennial, noted the evidence it afforded "of how our young republic . . . has thrown off the simplicity of living of its early days when existence was a long struggle with poverty and, with increasing wealth and prosperity is gathering to itself the most costly and elegant appliances for making life not only comfortable, but luxurious, which money can buy." This was literally true; immense wealth was being accumulated. It was known, for instance, that Cornelius Vanderbilt increased his fortune from ten to one hundred million dollars by railroad financing. And there were other Americans whose personal wealth was seldom matched by Europeans.

The Empress Eugénie's studied, luxurious informality was adopted in America, where extravagance and the display of wealth became increasingly competitive. Art collecting was fashionable for men as well as for women; fortunately the men had good business heads and bought nothing involving large sums without an expertise that procured for America a heritage of priceless treasures.

Magnificent town houses were built, and additional fortunes were spent on carving, sculpture, and interior decorating. In 1881 Mr. and Mrs. William H. Vanderbilt commissioned William Morris Hunt as architect for their Fifty-first Street mansion in New York, with Christian Herter to design the interior. The project involved the employment of six hundred craftsmen for eighteen months. In 1882 Mr. D. O. Mills paid Herter sixty thousand dollars for the carved mahogany paneling in his library.

The majority of American architects were devotees of the French school, but the English architect Norman Shaw, a brilliant rebel against accepted tenets, had introduced a new style that drastically changed domestic interiors. The ground floors of his houses were not separated into rooms with doors but were open spaces subdivided by arches, pillars, and woodwork screening. Paneled halls had window seats, fireplaces, decorative staircases with halfway landings, and upstairs galleries. In America this idea was frequently adopted; interior doors were abandoned, cozy corners were established, and beautifully carved woodwork became an important feature of the new style, which in England was called "Free Classic."

In 1883/4 a monumental work was published by D. Appleton and Company containing a se-

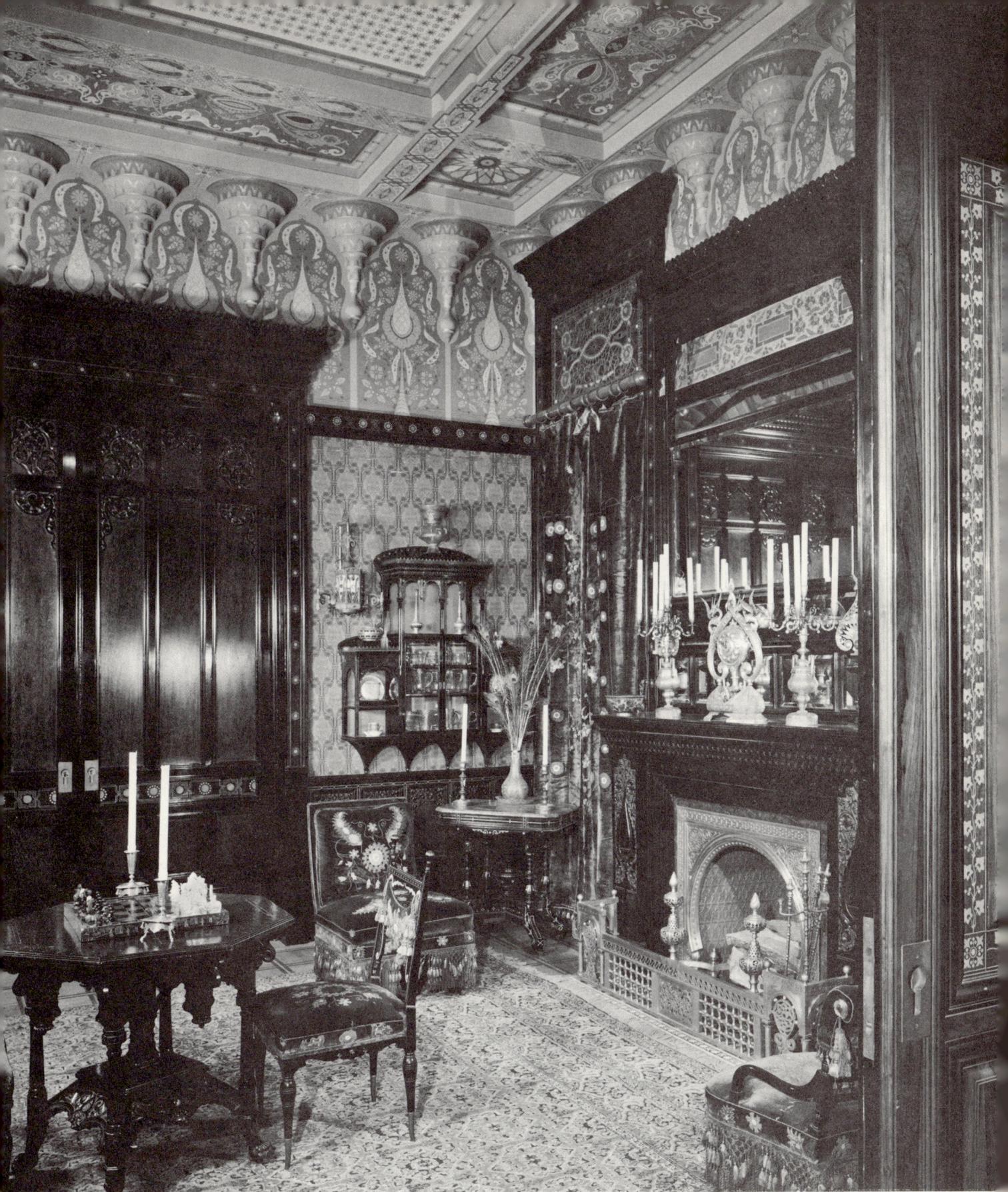

452. Moorish sitting room from the house of John D. Rockefeller, 4 West Fifty-fourth Street, New York. Interior fittings and furniture are of ebonized wood. The tables are fashionable types; one is octagonal and one oblong with rounded corners; each has carved pendent tabs on the frieze and ornamented legs. (*Brooklyn Museum.*)

ries of "interior Views of a number of the Most Beautiful and Celebrated Houses in the United States." In it, numerous versions of Shaw's revolutionary style are shown, halls and staircases almost without exception being in the new manner. The style had no apparent influence on furniture design. Individual pieces, among them many costly antiques, were favored, and the mixture of styles produced a fashionable air of informality.

Edith Wharton, writing on home decoration in 1897, commented unfavorably on the way in which most architects and decorators designed doorways. "Many recently built houses contain no doors . . . it is not now unusual to see a wide opening with no door in it. . . . The portiere has become one of the chief expenses in the modern room."

As in England, where the idea was transplanted to the better suburbs, so in America simpler versions of the Free Classic style evolved.

It is difficult to define the furniture style of the 1880s, but there were certain trends. Suites were not used, but sometimes a few basic pieces with matching frames — a settee, an armchair, a side chair, and a center or occasional table — were introduced. The upholstery of the seat furniture was not always in matching materials. A light type of furniture, referred to in the trade as "Modern Renaissance," was made of mahogany, with slender legs. Occasionally a projecting top drawer was used on desks, buffets, or bureaus. Some Italian influence was seen — fine individual pieces in walnut with carved panels, or of calamander wood (brown striped ebony) intricately carved and pierced.

Circular tabletops were often veneered with sections of wood arranged in a design. Display cabinets on short legs, glass-shelved and fronted, were filled with bric-a-brac; whatnots were square, with three open shelves and one drawer. A large circular or octagonal ottoman with jardiniere core frequently replaced the center table; in such rooms there were occasional tables of moderate size, circular or, more frequently, oblong in shape, for small groups.

For elaborate bedrooms basic items of fine design and workmanship were made *en suite*, often with a chaise longue, wicker chair, and antique occasional table added. Metal bedsteads were increasing in popularity.

In this decade it is noticeable that cabinet-made furniture almost disappeared from the award lists of the American Institute. In 1881 C. E. Sanger, 661 Broadway, received a Diploma for an Eastlake adjustable table; 1882 E. E. Stockwell and Wiswell, 21 East Fourteenth Street, were awarded the Medal of Excellence for Art Furniture. An interesting item was "Manufactures of Three-ply Veneer," for which Martin Herz, 412 East Twenty-third Street, received the Medal of Excellence. Folding beds were shown in quantity, as were adjustable, rocking, and reclining chairs and roll-top desks and bookcases.

Large-scale furniture manufacture began during this period. In 1880 the Kreimer and Brother Furniture Company of Cincinnati employed three hundred men, shipping to every part of the United States and to Australia, South America, and other foreign countries.

The Morris chair made its appearance in America in the 1880s and was a welcome addition to the variety of chair styles introduced during the decade. It was marketed by Morris and Co. in England, the idea having been taken from a chair "picked up in Sussex" by a member of the firm.

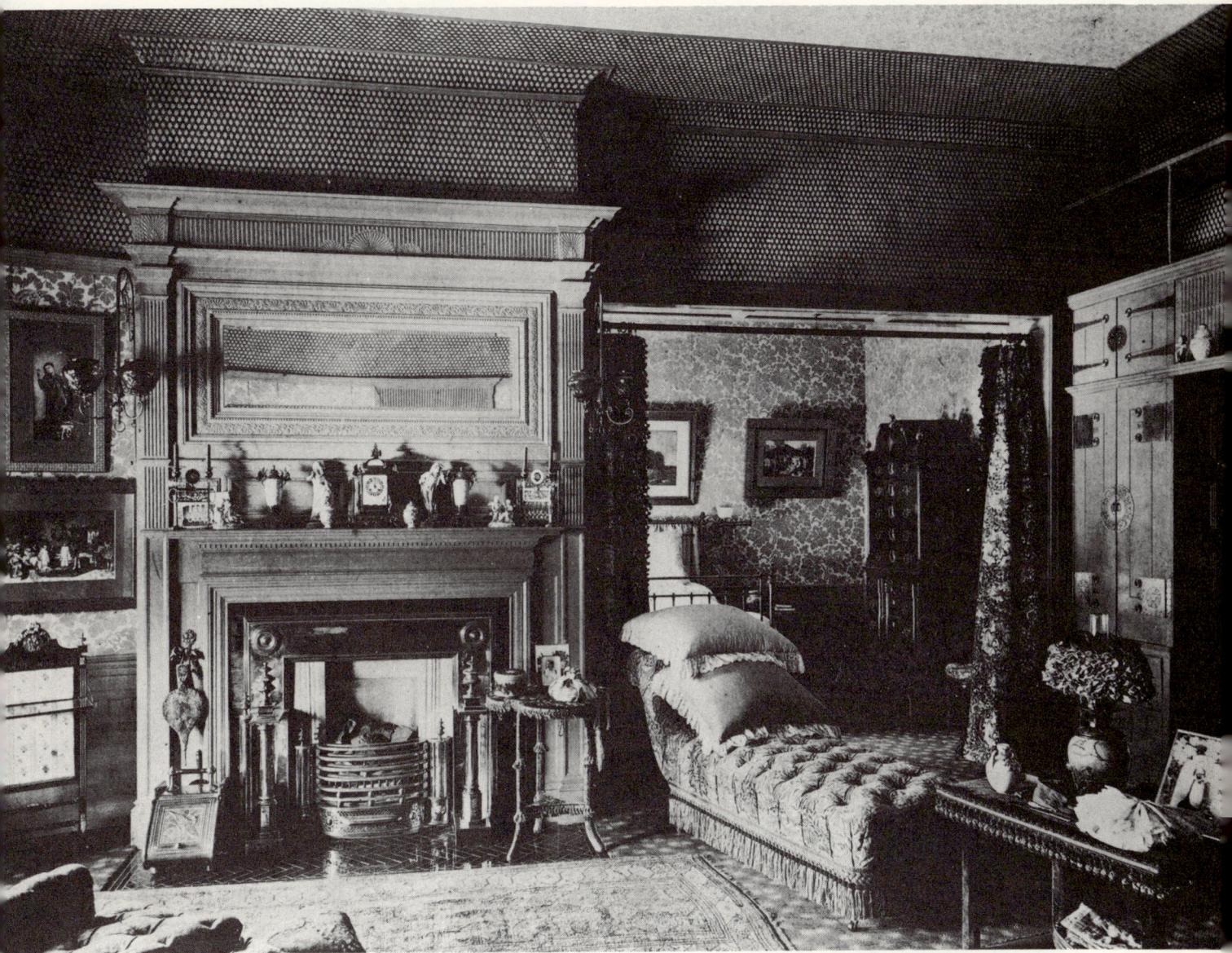

453

453. In the boudoir of Mrs. C. A. Whittier in her Boston home, the couch and easy chair are in the *"confortable"* style introduced by Empress Eugénie. Small gypsy and occasional tables are upholstered and finished with fringe. (*Illustration from* Artistic Houses, *1884.*)

454

454. Hexagonal Moorish tabourets became popular and were used not only in cozy corners but also as small occasional tables; their bases were composed of six flat sections, cut out in Moorish arches, inlaid in white and dark woods with rayed and pointed designs.

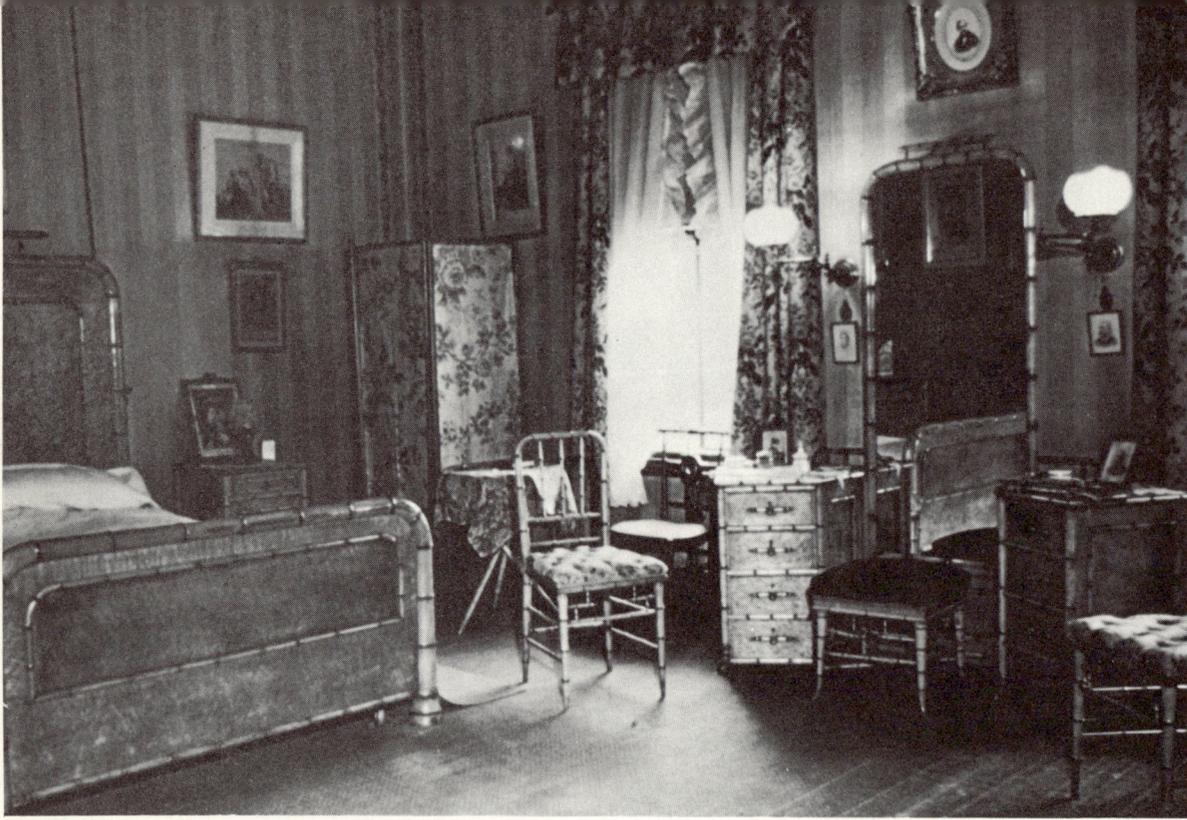

455

455. In the Gibson House, Beacon Street, there is a fine, complete set of bedroom furniture in figured maple. Bamboo-turned moldings outline the double bed, night table, and dressing table with stool, the four stick-back chairs with upholstered seats, and a gypsy table. A davenport, a mahogany Voltaire, and a Moorish tabouret are in the same room.

456

456. Henry J. Willing's house on Rush and Ontario Streets in Chicago was considered very handsome. The portiere in the drawing room and library was from the pavilion of the Empress of China; the center table with pierced rim and elaborately carved pillar had been owned by the Emperor Maximilian of Mexico. There were a fine print on an easel, a Moorish tabouret, an Italian carved chair; rattan and bamboo rocker; a wicker chair. The library fireplace of Iowa stone had high columns and a sculptured tablet. (*Illustration from* Artistic Houses, *1884.*)

457. Mr. F. W. Hurtt's drawing room, with its Moorish arches and low bookcases, is filled with fashionable objects: a heavy Turkish chair with embroidered back and seat, a wicker rocker with plush cushions. The trefoil top of a gypsy table is upholstered, with a nail-fastened lace edge. The Second Empire chairs, one with long fringe, are dissimilar. An upright piano has decorated panels. The presence of a painting on an easel is much in the mode as is the profusion of miscellaneous art objects. (*Illustration from* Artistic Houses, *1883.*)

In 1878 Harriet Spofford referred to the then current passion in the polite world for the art of the Orient. The Moorish style was characterized by use of the horseshoe arch, diaper pattern, and divan. The terms "Moorish" and "Turkish" were interchangeable; the Turkish cozy corner, bedecked with Moorish accouterments and saddle-bag upholstery, was featured for years. Mrs. Henry Adams, shopping in Europe in 1873, was "distracted between two old Moorish writing tables." For the comparatively new Japanese mode chairs of bamboo and rattan were favored. A photograph of President Garfield's bedroom at the White House shows a table and door framing ornamented with bamboo-turned moldings.

A different economic and social tempo seemed to characterize the nineties. The immense scope of available territory and natural resources nourished individual ambition and enterprise. The leaders of society were men engrossed in creative thinking and plans for developments far beyond anything the world had hitherto known.

A noticeable characteristic of furniture design of the nineties is the abandonment of the use of any detail of construction or ornament in the manner of Greek or Roman classicism. It was a logical tendency, influenced by the work of such architects as Louis Sullivan in Chicago, who disliked classicism and, after a lapse into Romanesque, developed his theory that form follows function. Chicago had the first building with steel beams in America, and what came to be recognized as the Chicago school of architecture had a strong impact on American design.

Two innocuous American furniture styles were introduced during this period. In 1885 Stanford White chose Colonial architecture as the inspiration for construction in Newport, and from this a Colonial type of furniture developed. Unpretentious and practical, this style lasted into the twentieth century. At the same time Mission furniture appeared, with weathered oak frames, made chiefly of flat slats, and with loose leather cushions. Mission furniture was inexpensive and deliberately primitive. The two styles met only a fraction of the market's requirements.

From the beginning of the nineties a trend toward new types of furniture and decoration is clearly perceptible. With a complete lack of formality interior designers mixed priceless antiques with wicker chairs, gypsy tables, and the heavily padded and upholstered *"confortables"* of Second Empire origin, which were called "Turkish." In addition, there was a vogue for stained-glass and Tiffany lamps, which contributed to the colorful conglomeration in room decor during the last decade of the century.

In 1893 Congress selected Chicago as the site of the World's Columbian Exposition. An enormous area on Lake Michigan was chosen. The ferment of Art Nouveau was already working, and architects gave their fancy full rein. Lighting effects contrived with Edison's electric bulbs and lake reflections were especially beautiful. The Exposition was opened on May 1; on May 6 the market crashed. Nevertheless, attendance did not falter, and visitors poured in from abroad and from every state in the country. As far as furniture was concerned, exhibits were limited in quantity, and criticism was generally disparaging. In the United States, according to the *Art Journal*, artistic designing and embellishment of household furniture seemed to be given almost no consideration.

This criticism was not justified; American manufacturers employed the best designers, were

458

459

458. Traditional styles were deliberately abandoned in this third-floor picture gallery in the house of Mr. and Mrs. H. O. Havemeyer, 1 East Sixty-sixth Street, New York. The interior was decorated by Louis C. Tiffany and Samuel Coleman in 1892. As usual, Tiffany mixed Moorish and Japanese styles in his scheme; Oriental rugs were laid on the marble floor. Highly interesting in design, the bench, tables, and chairs are reduced almost to elemental forms. Marble tables have square tops, the center support formed of four flat sections with united flange feet. The landing of the very unusual metal flying staircase of Moorish design shows Free Classic influence, as does the replacement of a door by a portiere. (*By permission of Mrs. Peter H.B. Freylinghuysen. Photo: Metropolitan Museum of Art.*)

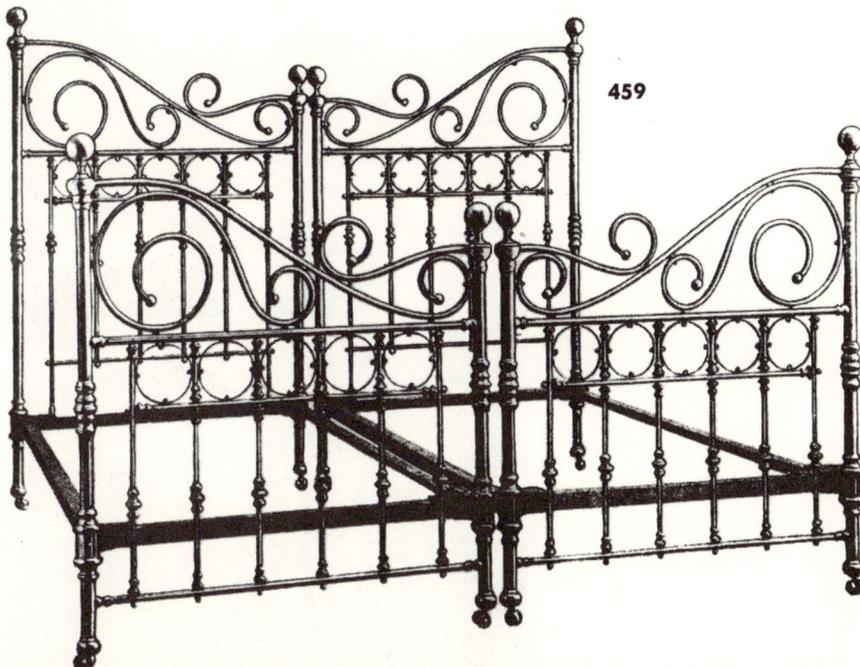

459. The use of metal bedsteads, especially brass, reached its peak in the 1890s. On medical advice twin beds were introduced and enthusiastically adopted. In September 1897 the cover of *The Furniture World* was used by Oscar E. A. Wiessner to introduce his new brass twin bedsteads, their crestings on head and foot designed with asymmetrical scrolls. Iron bedsteads were still widely used, as is shown by his offer of "seventy-one patterns ... ready for Fall."

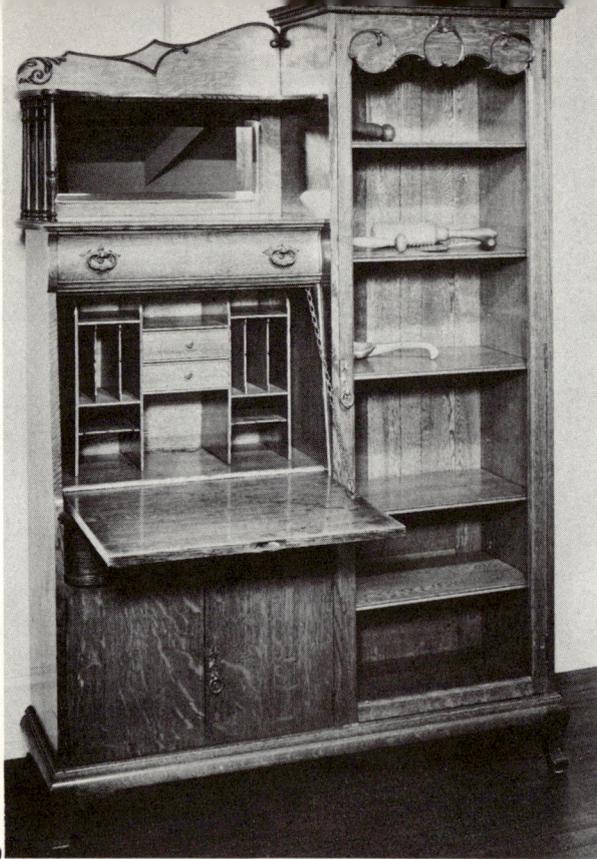

460. Asymmetrical "Quaint" secretary bookcase in golden oak, made by the Grand Rapids Chair Company in 1892. The vertical bookcase is protected by a full-length glass door; ornament is confined to slight carving. The secretary stands on the same plinth as the bookcase but otherwise does not correspond to it in any way. The execution and finish are good. (*Grand Rapids Public Museum.*)

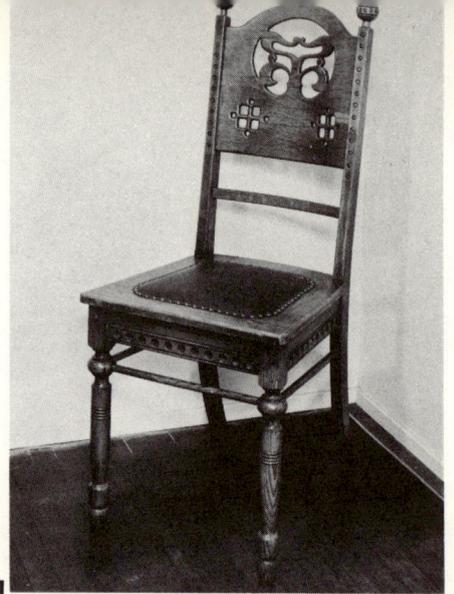

461. Quality dining chair in golden oak. Back legs continue as uprights surmounted by nail-head ornament; the back panel is arched, with pierced carving. The seat has a small leather center and indented ornament on the rail. Front blockings lengthen to bulbs, to which high stretchers are attached. Baluster front legs have double-flanged feet. (*Grand Rapids Public Museum.*)

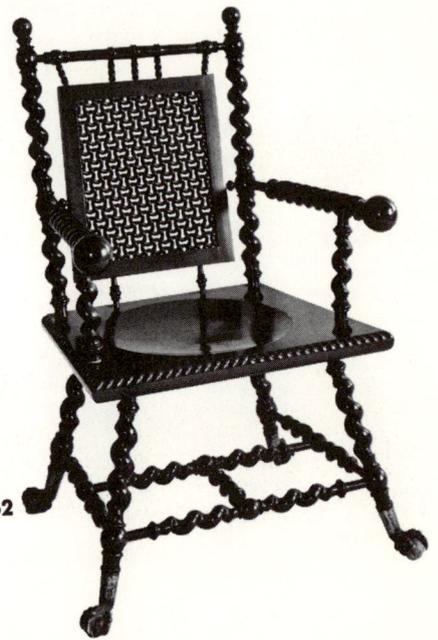

462. Spiral-turned mahogany open-arm chair with splayed legs and metal claw-and-ball feet. The square cobbler seat with a round hollow in the center was a new feature. It perhaps was made by Bodenstein and Kuemmerle of Philadelphia, who produced oak and mahogany chairs with cobbler seats and curious twists in the frame. Similar chairs were used in Mr. Franklin H. Tinker's library at Short Hills, New Jersey. (*Brooklyn Museum.*)

463. Bedroom washstand in curly birch designed by August Behrens of Grand Rapids in 1890. A serpentine-fronted drawer projects over a two-door cupboard, and the wooden back has high side posts holding a cross rail for towels. (*Grand Rapids Public Museum.*)

464

465

466

464 and 467. Chair and settee, part of a set of seat furniture bought in 1897, designed in the Colonial style. The frames are plain mahogany, with capping bands on the arms and cabriole legs with club feet. (*Mr. and Mrs. William E. Herrlich.*)

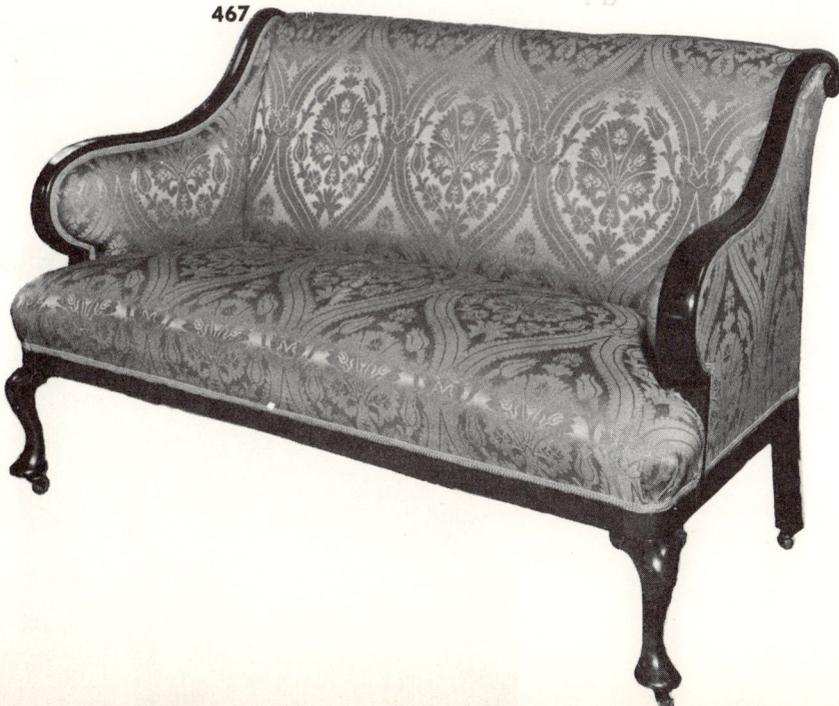

467

465. One of a series of heavily padded and upholstered backless couches for reclining, included in a Grand Rapids catalogue and taken from a type introduced by the Empress Eugénie; eighteen varieties were illustrated. The nonadjustable head is set at an obtuse angle; forty-four springs were used in this example. A couch of this type appears in a photograph of the state bedroom at the White House taken during the term of Benjamin Harrison, 1889–1893.

466. American Morris chair with adjustable back, made of golden oak with a strong grain. The combined front legs and arm supports have the contour edge facing sideways instead of forward. (*Brooklyn Museum.*)

masters of their machinery, and produced excellent furniture, including well-made and practical new items. A change in marketing methods took place; suites were abandoned, and each item was individually priced. Oak was increasingly used, in golden, antique, fumigated, English, weathered, or Flemish finishes; the most expensive was quartered. Covers were not used on tables whose tops were of quartered oak. Manufacturers and designers turned definitely from the past. The Grand Rapids Wholesale Furniture Company produced the "largest, most complete and expensive catalogue issued by any Wholesale Furniture House in America . . . only the choicest selections of High Grade Furniture from the largest and most prominent Manufacturers in the country." It is interesting to see, in this imposing catalogue, that, except for basic furniture norms, all traditional styles and ornamental motifs were avoided. No columns, pilasters, colonnettes, tablets, or panels were used, and stiles in the form of square posts were lengthened to serve as legs. The only chairs with padded back panels were parlor, easy, and rocking chairs. There were 112 patterns of wooden chairs for dining or kitchen, and some seats had a small caned or upholstered panel. Some good, simple bookcases were sixty-three to sixty-nine inches high, with full-length glass doors. Mirrors were undistinguished, in oak frames, some partly gilt. Easels, offered in sixteen versions, many brass-trimmed, were embellished with fretwork of three- or four-ply solid oak. "Pedestals, round or square — Very Stylish Design —" cost $4.25 to $9.25. Refrigerators ranged from the utilitarian to those made with four decorated panels on the door and a high back with mirror and small bracket shelves.

For the 1890s Oetzmann and Co. of London produced a furniture catalogue with over nine hundred pages of illustrations. One "modern" section presented various "Fitments: . . . Ingle Nooks, Ornamental Archways and Quaint Overdoors," apparently meant for use in free classic interiors. The term "Quaint" was probably chosen to disarm criticism and was also used in America. In *A History of American Furniture* (1902), Sironen refers to "Quaintly simple Gothic" and "a sideboard in the Quaint style of England." Many pieces were asymmetrical, an idea expressed in many ways, some of them practical. In the Grand Rapids catalogue one type of dressing bureau had its top drawer omitted; instead, a small case of drawers was set on the right hand and a lengthened mirror on the left in a comfortable and convenient fashion.

468. An American Free Classic staircase in the house of Mr. H. M. Flagler at Mamaroneck; a stuffed peacock is perched on the carved rail of the landing. (*Illustration from* Artistic Houses, *1884.*)

468

469

469. Mr. Robert Goelet's hall in the Free Classic style; rockers, a Turkish pouffe, a chaise longue, and Jacobean chairs are placed informally. Visible in the drawing room are one of the new small divan settees and an oblong table, upholstered all over, finished with fringe — both high fashion. (*Illustration from Artistic Houses, 1884.*)

470

470. Illustration of a Gothic room from *Harper's Monthly* in 1876, an example of the use of portieres with an open doorway. (*New-York Historical Society*.)

471. Illustration from *Annual Architectural Review* of 1892 showing an English Free Classic interior, with arched openings instead of doors and an upstairs gallery with a baluster railing and carved birds on the posts. The furniture includes a court cupboard, Jacobean armchair, Second Empire and wicker chairs; a bamboo tea table has suspended shelves; lamps and a spindle screen are Moorish.

472. Hall in the house of Mrs. Simeon M. Andrews, Greenwich, Connecticut, illustrated in the *Annual Architectural Review* of 1894. It shows an unpretentious American version of the Free Classic style; the paneling, woodwork, and staircase are simple in design and light in color. The fireplaces are of brickwork with a shelf instead of a mantelpiece; on the ground floor there are inglenooks, and portieres instead of doors. The effect is light, convenient, and informal. A design for a similar house in Portland, Maine, was illustrated in the *Review* in 1893.

471

472

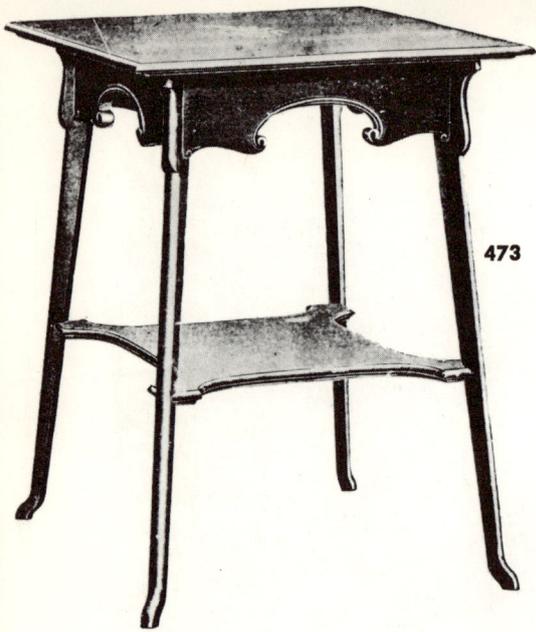

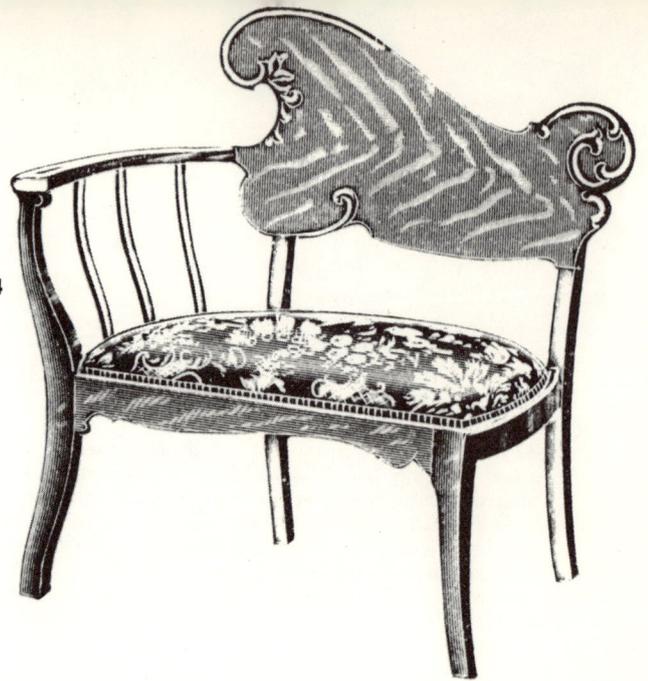

473. Small parlor tables were made with circular or oblong tops on four legs, with a low, shaped stretcher shelf.

474. Small divan (a Second Empire feature) with an original back.

475. Small, fashionable Louis XV dressing table with an egg-shaped mirror.

476. Divan with a centered back. The high arms are supported on a splat and a baluster over the front legs.

478

479

477. Chair, with back legs set under the narrowed base of the shaped back.

478–481. These four chairs were designed by John H. Goldhammer, superintendent of the Yeager Furniture Company, Allentown, Pennsylvania, and illustrated in *The Furniture World* in 1895. All are practical and present a stable appearance, but none of the ornamental detail is of accepted or traditional character. 478: Hall chair with a wooden saddle seat. 479: Curves unite the structural elements of the back of this parlor chair. 480: Chair with a circular seat and unusual leg placement. 481: The complicated back of this chair has angles only where legs and seat meet.

480

481

INDEX

(Figures in bold face are illustration numbers. Roman numerals refer to color plates.)